A HISTORY OF
PALEONTOLOGY
ILLUSTRATION

Life of the Past

James O. Farlow, editor

A HISTORY OF PALEONTOLOGY ILLUSTRATION

Jane P. Davidson

Indiana University Press

Bloomington & Indianapolis

This book is a publication of

Indiana University Press
Office of Scholarly Publishing
Herman B Wells Library 350
1320 East 10th Street
Bloomington, Indiana 47405 USA

http://iupress.indiana.edu

The paper used in this publication meets the minimum requirements
of American National Standard for Information Sciences—Perma-
nence of Paper for Printed Library Materials, ANSI Z39.48-1984.

Manufactured in the United States of America

Library of Congress Cataloging-in-Publication Data

Davidson, Jane P.
 A history of paleontology illustration / Jane P. Davidson.
 p. cm. — (Life of the past)
 Includes bibliographical references and index.
 ISBN 978-0-253-35175-3 (cloth : alk. paper) 1. Paleontological illustration—History. 2.
Fossils in art—History. 3. Zoological illustration—History. I. Title.
 QE714.2.D38 2008
 560.22'2—dc22
 2007052741

3 4 5 6 7 18 17 16 15

This book is dedicated to the memory of four men who, each in his own way, played a large role in my life as a historian. Edward Drinker Cope has been a subject of my scholarly interest for almost two decades. My dad and my Uncle Carter always encouraged me to learn and achieve as much as I could in whatever field I chose to study, or, as Cope put it to his own daughter, "Read and learn all thee can, for the more thee knows the more useful thee will be." My godfather, Ernest, showed me fossils and rocks and taught me about them when I was just a little girl. Because of Ernest, the very first book I ever took out of the public library "all by myself" to take home to read was Roy Chapman Andrews's *All about Dinosaurs.* I was six or seven years old. Thomas W. Voter's illustrations of fossil animals, showing them as they might have been in life, have been pursuing me ever since. Today a copy of Andrews's book sits on a shelf in my office right next to a specimen of *Placenticeras meeki* that Ernest gave me a very long time ago.

In memory of Edward Drinker Cope (1840–1897), paleontologist and artist

And in memory of my father, Robert W. Pierce (1913–2001), Carter P. Qualls (1921–1998), and Ernest Jones (1900–1978)

It is astonishing to find how tenaciously, until the middle of the eighteenth century, so many authors clung to such absurd ideas, even though the fossils were being made known by means of good illustrations to an ever-increasing number of observers. The works of Aldrovandi, Athanasius Kircher the Jesuit, Sebastian Kirchmaier, Alberti, Balbini, Geyer, Hartley and many others in the seventeenth century contain some very good figures, and extended the knowledge of the fossils found in various European localities. The fossils were, however, treated usually as mineral curiosities, or as illusions of nature.

Karl Alfred von Zittel, *A History of Geology and Paleontology to the End of the Nineteenth Century,* 1899

The story of Fossils—what they are and what they teach—is a thoroughly fascinating one, and involves a great deal more of real interest to every one of us than is generally realized. When we consider that Fossils constitute all of our documentary evidence concerning the character and evolution of the plants, animals and men of prehistory we see how very necessary is this study to any correct knowledge and understanding of life, past and present.

Richard Swann Lull, *Fossils: What They Tell Us of Plants and Animals of the Past,* 1931

Every generation of man is born to stare at something.

Thomas Hawkins, *Memoirs of Ichthyosauri and Plesiosauri,* 1834

CONTENTS

PREFACE

The science of paleontology has always been inextricably tied to art. Even in the age of digital cameras and cell phones with cameras, when one might not think that there would be any reason to draw a fossil, students are still being instructed to draw their lab specimens. This was my experience in a course in general paleontology that I sat in on a few years ago. The professor told the students in lab to at least try to draw the specimens, however badly, as a part of their lab notes. I found that advice fascinating.

Since it has always been impossible for scientists and the public to see every fossil, visual representations of fossils have always been essential. Some of the fossils turned out to be rather ordinary, others were extraordinary, but they were made famous through being described in imagery and words. Some of the people who created these images were already well-known scientists. Henry De la Beche, Edward Drinker Cope, and Samuel Williston are but a few examples; the list is vast. They frequently created their own scientific imagery, and sometimes collaborated with professional artists and illustrators. Other paleontologists worked as advisors to artists in an effort to help them represent fossils accurately and to make the images interesting to their viewers. That category might include anyone from colleagues to museum administrators, potential government patrons, or the "great herd," as Edward Drinker Cope at times called the public.

Then there were those who were not scientists but became famous because of their scientific art. The Dane Gerhard Heilmann (1859–1946) was one such. He studied medicine for a while but then turned to a career as a commercial and fine artist. His 1926 book *The Origin of Birds* was illustrated in part with his own drawings and paintings made after original fossil specimens. He also depicted life restorations that were literally drawn from his imagination. Heilmann had a lively imagination indeed, and is probably best remembered today for his illustration of two *Iguanodons* running along as though they are at a track meet. That was a pretty radical stance for a dinosaur to take in the scientific illustration of the early twentieth century. Other Heilmann vignettes of birds and dinosaurs were executed in a similarly lively and apparently naturalistic manner. A modern example of an artist whose work has made him widely influential among paleontologists is Greg Paul.

This book asks whether there is an artistic theory or aesthetics of style that is unique to paleontology illustration. Can a paleontology illustration be placed within the general context of art theories or styles common to the period in which the work was created? Or can a special set of characteristics be found in this form of art? One might ask further if a single theory or aesthetic

of paleontology illustration could exist when these illustrations cover a period of roughly five hundred years. Styles came and went, but some aspects of style, such as an interest in realism, remained important from century to century.

Our discussion begins with fifteenth-century art and progresses through book illustrations and other media that depict fossils. The period from the fifteenth to the twenty-first century encompasses several major periods of western art. At first glance, it might seem problematic to compare, for example, a painting by Petrus Christus (active in the first half of the fifteenth century) with a work by Monet. It could certainly be argued that Flemish renaissance art had nothing in common with impressionism. But, if one looks more carefully, one could indeed find style and aesthetic elements that they have in common. Christus and Monet experimented with novel techniques in oil painting. They tried to impress the viewer with their technical skills. Both were concerned with depicting effects of light in realistic ways. Both painted ordinary items with the intent of showing them as they looked, but also of using them as metaphors. The objects did not need to be significant in themselves. What was significant was how they were depicted for the viewer. Thus, we can argue that a rock crystal or a fossil shark tooth in Christus's *Saint Eligius* has much in common stylistically with a water lily in a painting by Monet. Centuries separate these artists, but the aesthetics of the Impressionists were derived from a longstanding emphasis in European art on the importance of realism. Let me state clearly that paleontology illustration is art, and it has its own place in western art history. There is no need to draw a distinction between scientific illustration and other forms of art.

Paleontology illustrations can generally be placed within the artistic context of the period or place in which they were created. But can we also find style and aesthetic characteristics that are unique to paleontology illustration? I believe that we can. There does appear to be an aesthetic of paleontology illustration.

Paleontological illustrations have portrayed all kinds of fossils. They have not been limited to vertebrates, or even to animals. Almost from the beginning there have been depictions of invertebrates, plants, and even environments. In each case, artists and scientists worked together to achieve what they believed to be scientifically accurate imagery. This desire for visual realism is, I believe, one of the unique characteristics of paleontology illustration.

The number of paleontological illustrations is extremely large. It is not possible to describe every artist or every illustration. Much of the imagery I have chosen falls into the category of "scientific illustration," although not all of it is taken from scientific treatises. I have also included art that represented fossils in popular and more general educational literature. In addition, I will discuss museum displays of various kinds. Here the line between "scientific illustration" and popular art may be less clear, as a museum display could be of instructive value to scientist and non-scientist. I have tried to examine paleontology illustrations in a number of media, although I will not devote too much time to cinema. Similarly, while vast numbers of fossils are depicted in cartoons, I will not discuss these. Although one can scarcely think of paleontology without thinking of Gary Larson, whose wonderful cartoons have

found their way into a number of scientific publications, I have limited my study to illustrations which had an instructive value to the observer. Thus a large purple theropod does not find a place here.

This book was inspired by a course on the history of paleontology illustration that I created as a seminar for seniors and graduate students. I discovered that there was no book that covered this subject in any comprehensive way. My students, on the other hand, were stunned at how much art was available, from which they could select seminar paper topics. One commented to me that she thought at first that her topic might have to be Pebbles and Dino, but when she began to do research on a topic, she was astounded by how much "stuff was there."

In any project, there are people to thank for their help and encouragement. Mike Everhart has generously offered his expertise, enthusiasm, and help to me time after time. Christopher Duffin likewise shared his own work with me and sent me looking into materials I might otherwise have neglected. Thanks go to Earle Spamer of the American Philosophical Society, who has been my friend, colleague, source of information, and sounding board for more than a decade now. Paula Noble, paleontologist at the University of Nevada, kindly let me attend two of her senior/graduate level paleontology courses. Thanks also to Dan Varner and Richard Forrest. An anonymous reviewer for Indiana University Press read the proposal for this book and made a number of useful suggestions. Thanks to Jim Farlow for his careful reading and editing of the text, and thanks to Bob Sloan for his help and editorial expertise. Thanks also to Douglas Rhiner of High Mountain Imagery, Reno, Nevada.

In this book I have for the most part retained the scientific names used at the time when the works of art I am discussing were created. When a name is no longer in use, it will be accompanied by the specimen's current scientific name. This I did in order to retain the historical status of the works. The artists named their works according to the nomenclature of the time. We could not rename any other work of art. We should not rename paleontology art either.

A HISTORY OF
PALEONTOLOGY
ILLUSTRATION

Gloſſopetra denticulata Geſneri.

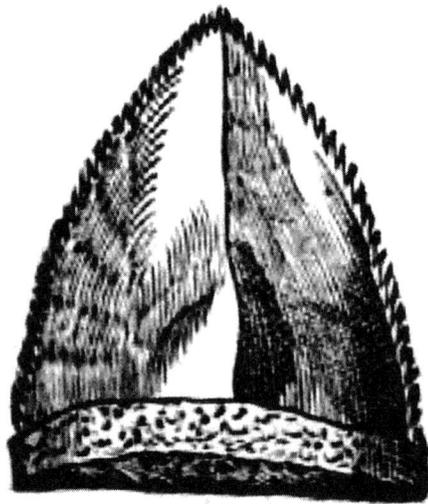

FOSSILS IN ART AND BOOK ILLUSTRATION IN EARLY MODERN EUROPE

1

Fifteenth- and sixteenth-century artists were extremely concerned with realism. In northern Europe, Flemish masters, such as Petrus Christus, took this typical renaissance desire for accurate visual representation almost to the point of obsession. Northern European renaissance art is characterized by extremely fine details. Because the northern masters used oils, they were able to literally draw the fine details of the objects they depicted, using brushes of only a few hairs to lay down many layers of very thin oil paints. They could then depict items such as clasps on jewels, refracted light as it passed through crystal, and even eyelashes or individual hairs on a person or an animal.

This realism was applied to scientific illustration. It went hand in hand with the emergence of modern science, wherein observation and comparative study became important. The intellectual life of early modern Europe demanded the investigation and comparison of data and specimens. Accordingly, authors who discussed fossils had their books illustrated, usually with prints made from either woodcuts or copper-plate engravings. Scientific authors tried for the most part to include high-quality and accurate images in their works.

Fossils were collected and studied by scientists and "amateurs" alike prior to the appearance of scholars whom we might begin to call "geologists," such as Nicolas Steno, and even before images of fossils began to be published in scientific treatises in the sixteenth century. The word "amateur" meant "one who loves something," and did not connote a lack of formal training in a field, as it does in modern English. Amateurs were those people who collected art, luxury items, and unusual objects for ostentatious display or for study. They are important figures in the history of science in early modern Europe. Some of them, including many popes, amassed significant natural history and mineral collections. Wealthy patrons, often members of royalty or nobility or princes of the Church, also collected art and objets d'art. Any of these items, including natural specimens or fossils, could find a place in what were commonly called *kunstkamern* or cabinets, and many of these collections became the foundations for many of Europe's largest and oldest museums.

But the owner of a *kunstkamer* need not have been a member of the nobility. Many wealthy people established such collections on a smaller scale, as entertainment, as an investment, as an ostentation, or to foster the growth of knowledge. A burgher in Bruges who owned a collection of, for example, stuffed West Indian iguanas brought home by sailors, paintings, Chinese ex-

Figure 1.1. Ulisse Aldrovandi, *Musaeum metallicum*, 1648. Fossil shark tooth. *Courtesy Ed Rogers.*

port porcelains, and fossils or mineral specimens might collect them together for the delight of his friends. By the end of the sixteenth century, paintings and engravings depicted the contents of actual *kunstkamers*. Petrus Christus's painting *A Goldsmith in His Shop, Possibly Saint Eligius,* executed in 1449, depicts a *kunstkamer* with many rare and unusual items on display in the guise of the saint's goldsmith shop. Frans Francken I, an early-seventeenth-century Flemish master who died in 1625, also painted depictions of art collections. The museum of rarities of Pope Pius V and his successors was depicted in a series of engravings destined for a book to be called *Musaeum metallicum*. Viewers of such works were meant to enjoy both the artwork and the items depicted in it. Not only were specific collections shown in paintings, but these paintings themselves became part of the collections, much as paintings of restored fossil life, dioramas, or photographs are combined with actual fossils in museums today.

Petrus Christus
A Goldsmith in His Shop, Possibly Saint Eligius

The Flemish painter Petrus Christus (active as a master in Bruges by 1444, died 1475–1476) was among the first artists to depict a fossil that may be readily identified, in a painting that also showed the typical contents of a *kunstkamer*. Christus is traditionally thought to have been a pupil of Jan van Eyck (c. 1390–1441), although this has not been documented.[1] Christus was certainly influenced by his contemporary van Eyck, electing as van Eyck did to use the rather novel medium of oils, and his technical style is similar to van Eyck's. Christus delighted in using fine oil glazes to illustrate, with great detail and precision, items of still life, drapery, and facial features. In 1449 he painted a panel depicting the legend of the goldsmith Saint Eligius.

A Goldsmith in His Shop, Possibly Saint Eligius (color plate 1) belongs today to the Metropolitan Museum of Art in New York. It is possible that this painting was executed for a member of the Bruges Guild of Goldsmiths, and indeed its provenance can be traced back to a member of that guild in Antwerp.[2] The painting depicts a young couple who have come to the shop to buy a wedding ring. It is executed on an oak panel and measures 39.4 × 33.8 inches, medium-sized for the period. Flemish renaissance painters frequently painted on small panels as a means of demonstrating their skill with the medium of oils. Items that were measured in inches were painted with tremendous delicacy and detail to entertain and impress the viewer. A painting of this size would have been itself part of a *kunstkamer*. Joel M. Upton, in his *Petrus Christus: His Place in Fifteenth-Century Flemish Painting,* has suggested that *A Goldsmith in His Shop* could have been part of a small altarpiece such as would have been found in a guild chapel, but notes that its original use is unknown.[3] It seems more likely that the painting was destined for private use. It might have been part of a collection itself. Perhaps it was a visual pun, showing the patron's objets d'art within another work of art. Two men are seen reflected in the convex mirror in the saint's shop window, and their act of viewing is the same act performed by observers of the painting. They serve as another visual pun.

To record the rare and the beautiful was part of the purpose of this

painting. It is not impossible that the items seen in the saint's shop belonged to the person who commissioned the painting. How fascinating it would have been for his or her friends to look at the painting and then pick up the branch of red coral, the rock crystal wand, or the fossil shark teeth for further examination and study. Without question, Christus had seen the specimens of fossil shark teeth that he depicted in this painting. It is also possible that he owned them himself. He was certainly successful enough as a painter to have afforded rarities for a personal *kunstkamer*. Or some patron might have given them to him.

Similar geological rarities (although not fossil shark teeth) are to be found in paintings by Jan van Eyck. Van Eyck painted many rock crystal wands incorporated into bishop's crosiers, staffs held by saints, and, in his famous *Ghent Altarpiece,* the staff held by God the Father. Coral prayer beads are held by the Christ Child in van Eyck's *The Madonna and Child at The Fountain of Life* (1439; in the Koninklijk Museum Voor Schone Kunsten, Antwerp).

Just as the works of Flemish painters had multiple uses, they also had multiple layers of iconography. This complexity of symbolism is also a part of Flemish renaissance style. Christus's *A Goldsmith in His Shop* is no exception. Its complex iconography derives both from the saint's life and from the uses of the rare items found in the saint's goldsmith shop. This painting is in part, and on the surface, an allegory of the dichotomy between the saint's holiness and the worldly temptations provided by the items he crafted and sold. The young couple who have come to buy a wedding ring from the saint represent worldliness. Eligius, on the other hand, represents detachment from worldliness. But there is more going on here than just the story of Eligius the goldsmith.

According to legend, Eligius was born about 588 and was apprenticed by his parents to a goldsmith. He was so skilled as a goldsmith that his work became known to the Frankish king, who commissioned works from him, as did several cathedrals. But the young man was well known for his saintly demeanor and disdain for the very wealth he worked with, and he entered the priesthood and was eventually made the bishop of Noyon. Here Eligius ministered to Christian and pagan alike. He was famous for his charity and care of the poor and the ill. As a saint, he was invoked against the plague. He was also a patron of horses, coachmen, and blacksmiths, and of the Netherlands in general.[4] He thus has many iconographic roles to play, and is seen in this painting as both a goldsmith and an apothecary or physician.

We can identify the saint as an apothecary by the hat he wears: a typical physician's hat. Similar hats are seen in paintings by Rogier van der Weyden (c. 1399–1464) of Saint Luke, who is also identified by tradition as a physician. Rogier depicted Saint Luke dressed in red, just as Eligius is, and wearing a physician's hat in his *Saint Luke Portraying the Virgin Mary* (about 1450; Museum of Fine Arts, Boston, Mass.), and also in his *Virgin and Child with Four Saints (Medici Madonna)* (about 1435–1440; Staedelsches Kunstinstitut, Frankfurt), wherein Luke not only wears the physician's hat but carries a flask of urine, which is both a reference to his tradi-

tional role as a physician and a visual pun on "Medici," the name of Rogier's patron. Such complexity is typical of Flemish renaissance iconography.

On the shelves of his shop Saint Eligius has items which might have been useful to either a goldsmith or a doctor or alchemist. Crystal, coral, and fossil shark teeth were all believed to have curative and protective powers. A description of the folk belief that coral was effective in protecting infants from witchcraft or the "evil eye" is found in Johann Weyer's (1515–1588) famous text, *De praestigiis demonum* (literally "The Impostures of Demons"; it is also translated as "On Magic"), first published in 1563. Weyer commented on a belief that dated to antiquity: "They say that red coral hung about the neck of infants or enclosed in bracelets and worn on the arm, or simply kept in the house, has a special efficacy against the evil eye."[5] Whether Weyer himself believed this is not terribly important here, and from his text it seems he probably did not, but his comment makes clear that many people did.

That coral was useful as a medication or a protective charm for infants and women was widely believed in the Renaissance. It was also believed to change color in the presence of poison or severe illness. The Christ Child is shown with coral in paintings across Europe. For example, Piero della Francesca's (c. 1420–1492) magnificent *Urbino Madonna,* painted about the same time as Christus's *Saint Eligius,* includes a very large piece of branched red coral hung about the child's neck.

The medicinal uses of coral and crystal were discussed by Ambroise Paré (1517–1590). Paré was a French surgeon who served in the army of Francis I, gaining fame for his treatment of gunshot wounds and amputation. (His discovery that amputees were more likely to survive if the arteries of the limb were tied off rather than cauterized prevented untold agony and death.) His collected works were issued in a number of editions and languages in the sixteenth and seventeenth centuries. The English edition of 1678 is illustrated with hundreds of woodcuts, ranging from depictions of surgical tools to a representation of Albrecht Dürer's engraving *The Rhinoceros,* to depictions of birth defects (there are several images of conjoined twins), to exquisitely detailed diagrams of human veins, arteries, and nerves. Paré wrote about surgery, obstetrics and gynecology, the treatment of illnesses such as the plague, and the field of medicine in general. He also discussed medicines and how to compound them, how to write up an autopsy report, and how to embalm the dead, and he gave practical advice, such as to ensure that the patient had truly died and was not merely unconscious from a seizure. His description of what today is commonly called a petit mal seizure is extraordinarily accurate and immediately familiar to anyone who has witnessed one.

Paré did not mention fossil shark teeth, but he did write about coral and crystal. Book 26 of his treatise on surgery, "Of the Faculties of Simple Medicins and Also Their Composition and Use," provides the practitioner with ideas and recipes for compounding medications from various sources. Paré notes that "from the salt water are taken Salt . . . all sorts of Coral, [and] Shells of Fish." In chapter 17 of book 36, "Of Distillations," Paré mentions, in a "table or catalog of medicines," the use of "white and red coral" and also "chrystal." He commented that coral could be used in "repelling

or repucussive medicines." These were astringents, but not merely astringents; they were "cold" and drove humors inward. Folk medicine seems to have advised placing coral in a child's room to protect it from witchcraft, but it was not advisable, according to Paré, to use a coral repercussive on "the bodies of Women, Children or Eunuchs," who were not able to withstand the cold of a strong repercussive.[6] So crystals and corals were logically to be found in the shop of an apothecary, such as Saint Eligius.

Fossil shark teeth, also known as tongue stones or glossopetrae, had similar properties and right of place in such a shop. They might have been destined for medicinal or magical use in a *Natternzungenbaum,* or "adder's tongue tree," a large decorative display festooned with fossil shark teeth (the tongues), or in an amulet. Christopher Duffin has pointed out that the belief that fossil shark teeth offered powerful protection against illness and snakebite can be traced into antiquity, and was certainly prevalent throughout Europe in the fifteenth through seventeenth centuries. The fossils were also believed useful in any sort of oral or dental problem and in childbirth. They were even associated with love magic and thought to be useful in seduction. This belief goes back as far as Pliny.[7] By depicting fossil shark teeth, coral, and crystal, together with other important objects, in Saint Eligius's shop window, Petrus Christus could refer to various stories of the saint, suggest good health, lust, love, marriage, and birth, and also present rarities to the viewer as additional points of enjoyment.

One of the keenest observers of nature, Leonardo da Vinci (1452–1519) left behind a number of drawings of rock formations. Some of these were probably useful to him in depicting such formations in paintings and other works, such as *The Virgin of the Rocks* (c. 1485; Louvre) and the magnificent *Virgin and Child with St. Ann and the Infant John the Baptist* (c. 1498; National Gallery, London). Leonardo's drawings were a compendium of a lifetime of observations and were sometimes accompanied by commentaries. Although they are now compiled into various "notebooks" and collections, they were not assembled or collated by their author. Because of this, dating the drawings and notes is often quite problematic. Some are connected to specific events or projects in the artist's life, such as sketches he made for his fresco *The Last Supper.* But in many instances dates remain relative and speculative.

Among the drawings that can be dated only tentatively are the drawings and notes he made concerning fossils. These are thought to have been executed about 1510. However, there is no reason to assume that Leonardo studied them for only a brief period. Indeed, we know that he carried out some of his scientific studies, such as those of human anatomy, throughout his life. Geology and hydrology were for Leonardo merely other forms of knowledge that he routinely gathered and eventually utilized in his art. For this reason we can include Leonardo among the scientist-artists.

One of the most famous of his drawings of rock formations is owned by the Royal Library, Windsor. *A Study of Rock Formations* (Windsor Library

Leonardo da Vinci

Observations on Fossils and Strata

Why do we find the bones of great fishes and oysters and corals and various other shells and sea-snails on the high summits of mountains by the sea, just as we find them in the low seas?

Leonardo da Vinci

no. 12,394) was executed in pen and ink over black chalk, and it probably dates to about 1508–1510. It is this drawing that is frequently referenced in discussions of Leonardo's scientific interests and his study of fossils. Yet the work does not depict fossils. Leonardo left several comments concerning stratified rocks and fossils, but there seem to be no extant drawings of fossils by him. This does not mean he never drew a fossil, of course. It means we know of no surviving examples. Since comments like the ones he made on fossils were often accompanied by an explicatory sketch, there is every reason to assume that he did indeed draw fossils. But in order to learn what he thought about stratified rocks and fossils, we must turn to his writings.

Leonardo's writings contain several examples of his carefully detailed observations of stratified rocks. He argued that marine fossils could not have been deposited on mountains by the biblical Deluge. "In this work you have first to prove that the shells at a thousand *braccia* of elevation were not carried there by the deluge because they are seen to be all at one level and many mountains are seen to be above that level." Moreover, he did not think that the Deluge was a universal event, and if someone were to claim that it had brought the fossil shells to the mountains of Italy, "I should answer that if you believe that this deluge rose seven cubits above the highest mountains—as he who measured it has spoken—these shells, which always live near the sea-shore, should have been left on the mountains; and not such a little way from the foot of the mountains; nor all at one level, nor in layers upon layers."[8] In pointing out that the fossils are found in many places but only one elevation, he seems to have been casting doubt on the truth of the Flood story. (It is always well to recall that Leonardo's "notes" were compiled by others and that these surviving documents probably do not preserve every thought he recorded on a given topic. If thoughts seem missing, indeed they may be missing.)

Leonardo provided a description of the movements of living cockles, having obviously concluded that the fossils had once been living cockles and other marine organisms. The cockles, he argued, could not have merely crawled up the mountainsides, following a rising shoreline. Nor could the shells in the mountain strata be the remains of dead organisms that had been washed upward, because closed shells, like those of living animals, are also found in the strata. Indeed, he had found a stratum in which all the shells were closed underneath one in which they were opened and separated.[9] And if they had been transported by a muddy deluge, such as one might see in a flood not of biblical proportions, the shells "would have been mixed up and separated from each other amidst the mud, and not in regular steps and layers as we see them now in our own time."[10] Leonardo also discussed other fossils besides those of marine bivalves. In one note, he remarked on the presence of shells alongside "bones and teeth of fish which some call arrows and others serpents' tongues"; in other words, he made mention of fossil shark teeth or glossopetrae.[11] Leonardo obviously devoted much study and time to strata and fossils within them, and it is too bad that he evidently left behind no drawings of fossils. His comments are highly significant nonetheless, because he stated very early in the sixteenth century that the fossils were indeed

the remains of once-living animals; they were not generated *in situ* in the rocks, and had not been carried to them by the Flood.

In renaissance Europe, it was unusual for paintings to include depictions of fossils, as Christus's *Saint Eligius* did; such depictions were generally found only in books. Most of these books were what we now term natural histories; they dealt with animals, plants, minerals, and, frequently, medicine. Sixteenth-century book illustrations were either woodcuts or copper-plate engravings. To make a woodcut, the artist cut a mirror image of the desired picture into a wooden block. The block was then coated with ink and the ink wiped off, so that it remained only in the grooves; then paper was pressed onto the block, firmly enough that it was forced into the grooves and thus picked up the ink. Engravings, which grew in popularity as the century progressed, were made the same way, except that the image was incised into a copper plate. These techniques (forms of intaglio printing, from the Latin for "cut in") have remained essentially unchanged to the present; the same tools are used now as in the 1500s.

Copper-plate engraving generally allows for finer lines and more detail than does the woodcut technique. Indeed, today the term "woodcut" often calls to mind a crude-looking image. But many renaissance woodcuts were quite sophisticated and detailed, resembling engravings in their delicacy and complexity of design. One could cite, for example, the magnificently executed illustrations in Albrecht Dürer's *Woodcut Apocalypse,* printed in 1498. At approximately 10.5 × 14 inches, the images occupy the entire page, with text printed on the reverse. Woodcuts varied in detail and quality, of course, from book to book. This variation may be explained by the different levels of technical skill that various artisans possessed, how much money the printer wished to spend on illustrations, and certainly by the author's level of concern for quality and realism in the images. I think in general that both scientists and artists tried to depict fossils realistically. These were unusual and problematic natural items, and it was important to show them as they really appeared so that the reader might study them and form conclusions about them. Poorly drawn and printed imagery was of little use. This interest in realism and accuracy of detail is, of course, part of the aesthetic theory of the Renaissance. We have seen this great concern with realism expressed to an almost obsessive level in works by Christus and Leonardo. Book illustrations could be executed with the same quality and realism.

Etching, a seventeenth-century invention, was occasionally used to create book illustrations as well. Etchings, like engravings, are produced by inking a metal plate into which fine lines have been incised. Instead of cutting them by hand, however, the artist covers the plate with wax and draws the design in the wax with a pointed tool, exposing the metal below. The plate is then dipped into sulphuric acid, which eats away the exposed metal. Because it is easier to draw a sharp tool through wax than to engrave metal, and because the plate can be repeatedly waxed and the acid reapplied to selected parts of the design, etchings can be finer than engravings. In addition, the

Technologies of Illustration
Woodcuts, Cooper-Plate Engravings, and Etchings

grooves can be of varying depth, creating lines of varying darkness and tone in the final print. Etchings were a popular medium for fine art in the seventeenth century, but they were not much used as book illustrations. Copperplate engravings were quicker and cheaper to produce for commercial purposes.

Sixteenth-century illustrations are frequently placed on the page and surrounded by text. The resulting page layout looks strikingly modern. In some cases, the author provided his own drawings to be used as the models for the woodcuts or engravings. In other cases, they were drawn by artists in the employ of the printer. It is normally easier to identify such images than an author's own, because the house artists frequently monogrammed their work. Much is known about which artists worked as illustrators for which printing houses.

Konrad Gesner

De rerum fossilium (1565) and *Historia animalium Liber IIII* (1551–1558)

Konrad Gesner's publications provide interesting examples of sixteenth-century illustrations of fossils. The sixteenth century was the age of the polymath, and Konrad Gesner (1516–1565), like Leonardo da Vinci, deserves the title. Gesner and Leonardo incorporated the newly emerging empirical science into their writings and the art which accompanied these works.

Gesner's book on "fossil objects"[12] appeared in the summer of 1565, just a few months before Gesner's death on December 13. While the book did treat what we call fossils today—that is, the remains or traces of previous life forms—the word "fossil" in Gesner's time meant "something that has been dug up." The full title of the book probably elucidates Gesner's intentions better: *De rerum fossilium lapidum et gemmarum: maxime figuris & similitudinibus.* As it indicates, Gesner discussed and illustrated things "dug up," including gemstones and rocks as well as what we now call fossils. This book was one in a series of natural history publications for which Gesner was famous in his own lifetime. Today Gesner may actually be better known for his massive four-volume opus on natural history, *Historia animalium* (1551–1558). These thick, folio-sized volumes dealt with quadrupeds, fish, birds, and "stinging animals," an Aristotelian catchall term that included snakes, other reptiles, insects, and the like. Gesner's natural histories of animals were translated into various languages, appeared in many editions, and were paraphrased and expanded upon in the seventeenth century by Edward Topsell (1572–c. 1625) as *The History of the Four Footed Beasts, Serpents and Insects,* which was published in 1608 and reissued in 1658. Besides these natural histories, Gesner also wrote about botany, linguistics, and medicine (he earned a medical degree in 1541 at Montpelier).

While Gesner was not prepared to state that he accepted fossils as actual remains of previous life forms, he did find them interesting and felt that they needed to be discussed and presented to his readers. He had already noted similarities between fossils and extant organisms in his *Historia animalium,* and did so again in this volume. Further, it was thought that fossils, like other minerals, might have medicinal uses (as shark teeth did). So these items were of interest to the naturalist and physician alike.

Fossils were a part of what Gesner's contemporary Giovanni Baptista della Porta would term "natural magic."

Martin Rudwick has pointed out that *De rerum fossilium* opened new territory in science, in that it was the first significant western publication to depict fossils alongside a discussion of them. (However, he also makes much of what he considers the relative crudeness of the book's illustrations. He has gone so far as to comment that their medium, woodcut, "enforced a relatively coarse style of drawing." This of course is not correct, as has already been discussed.) Other sixteenth-century scientists had described fossils and considered their origins, but had not included much if anything in the way of illustrations. Christophorus Encelius published a few small images of fossil shells in 1557, and Agricola wrote about fossils in 1546 but did not provide illustrations. Rudwick rightly states that Gesner's work on fossils (for that matter, his other illustrated natural histories as well) are similar to such illustrated books of science as Vesalius's *De humani corporis fabrica* (1543).[13] The invention of the printing press in the previous century had made it possible to reproduce illustrations quickly and easily, but the increased interest in depicting an organism, or in this case a fossil, was due to more than a technological development. It was important not only to categorize and compile data, but also to show the specimens to the reader as a part of the investigation. Readers will have noticed by now that art historians like myself are fond of speaking of the Renaissance as concerned with realism, and it is realism that one sees in Gesner's work. The author wished to give his readers a realistic presentation of fossils, and using images made it easier to do so. With them, readers could see for themselves what the fossil looked like and use this information, along with the text, to form their conclusions about it. The fossils depicted in Gesner's works are identifiable as ammonites, belemnites, crinoid parts, and so on. The illustrations are not so primitive or lacking in detail as to be useless as sources of information for the reader. They are generalized images, not illustrations of particular species, but they clearly depict the type of fossil in question.

This concern with realism was so pervasive that illustrations were included as exemplars in all sorts of books. Books that would seem to be far removed from natural history, such as Ulrich Molitor's *De lamiis et phitonicis mulieribus* (*Concerning Demons and Witches*), first issued in 1489 and appearing in many subsequent fifteenth- and sixteenth-century editions, contained full-page illustrations. Molitor's book was intended to elucidate witchcraft beliefs and ask whether they were legitimate. Showing a male witch riding along on an enchanted wolf was as much a part of the emerging science of the Renaissance as showing a fossil or a fish.[14]

Gesner had earlier published an illustration of a shark and a fossil shark tooth, or glossopetra, in the book on fish in the *Historia animalium*. Here he compares the tongue stone to the teeth of extant sharks. (Interestingly enough, the illustration of the fossil is much more accurate than that of the shark.) It is likely that Gesner's illustration in *Historia animalium* is the first depiction of a fossil shark tooth in print. In *De rerum fossilium* Gesner again addressed the resemblance between fossils and living organ-

isms. He included the glossopetrae but also included illustrations of sea urchins and fossil echinoids, which he compared to the living specimens. Again, the quality and detail of the images varied widely. This uneven quality of illustration seems characteristic of Gesner's publications; it appears even in *Historia animalium*'s volume on quadrupeds, for which he should have been able to obtain better illustrations of well-known animals.

Gesner's place in the history of paleontology illustration is noteworthy. He was not a paleontologist, of course, but he was a naturalist and a scientist of considerable stature, and his works were well known and frequently translated and reprinted. By selecting fossils as topics worthy of study and presentation, he gave fossils a greater level of importance in the emerging sciences of the sixteenth century. He also collected fossils himself, and in this regard he occupies a special place in the development of paleontology illustration.[15] While we cannot demonstrate that he drew any of his own illustrations, he was among the first authors to work closely with artists in the production of his books. Gesner's practice of consulting with his illustrators, which doubtless arose from the concern for realism inherent in his position as a renaissance scientist, became an important aspect of later paleontology studies.

A number of natural histories similar to Gesner's were published toward the end of the sixteenth century. Examples include the works of Girolamo Cardano (1501–1576) and Bernard Palissy (1510–1589). Ferrante Imperato (1550–1625) depicted various marine invertebrates in his 1599 *Historia Naturale*. The images in many late-sixteenth-century natural histories compare quite well in quality to those in Gesner.[16]

Michele Mercati and the Metallotheca

Michele Mercati (1541–1593), like so many who were interested in fossils and natural history in general, studied medicine. He eventually became the personal physician of Pius V (r. 1566–1572) and held that position under the following five popes as well. As part of this duty, he had charge of the papal botanical gardens, in which medicinal herbs were grown.

Pope Pius V took an interest in natural history and supported the Metallotheca, the papal collection of minerals, ores, and fossils. He placed Mercati in charge of such specimens, and for the Vatican collections Mercati obtained such fossils as glossopetrae. (Again, mineral materials also had close connections to medicine.) This appointment and papal support were significant for the history of paleontology illustration, because Mercati planned an entire illustrated catalogue of the collection. The plates for this catalogue whose provenance is known were made by a German engraver, Antoni Eisenhout, just prior to 1600, but the book was not published until 1717. Some of the plates depicted fossils such as shark teeth, marine echinoderms, mollusks, and various other invertebrates. In general, these illustrations are reasonably accurate and detailed. Some are of higher technical quality, including one of a group of the pope's courtiers showing him mineral specimens. Another illustrates the layout of the museum, with the arrangement of display and storage cases. The discrepancies in technical quality suggest that more than one hand was at work on these engravings. It is also possible that some, such as that of the

papal entourage, were made at a different date than the fossil plates. The edition of 1717 was published under the aegis of another papal physician, Giovanni Maria Lancisi, who served Pope Clement XI. A second edition, with an added appendix, appeared in 1719. Long before this, however, Nicolas Steno had borrowed Mercati's plates of tongue stones to use in his famous treatise on the true nature of fossil shark teeth, published in 1667 (and discussed below).[17]

Ulisse Aldrovandi (1522–c. 1605) may be seen as a logical successor to Gesner in the disciplines of the natural sciences. He was a physician (although he does not seem to have practiced medicine), a naturalist, and a professor in Bologna. As a young man he also studied law and mathematics. Aldrovandi had the patronage of two popes, Pius V (r. 1566–1572) and Gregory XIII (r. 1572–1585); Gregory was in fact his distant relative.[18]

> ### Ulisse Aldrovandi
>
> *De reliquis animalibus exanguibus libri quatuor* (1606) and *Musaeum metallicum* (1648)

In accordance with his papal patrons' interests in learning and natural history, Aldrovandi was also a dedicated collector of specimens of all kinds, amassing what amounted to his own natural history museum from which to select items for study. His varied interests are reflected in the topics of his many books, which include studies of fossils, geology, plants, birds, insects, quadrupeds, "serpents and dragons" (i.e., reptiles), and even "monsters." This last category included oddities like strange-looking creatures, foreigners, and people with birth defects.[19] His interest in the latter may have derived from his study of medicine. Aldrovandi also founded and administered the Bologna botanical garden. His major books all appeared posthumously. Aldrovandi's *De reliquis animalibus exanguibus* (his "large book of fossils," as Rudwick called it) appeared in 1606, shortly after his death, and was quite popular during the first half of the seventeenth century, with later editions in 1618, 1623, 1642, and 1648. Most of these were published in Bologna, although the 1623 edition was published in Frankfurt, indicating the international appeal of Aldrovandi's work. Aldrovandi also addressed the topic of fossils in several places in his *Musaeum metallicum,* published under the editorship of Bartolomaeus Ambrosinus and Marcus Antonius Bernia in 1648. This book dealt with many aspects of geology, including metals, minerals, fossils, concretions that might include fossils, and precious stones. The title page depicted Aldrovandi and also had vignettes of people working in mines. (They are reminiscent of the many vignettes of mining activities in Agricola's famous *De re metallica,* which may have inspired Aldrovandi's illustrators.)

Musaeum metallicum included illustrations of fossil shark teeth, coral, and other fossils. Some of the engravings of coral are exquisite. *De reliquis animalibus exanguibus* contained illustrations of a number of life forms, including crustaceans (some are better detailed than others) and both fossil and living echinoderms. Again, these illustrations vary in quality and detail, just as did the illustrations in Gesner's works. Indeed, Aldrovandi's illustrations are quite similar to Gesner's. The title page of *Musaeum metallicum* was printed from a copper plate and is baroque in style, as is typical

of title pages in this period. Similarly, the title page of the 1642 edition of *De reliquis animalibus exanguibus* is engraved in an up-to-date style. Printers were content to update only title pages and retain the earlier interior illustrations, or at least to make exact copies of them.

In the illustrations of these early natural histories one sees the seeds of editorial patterns to be found in later books on geology and paleontology. The authors selected from specimens that they had collected themselves, or had at least acquired themselves. They worked with their illustrators. And they sought out powerful and wealthy patrons to help publish their books. All of these editorial practices continue to this day in paleontology. Today's "popes" are those who award and administer large government grants.

Illustrations in these sixteenth-century natural histories were being utilized to show what fossils are and what they look like. In the interest of furthering scientific investigation, authors such as Gesner and Aldrovandi were telling their readers, here are interesting and unusual natural items. The nature and origins of some of these fossils are not understood yet. It is up to you to study them in order to be able to identify others like them and to decide what they are. Comparisons were often made between living organisms and fossils that looked similar to them.

There can be no doubt that the authors and publishers of the late sixteenth century wanted to provide adequate illustrative materials for the reader to study. But at the same time the quality of the illustrations might vary considerably within a given book. This is a part of the character of book illustration during this period, and it remains true to this day.

Illustrations originally produced for one book were sometimes reused in another. In some cases, this was done to save money. Or the printer and the author may have thought that the illustration was exactly accurate, depicting a "truth" that should not be altered. Such uniformity in iconography is visible in other books of this period. The activities of witches, for example, are routinely shown in exactly the same way from one book to another. Sometimes the same illustration is used repeatedly, in book after book, over decades.[20] It was truth and, in this case, an article of religious teaching that was being shown. These sorts of factors may have had an impact on early paleontology illustration as well. We have some data about sizes of print runs and printing costs in this period, but that data is in no respect adequate to tell us in every case why a book might have better or worse illustrations.[21] Thus we cannot merely presume that printers were cutting corners to save money when they used older or less well crafted illustrations.

It is a myth that illustrations become uniformly better as time passes. It is also a myth that all illustrations in a particular book would be uniformly good, or detailed, or accurate. Belief in such myths arises from patterns of thought similar to those of early archaeologists and ethnologists who believed that people who were not white or who came from cultures without the blessings of modern industrial technology were uniformly primitive and ignorant. What is not a myth is that variations in detail and quality between one illustration and the next are part of the foundational pattern these books set for the future of paleontology illustration. Many

factors caused such variation in renaissance illustrations, and the same factors can be responsible for such variation in modern times as well.

Richard Rowlands (c. 1550–1640), who wrote under the pseudonym Verstegan, was an expatriate English Catholic polemicist whose interest in the cultural history of England led him to write one of the earliest seventeenth-century commentaries on fossils.[22] Verstegan was not a scientist, but, like many of his scholarly contemporaries, he did have considerable interest in natural history and geology. These topics he included in his *Restitution of Decayed Intelligence in Antiquities* (1605), considering them a part of the history of England that he was trying to describe.

Verstegan was probably born in London. He was educated for a time at Oxford, although he left without taking a degree there. His departure was probably a result of his religious zealotry and his outspoken opposition to Queen Elizabeth I. (His pseudonym means "the opponent" in Dutch.) He migrated to the Continent sometime between 1577 and 1580, eventually settling in Antwerp in the Catholic Southern Netherlands, and never returned to England. Verstegan wrote many religious tracts and pamphlets, both in his native English and also in Latin, French, and Dutch. His scholarly interests ran in the main to linguistics and cultural history. But he was a prolific and wide-ranging author. He is remembered as an important Dutch writer mostly for his witty poems and aphorisms in that language. Such materials were quite popular with the Dutch reading public in the seventeenth century.[23]

Verstegan traveled to Paris sometime in 1580 and remained there until 1584, when he went to Rome. He stayed in Rome until 1586 and then returned to northern Europe. We know that he was settled permanently in Antwerp in 1588. While in Rome, he most likely was able to visit the papal Metallotheca. He probably also met Mercati, as Verstegan had very close connections with the Church through his activities as a Counter-Reformation polemicist.[24]

In 1605 Verstegan published *A Restitution of Decayed Intelligence in Antiquities, Concerning the Most Noble, and Renowned English Nation*. It was published in Antwerp; apparently Verstegan did not relish returning to England or seeking an English printer for his book, even in what might have been a slightly more comfortable political climate. The title page does indicate that the book was intended to be sold in London (presumably through an arrangement among the Dutch printer, the English bookseller, and Verstegan himself), and it was dedicated to James I. Such a dedication would probably have made later editions of the book easier to sell in London, by making it seem to have been published with the king's approval, even though its author was well known as an opponent of James's predecessor. It was not at all unusual for authors in this period to dedicate their works to members of the local nobility, even royalty, in order to enhance the work's popularity. Those who knew about Verstegan's fierce opposition to Elizabeth I would not have been deluded into thinking his stance had somehow changed. Whether the king ever saw the book, or even knew anything about it, is essentially moot.

Richard Verstegan

A Restitution of Decayed Intelligence in Antiquities (1605)

Restitution was a large book, comprising three hundred and thirty-eight pages and eleven engravings. Although Verstegan saw himself as a linguist, a historian, and a staunch and angry Catholic apologist, not as an artist, he drew his own illustrations for the engraver, which places him among the gentlemen collectors who took extreme care for their illustrations. *Restitution* seems to have been a publishing success, being reissued in England by London printers in 1628, 1634, 1653, 1655, and 1673. Some of these editions were in octavo, like the first, and others were in quarto. Their illustrations were copies of those in the 1605 edition; an artist redrew the images, and new plates were engraved from these drawings. This indicates that the original plates used in Antwerp in 1605 were not sent onward to England. The result of this copying was that the later editions sometimes contain mirror-reversed images of the images in the 1605 book.

The illustrations in *Restitution* mostly depict Saxon gods or supposed events in England's ancient past, but one depicts fossils. The historical illustrations are nothing special and their iconography can be connected to other sources, such as emblem books. But the illustration on page 104, which depicts three pieces of fossilized bone (probably ichthyosaur), two fossilized bivalve shells, and one fossil shark tooth, is in another category altogether. Verstegan's illustration of a fossil shark tooth is not the first to be found in a printed book. That distinction seems to go to Gesner. But Verstegan's is certainly a very early example. Verstegan pondered the tooth's origin and decided that it was the petrified tongue of a fish, rather than a fish's tooth. Although he was not a scientist or physician, Verstegan was among the earliest scholars to identify fossils as objects with an organic origin. While Gesner had noted that tongue stones looked like the structures of living things, he was not ready to state that they had an organic origin. Aldrovandi and Fabio Colonna would go farther in arguing that fossils were petrified organic materials, but their works appeared after Verstegan's *Restitution*.

Verstegan collected fossils himself and also witnessed their discovery. He made empirical observations of their shape and structure and of the places where they were found. He observed that these petrified objects did not seem indigenous to the dry inland locales where they were dug up. Because of this, and because he thought that they were the remains of living things, Verstegan then posited that England must have once been connected to the European continent as a peninsula extending from France.

> [I]n digging about two fadome deep in the earth, though in some places more and in some lesse, innumberable shelles of sea life are found, and that commonly in all places of these plain and even grounds both in field and town and hereof to be thoroughly informed I have talked with such laboring men as usually digged welles and deep foundations of buildings and they all agree that they do commonly in all places find an innumerable quantitie of these shelles some whole and some broken and in many places the great bones of fishes whereof I have seen many and have had some even as they have bin digged out of the earth. For more a plain description of the manner and forme of these bones and shelles of fishes and to give the curious reader herin the more satisfaction I have thought good in the next ensuing page to set down some of them in picture.

Figure 1.2. Richard Verstegan, *A Restitution of Decayed Intelligence in Antiquities,* 1605. Various fossils.

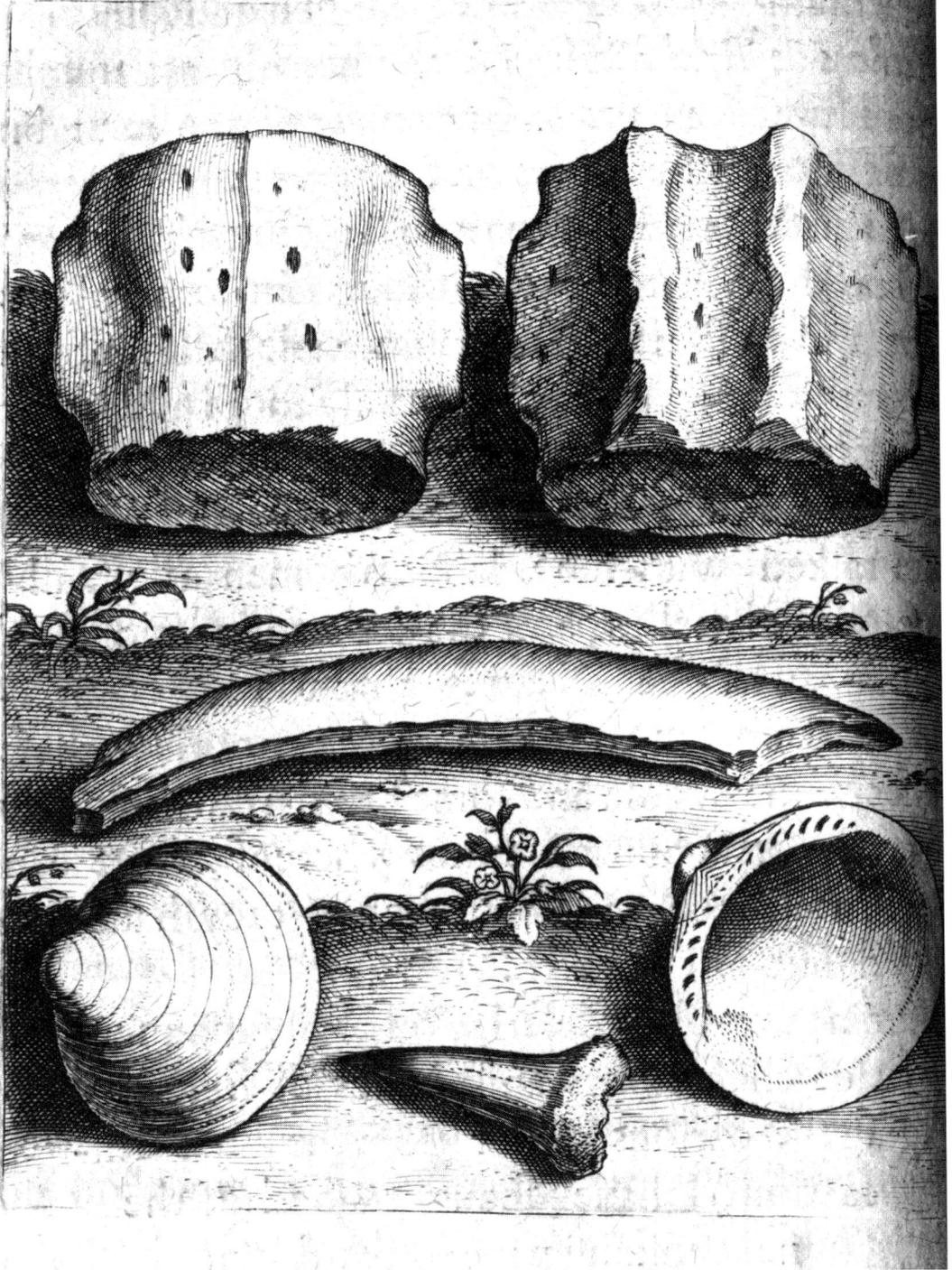

Verstegan accompanied his illustration of these fossils, which he entitled "Great bones of fishes found in the earth," with a detailed description of them.

> The chyne bones are commonly found in this manner, of about a foot in length, some much more and some lesse, the peces of broken ribbes are sometymes found as thick as a beam of timber and sometimes far lesse, the shelles are not lyke unto our cocle shelles, but on the outsyd plain & eue [even] & about a quarter of an inch thick, especially the bigger sorte which are of ten or twelue inches in compass.[25]

The fossils illustrated and discussed in the *Restitution are* examples of the variety of paleontological materials under discussion at the turn of the seventeenth century. Verstegan was obviously up to date on the latest arguments for and against the organic origin of fossils. His work and his conclusions indicate that these topics were debated in the formative years of paleontology. There can be no doubt that Verstegan was influenced by Mercati and the specimens he saw in the Vatican Metallotheca. Verstegan's inclusion of a carefully drawn illustration and an equally detailed description of his English fossils reflects this influence. He realized that an accurate visual image was a necessary component of his scientific discussion.

Fabio Colonna

Aquatilium et terrestrium aliquot animalium (1616)

Fabio Colonna (1567–1650) was a member of the Accademia dei Lincei, the Academy of the Eye of the Lynx, a group of Italian scholars and writers that included Galileo Galilei, Cassiano del Pozzo, Giovanni Batista della Porta, and Federigo Cesi. Most of his books were reprinted well into the eighteenth century. He was mostly known among his contemporaries as an expert on plants and herbalism, and he wrote several books on plant and animal life, including that of the New World. His interests were wider than this, however, and he also wrote on musical instruments and music theory, marine fossil invertebrates, and fossil shark teeth. In *Aquatilium et terrestrium aliquot animalium,* published in Rome in 1616, Colonna used illustrations to compare extant marine mollusks to fossil mollusks. His work on tongue stones, also appearing in that year, argued that they were fossilized shark teeth.

Colonna was an artist and did his own artwork for his publications. His engravings were well executed and detailed, of high enough quality to be useful to readers. His studies of fossils make nice counterpoints to the watercolor drawings collected by Cassiano del Pozzo for what he called his "paper museum."[26]

Athanasius Kircher

Mundus subterraneus (1664–1665)

Athanasius Kircher (1602–1680) was a German Jesuit whose writings and scholarly pursuits well illustrate the support that the Catholic Church and the papacy gave to scientific investigation. He joined the Jesuits in 1616 and was ordained a priest in 1628. Like many members of his order, Kircher excelled in scholarship and worked extensively to open up new areas of academics. He made several important, if somewhat notorious, contributions to the fields of geology, paleontology, ethnology, and archaeology. In earth

sciences he is best remembered for his *Mundus subterraneus,* published in 1664–1665. He is also well known for his studies of Oriental cultures and his attempt to decipher Egyptian hieroglyphics. Since Kircher was a specialist in linguistics, his desire to read hieroglyphs is not at all surprising; he had at least some familiarity with some sixteen languages.[27]

Kircher counted among his patrons two of the seventeenth century's most powerful and famous popes, Urban VIII (r. 1623–1644) and Alexander VII (r. 1644–1655). They are well known for their efforts to modernize and beautify the city of Rome as well as for their efforts to aggrandize the Church. Both were major patrons of the famous baroque sculptor and architect Gianlorenzo Bernini (1598–1680), who essentially served as their court artist. Urban VIII appointed Bernini architect of Saint Peter's and architect in charge of the city of Rome in 1629. Although the infamous trial of Galileo took place during his reign, this Jesuit pope also fostered considerable scholarly activity among his clergy.

Today Kircher's *Mundus subterraneus* is a titan among rare books, commanding huge prices from dealers.[28] It deals with a number of geological topics, as well as other subjects. Kircher discussed the nature of the earth's interior, volcanoes (including Vesuvius and Stomboli), minerals, hydraulics, metallurgy, mining, gravity, meteorology, alchemy, poisons, herbs, medicine, astrology, and, of course, fossils. In essence the book was encyclopedic, just like his own knowledge. Kircher comes in for much criticism and downright mocking from scholars today for his belief that some fossils were not organic, but were created by a generative force that permeated the earth, causing stone to mimic, Platonically, the forms of organisms. Perhaps what is more important is that Kircher was interested in fossils, even though his interpretation of their origins must take a place in history beside his interpretation of hieroglyphics.[29] But it is clear that Kircher believed that some fossils might have organic origins. Kircher, like many of his contemporaries, was confused about fossils, especially fossils that didn't resemble living organisms. And he was trying to find his way through this confusion.[30]

Kircher established his own museum in Rome, in which he displayed many of the items he wrote about. The Museum Kircherianum was housed at the Roman College, where Kircher taught. Here one could see fossils, Egyptian artifacts or replicas of them, natural history exhibits, Kircher's own inventions, and much more. Kircher holds an important place in the history of paleontology illustration and especially in the history of museology. His career as a scholar and amateur, while extremely impressive, was also typical of educated people of his day. Members of the clergy as well as the nobility (the categories sometimes overlapped) fostered the newly emerging scientific disciplines and worked to make them better known to the public.

Niels Stensen Steno (1638–1686) has often been given the title "father of geology, mineralogy, and paleontology." He receives credit for being the first scientist to emphatically state in print that "tongue stones" were indeed fossil shark teeth, which he did in *Canis carchariae dissectum caput,* his

Nicolas Steno

Canis carchariae dissectum caput (1667)

1667 treatise on the dissection of a Great White shark. The animal had been sent to him for dissection in 1666 by his patron, Ferdinando II, the grand duke of Tuscany. By comparing the teeth of the extant animal to the "stones," Steno demonstrated that they were indeed teeth. "That they are shark's teeth is proved by their shape, since they are quite alike, planes to planes, sides to sides, base to base. . . . It appears that they cannot be far from the truth who assert that tongue stones are shark's teeth." He argued that the earth in which fossils were found had once been covered with water and that fossils were petrified organic remains.

> The bodies resembling various parts of aquatic animals, whether they are dug out of hard or soft soil, resemble exactly not only each other, but also the parts of the animals to which they correspond. . . . The soil from which the bodies resembling parts of animals are dug out does not seem to produce these bodies today. . . . That they are not produced in our time in hard ground [terra dura] one may conclude from the fact that they are found all through rock of the same consistency, and that they are surrounded on all sides by the hard material; for if any such bodies were produced today anew in these rather hard soils, the surroundings ought to give way to them when growing, and the bodies no doubt would show differences from those produced long ago. . . . I cannot see what should prevent us from regarding this soil as a sediment of water gradually accumulated.[31]

Steno's illustration of fossil shark teeth was printed from the plate that Antoni Eisenhout had originally made for Mercati's *Metallotheca,* the catalogue of the papal collections. He borrowed it and a plate showing a shark's head (the latter was not made by Eisenhout, nor was the head included in the papal collections) from Carlo Dati (1639–1676).

> The diagram that is shown under the names of Lamia, I owe to the kind favor of a very learned friend, Carlo Dati, who when he saw that an engraving of the lacerated head was less than satisfactory for the reader's purpose, bearing in mind the Metallotheca Vaticana by Michaele Mercati of Miniato, granted me, from the various bronze plates that belong to it and are in his possession, the use of those which illustrate the head and teeth of the Lamia and the larger tongue stones.[32]

Dati was a philologist whose patrons included the same two Medici dukes who supported Steno. Dati was interested in natural history and geology and was a pupil of Galileo.

Dati, Steno, and the Medici family were all associated with the Catholic Church, and this association had a significant impact on their contributions to scholarship. The Church was supporting the relatively new sciences of geology and natural history and the emergent science of paleontology.

Agostino Scilla

La vana speculazione disingannata dal senso (1670)

The scientific and intellectual activities of the Italian painter Agostino Scilla (1639–1700) provide a good example of the wide-ranging interests of seventeenth-century amateurs.[33] Scilla was a professional artist who worked mostly for Catholic religious patrons, although he did illustrate a monograph on in-

sects of the region around his home city of Messina. He was a student of Andrea Sacchi (1599–1661), a much better known baroque painter,[34] and his style resembles Sacchi's. As well as an artist, Scilla was a self-trained naturalist and an amateur who not only collected and studied fossils on his own, but wrote and illustrated a treatise on them: *La vana speculazione disingannata dal senso* (Vain Speculation Undeceived by Sense), published in 1670 in Naples. In this work, Scilla refuted the theory that fossils, while formed in nature and frequently resembling living organisms such as corals or sea shells, were not petrified remains of once-living organisms, arguing that they were. (Here he may have been arguing against Kircher.) He was somewhat ambivalent about the role of the Great Flood in displacing organisms that later became fossils, speculating that some forces of nature similar to the Flood, but perhaps not the Flood itself, might have been the agent. And he had no concept of the extinction of species.[35]

The layout of the title page of *La vana speculazione* is typical of its time. It depicts an allegorical figure of Sense teaching Vain Speculation that fossils are the remains of once-living organisms. Floating above these figures is a banner inscribed with the book's title. Several Latin editions appeared in the eighteenth century, under the title *De corporibus marinis lapidescentibus quae de fossa reperiuntur,* and these contained the original title page as a frontispiece, replacing the title with a Latin caption. It would appear that the original plate was reused and the original inscription burnished out. These later editions also included the same interior illustrations as the original. Besides an illustrated title page, preserved as a frontispiece in later editions, *La vana speculazione* had twenty-eight additional illustrations, depicting both fossil and extant organisms. Clearly Scilla meant to compare these specimens. These interior illustrations were also retained in the later Latin editions.[36] In the central image Vain Speculation, shown as a young man, holds a fossilized sea urchin and a tongue stone in his hand. He gestures to nearby rocks, where there are several other fossils. Echinoids, shark teeth, ammonites, gastropods, and even a fish are shown, although it is not entirely clear whether these fossils are actually inside the rocks or merely lying on them. The latter seems more likely; and since Scilla thought that fossils might have been deposited by a great flood, the positioning of these items in the illustration is suitably ambiguous. Still more interesting are the types of fossils shown. They are again visual generalizations, and their genera or species cannot be determined; they seem to be intended as typical sea urchins, shark teeth, and the like.

This use of ambiguous and generalized images is both fascinating and typical of book illustrations in the seventeenth century. The fossils shown on the title page in no way compare with the distinctive accuracy and individuality of the shark teeth painted two hundred years earlier by Petrus Christus. The scientific names of those sharks might be determined today from Christus's images. Still, not all seventeenth-century imagery is as generalized as Scilla's. Paintings are far more detailed than book illustrations. Moreover, the illustrations in Scilla's book are not uniform in detail or quality. Illustrations which depict actual fossils are more detailed than

the title-page illustration. They show fossils and some extant organisms which might be identified scientifically. Scilla's use of extremely realistic details is also typical of seventeenth-century baroque art. For example, the Flemish master David Teniers II (1610–1690) painted several works that included images of stuffed West Indian iguanas. These are so correctly depicted that their genus and possibly even species can be identified today.[37]

Most of Scilla's engravings for *La vana speculazione* were of invertebrates, although some sharks and non-fossilized shark teeth were shown. The plates were reused for the later Latin editions; this is obvious because the figure numbers are still given in Italian rather than in Latin. Scilla took care to make clear which images showed fossils and which depicted living specimens, labeling the former "changed into stone." (In the Latin editions of the eighteenth century, the translators used "conversus" and "mutatus" interchangeably.)

In several instances, the specimens are shown in their rock matrix. Plate 3, for example, shows fossil shark teeth, "commonly called tongue stones," in their matrix. Its caption reads "Shark teeth changed into stone, commonly called tongue stones, that were formerly picked up at random from Maltese rocks." Scilla took pains to show his readers that these fossils had once been embedded in the rock matrix, and he went to equal lengths to note in his captions that these fossils were shells, teeth, urchins, and so on "turned into stone." The repetition demonstrates that Scilla was trying to drive home his point. Fossils were once living and were now petrified and located in rocks. More than half of the plates depict fossils in their matrix, including echinoderms, fish vertebrae, gastropods, corals, and shark teeth. Scilla, the writer-artist, was making significant contributions to modern science by depicting fossils accurately and by stating that they had once been living organisms. Accuracy of depiction was obviously of extreme importance, since his images were meant to reinforce his premise. It would not do to have sloppily drawn images any more than it would be acceptable today to use an out-of-focus photograph to depict a specimen.

Significantly missing from the *Vana speculazione* illustrations are ammonites. This seems odd, since Scilla may have included an ammonite on his title page; two fossils lying near the fossil fish in that illustration may be either ammonites or partial specimens of sand dollars. Rudwick notes that it was easy for Scilla to argue that fossils had once been living when they looked like living specimens, whereas fossils that looked organic but didn't resemble any living organism were less easily interpreted.[38] He has in mind here the problematic ammonites.

From the purely stylistic standpoint, Scilla's illustrations are typical of baroque art in this century. They are carefully drawn and they show a great interest in realism, The illustrations also depict strange and unusual items: fossils. Baroque artists were usually interested in depicting things that were beautiful, odd, unusual, exotic, or strange: things outside the ordinary. Fossils fit these criteria well. Scilla's baroque style also enabled his readers to visualize them accurately, and this too was in keeping with the style itself. Baroque masters indulged in factual reportage as a matter of course.

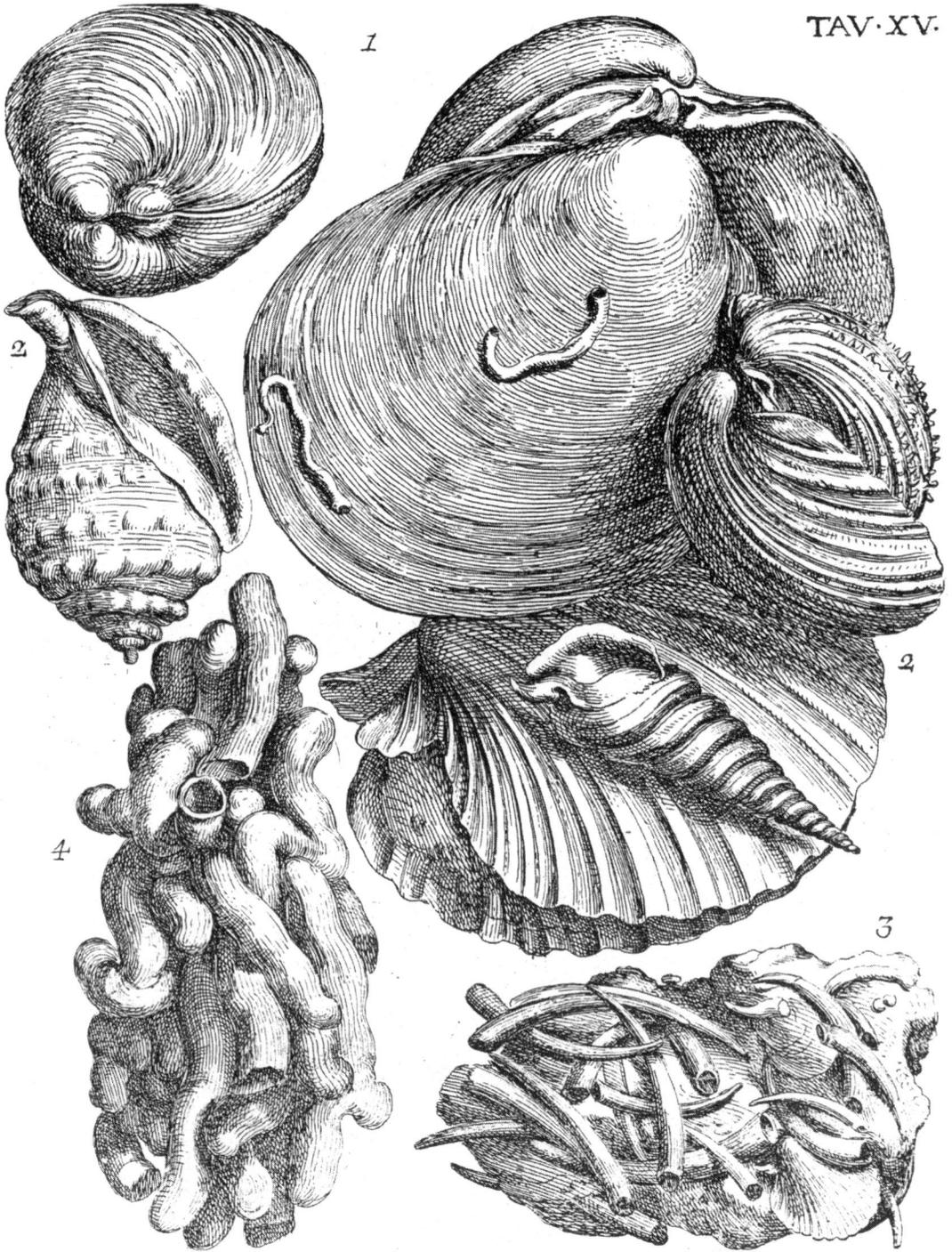

TAV·XV·

1

2

2

4

3

Figure 1.3. Agostino Scilla, *La vana speculazione disingannata dal senso*, 1752. Various fossils, including coral.

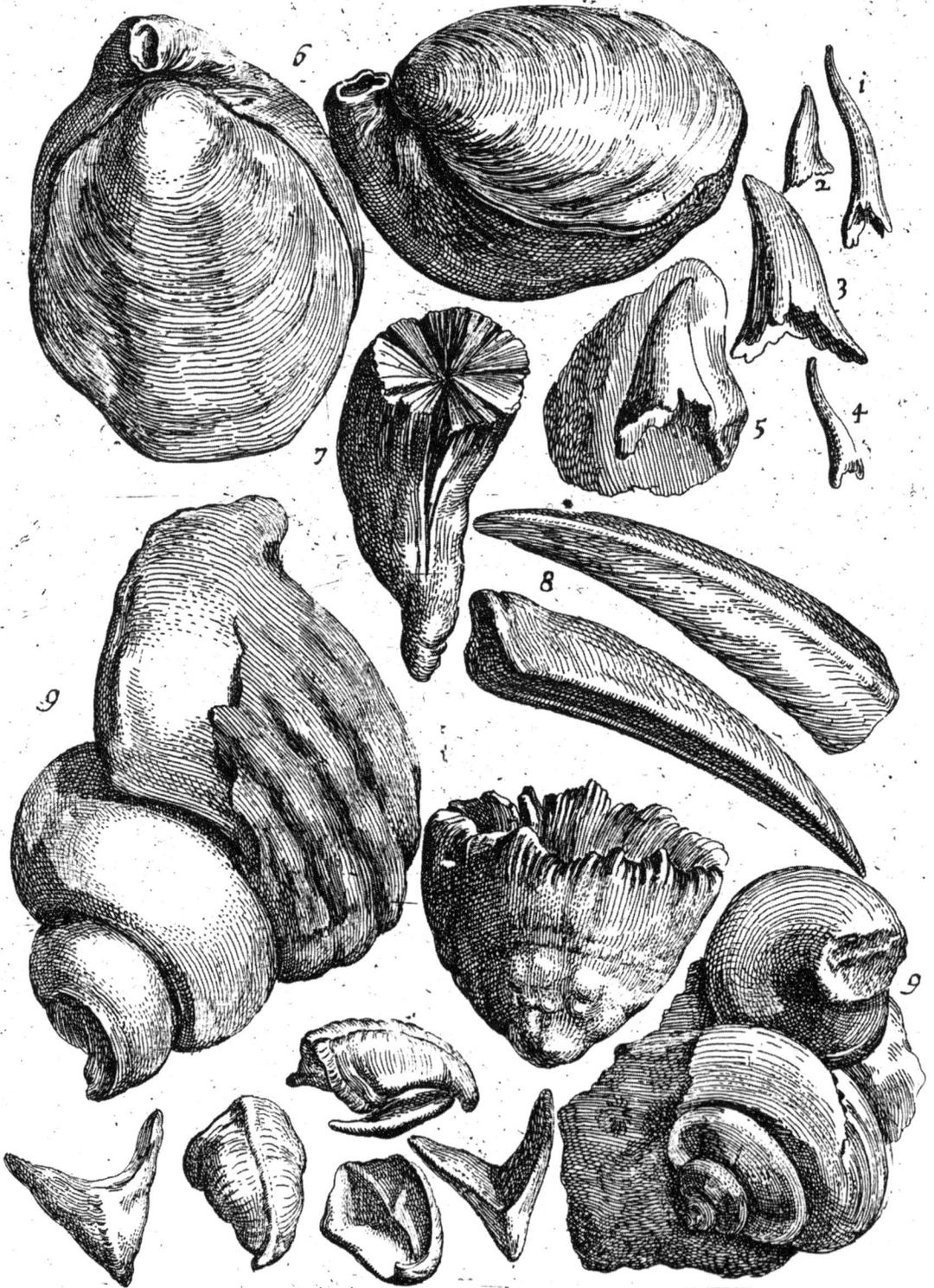

Their works were employed in contemporary science. Scilla's images of the fossils of Malta were the same type of scientific illustrations that one sees, for instance, in the paintings that the Dutch landscapist Frans Post made to record his journeys into Central and South America in the company of Johann Maurits. These paintings faithfully showed the plants, animals, geological details, and people that Post saw. They were considered part of the results of the expedition.

Figure 1.4. Agostino Scilla, *La vana speculazione disingannata dal senso*, 1752. Various fossils, including shark teeth.

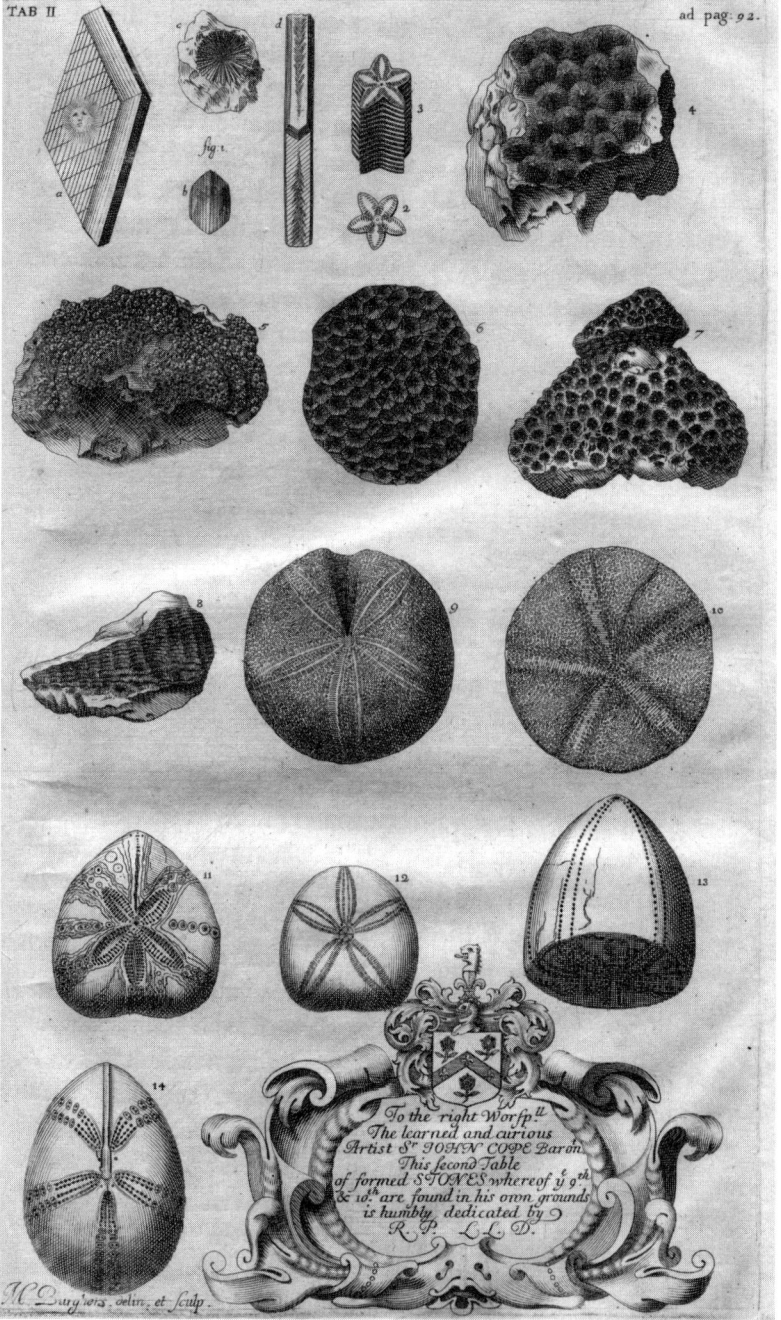

THE LATE SEVENTEENTH CENTURY AND THE EIGHTEENTH CENTURY

2

A number of different publications in the last quarter of the seventeenth century dealt with topics of geology and paleontology. Some of these works were natural histories, containing a variety of observations about both living and extinct animals and plants, minerals, local histories, and even genealogies. This genre remained popular throughout the eighteenth century. The paleontology books of the period varied widely, both in the theories put forth by their authors and in the quality of their illustrations. Copperplate engravings and woodcuts continued to be used, and etchings now appeared occasionally as well.

Of the artistic styles popular in the seventeenth century, the baroque is probably best known. Most seventeenth-century baroque painters, unlike painters of the sixteenth century, used layers of oil paint that were of varying thicknesses. This painting technique is called impasto. Impasto painting enabled artists to show fine details and realistic renderings of light, but they no longer literally drew the details, as had painters like Petrus Christus. Baroque art was characterized by technical excellence, a considerable amount of realism, and the desire to depict rare, strange, and beautiful items. This interest in the unusual could easily include fossils. I do not know of any paintings in which fossils are depicted, but baroque illustrations of fossils certainly appeared in books. In these illustrations the scientist's desire for realism and careful detail was combined with the period's considerable interest in the strange.

Seventeenth- and early-eighteenth-century books represent scientists, both amateurs and professionals, in the process of finding their way toward the modern sciences of paleontology, geology, and biology. Questions and theories about the nature and origin of fossils and the age of the earth continued to be expressed and investigated. Similarly, authors theorized about evolution and extinction. Some authors were naturalists in a rather broad sense of the word. Others were learned in one or more specific disciplines, such as medicine and chemistry. Some, like Charles Leigh, wrote magnificent humbug strewn with beautiful illustrations of fossils. Some of their books turned out to be of lasting significance, while others disappeared into an extinction as final as that of the fossils they discussed, and are preserved now in the environmentally controlled matrices of rare book libraries. A few found their way into the hands of rare book dealers and then into the fire safes of private owners.

Figure 2.1. Robert Plot, *The Natural History of Oxfordshire*, 1677. Plate 2.

Robert Plot

The Natural History of Oxfordshire (1677)

Robert Plot (1640–1696) was educated at Oxford and took a B.A. there in 1661, an M.A. in 1664, and a B.C.L. and D.C.L. in 1671. He was a chemist and an apothecary, and became a professor of chemistry at Oxford. Plot became the keeper of the Ashmolean Museum at Oxford in 1683 and held that position, as well as his professorship, until 1690, when he resigned them both.[1] He was also interested in local antiquities, and some of his observations on the site at Glastonbury were included in Thomas Hearne's *The History and Antiquities of Glastonbury,* published in 1722. Plot turned his attention to natural history about 1674, when he began work on his *Natural History of Oxfordshire.* This book describes the natural resources and features of his home county.[2] (It was the first of a planned series on English counties, of which he completed only one more, the 1686 *Natural History of Staffordshire.*) In it, which, interestingly enough, he sent to the royal censors, Plot takes his readers on a tour of the area, commencing with a large foldout map showing towns and cities, where major geographical features lie, and so on. This map also enables the reader to easily locate areas in which fossils were found.[3] The book's fifth chapter is devoted to what he termed "formed stones," in other words fossils and other interesting mineral specimens that he thought resembled living organisms or parts of them. It discusses in considerable detail a number of fossil specimens, including at least one vertebrate specimen. The book is well illustrated with good-quality full-page engravings of the specimens and places discussed, and seven plates depict fossils and other formed stones. Three of these are signed by the engraver, Michael Burghers. It is likely that he executed them all, as their technique and draughtsmanship look uniform. Plate 2 contains illustrations of fossils taken from the lands of Sir John Cope, and a note on the engraving indicates that the gentleman himself made the preliminary drawings of his specimens.[4]

Plot considered the various opinions of his day on the nature and origin of such formed stones. He concluded that fossil shells were not the remains of animals, but his approach to the subject was far more complex. However, he does seem to have believed that some fossils were petrified—that is, mineralized—as modern scientists would define that term. Plot spends much time in *The Natural History of Oxfordshire* discussing possible processes of petrification, trying to find ways in which organic materials might have turned to stone. These discussions no doubt stemmed from Plot's training as a chemist.

Plot devoted chapter 5 of *The Natural History of Oxfordshire* to fossils, or, as he called them, formed stones. But he discussed petrification in chapter 1. Grasses that grow on the banks of streams may become covered with stone: "living blades of grass of not above half a years growth, within that small time are all covered with stone [brought to them by the water], and hang down the bank like so many Isicles." He seems to suggest that this process might be a preliminary step toward the mineralization of once-living tissue. Indeed, "the roots of rushes, grass, moss, and etc. are in a while so altogether eaten away that nothing remains after the petrification is completed, but the figures of those Plants with some augmentation." A similar petrification can occur in wood that happens to become submerged. Plot went on to describe the "pump at the Cross-Inn near Carfax," where

wood had become encrusted with minerals carried in the water, and when the wood rotted away, the minerals remained in its place—petrification as it is described today.[5] Since Plot understood the precipitation of minerals (he was a chemist, after all), it seems odd that he could accept this process as an explanation for some instances of petrification, but not for others. Of course, not all fossils, as the term is understood today, are the result of permineralization, in which the pores of organic matter are filled with mineral matter. But in these passages Plot was trying, not to explain the origin of fossils, but to investigate the process of petrification. His complex approach to the subject reflects the ongoing controversy in the infancy of paleontology. Richard Verstegan had stated as early as 1605 that fossils were once-living organisms now turned to stone. Decades later, Plot and others were still speculating about their nature and origin.

In chapter 5, "Formed Stones," Plot described some specimens that we would still call fossils today, including ammonites, belemnites, fossil corals, and fossil bivalves, and others that we would define as chimeras or mineral oddities. These include stones shaped like human eyes, a stone shaped like a human heart, one shaped like a devil (complete with horns), and one shaped like an owl. Items like these seemed to resemble organic structures, but many thinkers of the time did not consider them of organic origin. And if they were not, some concluded, then none were. Plot's approach was more objective.

Plot went to considerable detail in describing the specimens he and his colleagues had gathered from around the county and invited his colleagues to consider their origins. He also provided large, good-quality engravings of them. That these illustrations are engravings can be seen from the plate marks left on the pages as the paper went through the printing press. The pages of *The Natural History of Oxfordshire* measure approximately 12.5 × 7.5 inches, and the illustrations, and therefore the copper plates from which they were printed, are 10 × 6 inches. These were large pieces of copper, which was always an expensive commodity.[6] Added to these large illustrations is the fold-out map of Oxfordshire, which is slightly more than twice the size of the other pages. It is clear that a fair amount of money went into the production of Plot's book. I suspect that the gentlemen landowners whose fossils Plot studied were also subscribers to his book, and their support would have enabled Plot and his publisher to undertake such an expense.

Chapter 5 is a running commentary on formed stones. Plot presented these to his readers in an empirical fashion, describing a stone, giving a picture of it, and then leaving readers to decide for themselves what it actually was. Formed stones found in the same area are grouped together in the engravings. Thus, readers could consult the map of the county and know where they might be able to find similar specimens (if the local lord would permit access to his lands).

Plot seems to have been as confused about what his formed stones were as he was about how they were formed. An example of Plot's particular blend of empirical science and folklore can be seen in his description of belemnites. He said that they were "thought by the vulgar to be indeed the darts of Heaven" and placed them in the category of "stones related to the

Heavens" partially because of this common belief. He then described them, noting that "their texture is of small striae, or threds radiating from the center, or rather axis of the Stone, to the outermost surfaces."[7] Several engravings of belemnites show both these striations and the overall bullet shape of the fossil. Four examples of belemnites are shown in plate 3, opposite page 100, which depicts fossils and other formed stones found on the property of Viscount Henry of Clarendon.

Several fossil bivalves collected from the lands of the Earl of Anglesey are illustrated in great detail in plate 4. Plot wrote that they were similar in morphology to extant shellfish, such as cockles, oysters, and scallops. He carefully described the coloration of the fossils. Ammonite and echinoderm specimens found on the property of Thomas Stonor are illustrated in plate 5, in similar detail. Two illustrations in the plate depict fossils embedded in the matrix.

Plot expressed confusion about the origins of these fossils. In this he typified the bewilderment of scientists faced with some fossils that resembled extant organisms and others, like the ammonites, that did not. Initially he merely asked questions as he provided his descriptions and illustrations. What are these things? Which explanation should we accept? Are they once-living organisms moved inland by a flood like the biblical deluge or are they something else? Did they form as mineral concretions? Plot concluded that most of these fossils were not the remains of once-living organisms, but he did allow for some exceptions. One was the petrified plant material discussed in chapter 1, and the other was a unique fossil that was clearly a petrified thighbone.[8]

Plot's approach to describing fossils and other "formed stones" that we would not term fossils now has been characterized by David Weishampel as the replacement of "religious acceptance" by "scientific research." This means that Plot attempted to explain at least some fossils as the results of something other than, as Weishampel has put it, "the grandness of God's design."[9] Plot discussed what he believed was a petrified portion of a thighbone (found on the property of Sir Thomas Penyston) and presented an illustration of this fossil in plate 8. The fossil is shown alongside other items from the estate, including a rock resembling a human ankle and other items that are clearly crystals. Plot thought that this fossil bone was probably not from a human, but rather from a horse or ox, or more likely an elephant. It was too large to have come from a smaller animal. Since the Romans had brought elephants into Britain, this might be a petrified elephant bone.[10] But its shape seemed wrong for an animal bone, and he also suggested that it might be the bone of a giant, such as are described in the Bible. "If then they are neither the bones of Horses, Oxen, nor Elephants, as I am strongly persuaded that they are not, upon comparison, from their like found in Churches: It remains that (notwithstanding their extravagant magnitude) they must have been the bones of [giant] Men or Women."[11]

Today we know that this bone is part of a femur of *Megalosaurus* or of some similar dinosaur. It is fairly certain that Plot's is the first illustration of a dinosaur bone.[12]

Richard Brooks, an eighteenth-century naturalist, decided that Plot was

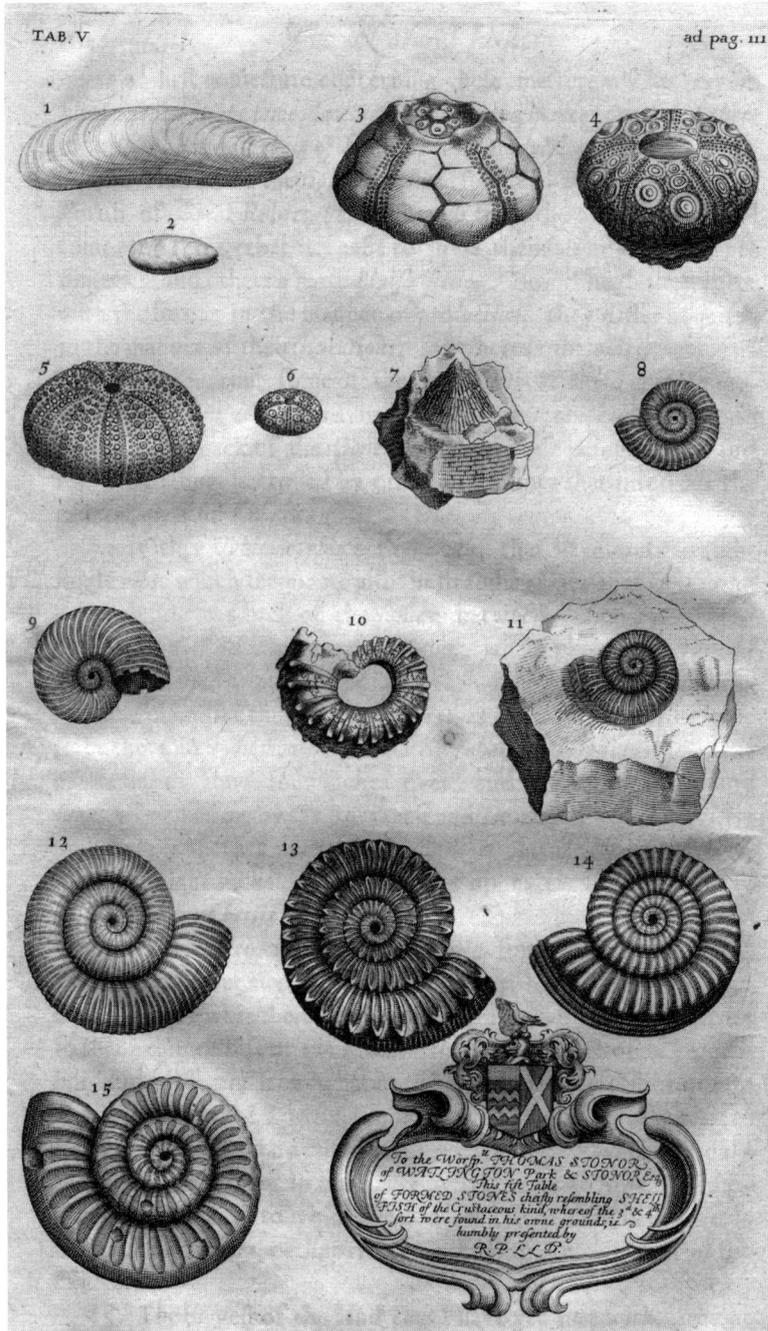

Figure 2.2. Robert Plot, *The Natural History of Oxfordshire*, 1677. Plate 5.

correct in thinking that this fossil was probably a portion of a bone, but when he republished the image he gave it the confusing name *Scrotum humanum*, for its overall shape. And then another eighteenth-century author, Jean-Baptiste Robinet, took this name seriously and wrote that the fossil was petrified human genitalia. What is important here is not that this misinterpretation came about, but that the image was repeated in a book published nearly one hundred years after Plot's.[13]

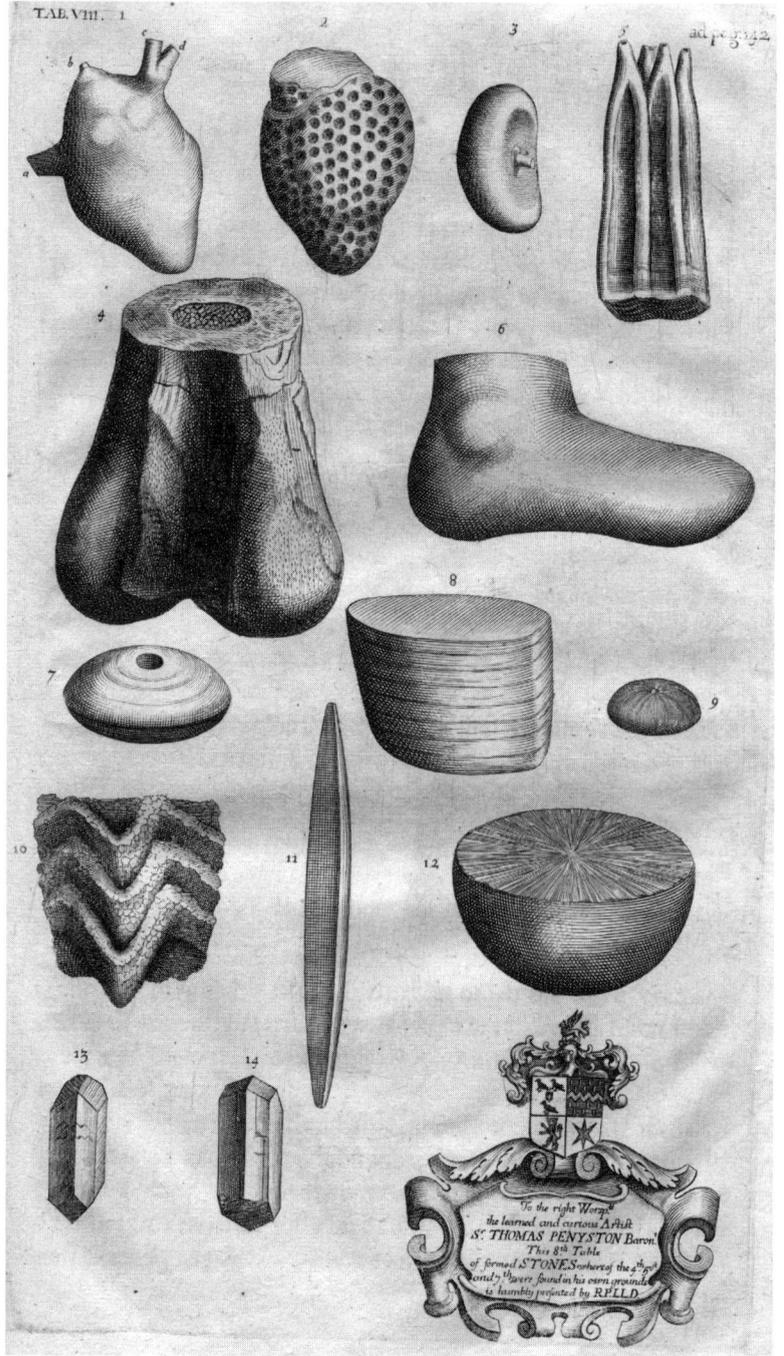

Figure 2.3. Robert Plot, *The Natural History of Oxfordshire*, 1677. Plate 8: *Megalosaurus* partial femur.

The English scholar Martin Lister (1639–1712) studied a variety of scientific disciplines, including (like so many others) medicine, although he seems to have concerned himself more with natural history, geology, and paleontology.[14] He did not complete a medical degree, but was awarded an honorary M.D. by Oxford University in 1684. He did practice medicine, and became a physician to Queen Anne in the later years of his life. His work in geology and paleontology fits into the later seventeenth century's confused patchwork of published theories. He recognized fossils as important to the study of the history of the earth, and yet he did not think they had an organic origin. He spent many years studying living bivalves and mollusks, as well as insects and spiders, and wrote a very important early treatise on the classification of arachnids and two books on conches. In 1678 Lister published his *Historia animalium angliae,* which dealt with fossils. Since he did not believe that they had an organic origin, he did not think that they could have been formed by the biblical Flood or some other such deluge. On the contrary, Lister thought fossils were formed by inorganic processes. But, at the same time, he published figures of fossils and compared them to extant organisms, which he also illustrated. He suggested that fossils might have a use as indices for strata, and that strata could serve as the basis for geological maps. Lister's plates in *Historia animalium angliae* were engravings of considerable detail and good quality, depicting echinoids, mollusks, and belemnites, among others.

The turn of the eighteenth century saw conflict continuing among European intellectuals over the nature and origin of fossils. In more than a century of study and discussion, nothing had been settled. Problems arose in part because of the teachings of the Bible, which were still accepted by most Europeans, but also because scholars didn't know what to make of fossils, like ammonites, that did not resemble any known living organism. The question of whether species could go extinct was by no means settled in 1700. Some authors continued to ascribe fossils to the biblical Flood, while others echoed Leonardo da Vinci's suggestion some two centuries earlier that while some sort of flood might have been involved, it was not likely to have been the one described in Genesis. Just as questions about fossils continued to be debated, so also illustrations of varying accuracy and level of detail continued to be used.

In his study of Lancashire and its nearby locales, Charles Leigh (1662–1701?) continued the tradition of writing local natural histories of English counties established by his contemporary Robert Plot. *The Natural History of Lancashire, Cheshire and the Peak in Derbyshire* appeared in 1700 and had a second printing in 1705. It is a sort of printed *kunstkamer*: "a catalogue of antiquities, an archaeological survey, and a freak show, all in one. . . . The plates include the 'Devil's arse,' a woman with horns, Greek carved tablets, fossils, birds, skulls and crustaceans."[15] Before we too quickly dismiss a work like this as a quaint relic of the credulous past, it is well to place it within its context. Books like this one were not at all uncommon even in the early eighteenth century. Medical texts continued to combine discussions and illustrations of

Martin Lister

Historia animalium angliae tres tractatus (1678)

Charles Leigh

The Natural History of Lancashire, Cheshire and the Peak in Derbyshire (1700)

rarities and unusual items with more sophisticated and modern scientific observations, just as Ambroise Paré had in the sixteenth century. The Enlightenment did not happen suddenly one morning in 1700. A book such as this was no doubt understood by some of its readers to be a blend of the silly and the scientific. But other readers would have assumed that its contents were accurate and true.

The premise of Leigh's work was by now not unusual. He held that there had indeed been a great flood of some type in the far past, and that this flood had been responsible for depositing not only fossils but other artifacts in England, specifically in Lancashire. Works like this were certainly of some value, even if the author's premises were somewhat weak. This sort of book was the eighteenth century's equivalent of the many modern television programs that blend folklore, science, and urban myths. Often those programs are lavishly designed and use fancy modern technologies such as computer-generated animation. Leigh's book easily compares with any number of such programs on ancient Egypt, unidentified flying objects, the Bermuda Triangle, Bigfoot, or the like. The taste for this sort of popularized science has endured for centuries. Leigh's book is well illustrated, with twenty-two full-page engravings and a double-page map. Clearly Leigh meant to imitate Plot. A plate that represents fossils is of interest in that it depicts two slabs of what appears to be fossiliferous limestone. Crinoid parts are clearly indicated. The plate also includes a clear illustration of an ammonite, a piece of fossil coral, and several other fossils. Some of the components of this illustration were executed with considerable attention to detail and would have been useful to readers wanting to learn what such fossils looked like.

Edward Lhwyd

Lithophylacii Britannici ichnographia (1699)

Edward Lhwyd (1660–1709) was Robert Plot's assistant while Plot was keeper of the Ashmolean Museum, and he replaced Plot in the position in 1691. He shared Plot's enthusiasm for fossils, and like Plot he collected fossils himself; he also bought them from others. He differed from Plot on how fossils were formed, however, and appended his theory to his book on British minerals and fossils. The *Lithophylacii Britannici ichnographia, sive, Lapidorum aliorumque fossilium britannicorum singulari figura insignium* was printed in London and Leipzig in 1699. The book was a catalogue of all 1766 fossils then in the Ashmolean collection, the first illustrated catalogue of a public collection of fossils published in England. It featured twenty-three pages of engravings of fossils, crystals, and minerals. It was printed by private subscription in only 120 copies, making it very rare today.[16]

Lhwyd thought that fossils had not been living organisms but were created by some type of seed, an "animalculum," that had washed into the ground, perhaps in the biblical Flood or some other great deluge, and had grown into stones that looked similar to living organisms.[17] Plot and many others had proposed such a theory; it was not original to Lhwyd. But the complexity of his catalogue and the quality of its illustrations make his book impressive in spite of his theories. Lhwyd's illustrations are well executed and detailed and provide good visual documentation of fossils such as fossil ferns,

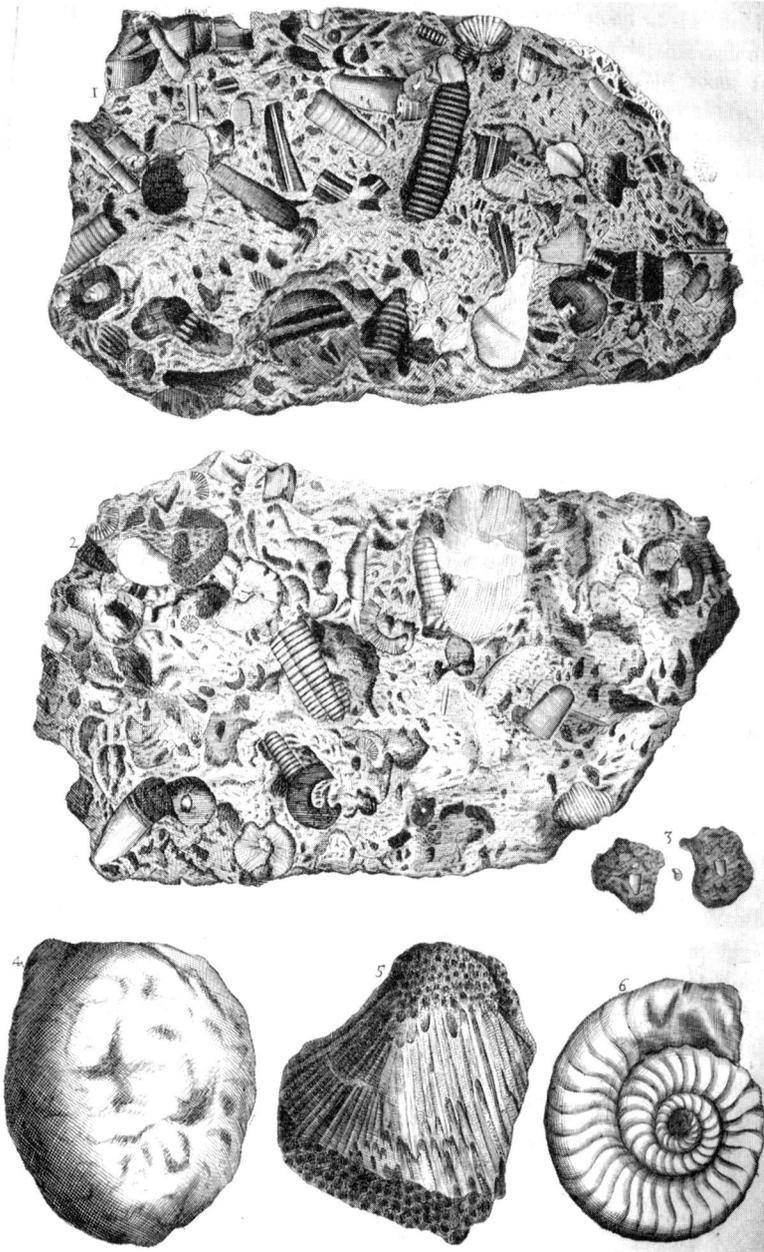

Figure 2.4. Charles Leigh, *The Natural History of Lancashire, Cheshire and the Peak in Derbyshire*, 1700. *Courtesy James Gray.*

ammonites, trilobites, and shark teeth. They are designed to be good enough to "enable even beginners to recognize immediately those things that they might discover." One illustration shows two specimens of fossil ferns, clearly and carefully depicted *in situ* in the rock matrix. The blocks of shale (or perhaps they are coal) are shown fractured into overlapping layers, with layers of fossil ferns "splitting out." Another illustration shows a three-dimensional view of a rock within which one can see fern fossils on various planes. This is, of course, exactly how fossil ferns in a shale matrix look. These illustrations are splendid.[18] Yet another illustration depicts an ammonite specimen that

Figure 2.5. Robert Lhwyd, *Lithophylacii Britannici ichnographia,* 1699. Ammonite. *Courtesy Sotheby's.*

CL.IV. Turbinata

Tab. 7.

has been split in half. The interior chambers are filled with calcite crystals. This fossil is among many that can be identified in the collections of the Oxford Museum of Natural History.

Robert Hooke
"Discourses of Earthquakes" (1705)

Hooke was not a geologist, but a physicist and mathematician. He was the curator of experiments for the Royal Society. And Hooke was also an accomplished artist. He wrote this work primarily in 1688 and 1689, but it was

A History of Paleontology Illustration

not published until after his death. He had already turned his attention to fossils in 1665, when he described the internal structure of specimens of petrified wood seen through the compound microscope. He also studied a microfossil at this time. Richard Waller, who published Hooke's *Posthumous Works* in 1705, included an illustration of a specimen of foraminiferan in this book as well. These are probably the earliest images of fossils shown as they appeared under the microscope.[19] When it was posthumously published, the "Discourse of Earthquakes" was accompanied by an exquisite illustration of various specimens of ammonites, those troublesome organisms, that Hooke had drawn himself. The detail in this illustration is wonderful, and it is a well-composed artistic design as well as a useful scientific illustration. Examples of the sutures of various specimens were also included.[20]

William Stukeley

"An Account of the Impression of the Almost Entire Sceleton of a Large Animal in a Very Hard Stone" (1719)

William Stukeley (1687–1765), a self-proclaimed antiquarian, was a medical doctor who produced a study of gout in 1736, but who is much better remembered today for his marvelous, if imaginative, studies of British antiquities. Stukeley was also an artist of some ability, and illustrated several books on monuments such as Stonehenge (1740) and Abury (1743). In these books Stukeley used engravings after his own drawings of the monuments as they appeared to him as well as how they might have looked in their heyday. In keeping with the romantic theories of his day, Stukeley thought that Stonehenge and Abury had been built by the Druids in the times of the Caesars. More interestingly for our purposes, he also turned his attention to a fascinating fossil, that of a plesiosaur. He obtained it in 1719 and studied it at length, publishing his article on it later that year.

Some who had seen the skeleton thought it was human, but Stukeley realized that this was not a set of human bones. He rightly noted that the vertebrae had a reptilian character, and while he could not say what the animal had been, or indeed whether it was a reptile or not, it definitely could not "be reckoned Human, but seems to be a Crocodile or Porpoise." In his article, Stukeley described the bones and termed them fossils. He thought that the fossil was produced by the burial and petrification of an animal killed in the biblical Flood.[21] That theory was neither novel or unusual, of course. What made this short treatise special was that Stukeley went to great pains to describe the shapes of the bones and even the color of the rock in which they were embedded; he even gave the dimensions of the block of matrix. Additionally, he included an illustration that he probably drew himself, which is most likely the earliest illustration of a plesiosaur fossil. This small engraving of the bones in matrix is well enough rendered that ribs, vertebrae, pelvic bones, and some limb bones are identifiable. Nearly a century before De la Beche and Conybeare, Stukeley had provided his colleagues at the Royal Society with a most unusual and novel specimen.

Louis Bourguet

Traité des petrifications
(1742)

The ocean is a new world within our globe. It has its own particular plants, animals, and rules of mechanics.

Louis Bourguet

Figure 2.6. William Stukeley, "An Account of the Impression of the Almost Entire Sceleton of a Large Animal," 1719. Plesiosaur.

Louis Bourguet (1672–1742), a professor of philosophy from Neufchâtel in Switzerland, held, like John Woodward (1665–1758), that fossils probably originated in a flood or deluge. His *Traité des petrifications* is structured as a series of letters dealing with geology, the biblical Flood, and fossils, purportedly written in 1740 and 1741 to various gentlemen. I am not certain that these letters were ever delivered; they may be only a literary device. The book itself was published by a Parisian firm and features etchings that were executed with considerable attention to the structural details of the fossils. The beautiful plates were engraved under Bourguet's direct supervision and printed in The Hague.[22] Although some of the images were copied from elsewhere, all the etchings were newly done for the book.

This book is a joy to peruse. It has a wonderful quality of enthusiasm and astonishment. Because the chapters are in the form of letters, they have a conversational style. At the same time, Bourguet was trying to convey accurate and detailed information about his fossils and to make clear his support for the positions of Johann Scheuchzer. Its etchings of fossils, sixty plates depicting 441 specimens, were for the most part well executed. The author tried his best to relate what he saw in these fossils, using both imagery and text. Bourguet identifies their sources; many had been collected by Scheuchzer and Karl Nicholas Lang from the quarry at Oningen, so without question he was able to see at least some of them. The etchings are at the

Figure 2.7. Louis Bourguet,
Traité des petrifications, 1742.

XXXV

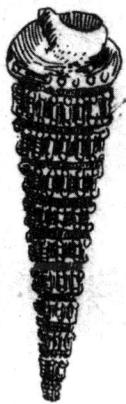

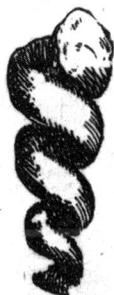

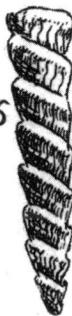

back of the text and are accompanied by legends and commentaries. All are printed on two-page foldouts, with the image on the right side and the left side blank. Readers could thus see each one next to the page discussing it; the printed page covered only the blank half of the foldout.

Plate 60 depicts the infamous fossil of the "man who witnessed the Flood," made famous by Johann Scheuchzer. Scheuchzer (1672–1733) was a Swiss naturalist and medical doctor. He was interested in fossils, which he believed had been produced by the biblical Flood of Noah, and his attention to the effects of that flood is clear in all his publications that deal with

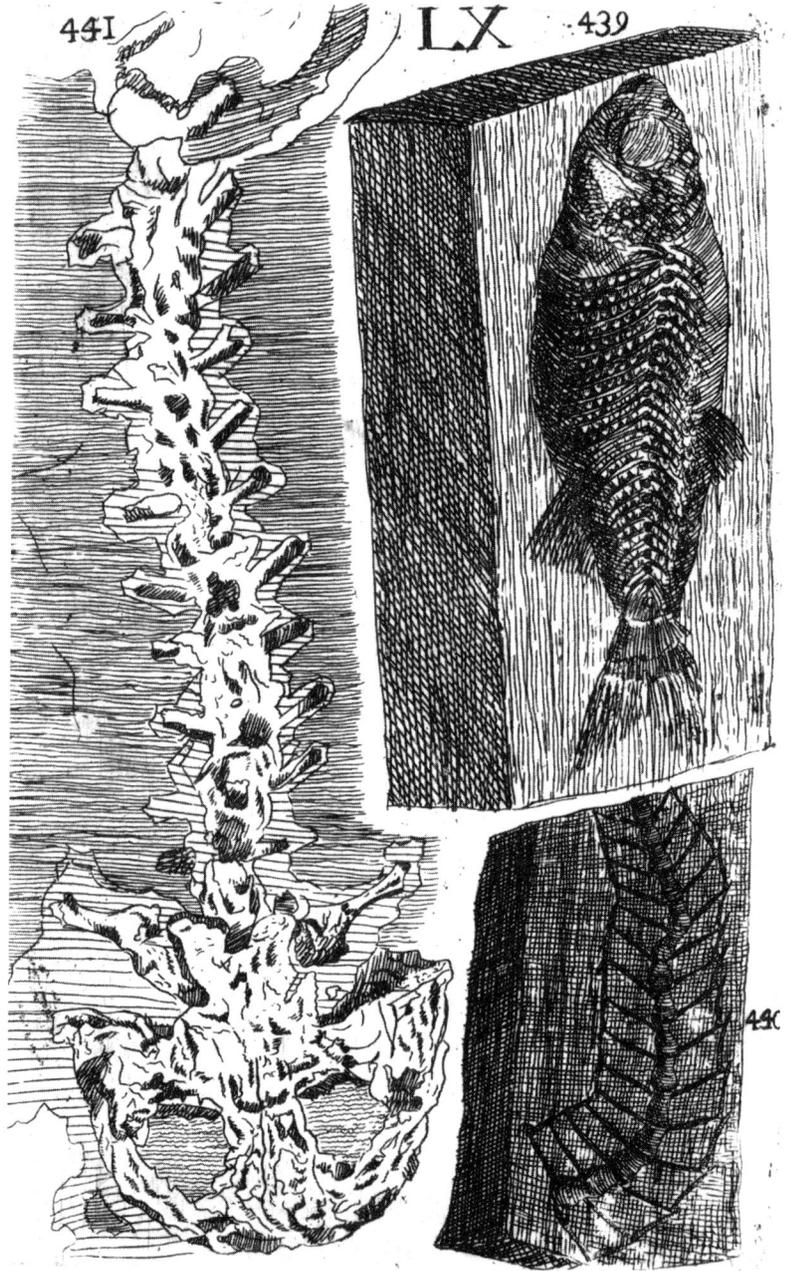

Figure 2.8. Louis Bourguet, *Traité des petrifications*, 1742. *Homo diluvii testis.*

geology. His 1709 work, *Herbarium diluvianum*, contains illustrations of fossil plants and other items that he thought were remains of it. The book is among the earliest works to deal with fossil plants. But he is probably best remembered for the fossil that he published in 1726 and again in *Physica sacra* (1731–1733). It was a fossil salamander (as Cuvier and others later pointed out), but Scheuchzer thought it was the partial skeleton of a human and labeled it *Homo diluvii testis,* "The man who witnessed the Flood." Bourguet's plate 60, a close copy of Scheuchzer's illustration, shows the skull and portions of the vertebrae. Interestingly enough, not all of the fos-

sil is shown in these eighteenth-century illustrations. The actual fossil is in the Teylers Museum, Haarlem, and comparing it to the etching reveals that either the specimen underwent further cleaning up (more rock matrix was removed) or Scheuchzer and his supporters chose not to depict some parts of it, in order to support their claim that it was a human skeleton. There is no doubt that Bourguet thought it was. He made this amply clear in his notes to the illustration, speaking of the fossil as including a human skull and discussing its jugal bone, right and left zygomatic bones, eye sockets, nasal vomer, and so forth.[23]

Most of the fossils depicted in the *Traité des petrifications* are marine organisms. The book contains illustrations of corals, oysters, various bivalves, mollusks, ammonites, echinoids, crinoids, belemnites, shark teeth, and two fish, as well as the "man who witnessed the Deluge." Plate scars are apparent on the foldouts, evidence that they are the actual prints, bound into the book. The plates were approximately 5.5 inches wide and 7.75 inches long. The use of the actual etchings and the fact that the illustrations were printed in The Hague and then presumably shipped to Paris to be bound in with the text pages must have made the book an expensive item.[24] These etchings are reasonably well done, though of course they do not compare to the work of a technical genius like Rembrandt van Rijn.

Each illustration is numbered within the plate and keyed to text that identifies the specimen and indicates where it (or the image of it) came from. Some of these images were taken from Scheuchzer and Lang, but Bourguet had others made from specimens in various private collections, including his own.[25] (Some of the letters that form the chapters of the book are addressed to these collectors.) Numerous fossils are illustrated, but also specimens of living organisms, and it is sometimes difficult to tell which is which from just the illustrations and their descriptions. Obviously crinoids, belemnites, and ammonites are fossils. But some of the corals and other specimens might not be. Bourguet calls some items "petrified," but not others. There are numerous illustrations of ammonites, which Bourguet commented were thought by some people to be petrified serpents.[26]

On balance, this book's chief value lay in its illustrations. Bourguet tried to be scientific in his approach to his subject matter. He provided a lengthy bibliography and an index of places in various European countries where fossils were to be found. He carefully labeled his specimens and again took care to make it obvious from whom or which book they came. The text reads more like the work of an amateur than of a trained scientist, but the images are wonderful. Today the *Traité* is an interesting historical document that gives insights into the contents of private collections and the amount of published materials in geology and paleontology that were available to collectors.

Antoine-Joseph Dézallier d'Argenville

L'histoire naturelle éclaircie dans une de ses parties principales, l'oryctologie (1742 and 1755)

Art historians who specialize in the baroque art of northern Europe are familiar with Antoine-Joseph Dézallier d'Argenville as the author of a set of biographical sketches of famous Dutch and Flemish painters, the *Abrégé de la vie des plus fameux peintres,* which began appearing in 1745 and continued through 1752. Modern scholars use it as a very early and relatively accurate source of biographical information and some data on eighteenth-century locations of various paintings. Like many men of his time, Dézallier d'Argenville turned his interests to many topics. He made himself familiar with art and its history, but he also wrote about horticulture and landscape design, the biology of mollusks, geology, mineralogy, and fossils. His book on French fossils, *Enumerationis fossilium,* was published in 1751, and a posthumous volume on mollusks, *La conchyliologie,* came out in 1780.[27] The *Histoire naturelle éclaircie* dealt with both living and fossil animals.

Figure 2.9. Antoine-Joseph Dézallier d'Argenville, *L'histoire naturelle éclaircie,* 1755. *Courtesy Ed Rogers.*

The frontispiece to the 1755 edition of *L'histoire naturelle éclaircie* is reminiscent of the title page of Scilla's *Vana speculazione.* In it we see an allegory of Science (or perhaps Truth) watching as men work to unearth minerals and fossils. In one hand she holds an ammonite and in the other a branch of coral. Another interesting engraving in this volume incorporates the fossil salamander that Scheuchzer believed was a fossil human. Dézallier d'Argenville labeled this illustration "Parties de corps humain petrifiées," thus maintaining the notion that this was the "man who saw the Flood." The engraving also contains a poorly drawn skull, anatomically inaccurate, that apparently is to be taken for human, and two additional fossils that may be vertebrae. Dézallier d'Argenville was no

Figure 2.10. Christian Friedrich Schulze, *Betrachtung der versteinerten Seesterne und ihren Thiele,* 1760. Crinoids. *Courtesy Ed Rogers.*

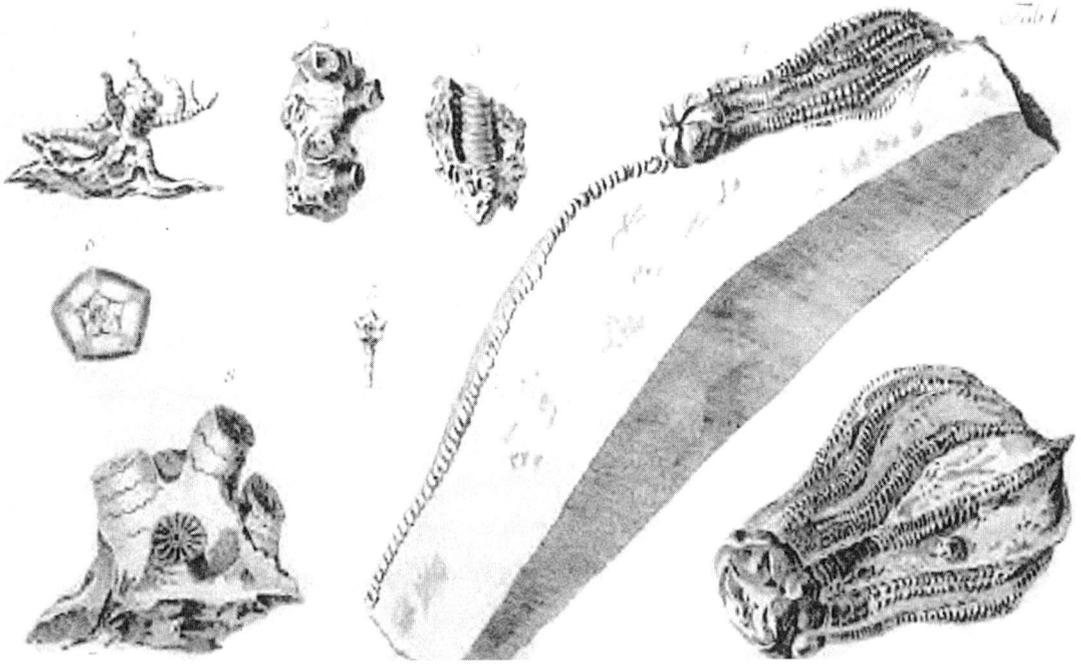

doubt on much safer ground with his studies of fossil and living mollusks. But he was making an attempt to come to terms with fossils and their origins.

Jacob Theodor Klein (1685–1759) was a Polish lawyer and diplomat who served the government of Gdańsk (Danzig). He was also trained as a mathematician. And besides these areas of expertise, Klein was a naturalist. He was responsible for setting up Gdańsk's botanical garden. And he was an enthusiastic collector of fossils and other natural history specimens. His personal collection ran into the hundreds of specimens. The *Tentamen methodi ostracologicae* is a catalogue of his collection. It is illustrated with 228 engravings, each depicting a number of extant or fossil shells, many of them mollusks. Klein had his portrait engraved and included in this work. He is shown standing beside a large bookshelf. Fossils as well as books sit on the shelf.[28] The illustrations are quite beautiful and this work certainly demonstrates Klein's interest in biology and paleontology, but it also makes clear that others were interested in such items as fossil shells too. This was not a mere vanity publication to document his collection. Klein published this book to be sold.

Christian Friedrich Schulze (1730–1775) was a German physician who also devoted time to the study of paleontology. He was especially interested in fossil plants and invertebrates, and his three books on them are illustrated with engravings depicting plants, various invertebrates such as echinoids, and many crinoids. The engravings are delicate and well drawn and show considerable verisimilitude and detail. Some of the illustrations of crinoids (for example, in table I of *Betrachtung der versteinerten Seesterne*) depict

Jacob Theodor Klein

Tentamen methodi ostracologicae (1753)

Christian Friedrich Schulze

Kurtze Betrachtung derer versteinerten Höltzer (1754), *Kurtze Betrachtung derer Kräuterabdrücke im Steinreiche* (1755), **and** *Betrachtung der versteinerten Seesterne und ihren Theile* (1760)

only parts of fossils, but others are images of almost entire organisms. Thus the reader could observe in one plate both the general morphology of the crinoid and specific aspects of it. In contrast to the rather poorly executed images in Dézallier d'Argenville's book, those in Schulze's are extremely well done and certainly could have served as scientific illustrations.

Francois-Xavier Burtin

Oryctographie de Bruxelles, ou Description des fossiles (1784)

Francois-Xavier Burtin (1743–1818) was a Brussels physician who, like so many others in his profession, had an interest in paleontology. He is thought to have been the first to publish on fossils found close to this city, and his book, which was published privately, is an early example of a study of the fossils in a specific locality. The title vignette shows various fossil-hunting excavations. One such excavation is a hundred-foot-long trench.[29] The plates include illustrations of gemstones as well as fossils. Some of the fossils shown are vertebrates, such as fish and turtles, but many are invertebrates (color plate 2). Specimens of petrified wood are also included, as are fossil teeth of various species of shark. What makes these engravings special is that each was hand-colored after it was printed. The result is a beautifully illustrated study of paleontology that has the advantage of demonstrating to the viewer the color not only of fossil specimens, but of the rock matrices as well. One illustration depicts a chunk of matrix from which numerous mollusk fossils protrude. It is a beautiful plate. The fossils are tan, pinkish-orange, and cream-white. Another shows a fossil fish in its matrix.

In some respects, Burtin was probably writing a history of his city, as Plot had written about Oxfordshire a century earlier. But this work was also a serious attempt at paleontology. Some of the species it depicts had been unknown prior to its publication. Martin Rudwick recently described the *Oryctographie de Bruxelles* as a "luxury work." This is an apt description, as the cost of publication would certainly have been high, considering the time and effort that went into making hand-colored illustrations. The book was subscribed by 142 individuals, among whom were many aristocrats and intellectuals.[30]

Georges Cuvier

Recherches sur les ossemens fossiles de quadrupèdes (1812)

Much has been written about Georges Cuvier's (1769–1832) contributions to paleontology, geology, and the natural sciences in general, and I will not repeat it here.[31] He did not believe in evolution, but he posited that fossils were the remains of extinct organisms, and that there had been periods, which he called revolutions, during which many life forms on Earth were simply wiped out. Cuvier's major work on fossils, his *Recherches sur les ossemens fossiles de quadrupèdes* (also known as *Révolutions du globe*) appeared in 1812 and was immediately translated into English. The book received the attention of a wide audience and is still reprinted today. Cuvier's paleontological research was founded on comparative anatomy. For instance, he identified *Megatherium* as a fossil sloth by comparing the bones of the fossil to those of extant tree sloths. This highly logical method of classifying fossil organisms appealed to many early paleontologists, no

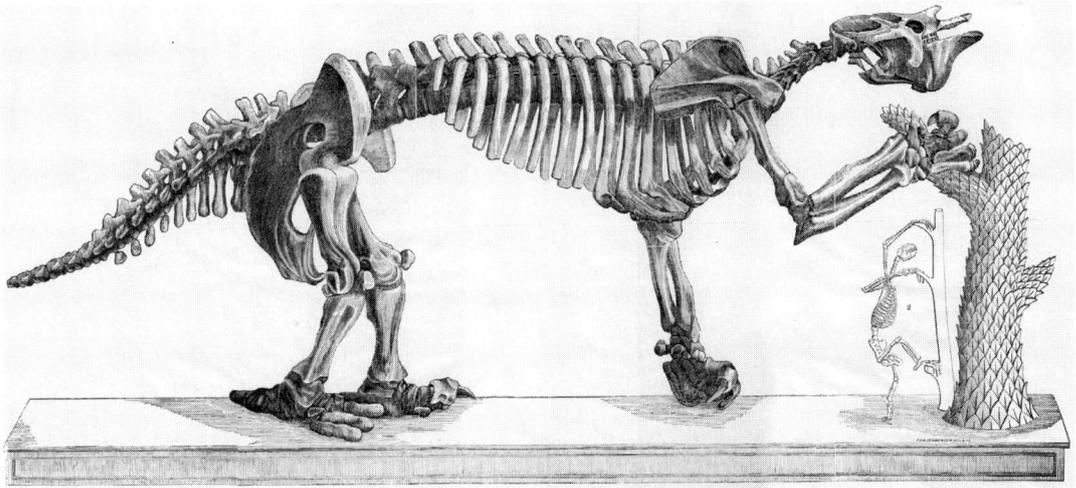

SKELETON OF MEGATHERIUM CUVIERI.

Fig. 2, Bradypus Tridactylus (Sloth).

SCALE 1-14: *about one inch to the foot.*

doubt in part because many of them were trained as physicians. It became a standard means of identifying fossil materials, and is still used for that purpose. While he did not include restorations in his publications, Cuvier did make some drawings for his personal use in which he tried to sketch muscles and general body outlines over skeletons. At the very least, the idea of restoration was in his mind. As Rudwick has put it, to Cuvier these fossils "were creatures as real as any living mammals."[32]

The illustrations in Cuvier's *Recherches* are comparable to others of the period, varying in quality depending on who did the initial drawings and the subsequent engravings. Like many other scientists, Cuvier himself did many of the drawings the engravers used, and his work was frequently of a high technical quality. He was also generally careful to ensure the quality of the finished prints. Many of these dealt with vertebrate fossils, in which he was greatly interested. Others—perhaps based on drawings by other artists—are less impressive. They are significant nonetheless, because of Cuvier's stature.[33]

Reproductions of Cuvier's image of the reconstructed skeleton of *Megatherium* beside the skeleton of a tree sloth became quite popular in the nineteenth century and were even made into models for display and sale. Henry A. Ward issued a catalogue of such models in 1866 that included one of a *Megatherium* skeleton posed with that of a modern sloth, following Cuvier. (The catalogue image had already appeared in a pamphlet on *Megatherium* he published two years earlier.) Ward's model was based on a cast of the skeleton that had been prepared in London and donated to the University of Rochester by Hiram Sibley.[34]

Figure 2.11. Henry A. Ward, *Notice of the* Megatherium Cuvieri, 1864. *Megatherium, after Cuvier.*

XXI—Ideal scene in the Lower Cretaceous Period, with Iguanodon and Megalosaurus.

THE NINETEENTH CENTURY

3

Many nineteenth-century paleontology studies contain examples of novel and even experimental illustrative techniques. Scientists and publishers alike attempted to provide illustrations that would be not only informative but also accurate, and in this effort they used color, high-quality printmaking processes, and even photography. Because of this, some of these printed works were no doubt expensive to produce. Traditional printmaking techniques, such as woodcut and especially engraving, were used, but now books also began to be illustrated with lithographs. Lithography was invented at the end of the eighteenth century. Instead of being engraved on a plate, an image is drawn or painted on one (originally on a stone, hence the name) in an oily medium. Water is applied to the plate, and the oily areas repel it; then ink is applied, which adheres to the oily areas but is repelled by the water. Paper pressed against the plate thus picks up an inked mirror image of the original drawing. Lithographs could include very delicate details and could be printed in color, with a different stone used for each color.

With the advent of photography, publishers began to use not only actual photographs in paleontology books, but also the quite experimental techniques of photoengraving and photolithography. Daguerreotypes, which are made without negatives, had to be redrawn on the lithograph plate by hand. When calotypes were invented in 1841, their glass negatives could be placed on a metal plate coated with photosensitive chemicals, transferring the image directly to the plate. As always, the goal was to provide a realistic and detailed image of the fossil. In addition, authors wanted their illustrations to be beautiful. The close associations between paleontologists and illustrators continued to flourish during this century. As before, many prominent paleontologists were themselves artists.

Nineteenth-century scientific books and papers dealt with a diverse set of topics. Some were exclusively devoted to fossil invertebrates, some to fossil plants, and some to trace fossils such as footprints and trackways. Others reconstructed scenes of paleoecology. A few popular works, such as Louis Figuier's 1863 *La terre avant le déluge,* covered the topic extensively and depicted such scenes in vignettes. Some, like David Thomas Ansted's 1863 *The Great Stone Book of Nature,* showed fossil life restored and placed into what the author believed were accurate habitats. Ansted's book could have been read by adults, but it was designed to be accessible to anyone with a high school education. It thus straddled the boundary between educational text and popular presentation.

It was not only in popular books that prehistoric habitats were recon-

Figure 3.1. Louis Figuier, *La terre avant le déluge,* 1867 (English ed.). "Lower Cretaceous scene."

Figure 3.2. David T. Ansted, *The Great Stone Book of Nature,* 1863. Frontispiece.

structed and depicted. Waterhouse Hawkins's reconstructions at the Crystal Palace dinosaur display and his proposed designs for a similar Central Park display may be seen as attempts to place fossil life in a lifelike setting. Hawkins also prepared designs for indoor museum displays, which sometimes contained vignettes of ancient ecology. And Edward Drinker Cope accompanied his 1869 article "The Fossil Reptiles of New Jersey" with a vignette he had drawn about two years before, further evidence that museum displays and scientific papers could also contain reconstructed ecological settings and fossil life forms.

Most scenes of ancient environments were included in works that dealt with specific fossils. They allowed the scientist and the reading public to see restorations of those fossils in what was believed to have been their ecological setting. Gradually, the designers of museum displays began to incorporate life restorations and ecological settings into their displays, so that a larger public might be able to imagine fossils as the animals and plants they had been in life.

Examples of the Early Use of Colored Illustrations: Parkinson and Agassiz

Many nineteenth-century scientific treatises are now seen only as important historical documents, sources for those interested in the history of taxonomy. But they also indicate the century's infatuation with the inventions of the Industrial Revolution. And many of them are simply beautiful. These works helped to firmly establish patterns and standards for scientific illustration in paleontology. Scientists would continue to consider it important to provide excellent and accurate illustrations of fossils, and to try out new techniques of producing these illustrations. James Parkinson and Louis Agassiz took pains to use colored illustrations of high quality in their works. Today's read-

FIG. 9.—Restored Fossil Reptiles of New Jersey. *(From the American Naturalist.)*

ers are so familiar with color imagery that they may not realize how impor-
tant these early colored images were. With them, scientists and artists could
provide readers with an additional level of representational accuracy. Fossils
and rock matrices could be seen as they actually appeared. Colored litho-
graphs were produced in two ways. Some were printed in color, using multi-
ple plates; others were individually hand-painted with watercolors.

Figure 3.3. Edward D. Cope, "The Fossil Reptiles of New Jersey," 1869.

James Parkinson, *Organic Remains of a Former World* (1804–1811)

James Parkinson (1755–1824) was a physician, chemist, and naturalist. He is
remembered in modern times as an important contributor to the history of
medicine, having described the palsy disease that today bears his name.[1]
Parkinson's treatise on paleontology ran to three volumes. He was a firm be-
liever in the biblical Flood and felt that fossils were remains created by that
event, although he came to think that scientists like Lamarck were correct in
suggesting that some sort of evolutionary development had taken place. This,
Parkinson stated, did not conflict with the teachings of Genesis. In essence,
those seven days of Creation just took a very long time, during which organ-
isms changed.[2] The three volumes of his *Organic Remains of a Former World*
were illustrated with detailed engravings, some of which were colored, and
which may have been executed from his own drawings.[3] They were of suffi-
ciently good quality that Gideon Mantell reproduced many of them, includ-
ing specimens of both vertebrates and invertebrates, in his 1850 *A Pictorial
Atlas of Fossil Remains.* Many of Parkinson's illustrations were of invertebrate

fossils, such as crinoids. There were also depictions of fossil shark teeth. It may be assumed from the coloration of the engravings that Parkinson was striving to reproduce the color of the fossils and their matrix.

Louis Agassiz, *Recherches sur les poissons fossiles* (1833–1845)

In most of his *Recherches sur les poissons fossiles,* Louis Agassiz made every effort to ensure that his illustrations (many of which were in color) were of good quality. These illustrations are chromolithographs, often based on watercolor drawings of the specimens, although some may have been drawn onto the lithographic stone from the specimens themselves. Some of the preliminary drawings were done by Agassiz, while others were provided by various artists and even collectors with whom Agassiz worked.[4] The details are remarkably fine, and the use of color made the book an even better guide to the identification and study of various species of fossil fish. Agassiz also used chromolithographs in his later volume, *Monographie des poissons fossiles du vieux grès rouge* (1844–1845), but this book's illustrations were generally of a lesser quality, and fewer of them were in color. The same diminished quality can be seen in some of the later editions of the *Recherches,* although the illustrations were still quite fine as late as 1843.[5] (See color plate 3.)

William Buckland

"Notice on the *Megalosaurus* or Great Fossil Lizard of Stonesfield" (1824) and *Geology and Mineralogy Considered with Reference to Natural Theology* (1836)

William Buckland (1784–1856) strove to weave together contemporary theories of the geologic development of the earth, theories of evolution, and the Judeo-Christian belief in a deity who had designed the world and its life forms.[6] This is hardly surprising, considering that he was a minister as well as a naturalist and geologist. Buckland was a reader in geology and mineralogy at Oxford University and a canon of Christ Church, Oxford. He began to lecture at Oxford in 1819, and it was his mission to make geology and paleontology compatible with religion. In his 1836 contribution to the "Bridgewater Treatises," a published series of lectures by various people at Oxford, Buckland explained his theories of what was known then as "natural theology," echoing the principles of comparative anatomy supported by Cuvier:

> The myriads of petrified Remains which are disclosed by the researches of Geology all tend to prove, that our Planet has been occupied in times preceding the Creation of the Human Race, by extinct species of Animals and Vegetables, made up, like living Organic Bodies, of "Clusters of Contrivances," which demonstrate the exercise of stupendous Intelligence and Power. They further show that these extinct forms of Organic Life were closely allied, by Unity in the principles of their construction, to Classes, Orders, and Families, which make up the existing Animal and Vegetable Kingdoms, that they not only afford an argument of surpassing force, against the doctrines of the Atheist and the Polytheist; but supply a chain of connected evidence, amounting to demonstration, of the continuous Being, and of many of the highest Attributes of the One Living and True God.[7]

While Buckland tackled the problems presented by natural theology, an effort hardly novel in the early nineteenth century, he made significant

contributions to paleontology. His *Geology and Mineralogy Considered with Reference to Natural Theology* is a veritable encyclopedia of paleontology. Its illustrations depicted invertebrates, vertebrates, fossil tracks and footprints, geological cross sections, and so forth. It was reissued in 1837 in London and also appeared in that year in an American edition. Subsequent British and American editions were published into the middle of the century. Its illustrations became well known and were frequently reprinted in both scientific and popular works.[8]

Geology and Mineralogy was not Buckland's first publication, of course. It represented a culmination of many decades' work, as well as his study of the publications of others. Buckland's 1824 paper on *Megalosaurus* is a good example of his earlier work and his use of scientific illustrations. He read this paper before the Geological Society of London on February 20, 1824, and it was subsequently published in the *Transactions* of the Society. The published paper contained five lithographs showing the jaw and teeth, vertebrae, ribs, scapula, and limb bones of the animal. Four of these lithographs were signed by M. Merland, draughtsman, and Henry Perry, designer of the lithographic plate, and were printed by C. Hallenmandel. Plate 40, which shows the jaw and teeth, is not signed, but was probably also prepared by the same team. The lithographs were of a good quality and would certainly have been useful to readers who had not seen the original specimen.

The first volume of *Geology and Mineralogy* included illustrations, and the second volume consisted entirely of them: 87 plates containing 705 individual images. Most were engravings; a few, however, appear to have been lithographs, or at least reproductions of lithographs. A number of the illustrations were copied from previously published works, to which Buckland was careful to give credit. Most were drawn by J. Fischer. Another artist whose name appeared frequently was J. Sowerby, known by his monogram, JDCS. Plate 34, showing the "animal of *Nautilis pompilius*," was drawn by none other than Richard Owen.[9] Hallenmandel printed many of the plates, and others were printed by Zeitner.

The images of prints and trackways in this work are quite significant, as some of them were taken from the work of Edward Hitchcock, who had only recently published this material. Some of the images in Buckland's plates 26a and 26b are taken directly from Hitchcock's 1836 "Ornithichology," and one illustration in plate 26b was drawn directly by George Scharf from a mold that Hitchcock himself had supplied to the Geological Society of London. Buckland agreed with Hitchcock that these tracks had been made by birds.[10] At that time, of course, no one had conceived of bipedal dinosaurs.

George Scharf (1788–1860), a commercial lithographer and theatrical set designer, was much in demand as a scientific illustrator. He worked for most of the important British paleontologists of his day, including Henry De la Beche, William Conybeare, Thomas Hawkins, and Richard Owen, and he contributed several lithographs to Buckland's work, including figure 1, showing a restored *Megatherium* skeleton, and figure 26, showing a collection of fossilized trackways and footprints. Scharf's draughtsmanship was excellent and he was able to depict extremely fine details; the im-

ages he provided to *Geology and Mineralogy* are noticeably better than those by Buckland's other illustrators.[11]

Henry De la Beche and William D. Conybeare

"Notice of the Discovery of a New Fossil Animal, Forming a Link between the *Ichthyosaurus* and Crocodile" (1821)

The English geologist Henry Thomas De la Beche (1796–1855) is best known among paleontologists today for his pioneering contributions to the study of plesiosaurs and ichthyosaurs. Because he was a personal friend of Mary Anning, he had immediate access to the fossils she had found.[12] De la Beche and W. D. Conybeare (1787–1856) published and illustrated Anning's two most famous discoveries in a paper presented in 1821. Herein De la Beche illustrated the head of *Ichthyosaurus* and vertebrae and other bones of *Ichthyosaurus* and *Plesiosaurus*. Three illustrations were based on De la Beche's drawings from the original specimens: "Osteology of the head of the *Ichthyosaurus*," "Vertebrae of the *Plesiosaurus* and the *Ichthyosaurus*," and "Bones of the *Plesiosaurus*." This last depicted some portions of limb and paddle bones.[13]

As a draughtsman De la Beche was possessed of considerable technical skills. He created delicate and intricately detailed drawings of fossils, which were well adapted to the medium of engraving, and his printed illustrations were usually equally elegant and well executed. He demonstrated his skills in most of his geological publications as well, wherein one sees splendid images of geological formations. He was also particular about the quality of illustrations made by others that appeared in his publications. His 1839 *Report on the Geology of Cornwall, Devon and West Somerset* is a beautiful work of art. By contrast, the production quality of the illustrations in his 1851 *The Geological Observer* is by no means as high, perhaps because, unlike the 1839 *Report*, it was not published with the Crown's financial support. Like the earlier book, however, it contains illustrations based on his own drawings.

De la Beche turned his wonderful imagination and marvelous talents as a draughtsman to the creation of straightforward works of scientific illustration as well as to fossil singeries: works of art in which animals take on the roles and garb of humans. As early as 1825, he sketched a coat of arms for the Geological Society of London that was supported by a rampant skeletal ichthyosaur and a skeletal plesiosaur.[14] Five years later he satirized Charles Lyell's *Principles of Geology* with a blistering lithograph entitled "Awful Changes." Lyell's theory of uniformitarianism held that geological processes repeated over time. Thus it might be possible for extinct animals to reappear. In this famous caricature De la Beche showed Lyell (1797–1875) as Professor Ichthyosaur, lecturing on the remains of a human while a group of ichthyosaurs, plesiosaurs, and other fossil reptiles listen intently. The title and caption of the lithograph read,

> Awful Changes. Man only found in fossil state. Reappearance of ichthyosauri. "A change came o'er the spirit of my dream." Byron, A Lecture. "You will at once perceive," continued Professor Ichthyosaurus, "that the skull before us belonged to some of the lower order of animals, the teeth are very insignificant, the power of the jaws trifling, and altogether it seems wonderful how the creature could have procured food."[15]

De la Beche was not the only early-nineteenth-century artist to employ fossil animals in singeries. In 1849 W. H. Baily, founder of the Geological Survey of Great Britain, devised a coat of arms for that group on De la Beche's model. Baily's coat of arms has a shield made up of a trilobite, supported by an ichthyosaur and a plesiosaur who have been fleshed out and given human clothing to wear. The ichthyosaur is dressed like a gentleman in a frock coat. He wears glasses and has a magnifying glass suspended from his neck. His counterpart, the plesiosaur, is dressed as, in McCartney's words, a woman "of high fashion with more than her ankles showing."[16] That is, she is in a low-cut dress and, unlike a proper Victorian lady, exposes quite a lot of her lower limbs. She has paddles at the ends of her forelegs, but her "feet" are encased in sharp patent-leather shoes. Could she have been a smile and nod to Mary Anning?

De la Beche is also well remembered for a color lithograph made about 1830 by George Scharf, from De la Beche's watercolor of fossil life in prehistoric Dorsetshire. The print, known as *Duria antiquior,* "an older Dorsetshire," is a very early attempt at describing paleoecology, and shows a variety of animal and plant life. Copies were sold for the benefit of Miss Anning, who had fallen on hard times. Today the original drawing is owned by the National Museum of Wales, which continues to sell replicas of it. This print has to be one of the earliest uses of paleontology illustration as commercial art. But at the same time, it was intended for educational purposes and fundraising.[17] While most of De la Beche's scientific illustrations were of fossil remains, in this picture he depicted plesiosaurs and ichthyosaurs restored to life, swimming and foraging in a natural setting. Rudwick notes that De la Beche allowed the observer to see what was happening under the water, as though standing in the water along with the animals, and that this novel presentation of prehistoric ecology comes too early to be the result of a new Victorian-era interest in aquariums. That is probably true, although aquariums had been known since around 1700.[18] De la Beche was more likely trying to show what the living animals had been like. To show their feeding and swimming, he had to allow the viewer to look underneath the water, as it were.

De la Beche's scene is a very early attempt to show ancient ecology and how these animals might have looked and behaved. It is a beautiful print. The colors are both lively and, by the standards of the day, believable: rather fishlike light grayish browns and greens. The feeding postures of the ichthyosaurs and plesiosaurs are charming. Since little was known about these extinct reptiles, including about how they moved, De la Beche had to rely on educated guesses.[19] One ichthyosaur is shown swimming up to a fish with its mouth gaping to swallow the fish head-first, just as one fish would swallow another. A second ichthyosaur reaches up out of the water to grasp a plesiosaur's neck in its jaws. Many future feeding scenes would reproduce that motif. In the background a third ichthyosaur has surfaced much as a whale or dolphin would, and is spouting water from its nostrils. This motif would recur frequently as well. The print also showed pterodactyls, ammonites, and fossil species of fish. It was a compendium of much of what was known about fossils in 1830. Dead creatures are shown strewn about the sea bed; the draw-

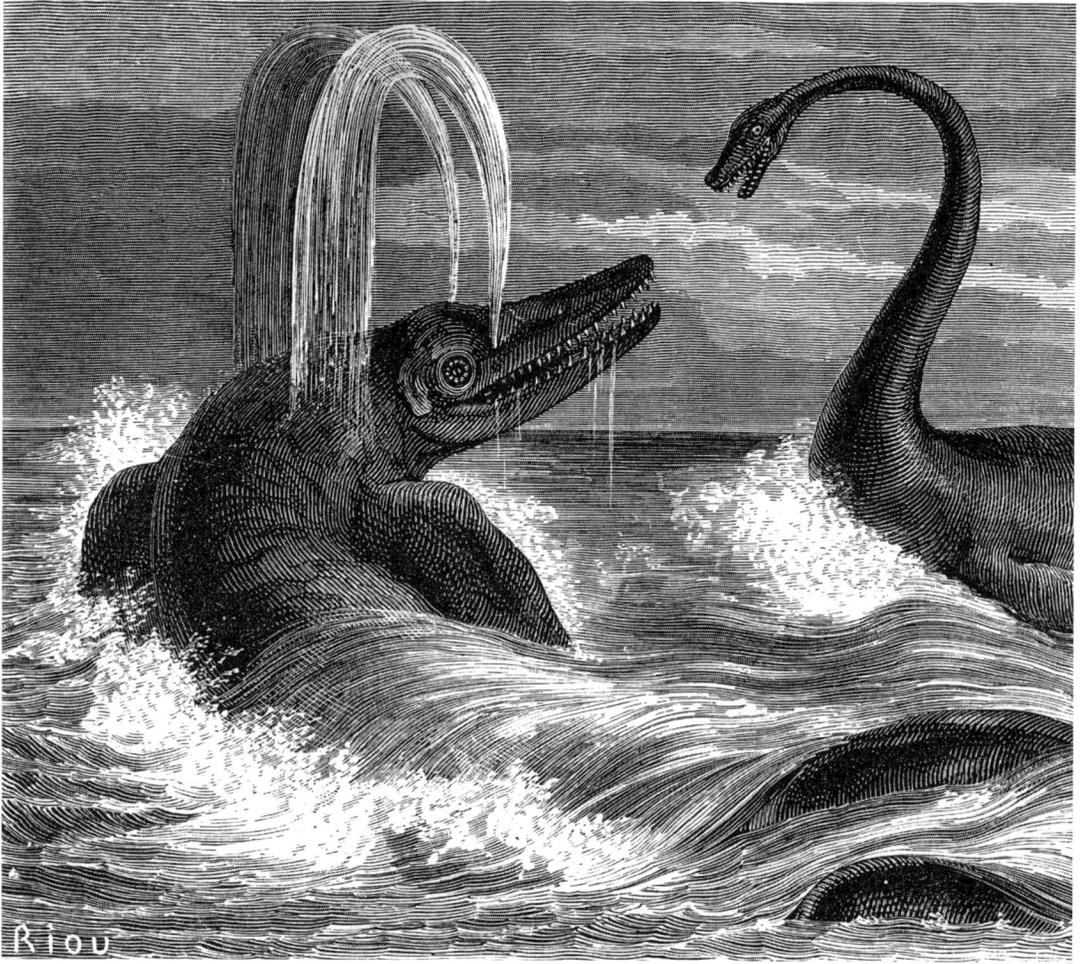

Figure 3.4. Louis Figuier, *La terre avant le déluge*, 1872.

ing is clearly an attempt to instruct the viewer about types of ancient life and how they became fossils.

And then there are the coprolites: fossilized feces. Many of the animals in *Duria antiquior* are shown defecating. Both Rudwick and McCartney have commented on De la Beche's interest in coprolites. In an 1829 lithograph called *A Coprolitic Vision,* De la Beche made great fun of Buckland, an expert on coprolites.[20] The lithograph depicts Buckland standing at the entry of a cave. He holds a geologist's hammer and is dressed in full academic attire, just as he would have been while lecturing to his students. His back to the viewer, he stands with arms spread out as though amazed at what he sees inside the cave. In the cave are all sorts of living and extinct animals, including pterodactyls flying overhead. All are defecating. At Buckland's feet, and even between his feet, are more coprolites. McCartney notes that the cave looks like "the nave of a cathedral" because of the columnar shapes of rock formations within it.[21] To me, the cave looks less like a cathedral of learning than like the interior of a digestive tract, and the columnar rock formations seem like enormous coprolites. Indeed, the opening of the cave itself forms an abstract shape rather like a coprolite.

Fig. 190.

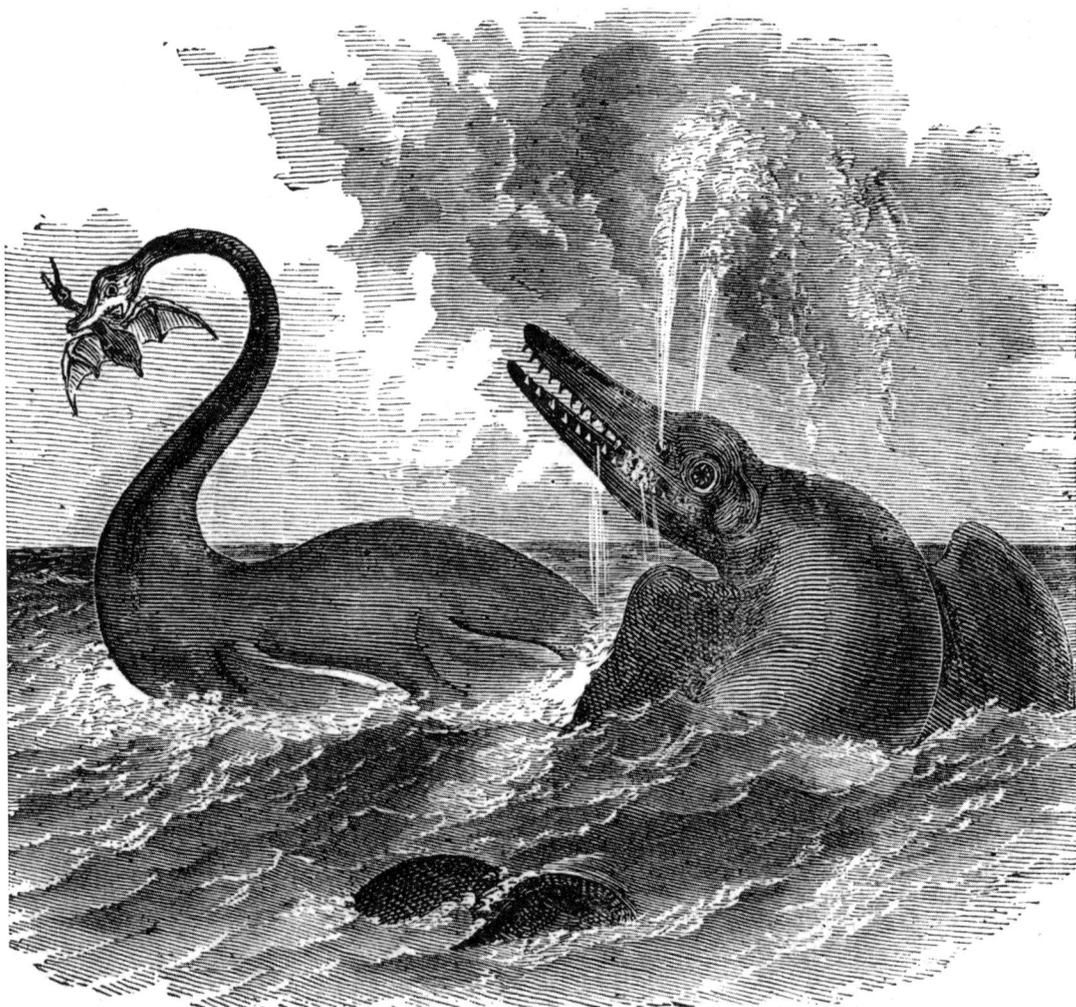

Plesiosaurus and Ichthyosaurus restored.

Perhaps De la Beche's humor was sharper than is generally realized. De la Beche's caricature of Buckland seems to have been an attempt to straddle the line between innocent hilarity and biting satire.

Martin Rudwick deals at length with restorations of fossil life in his *Scenes from Deep Time*, spending much time on the impact of De la Beche's work, particularly *Duria antiquior*. Many subsequent illustrations were based on it; nineteenth-century scientific and popular illustration is swarming with images in which plesiosaurs, ichthyosaurs, and later mosasaurs are shown hunting and capturing their prey in postures taken from *Duria antiquior*, or ich-

Figure 3.5. Sanborn Tenney, *Geology for Teachers, Classes and Private Students*, 1876.

A De la Beche Legacy: Life Restorations of Fossil Marine Reptiles

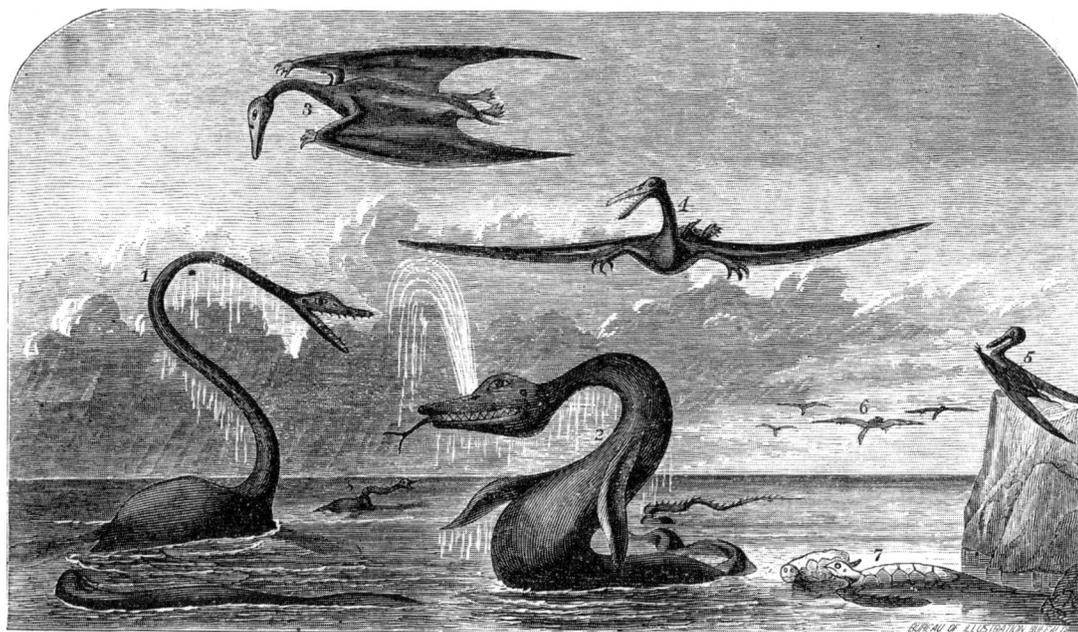

THE SEA WHICH ONCE COVERED THE PLAINS.

1. Elasmosaurus platyurus. 2. Liodon proriger. 3, 4, 5. Ornithochirus umbrosus. 6. Ornithochirus harpyia.
7. Protostega jigas. 8. Polycotylus latipinnis.

Figure 3.6. William E. Webb, *Buffalo Land,* 1872. Illustration of prehistoric ocean by Henry Worrall.

thyosaurs are shown spouting air (or water mixed with air) from their nostrils. It is almost fair to say that every paleontological illustration copied De la Beche.[22] Images of spouting ichthyosaurs appear, for instance, in Louis Figuier's *La terre avant le deluge,* which appeared in multiple French and English editions, and in Sanborn Tenney's *Geology for Teachers, Classes and Private Students,* an American high school textbook that also had multiple editions. The spouting ichthyosaur must have been impressed on the minds of hundreds of young persons. A book entitled *Buffalo Land,* written by a land agent for the Kansas Pacific Railroad who was a friend of Edward Drinker Cope, included a draft of Cope's "On the Geology and Paleontology of the Cretaceous Strata of Kansas," and an illustration for it by Henry Worrall showed various prehistoric Kansas marine fauna, including a mosasaur, *Liodon proriger,* spouting water from its nostrils.[23]

It can be argued that reaching out of the water to bite the neck of prey is not so different from the predation tactics of modern marine predators, and that it was not peculiar to show an air-breathing marine animal in the act of surfacing. Nonetheless I think De la Beche took a fairly big leap in showing his ichthyosaur spouting water from its nostrils. There was no evidence that it had done so.

Thomas Hawkins

Memoirs of Ichthyosauri and Plesiosauri (1834) and *The Book of the Great Sea Dragons* (1840)

Thomas Hawkins (1810–1889) produced two books, both with magnificent illustrations. The frontispiece of *Memoirs of Ichthyosauri and Plesiosauri* was by John Samuelson Templeton, and that of *The Book of the Great Sea Dragons* was by the popular English artist John Martin. Both show restorations of ancient life in a landscape setting. I take some exception to Rud-

wick's claim (1992, 80) that Samuelson's image is essentially a rendering of biblical ideas of pre-Adamite life, while Martin's is more influenced by modern natural history. Rudwick gives Martin much credit for influencing other illustrators to describe natural history rather than offering "historical, particularly biblical, illustration," but I think this is a bit of an overstatement. Both artists were trying to represent ancient life realistically. Rudwick himself concedes the influence of De la Beche's *Duria antiquior* on Samuelson. I think the differences between these two frontispieces are due to the increase in knowledge of ancient marine reptiles over the six years between the first book and the second.

The scientific illustrations in the two books are lithographs, and are well done and quite detailed. They were executed with a much higher level of artistic skill than the two frontispieces. This is especially true of those in *The Book of the Great Sea Dragons*. Most of the illustrations in *Memoirs of Ichthyosauri and Plesiosauri* were drawn and lithographed by H. O'Neill. In addition, another lithographer, B. G. Rossitor, worked on the plates. Hawkins himself drew the skeletal restorations of the ichthyosaur and the plesiosaur, plates 2 and 23. Many of the earlier book's illustrations reappeared in the later one, beautifully redrawn and relithographed by George Scharf. The highly detailed illustrations of the skeletons stand in considerable contrast to John Martin's more inventive illustration. The *Memoirs* is an interesting foray into the newly discovered world of marine fossil reptiles. It was subscribed to by a collection of notables in the disciplines of geology and the new science of paleontology, including Buckland, Conybeare, De la Beche, Mantell, and Sedgwick. While it is fashionable in the twenty-first century to snigger at Hawkins's verbose and pontificating writing style, his contemporaries held him in greater esteem. Reading Hawkins is an adventure which all should attempt at some point. Rudwick has commented that while Conybeare and Buckland did not think much of Hawkins's literary style, "they conceded its scientific value" (1992, 63–64).

The illustrations of the animal now called *Chirotherium,* which is known only through the fossil imprints of its tracks, are a fascinating example of how paleontology images can persist long after they are known to be inaccurate. They are also a good example of how confusing specific paleontology illustrations could become, especially of an animal known only through trace fossils, not skeletal remains. The trackways of *Chirotherium,* which are abundant in the fossil record, are thought by modern paleontologists to have been produced by various archosaurs. In the nineteenth century mammals, amphibians, and reptiles were all suggested. The exact identities and morphologies of the trackways' makers is still debated.[24]

As early as 1836, only about three years after the discovery of the first *Chirotherium* tracks, William Buckland published descriptions and illustrations of them in his *Geology and Mineralogy Considered with Reference to Natural Theology.* Buckland "referred [the tracks] to an animal named provisionally Chirotherium," and reported the suggestion that some of the

How *Labyrinthodon* Became *Chirotherium* (Or Did It?)

tracks might have been made by "gigantic Batrachians."[25] That analogy was to have a long influence on paleontology illustrations. Decades after paleontologists realized that the trackways had not been made by some type of big frog, illustrations of the tracks combined with images of something resembling such an animal persisted.

Henry Augustus Ward included a cast of *Chirotherium* tracks in his 1866 *Catalogue of Casts of Fossils*. The illustration depicted the cast with a man standing next to it so that the customer could get a sense of scale. Ward stated in his copy that the track belonged to the Rochester University Museum and had been found in Jena, Germany. It was 6 feet 2 inches by 18 inches and a cast of it cost $10. As in most of his catalogue entries, Ward was intent on educating his customers:

> Track on slab (relief). The remarkable footmarks strikingly resemble the impression of the human hand, whence the generic title. The tracks of the hind-foot are almost eight inches long and five wide. Less than two inches in advance of them are the prints of the fore-feet, which are only four inches long and three wide. The foot-prints follow one another in pairs, about fourteen inches apart. Dr. Kaup, who first described these ichnites, conjectured that the animal might have been a large species of the Opossum; but in the didelphic quadrupeds the thumb is on the inner side of the hind-foot.
>
> No certain remains of the Cheirotherim have been found; but bones of *Labyrinthodon* have been found in the same locality as the foot-prints; and it is highly probable that the Cheirotherian tracks are those of Labyrinthodont Reptiles.[26]

Ward followed this item with two additional casts of trackways, another from Germany and one from England, also labeled "Cheirotherium." Even at this rather early point, it was evident that such trackways were abundantly distributed throughout Europe.

Ward also offered for sale small replicas of the animal restorations by Benjamin Waterhouse Hawkins that had been placed at the Crystal Palace site at London's Sydenham Park. Hawkins (1807–1889) was a sculptor who had been named director of the Fossil Department for the Crystal Palace Exhibition in 1851. He worked in conjunction with Richard Owen to create what they felt were authentic-looking representations of the animals in lifelike settings. Hawkins made scale models of the various animals to be included, from which life-size clay models were made. From them, Hawkins's crews cast molds and made a metal cast of each animal. Some of these models were extremely large; even some of the clay models weighed in excess of thirty tons.[27] A "flourish" dinner party was held inside the belly of the model of *Iguanodon* on New Year's Eve in 1853 and described in the *Illustrated London News* shortly thereafter, and the exhibit opened in 1854. Ward's *Labyrinthodon* model has *Chirotherium* tracks on its base. In other words, Ward combined *Labyrinthodon* with the trackway that some thought it had made. And he was certainly not the last to do this.

Hawkins's drawing, entitled "Diagram of the Geological Restorations at the Crystal Palace," and an explanation of how he built his models and finished sculptures were included in the published version of a talk that he gave

Figure 3.7. Henry A. Ward, *Catalogue of Casts of Fossils,* 1866. *Chirotherium* cast.

No. 294. Cheirotherium Barthi, Kaup.

TR/
remar
resem
humai
title.
are ab
five w
in adv
of the
four ii
The fo
in pai
apart.
scribec
ed th;
been a
sum ;
rupeds
side ol
remaii
have
Labyr
in the
prints
that tl
those (
This s

New Red Sandstone (Lower Trias) at Jena, Germany.
seum in the University of Rochester. Size, 6 ft. 2

No. 295. Cheirotherium Barthi, Kaup.

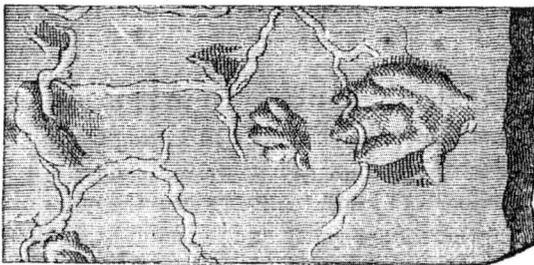

1
Fr(
hai
the
Siz

No. 296. Cheirotherium ———.

No. 302–308. Restorations of Fossil Reptiles,

Pterodactyle, Megalosaurus, Iguanodon, Labyrinthodon, Ichthyosaurus, Plesiosaurus dolichodeirus and *P. macrocephalus.* They are reduced (one inch to the foot) from the gigantic models in the Crystal Palace, London; constructed to

No. 302. PTERODACTYLE

No. 303. MEGALOSAURUS.

scale by B. Waterhouse Hawkins, F. G. S., F. L. S., from the form and proportions of the fossil remains, and in strict accordance with the scientific deductions of

No. 304. IGUANODON.

No. 305. LABYRINTHODON.

Professor Owen. Preliminary drawings, with careful measurements of the originals in the Royal College of Surgeons, British Museum and Geological Society,

Nos. 306–308. ICHTHYOSAURUS WITH PLESIOAURI.

to the London Society of Arts in 1854.[28] The drawing shows each model labeled with its scientific name and with the stratum from which it was taken. From left to right, they are *Pterodactyle, Iguanodon, Hylosaurus, Megalosaurus, Taleosaurus, Plesiosaurus, Ichthyosaurus,* and lastly *Labyrinthodon.*

If Hawkins did not provide much in the way of an illustration for his talk to the Society of Arts, it must be remembered that, after all, everyone there had seen the models anyway. But Hawkins's comments indicate how important scientific illustration was at this point in the history of paleontology. The Society of Arts was one hundred years old at the time of the Crystal Palace Exhibition, and Hawkins's remarks make clear that its members were eager to hear about the display of fossil life. Hawkins told them of his intentions in making the models and said that he placed considerable importance on art as a teaching component of science:

> This direct teaching through the eye has been recognized as a principle and a facility of education for some years past, even in the limited sphere of schools; . . . it will be the things with their names that we shall present to the people; and not only the people in the restricted sense of the word, but to the million, including the well-informed and those above the average in education and acquirements; to the majority of these the geological restorations will present all the novelty of a first acquaintance, for, with reference to the true form and size of the extinct animals, little more than the name was known to many who had an earnest desire to acquire some knowledge of geology.

Hawkins stated that he had made every effort to restore his fossils accurately, according to scientific opinion. It was important to do this, for while museums had fine fossils, many were fragmentary or were in museums that were not easy for the public to visit. Today, scientific literature and museum displays are routinely accompanied by restorations. But it was at this time, in the early nineteenth century, that this practice became routine. Scientists now had more fossil material to work with, they understood far better that these were the remains of previous life forms, and they were better able to comprehend and classify them (because, as Hawkins remarked to the Society of Arts, they were utilizing comparative anatomy in their research endeavors). Scientists themselves wanted to see what the animals and plants had been like when they were alive. Restorations made this possible.

> The inevitably fragmentary state of such specimens of course left much to the imagination, even to those who looked at them with some little knowledge of comparative anatomy, as that amount of knowledge is not found among the average acquirements of the public at large. . . . [My goal is] the revivifying of the ancient world—to call up from the abyss of time and from the depths of the earth, those vast forms and gigantic beasts which the Almighty Creator designed with fitness to inhabit and precede us in possession of this part of the earth called Great Britain.[29]

Hawkins commented on the track maker known as *Chirotherium* and the "hand-like shape of the footmarks." These are included in a sketch by Hawkins that accompanied his published remarks, although they are difficult to make out. Thus, the prints would have been included in the Crystal

Palace Exhibition alongside the restoration of the animal that Hawkins and Owen thought had made them. These models evidence the joint efforts of a paleontologist and an illustrator to create scientifically accurate images of fossil life. Hawkins himself made that clear in his remarks. In order to present the animals as correctly restored and therefore as a tool for education, he needed to work with someone whom he considered an expert paleontologist. Owen, for his part, was seeking out a good artist to bring his beasts to life out of that "abyss of time." Such a collaboration of scientist and artist was not new in the early nineteenth century, but their work makes clear how important such associations between the scientist and the illustrator had always been.

> [T]he imprint of its footmarks . . . , at one time, was all we knew of the extraordinary inhabitants of the New Red Sandstone, when it was called Chirotherium, from the hand-like shape of the footmarks, until the mighty genius of Professor Owen placed the teeth and the head before us, with such indisputable characters as united them to the foot-marks, and thus, by induction, the whole animal was presented to us.[30]

The representations of the animal that had made these tracks, which bore the name *Chirotherium* or *Labyrinthodon,* underwent several morphological changes during the nineteenth century. At times, as in Buckland's work, the animal was not represented at all; merely its footprints were shown. Gideon Mantell did the same thing in his 1838 *Wonders of Geology,* giving the name *Chirotherium* to the creator of the trackway (which he believed to have been amphibian) and *Labyrinthodon* to the amphibian from which he (following Owen) believed several fossil teeth had come. These teeth were from a "gigantic reptile of Wirtemberg . . . [but their structures] suggested the name assigned to this genus of fossil Batrachians. . . . The gigantic Wirtemberg Batrachian must have borne the same relation in magnitude to the diminutive existing frog-tribe." Mantell, like Buckland, gave an illustration of the trackway but not of the animal.[31]

Chirotherium or *Labyrinthodon* began to take a physical form in publications in the 1840s, and one of these early restorations became quite popular. This restoration was not the rather hostile-looking creature of Waterhouse Hawkins and Henry Ward, but one shown in an 1849 broadsheet called "The Antediluvian World," engraved by John Emslie (1818–1875) and printed by James Reynolds. Herein one finds a frog-like animal with a long snout, an odd gait, and strangely positioned hind limbs, together with the obligatory footprints. The positioning of the animal's hind limbs was necessary to make them accord with the actual relative positions of the footprints in the slabs.[32] But although this became the most popular restoration, it was not the only one. Franz Unger's 1851 *Primitive World* shows a creature that is less frog-like and that has a long tail, perhaps more reptilian than amphibian. This animal is also shown making tracks. Interestingly, the tracks are described in the text as those of "Cheirosaurus, an amphibious animal."[33] This image was produced about the same time as Hawkins's sculpture. An animal that looked more like Hawkins's sketch and less like the sculpture appeared in Elizabeth Duncan's 1860 *Pre-Adamite Man,* in which the artist, W. R. Woods, depicted Hawkins's creatures from the Crystal Palace.[34] An illustration in the form of

Fig. 143.

Rem. Mr. Owen has suggested that the tracks referred to the chirothe-
rium, were made by a gigantic batrachian, or frog, whose hind feet were
much larger than his fore feet. He has given a sketch of the animal restored,
(the bones of the head only have been discovered,) and of the manner in
which the tracks might have been produced. Fig. 144 is a copy.

Fig. 144.

Labyrinthodon pachygnathus : Owen.

an outline drawing in Edward Hitchcock's *Elementary Geology,* 1856, shows
the footprints of *Labyrinthodon* along with the animal. Here the animal is
reduced to an ambulatory frog whose jaws are furnished with many large
teeth. Hitchcock stated that the drawing was taken from Owen. Some influ-
ence from Hawkins can also be seen here, but this animal is different from
those of the Crystal Palace.[35] Hitchcock had his doubts about the amphibian
classification of *Labyrinthodon.* He commented,

> Mr. Owen has suggested that the tracks referred to the *Chirotherium,*
> were made by a gigantic batrachian, or frog, whose hind feet were much
> larger than his fore feet. . . . It seems clear to me that an animal like the
> above sketch could not have made such tracks. . . . Such tracks are made
> by rather long-legged quadrupeds, like the cat or dog, but never, I appre-
> hend, by any living batrachian.[36]

Chirotherium or *Labyrinthodon* continued to be depicted in multiple
ways for quite some time. The second English-language edition of Louis
Figuier's *The World before the Deluge,* for example, which appeared in 1867,
contains three illustrations of the animal. In one *Labyrinthodon* is described
as a reptile and shown by the artist, Edward Riou, as a frog-like creature,
again with long jaws and a skull that recall those of Hawkins's restorations.
But a second illustration depicts an animal with a shorter skull and jaws and

Figure 3.9. Edward Hitch-
cock, *Elementary Geology,*
1856.

Figure 3.10. Louis Figuier, *La terre avant le déluge,* 1867 (English ed.).

Fig. 81.—Labyrinthodon restored. One-twentieth natural size.

a rounder body. And both versions are shown with the tracks it supposedly made! These images were repeated in subsequent French and English editions.[37] In two of the three illustrations Figuier placed the animal in landscape settings, indicating how it would have looked in life. In his text, he referred to it as *Labyrinthodon*. But the third illustration of it in the English edition of 1867 indicates that at least at that time, Figuier was not entirely clear what to call his beast. Entitled "*Labyrinthodon* restored," it was also drawn by Riou, and is the large frog with long jaws and a slightly rounded skull. And of course there are tracks. Figuier's description of it straddles the issues of what this animal was, what should it be called, and whether it made the tracks with which it was routinely associated:

> [I]n this age a gigantic Reptile appears, on which the opinions of geologists were for a long time at variance. In the argillaceous rocks of the Muschelkalk period imprints of the foot of some animal were discovered in the sandstones of Storton Hill in Cheshire, and in the New Red Sandstone of parts of Warwickshire, as well as in Thuringia, and Hesseburg in Saxony, which very much resembled the impression that might be made in soft clay by the outstretched fingers and thumb of the human hand. These traces were made by a species of Reptile furnished with four feet, the two fore-feet being much broader than the hinder two. The head, pelvis, and scapula only of this strange-looking animal have been found, but these are considered to have belonged to a gigantic air-breathing reptile closely connected with the Batrachians. It is thought that the head was not naked, but protected by a bony cushion; that its jaws were armed with conical teeth, of great strength and of a complicated structure. This curious and uncouth-looking creature, of which the woodcut (Fig. 81) is a restoration, has been named the *Cheirotherium,* or *Labyrinthodon*.[38]

Figure 3.11. Louis Figuier, *La terre avant le déluge,* 1867 (English ed.). "Ideal Landscape of the Muschelkalk Sub-Period."

The various versions of the ambulatory frog are found in late-nineteenth-century texts as well. Worthington Hooker's *Science for the School and Family,* 1884, for example, includes a line drawing of an ambulatory track maker, this time a frog with what seems more like the skull and jaws of a crocodilian. The *Labyrinthodon,* the reader is told with the assurance that such texts frequently have in this era, was an animal "having a head of three or four feet in length, teeth three inches long, and . . . about the size of an ox[;] with his long hind legs, he was very much like a frog." The reader is informed that the restoration seen in the text is based on Owen! And the name of *Cheirotherium* "was given to this supposed animal because the tracks were so much like the print of a hand. . . . It is now pretty well ascertained that these tracks were all made by the *Labyrinthodon.*"[39]

In 1901 Frederic A. Lucas, curator of comparative anatomy in the U.S. Museum of Natural History, published a book for the general reader, *Animals of the Past,* that was illustrated with the elegant art of Charles R. Knight (1874–1953) and with photographs of some important specimens, such as *Archaeopteryx.* The book went through several editions. In this work Lucas did not present an illustration of *Labyrinthodon,* but he perpetuated the analyses of the previous century by saying that it was "generally believed that the impressions [the tracks of *Chirotherium*] were made by huge (for their kind) salamander-like creatures known as labyrinthodonts, whose remains are found in the same strata."[40]

Fig. 139.

to belong to another animal, whose remains, however, had never been discovered. The name of Cheirotherium was given to this supposed animal because the tracks were so much like the print of a hand, the word being derived from two Greek words, *cheir*, hand, and *therion*, beast. It is now pretty well ascertained that these tracks were all made by the Labyrinthodon. This name is given to this animal from the structure of its teeth. In Fig. 140, at *a*, is a tooth half its natural size, and at *b*

Fig. 140.

Figure 3.12. Worthington Hooker, *Science for the School and Family*, 1884.

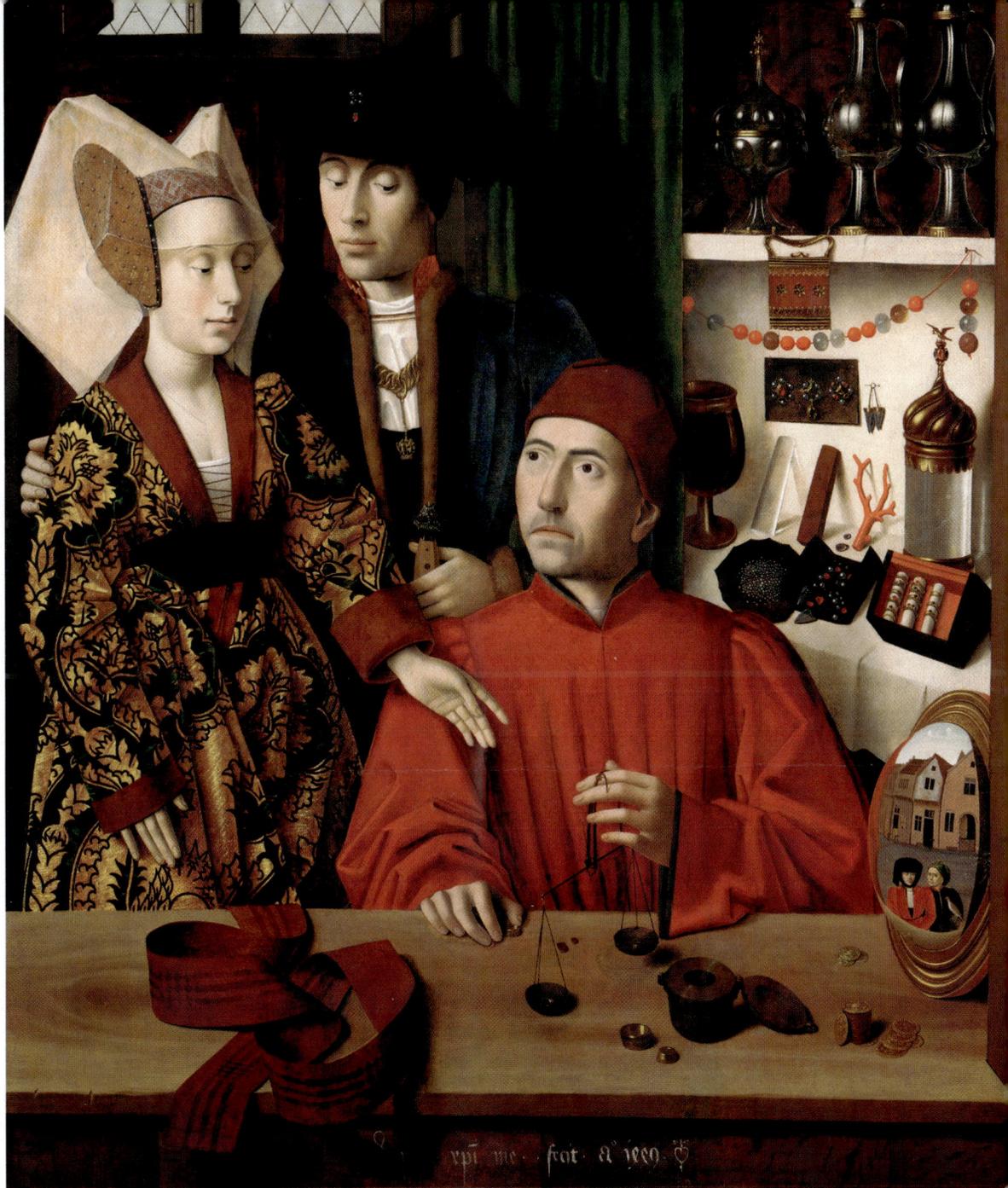

Color Plate 1. Petrus Christus, *A Goldsmith in His Shop, Possibly Saint Eligius,* 1449. *The Metropolitan Museum of Art. Robert Lehman Collection, 1975 (1975.1.110). Image © The Metropolitan Museum of Art.*

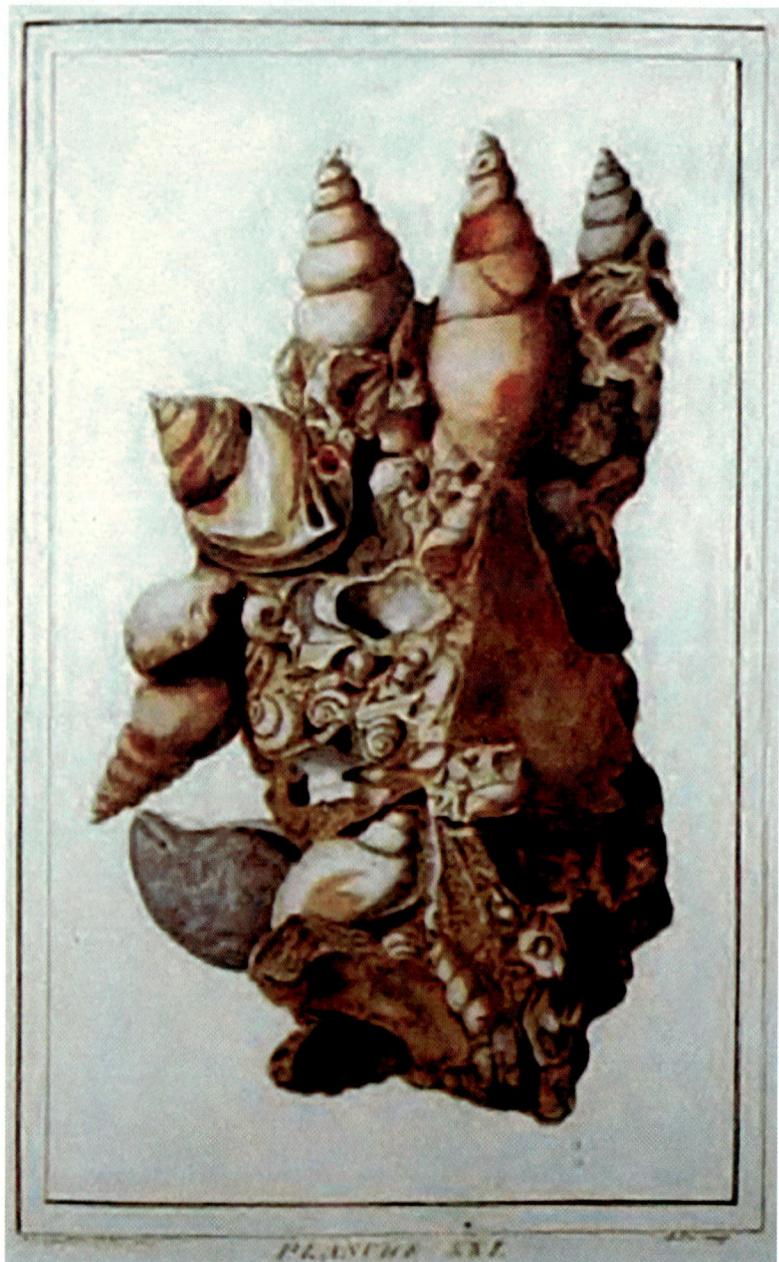

Color Plate 2. François-Xavier Burtin, *Orycto-graphie de Bruxelles, ou Description des fossiles,* 1784. *Courtesy Ed Rogers.*

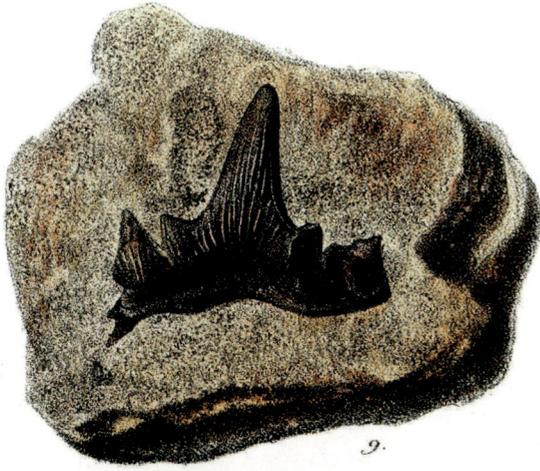

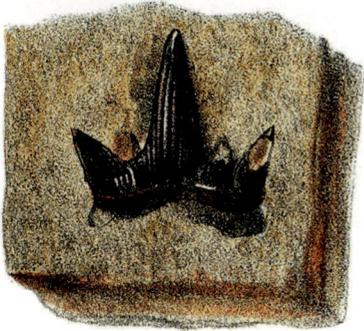

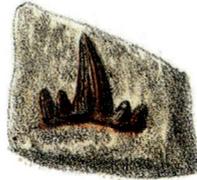

9.

10.

11.

12.

13.

Color Plate 3. Louis Agassiz, *Recherches sur les poissons fossiles,* 1843. Auguste Sonrel, *Cladodus. Courtesy David A. Ward.*

Color Plate 4. Ferdinand V. Hayden, *A Report of Progress of the Exploration in Wyoming and Idaho for the Year 1878. U.S. Geological Survey.*

PLATE XVI.

FIG. 1.

FIG. 2.

Brontozoum Sillimanium and B. minusculum.

Caudal Trail?

J. L. LOVELL, Photo.

Color Plate 5. Edward Hitchcock, *Supplement to the Ichnology of New England,* 1865. Tipped-in photograph of fossil tracks.

Color Plate 6. Dan Varner, *Off the Jersey Shore: Mosasaurus hoffmanni. Courtesy Dan Varner.*

Color Plate 7. Luis Rey, *Deinonychus antirrho-pus. Courtesy Luis Rey.*

Color Plate 8. Michael Trcic, *Lambeosaurus* vs. *Dromaeosaurus. Courtesy Michael Trcic, Trcic Studio.*

Henry Ward (1834–1906) was born in Rochester, New York. He had a variety of educational experiences, including study at Middlebury Academy, Williams College, Temple Hill Academy, and finally the Paris School of Mines. His more informal education included field work in Europe and Africa. After he returned to the United States in 1860 he became a professor of natural science at the University of Rochester. That institution today houses his papers, Ward family documents, and papers related to Ward's business of providing replicas of fossils and other natural history items.[41] In 1862 he founded a company that came to be known as Ward's Natural Science Establishment. Eventually it sold a wide variety of natural history education materials, including geological specimens, taxidermic specimens, mollusks and brachiopods, glass models of invertebrates, bones and skeletons (including human skeletal materials), and a wide variety of casts of fossils, from enlarged models of the tiny *Globigerina* to the bones of *Elephas*. In short, as Ward's Natural Science Establishment grew, it became quite the storehouse for natural history specimens to be used in schools and museums. Ward took a large role in the collecting of his fossil replicas. He was also a taxidermist, and is remembered for his assistance in the stuffing of P. T. Barnum's famous elephant, Jumbo, which was killed when it was struck by a train in 1885.

Fortunately for historians, Ward published extensive catalogues of the natural science items he had for sale. His catalogue of fossils appeared in 1866, and this early date demonstrates his interest in paleontology and also indicates that there was sufficient interest in this science to warrant his offering so many fossils for sale. (Subsequent editions of the catalogue appeared in 1870, 1889, and 1890.) It contained 1207 fossil casts (including 55 of invertebrates)—and this is before Cope and O. C. Marsh (1831–1899) discovered and shipped home literally crateloads of fossils from the western United States in the 1870s and 1880s. Ward provided brief descriptions of the casts, often with an illustration, and indicated where the original fossil was housed. Thus the catalogue is also a guide to the fossil holdings of a number of important European museums, as well as some American collections, in the first half of the century. In addition to the 1207 fossil specimens, Ward also included a cast he termed "rain prints." This he described as "pittings or depressions made in ancient times by drops of rain on a surface of clay or half-dried mud. . . . they furnish us with evidence of the intensity and continuance of the primeval shower." This item was large, three feet by 2 inches by 22 inches, and cost a large sum for the times: $4.00. If the customer did not want fossilized rain, Ward also offered for sale a copy of the Rosetta Stone, "a faithful copy of the original now in the British Museum," for $12.00. Or there were always busts of Linnaeus, Buffon, Cuvier, and Geoffroy. These were cheaper at $6.00.[42]

Ward's catalogue of reproductions of fossil specimens, he tells his readers, grew out of his own desire for a complete set of specimens in his Paleontological Cabinet, as he termed his museum at the University of Rochester. Actual specimens were either too rare or too difficult to unearth, so he began making reproductions.[43] Ward's "cabinet" and his subsequent catalogue included specimens from the British Museum, the Jardin des Plantes in Paris,

Henry A. Ward: To Make More Fossils Known to More People

Museums of natural objects are becoming more and more a recognized necessity. . . . it is clear that in Geology, not less than the other Natural Sciences, something more is needed than simple textbooks and oral teaching. Visible tangible objects can alone meet this necessity.

Henry A. Ward, 1866

the Royal Museums of Berlin, Vienna, Copenhagen, St. Petersburg, Munich, Turin, Lyons, Darmstadt, and Haarlem, the Academy of Natural Sciences of Philadelphia, the Boston Society of Natural History, and the Museum of Comparative Zoology in Cambridge, Massachusetts. He was also able to obtain copies of Hitchcock's famous fossil tracks from Amherst College. These items Ward listed under the classification of Aves, although he assured his readers that while he did this because they were popularly considered bird tracks, "Geologists, however, are not assured of their ornithic origin; many of them are probably reptilian."[44]

Ward told his prospective customers that his casts were "in almost every case copies of the most perfect specimen of the object which has ever been found." Henry Ward was a good salesman. He took pains to explain that his casts were "intended to be exact copies . . . and such care is taken in their coloring that large numbers of them will hardly be detected *as casts*" (Ward's own emphasis). He also wished to educate his customers and the public; in the catalogue's index he translated all the Greek and Latin genus and species names that appeared in the text. And, lastly, Ward again demonstrated that he was a shrewd businessman as well as a scientist and devotee of paleontology. The customer is warned that the casts are sold on the "express condition" that their owner neither copy them nor allow them to be copied. On the other hand, packing (normally an extra 10 percent charge) was free for orders over $200. Just be sure, gentle customer, to send payment in advance with your order.[45]

Ward informed his customers that "few of them [the casts] are *restored* in any way, and when this is the case it is indicated" (Ward's emphasis). This statement almost seems to prophesy the shenanigans in restoration of which O. C. Marsh was later accused. It was rumored that Marsh did not know the difference between actual fossil bones and plaster restorations, and, worse yet, that he didn't bother to make such distinctions obvious to those who saw his restored fossils. Indeed, Henry F. Osborn reported that some of Marsh's laboratory assistants gave Marsh's specimens the sarcastic names of *Plasterosaurus* and *Plasterotherium*.

Ward's catalogue is simply fascinating. It hardly has an equal as a vade mecum to mid-nineteenth-century paleontology. It is also a complete picture of both illustrations of fossils and the preparation of museum displays at this time. Several of the illustrations in Ward's catalogue display the fossil alongside a sketch of a human, to indicate the scale of both the fossil and its replica. Item 36 (facing page 16), which is a specimen of *Glyptodon* whose original was in the Dijon Museum, is shown posed with a rather tall-looking gentleman dressed in what is either a laboratory coat or a duster. He reaches out toward the fossil, which, with its stand, is about as tall as he is. Interestingly, the humans placed with fossils are not especially realistic, almost cartoon-like, while the fossils are much more carefully drawn with attention to realism. After all, Ward was not selling living humans. Item 294 (page 78) is a trackway, *Cheirotherium Barthi* Kaup. Again the fossil is shown with a man dressed in a laboratory coat alongside it. He carries a long pointer. This specimen (from Jena, Germany) belonged to Henry Ward. Most illustrations are small, and several usually appear on each page. Many appear to be woodcuts, al-

Figure 3.13. Henry A. Ward, *Catalogue of Casts of Fossils*, 1866. Ammonite model.

No. 490. **Ammonites fimbriatus,** Sow.

This species is characteristic of the group, *"Fimbriati."* The specimen shows the ornamental characters of the external shell. From the Middle Lias, Charmouth, England, and now in the private Geological Cabinet of Mr. Ward, Rochester. Price, $0.75.

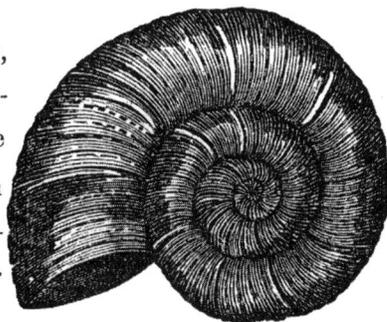

No. 491. **Ammonites fimbriatus,** Sow.

This specimen shows the internal layers of the shell, with the markings corresponding to those on the exterior. From the same locality as the preceding, and now in the Ward Museum, University of Rochester. Price, $1.00.

No. 492. **Ammonites gigas,** Zieten.

This species belongs to the group *"Coronati."* From the Upper Oolite, Yonne, France. Diameter, 9. Price, $1.75.

No. 493. **Ammonites ——.**

This specimen of a species allied to *Ammonites gigas*, Ziet., shows foliations, septa and siphuncle, and is from the same location as the preceding, and now in the Ward Museum, University of Rochester. Diameter, 18. Price, $4.50.

No. 494. **Ammonites giganteus,** Sow.

This is assigned to the group, *" Planulati"* of Von Buch. From the Upper

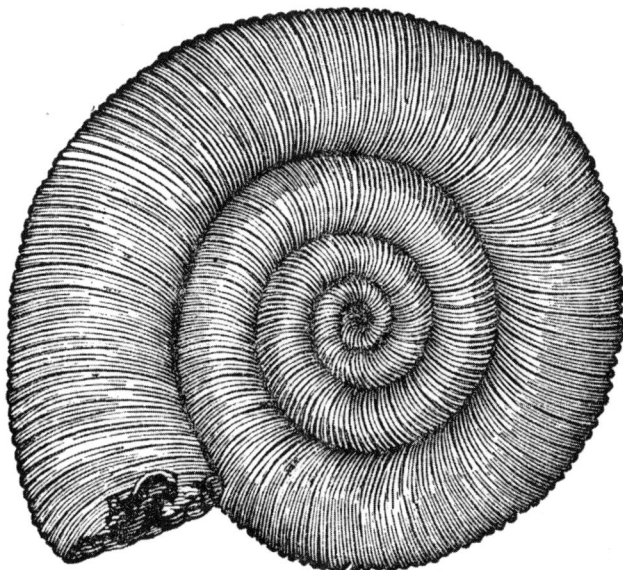

Oolite, Isle of Portland, England. Diameter, 26. Price, $6.00.

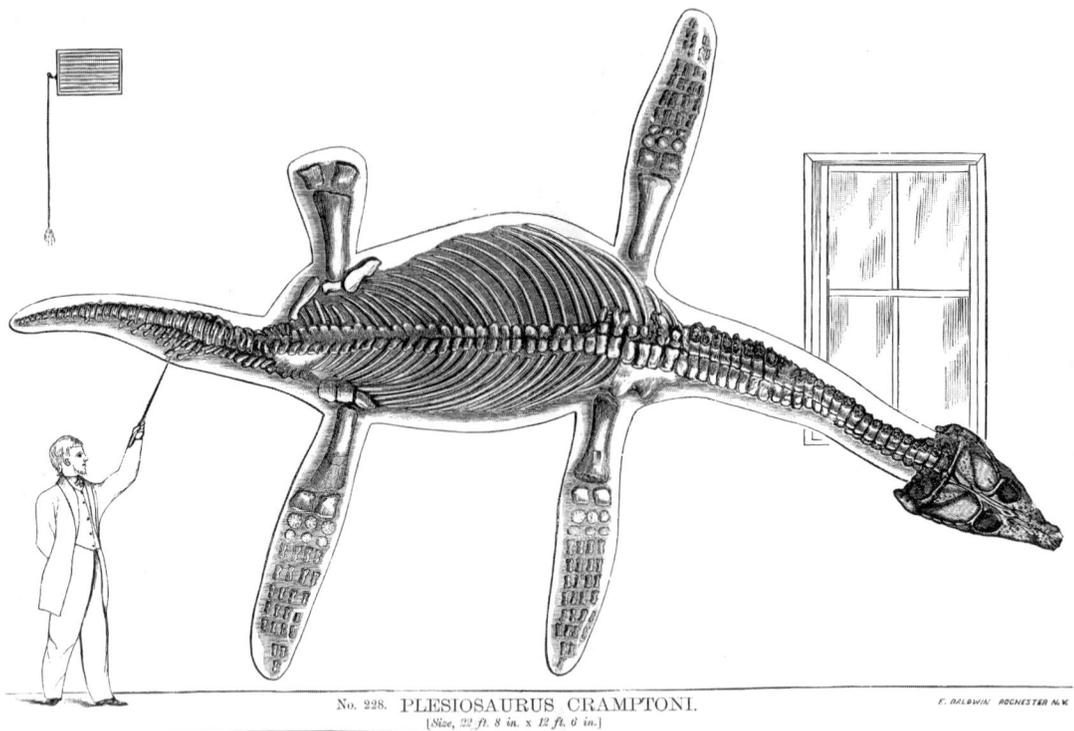

No. 228. PLESIOSAURUS CRAMPTONI.
[Size, 22 ft. 8 in. x 12 ft. 6 in.]

F. BALDWIN ROCHESTER N.Y.

Figure 3.14. Henry A. Ward, *Catalogue of Casts of Fossils, 1866. Plesiosaurus cramptoni. Thanks to Mike Everhart.*

though some are apparently engravings, and their details and draughtsman-ship are generally good. They by no means have the exquisite detail of some early-nineteenth-century illustrations, such as the magnificent images in Thomas Hawkins's books or Owen's treatises, but they are sufficient to inform the reader of what the fossil looked like. Two engravings, fold-out pages depicting a plesiosaur and the *Megatherium* of Cuvier, are signed, and each also includes a representative of another smaller species to assist in giving the viewer scale. One of them (item 228, *Plesiosaurus Cramptoni* Carte and Baily) is depicted in a three-fold expanded engraving. The plesiosaur is shown in a room, being examined by a man who gestures with a pointer to part of its tail. The print was executed by E. Baldwin of Rochester, New York. We are informed that a painted replica of the fossil sells for $150 and that it measures 22 feet by 8 inches by 12½ feet.

> This splendid Plesiosaurus—the largest ever discovered was found in 1848 in the Lias, near Whitby, England and adorns the Natural History Museum of the Royal Dublin Society. It lies in a prone position resting upon the ventral surface with the head and neck slightly inclined to the right. The skull is almost entirely free from the matrix and is very perfect excepting the zygomas. In contour it is crocodile-lacertian; it is somewhat flattened in proportion to its length and width, tapering from the parietal crest to the snout.[46]

Ward described the rest of the fossil cast in similar detail. The cast comprised eight pieces, which could also be purchased separately if a buyer wanted, say, only the head, or the left fore-paddle.

Today at least three of what may be Ward's original casts are owned by a

private company, Two Guys Fossils–Bay State Replicas, that sells fossils and fossil replicas. These are a cast of an ichthyosaur (*Ichthyosaurus intermedius* Conybeare) and two of plesiosaurs (*Plesiosaurus dolichodeirus* Conybeare, a type specimen, and *Plesiosaurus macrocephalus* Conybeare).[47] These three casts were displayed, along with a number of other Ward casts, at the 1893 World's Fair in Chicago. After the fair, the Field Museum of Natural History bought many of Ward's replicas, including these three, which eventually passed into the hands of Two Guys Fossils. The casts are carefully executed and display considerable skeletal detail.[48] The quality of the illustrations, however, varies. It is questionable whether we can consider Ward's casts works of art, as sculptures are. But their use in museum displays and in settings such as the World's Fair makes them components of works of art.

Comparing the catalogue illustrations of Ward's two surviving plesiosaur casts with the casts themselves makes clear that the illustrations are very faithful. Possibly Ward had copied earlier illustrations of these specimens. The illustration of the surviving ichthyosaur cast, however, is by no means as accurate. In fact, it does not even show the same animal. Ward's illustration is of an animal with its ribcage intact, but the cast is of an animal with displaced and broken ribs. In the illustration all the animal's paddles are in place, but the right front paddle of the cast is detached from the skeleton. On the other hand, the tail of the cast animal is broken and the illustration shows the tail bent downward at a similar place and angle, and the dimensions given in the catalogue for the fossil cast (9 feet 1 inch × 2 feet 11 inches) are almost exactly the same as those of the cast now owned by Two Guys Fossils (9 feet × 2 feet 11 inches). If indeed the illustration in the catalogue is meant to represent the cast once held by the Field Museum, then Ward did not use a drawing made from his fossil. Those who purchased the ichthyosaur cast must have been startled to receive an item so much worse preserved than it had been shown.

These discrepancies and variations in Ward's illustrations indicate that he utilized various sources for his woodcuts and engravings. Several artists may have been employed to make the drawings. And in some cases it is obvious that Ward used previously published materials. For instance, a large multi-fold page offers an illustration of *Megatherium Cuvieri,* item 23, that bears the signature of the original artist. The catalogue describes both the replica and the original fossil in considerable detail. The illustration is by Frauenberger and shows the skeleton of *Megatherium* posed with the skeleton of a much smaller animal, evidently a tree sloth. Ward's model was made of 124 different casts, and again customers could buy parts of it if they did not want the entire skeleton.

Ward's catalogue also includes the famous amphibian skeleton once believed to have been a human casualty of the Great Flood. Ward titles it *Andrias Scheuchzeri* Tschudi, after Scheuchzer, who called the fossil *Homo diluvii testis,* "the man who witnessed the Flood." Ward commented,

> This noted fossil—the *Cryptobranchus* of Van der Hoeven—was a Batrachian of the Salamander family. It was a large specimen of this extinct animal which was erroneously supposed by Scheuchzer to be a human skeleton and was described by him nearly a century and a half ago as

'*Homo diluvii testis.*' Cuvier demonstrated its near affinities to the Water-Salamander (*Menopoma*) of the United States.[49]

Another example of Ward's desire to be thorough, and also of his good business sense, is his inclusion of small copies of Waterhouse Hawkins's well-known models of prehistoric animals, made originally for the Crystal Palace Exhibition (figure 3.8). One could buy a whole set for $30, or purchase them separately for prices ranging from $5 to $10. The models ranged in dimensions from about 22 × 14 inches for the group of marine reptiles to 9 × 9 inches for the pterodactyl. While Ward did not normally inform his customers how his models were made, he did in this case:

> They are reduced (one inch to the foot) from the gigantic models in the Crystal Palace, London; constructed to scale by B. Waterhouse Hawkins, F.G.S.F.L.S., from the form and properties of the fossil animals, and in strict accordance with the scientific deductions of Professor Owen. Preliminary drawings, with careful measurements of the originals in the Royal College of Surgeons, British Museum and Geological Society, were prepared and sketch models made at a fraction of the natural size, and submitted to the above high authority. Clay models were then made of the natural size. To give an idea of these monster Saurians, Mr. Hawkins states that the Iguanodon, as it now stands in the Crystal Palace, is composed of four iron columns, 9 feet by 7 inches in diameter, 600 bricks, 1550 tiles, 38 casks of cement, 90 casks of broken stone, with 100 feet of iron hooping and 20 feet of cubic inch bar.[50]

Ward probably took this description directly from published remarks by Hawkins, and his catalogue shows his models posed in a setting similar to one Hawkins had drawn in a sketch for the design of the Crystal Palace display. The illustration of his *Labyrinthodon* restoration that Hawkins published in 1854, however, does not indicate how it may have inspired Ward's model makers.[51] Ward's animal has limbs reminiscent of a frog's, but a skull and face more like those of a large, hostile lizard. On the other hand, the picture of Hawkins's workshop that appeared in the *Illustrated London News* in 1853 shows a model that looks quite similar to Ward's. There is no evidence that Ward and Hawkins were in direct contact, although the possibility of such contact exists. But it is clear that Ward, like Hawkins, wanted to present images of fossil life to the public for its edification, and also to earn money by selling these restorations.

Ward's entrepreneurial desire to make more fossils known to more people spurred him to issue not just catalogues but more traditional publications as well. From time to time he published pamphlets intended to describe and publicize items of which he sold replicas and models. One of his most famous replicas was, of course, of the *Megatherium* of Cuvier. This large model Ward wrote up in a short publication entitled *Notice on the* Megatherium Cuvieri, *The Giant Fossil Ground-Sloth of South America*.[52] This pamphlet includes descriptions and illustrations of other extinct and extant sloth specimens in the University's museum and those of other institutions, but most of it is devoted to the *Megatherium* specimen. The fossil is shown in a large engraving, originally executed by Frauenburger, that poses it with the skeleton of an ex-

tant and much smaller sloth (figure 2.11). This pamphlet, like Ward's catalogues, was a nice blend of scientific literature, imagery, publicity for his University Museum, and advertisement for his own business.

The Academy of Natural Sciences of Philadelphia Archives own a unique collection of Hawkins ephemera that were once the contents of a scrapbook compiled by Hawkins himself between about 1872 and 1878. The scrapbook was presented to the Academy by an American donor in 1985. The collection comprises fifty-six newspaper clippings, photographs, drawings, and manuscripts. Many of them are framed with hand-ruled lines, some of which are painted in gilt paint. One can see where Hawkins's hand wavered slightly as he painted the lines. These items offer a charming and informative view into the mind of Hawkins as both naturalist and artist.

The Scrapbook Album of Benjamin Waterhouse Hawkins

Saint George and the Pterodactyl

Among the visual materials are several drawings by Hawkins himself. Some of these are of special interest here as they shed light on his personality, including what was evidently a well-developed sense of humor. The drawings also demonstrate his considerable skills as an artist. Three photographs show the interior of Hawkins's workshop/studio in the Central Park Arsenal, with details of the preparation of the models of prehistoric fauna that were destined for display in Central Park. These photographs probably date from 1869, and no others of Hawkins's workshop are known to exist.[53] There are also two photographs of Hawkins posed with a sculptural life restoration of the Irish Elk, and one showing the Crystal Palace dinosaur display under construction.

Specimens of Hawkins's drawings are among the most interesting items in the scrapbook. There are several sketches of proposed museum displays for Central Park and also for the Smithsonian Institution. Some of these are photoprints of the originals, but they are of a quality good enough to make clear Hawkins's skill as a draughtsman.[54] Item 22 in the collection is an ink and wash drawing showing a proposed display of life restorations of prehistoric creatures for a museum in Central Park. This drawing is closely related to item 17, a line print of a similar drawing. The line print appears to be a study for a lithograph of such a proposed display that eventually appeared in the *13th Annual Report of the Central Park Commissioners* in 1869. In item 22 the restorations are positioned differently than they are in item 17, but the concept is the same. Hawkins showed the restorations displayed in the center of a large museum hall. There is a hodge-podge of life on view, including specimens of *Hadrosaurus* and *Laelaps* (*Dryptosaurus*), an *Elasmosaurus,* and specimens of *Glyptodons, Megatheriums,* some type of saber-toothed cat, and mammoths. People stroll past the display, stopping to study the fossil life. Others are observing the display from a second-floor gallery overlooking the hall. The hall has a vaulted glass ceiling similar to those of the buildings at the Crystal Palace, and strata are depicted on the walls under the gallery. Hawkins seems to have designed this display to give viewers a sense of being in a setting with the animals, although these animals did not live at the same times or in the same places. Even the ceiling was to be festooned with what appears

from the sketch to be foliage of some sort. Thus the visitors would see strata around them, animals alongside, and ferns overhead. There is a certain naïveté to such a display. Hawkins, of course, knew that the various animals did not belong together, but at the same time he was endeavoring to give the visitor as much information as possible about prehistoric life in one setting. It is well to keep in mind that a relatively small number of specimens were available for study at this point. This attempt to show the viewer everything was not ill-intentioned.

Hawkins may also have felt that the public would not know too much about what they were seeing anyway. Similarly, it is not unusual to find works of art that are mislabeled or misattributed in modern museums. The curators may rationalize an incorrect identification or attribution by arguing that the labeling reflects what the donor thought. They will sometimes confide that they do not agree with an attribution, but argue that those who know better will realize that the work is incorrectly identified, and they are not concerned with the general public: average viewers don't know better, and no one cares to take on the donor for the sake of enlightening them. Did Hawkins think in such a fashion when he designed museum displays?

Of all the animals in item 22's tableau, the *Elasmosaurus* is certainly the silliest-looking. It is clear that Hawkins had no concept of what *E. platyurus* was like when he made this drawing. It shows an animal with a head that looks more like that of a dinosaur than of a marine reptile. It has limbs in place of paddles, and a long trailing tail that makes the animal look for all the world as though it has the body of an eel. The relative lengths of the tail and neck are correct. The remainder of the restoration is fatuous. In his comments on this drawing, Donald Baird charitably says that "a nondescript replaces the Elasmosaurus."[55] Baird believes that item 22 was drawn about 1876, but that does not make sense. Cope had published this fossil, with illustrations of the skeleton (head on backward and then correctly), in 1869, so Hawkins's drawing must date from before then (although it could also be a later copy of an early drawing).[56]

Regardless of the accuracy of the anatomy in his restorations, Hawkins seems to have attempted to place his animals in plausible poses and situations. One *Hadrosaurus* is fighting off an attack by *Laelaps*. Two other *Laelaps* are engaged in a nasty struggle over the carcass of another *Hadrosaurus*. Poor *Elasmosaurus* seems to have come on shore and is just resting nearby. Did Hawkins not understand *Elasmosaurus* to be a marine animal? He should have, even if he had not yet seen the skeleton or Cope's restorations. I think that when Hawkins drew this picture he did not know how *E. platyurus* would have looked. However, in other representations of prehistoric life it is obvious that Hawkins took artistic license. Such license may even be seen in how he rendered the anatomy of the specimens of *Laelaps* and *Hadrosaurus* in this drawing. One hadrosaur reclines in a pose similar to that of some of the models Hawkins made for the Crystal Palace. It has its tail curled around its hindquarters like a dog. The one fighting with a *Laelaps*, however, is wiry and agile and looks anatomically similar to an iguana. Similar inconsistencies of anatomy appear in the specimens of *Laelaps*. Can we explain these discrepancies

Figure 3.15. Photograph of Waterhouse Hawkins's New York Studio. *The Academy of Natural Sciences, Ewell Sale Stewart Library, Collection 803, #35.*

as the results of Hawkins's having little information about the skeletal anatomies of the animals? That is possible. But here, I think, we also have a case of artistic license. Hawkins was trying to illustrate the activities of the animals, their mortal combat and fighting over carrion. He wanted to convey to the proposed museum visitor what life had been like for these prehistoric beasts. To do that, he emphasized, for example, the necks of the *Laelaps* that are shown arguing over a carcass. Tails writhe, necks bend, teeth gnash; the animals would certainly have been alarming-looking. It is easy to lose sight of the impact such restorations had on contemporary viewers. Many people who saw them in the 1850s or 1860s would have believed that the artist and his scientist advisors knew what they were doing and had made anatomically and behaviorally correct restorations. Even Henry Ward, who was striving to disseminate educational materials, chose to sell copies of the Sydenham sculptures. These restorations are interesting insights into Hawkins's personality, since he made them as accurate as he could, but then interpreted their activities on the basis of very little information from paleontologists or naturalists. We can think of his restorations as enhanced educated guesses.

In restoring pterodactyls, Hawkins chose between two routes. Some animals are restored as scientific illustrations, with the goal of accurately showing their anatomy and activities. Other pterodactyls are pure fantasy. Hawkins chose the pterodactyl as a subject for his art on several occasions. The scrapbook collection has three representations of pterodactyls. A pterodactyl adorned a hand-drawn invitation to the "dinner in a dinosaur," the banquet marking the opening of the Crystal Palace Exhibition, that Hawkins made for Joseph Prestwick. This invitation is item 6 in the Hawkins scrapbook album at the Academy of Natural Sciences. In this wonderful drawing

Figure 3.16. Invitation to the Crystal Palace banquet, drawn by Waterhouse Hawkins. *The Academy of Natural Sciences, Ewell Sale Stewart Library, Collection 803, #6.*

Figure 3.17. *Saint George and the Pterodactyl,* a drawing by Waterhouse Hopkins. *The Academy of Natural Sciences, Ewell Sale Stewart Library, Collection 803, #53.*

the pterodactyl is shown climbing up a rocky formation that leads to the stage on which the *Iguanodon* model, with the banqueters inside it, is set. The text of the invitation is written on the pterodactyl's wing in Hawkins's own hand, so that the animal is made to serve as a signboard.

The *Iguanodon* model in this invitation is larger than it is in other illustrations of the banquet, such as in the *Illustrated London News*. The model's scale can be discerned from the waiter, who is ascending a long ladder. Item 7 in the collection is another drawing of the banquet by Hawkins. In this drawing, the animal is not so tall. Several servers are going up a flight of stairs to the guests, but these stairs are not as steep as the ladder was. This illustration is more like that in the *Illustrated London News*. A lengthy inscription,

which also seems to be in Hawkins's hand, mentions Prestwick. The dates of these two items are unclear. The invitation to Prestwick is combined with a menu for the meal and appears to date from 1853. The date of item 7 cannot be determined, but it probably is from 1853 as well. It would have been peculiar for Hawkins to draw the scene later, and write out the lengthy poetic comment that goes with it. And how did these drawings return to Hawkins? If they were sent to Prestwick as invitations, surely he would not have sent them back to Hawkins. Were they sketches for a lithograph? This seems unlikely, at least for item 6, because the menu is printed on the card.[57]

The pterodactyl who graced Mr. Prestwick's invitation also returned in a wonderful drawing entitled *Saint George and the Pterodactyl* and in a design for a stained-glass window showing the same motif. In these the animal is used once more as a fantasy, becoming the saint's dragon. Photoprints of the drawings are held in the Academy Archives. The window design (item 23) shows a large stained-glass roundel placed in what is evidently a museum. People are looking at the window and what may have been meant to be a mural. Donald Baird thought that the window might have been intended for the Smithsonian. In it Saint George fights a fairly traditional-looking dragon, but the vignette is flanked by two pterodactyls who hold the medallion in which he appears. Item 53, a drawing of Saint George fighting the pterodactyl/dragon, bears two dates, "1873/1868." Baird suggested that it may have been a design for some decoration for the Paleozoic Museum, but that it was later reworked for another project. It seems also possible that 1873 is when the photoprint was made, but it is impossible to know. Saint George's pterodactyl/dragon is huge and obviously fierce. It is posed defensively on rocks and looks as though it might get the best of the combat. It strikes out toward George with its front leg, and its mouth is opened wide enough to be able to bite off a large portion of the saint's torso. It is a pity that the originals of these drawings are apparently lost.

Joseph Leidy

The Ancient Fauna of Nebraska (1853)

Joseph Leidy (1823–1891) wrote several treatises on paleontology. His *The Ancient Fauna of Nebraska,* which discusses the mammals and reptiles found in the *mauvaises terres,* or Nebraska badlands, is an example of the excellent scientific papers published by the Smithsonian Institution in the nineteenth century. (Many others came out under the auspices of the U.S. Geological and Geographical Survey of the Territories.) Its illustrations of fossils were made by a team of artists whose creations Leidy called "excellent and faithful drawings." That description is almost an understatement. Indeed, these drawings are marvelous. Comparing them to actual specimens shows that Leidy's team of illustrators worked carefully from the fossils in order to render finely detailed drawings, from which the firms of Sinclair (in Philadelphia) and Tappan and Bradford made exquisite lithographs. In fact, Sinclair was soon to be well known for its many fine illustrations in government paleontology treatises.[58]

The artists who worked on *Ancient Fauna* were Auguste Sonrel, who was from Boston, and A. J. Ibbotson, A. Frey, F. Shell, and I. Butler, all of

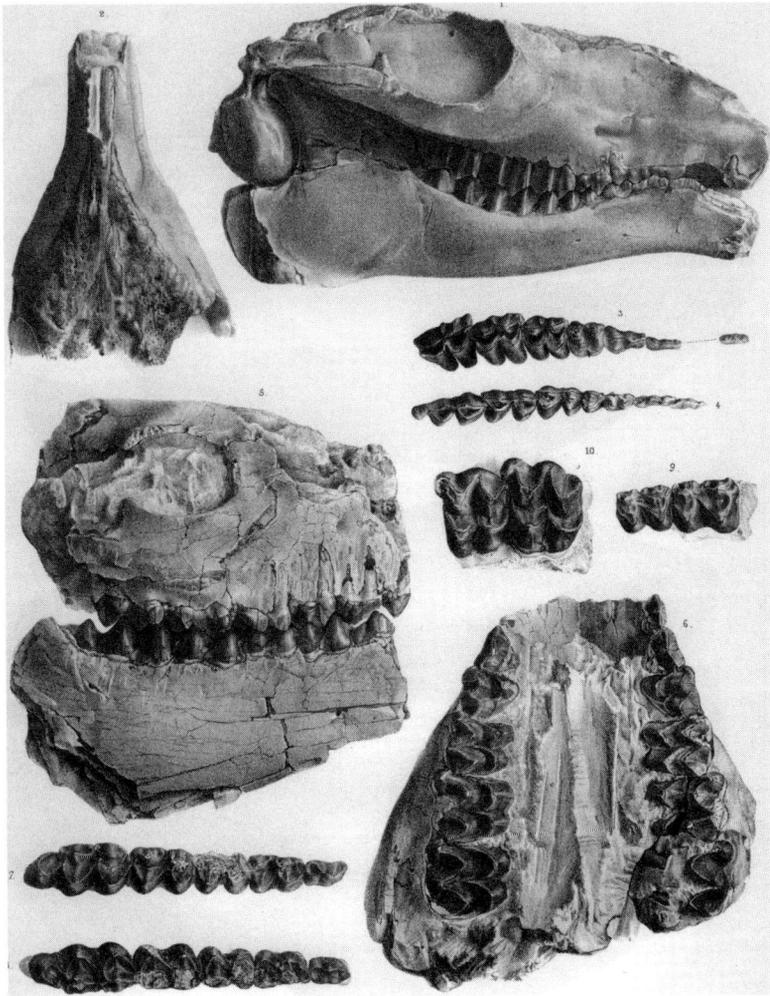

whom came from Philadelphia. These artists probably used camera lucida equipment, which allowed them to see an image of the specimen being drawn superimposed on the plate, in order to achieve the level of detail that is visible in the lithographs. These plates are fine art in themselves.[59]

Auguste Sonrel was also one of Louis Agassiz's lithographers. He worked with Agassiz in Europe and followed him to the United States in 1847, where he set up a lithography business in Boston. Sheila Andrews comments that some of the lithographs Sonrel made for Agassiz and others were drawn directly on the stones, without the use of a preliminary drawing. She suggested that the plates labeled as having been drawn on stone from nature had been made this way.[60] This may or may not be the case, but it is interesting to observe that at least some of the lithographs were drawn directly from specimens.

It is not inaccurate to say that the drawings look like the real specimens. They were outstanding substitutes for seeing the real fossils in the Smithsonian's collections. The logistics of making these prints are interesting in themselves. Did Leidy and his artists see the fossils in Washington? Did he bring some specimens to Philadelphia or Boston for them to study and draw? We

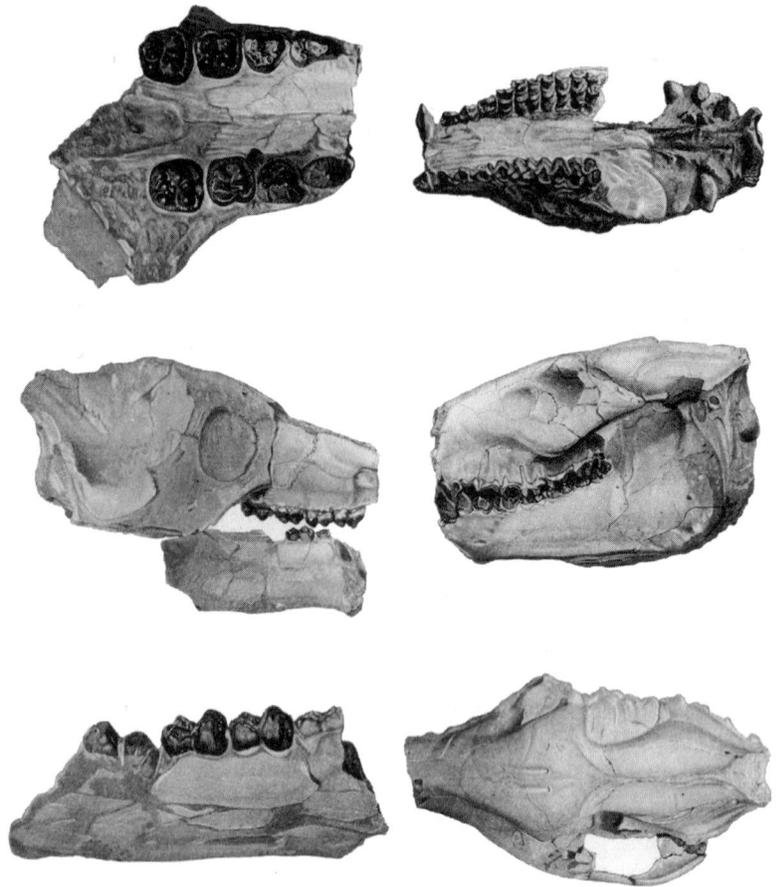

Figure 3.19. David Dale Owen, *Illustrations to the Geological Report of Wisconsin, Iowa and Minnesota,* 1852. Photoengraving.

simply do not know. But there can be no doubt that the artists worked from nature, as the inscriptions indicate and the images make obvious.

The illustrations in this volume compare nicely with those in David Dale Owen's 1852 *Illustrations to the Geological Report of Wisconsin, Iowa and Minnesota.* The two books depict similar fossils of mammals and reptiles. Owen's table 10 shows skulls of *Archaeotherium* and *Oreodon* which are comparable to illustrations in Leidy's 1853 volume. Owen's plate 10 is a steel engraving made from daguerreotypes of the various specimens, a very early use of photography in paleontology illustration. The illustrations in both books are well executed and clear, but Leidy's are far better detailed. At this time lithography allowed the most detail of any technique. However, the Owen illustrations are quite good as well, and they probably resemble the specimens closely. Owen and his printer were experimenting here with newer technologies in an attempt to produce illustrations of a higher quality. Their illustrations reveal their working methods and thought processes, and demonstrate what could be achieved by using medal-ruled engravings and photoengravings.[61]

Edward Drinker Cope (1840–1897) was one of the nineteenth century's most important scientists and one of the founders of the modern science of paleontology in the United States.[62] His publications ranged from short notices to books of hundreds of pages. A bibliography of his works runs to about 1400 items. This massive output he authored in a period of about forty years. His earliest publications date from his late teens, and he died at the relatively young age of fifty-six. Besides this extensive list of personal publications, Cope was for many years the editor of *The American Naturalist.* He was a polymath: an expert paleontologist, herpetologist, and ichthyologist. His contributions to the biology of living reptiles and fish were so extensive that today a journal for ichthyologists and herpetologists, *Copeia,* is named in his honor. Cope did not confine his writings to scientific topics. He wrote religious tracts, commentaries on politics, remarks on marriage and the rights of women, essays on the general status of races in the Reconstruction-era United States, and many papers theorizing on principles of evolution. Cope tended in general to follow the evolutionary theories of J. B. Lamarck. But he extended these ideas of mechanical evolution into more esoteric and almost mystical areas and wondered whether the human soul, mind, and character could evolve. Many of Cope's writings on evolution were compiled into two books, *The Origin of the Fittest* (1886) and *The Primary Factors of Organic Evolution* (1896). Both volumes dealt with Cope's theories of physical and metaphysical evolution.

All of this astounding amount of intellectual activity Cope did without benefit of a college education. In fact, he didn't finish high school. He attended what must have been excellent Quaker primary and secondary schools, including Westtown School (also known as Friends Select School) in West Chester, Pennsylvania, from 1853 through the spring term of 1856. His only experience with college was a one-semester course in comparative anatomy that he took from Joseph Leidy at the University of Pennsylvania. Armed with this, Cope went on to teach at Haverford College and the University of Pennsylvania itself and become one of the scientific luminaries of the nineteenth century. Without question, this was a genius. And this genius was also an artist.

Edward Cope obtained what training he had in art from his father, Alfred Cope, and probably also in the elementary and secondary schools he attended. The American Museum of Natural History archives contain examples of Cope's juvenile drawings that were included in letters to family members and a travel journal that he kept on a sailing trip to Boston in 1847. Obviously Alfred Cope was encouraging his brilliant little boy to practice his reading and writing as well as his skills as an artist. Alfred Cope took his son to Peale's Museum and the Academy of Natural Sciences in Philadelphia so that he could see the exhibitions there as well. The boy wrote up a detailed, floor-by-floor catalogue of the Academy's displays.[63]

In 1858 Edward Cope went to work for the Academy of Natural Sciences, recataloguing and reclassifying specimens. His first publication, discussing the collections with which he had been working, came out in January 1859. Cope was eighteen years old. The following year, the young man hired a language teacher, as he realized he needed to learn German and French.

An amazingly large amount of paleontological art by Edward Drinker Cope is extant, and his impact as an artist and a designer of books was significant. Cope drew most of his scientific illustrations himself, making preliminary drawings for the lithographer or engraver. I think it is likely that he made use of camera lucida equipment. Many of the illustrations are so detailed that it seems impossible that they were done with the naked eye. His original drawings have largely disappeared, but there are references to them in some of Cope's business correspondence. Cope was quite diligent about giving credit for images in his publications that were not his own work.[64] He didn't generally name the artists, but the prints bear the inscription of the firm that made them. They do not normally name an artist either, however. In nineteenth-century publications it was customary for the draughtsman's name to appear along with that of the printing firm. If the image was a lithograph, which many of Cope's illustrations were, then where an artist is named, he may have made the lithographic drawing, and not the original sketch. When no artist is mentioned at all, I think we must conclude that the work was made from a drawing by Cope himself. For instance, the lithographs by the Sinclair Company that are found in Cope's *The Vertebrata of the Cretaceous Formations of the West* (1875) are all of the high quality that one expects from Sinclair. There are sixty-seven plates. Only one, showing highly detailed and well-executed images of bones of *Cionodon arctactus*, bears the name of a draughtsman, E. C. Beaux. Some other plates are equally well made, but others are not. It is obvious that not all of the plates were drawn by Beaux, and I think we see the hand of Cope at work in others.

We know that Edward Cope was an accomplished artist himself, and that he drew all his life; it was routine for him. And we know that he supplied his preliminary drawings to the printers. He was particularly fussy about his publications and wanted the illustrations to be of good quality. In addition, he grumbled when the captions of illustrations did not suit him or were misspelled. Evidence of this is in the archives of the American Philosophical Society, which contain a number of Cope's letters to the Society's secretaries about their publication of his work. In these letters Cope discusses the procurement of illustrations and constantly carps at the APS about the quality of the printer's work. A letter dated December 16, 1866, to T. P. James mentions a woodcut that Cope had commissioned from the artist Edward Sheppard, which was to be sent to the Society the following day to accompany a paper on fish, and includes the bill for it. Two years later, on December 30, 1868, Cope wrote to the secretary with questions concerning a paper that Cope hoped to have published. Here he commented that he had employed Juno Collins to do woodcuts and also the drawings for lithographic plates. In addition, an artist named Sinclair was going to make illustrations. This no doubt indicates that the illustrations were to be made by the Sinclair firm. We learn from this letter that Cope sent drawings straight to the commercial artist or to the printing firm on various occasions. Sometimes Cope sent a sketch he had made to the APS and had them send it along to their printers. It is not surprising that the original drawings did not survive, as they may have been destroyed during the process of reproducing them as lithographs

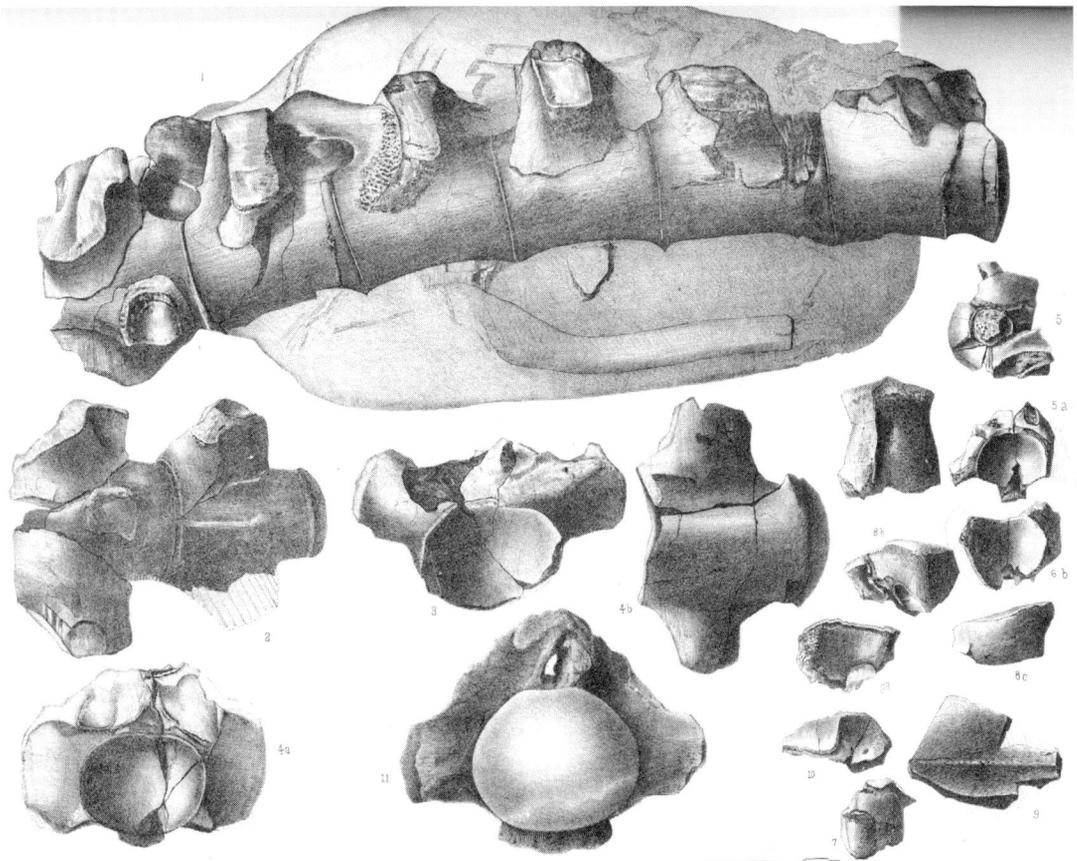

1-4, PLATECARPUS LATISPINIS, 5-10, PL. TECTULUS, 11, LIODON DYSPELOR

Figure 3.20. Edward D. Cope, *The Vertebrata of the Cretaceous Formations of the West*, 1875. Art by E. D. Cope.

or engravings. At least one does survive, however; a letter written to J. P. Lesley on May 5, 1877, still contains Cope's sketch of the brain case of *Procamelus occidentalis.* The Sinclair Company was to make the lithograph for $25. A letter from March 23, 1877, which discusses a proposed lithograph of the brain of *Coryphodon,* was written on half a sheet of paper; Cope must have used the other half for something else.[65] This is the Edward Cope that paleontologists and historians have come to expect: rushed, busy, sloppy in his handwriting. The fact that these letters and drawings are carefully and legibly labeled thus indicates how important those captions were to him.

Cope's magnum opus, *The Vertebrata of the Tertiary Formations of the West* (1883), contains over one hundred plates, all lithographed by Sinclair.[66] In no case is the name of the draughtsman of the original drawing or the lithograph given. However, F. V. Hayden noted in his letter of transmittal that "[t]he plates which illustrate this volume were engraved by Thomas Sinclair & Son of Philadelphia and the figures were drawn on stone from the specimens themselves under the immediate direction of Professor Cope."[67] This sentence does not preclude Cope's having made preliminary drawings himself, from which the lithographers worked. The opposite interpretation, that the lithographers stood over the specimens and drew them onto the stones while Cope watched, is implausible given the fact that they were dealing with literally

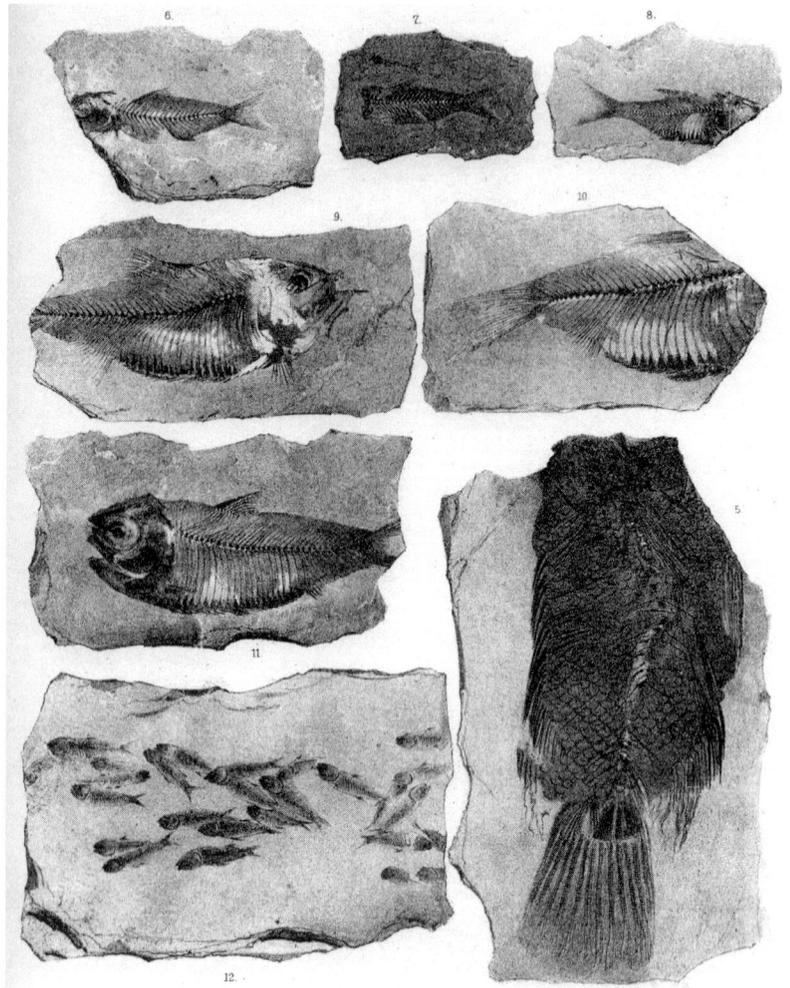

Figure 3.21. Edward D. Cope, *The Vertebrata of the Tertiary Formations of the West*, 1883. Art by E. D. Cope showing specimens from the Green River Shale.

thousands of fossils, some of which would have been heavy, others brittle, and none of which would it make sense to cart over to Sinclair and Company from either Cope's uptown home on Pine Street in Philadelphia or the family's warehouse on the docks at Walnut Street. Lithographic stones were heavy and expensive, and similarly would not have been carted to the fossils. Furthermore, during the late 1870s and early 1880s, when this book was taking shape, Cope was out of Philadelphia for long periods, traveling to Europe, working in the field, and trying his hand at mining ventures. He could not possibly have stood and watched the lithographic drawings take shape. It is my opinion that Cope made preliminary drawings for this book. His comments again reveal his intense interest in getting these images right: "The lithographic work of Messrs. T. Sinclair and Son maintains the well-known reputation of their house, and will prove satisfactory to students generally."[68]

Besides making drawings of specimens, Cope on occasion would create life restorations and even place his restored fauna into ecological settings. Most of these works of art remained in the drawing stage. But at least one was published as the illustration of fossil life in an ecological setting in

Cope's "The Fossil Reptiles of New Jersey." The drawing has become famous, because in Cope's restoration of *Elasmosaurus platyurus* he placed the skull on the wrong end of the vertebral column. In doing so, he made the animal appear to have a short neck and a long tail, when in reality it had a long neck and a short tail. He described his restoration in remarks to the American Philosophical Society on September 18, 1868, and April 2, 1869, and preprints of these remarks, dated August 1869, include an illustration in which the skeleton is shown with a short neck. Cope distributed some of these to friends and colleagues. His mistake was pointed out to him by Joseph Leidy, and as soon as Cope realized it, he tried to have all the preprints returned and destroyed. A new version of the article appeared with the skull correctly placed. But some of the preprints remained in circulation, and the whole incident became a great embarrassment to Cope. His scientific rival O. C. Marsh made fun of him for this incident for decades. Marsh's ridicule was certainly one of the causes of the two paleontologists' life-long animosity.[69]

Other life restorations may be found scattered among Cope's surviving papers. Some of them show animals engaged in unrealistic activities, such as elasmosaurs intertwining their (now long) necks. That illustration had an impact on Charles R. Knight, who certainly used it as a reference. But probably with this illustration Cope was teasing a little. Others, such as a sketch of *Laelaps aquilungis* (now *Dryptosaurus*) in the archives of the Academy of Natural Sciences, show no such frivolity. But, with the parsimony that was typical of Cope, he drew that one on a blank page in a letter written to him by Dr. H. Berend of New York City.[70]

Hayden's wording in his letter of transmittal is precisely the same used by Henry F. Osborn in his biography of Cope: "Illustrated with drawings and restorations by Charles R. Knight under the direction of Professor Cope." Osborn places Cope's sketches alongside reproductions of Knight's images, which were based upon Cope's work.[71] Cope's art had a significant influence on Charles R. Knight. And anyone whose art owed debts to Knight thus owed them to Cope as well. One of the aspects of Knight's life restorations that made him an important artist was that Knight tried very carefully to show his animals in action, rather than in static poses. This Knight learned from Cope.

Leo Lesquereux (1806–1889) was a specialist on fossil plants. Thirty-five years after Agassiz, Lesquereux drew his own illustrations of fossil plants from Pennsylvania's coal deposits and then had these translated into colored lithographs in order to achieve the realism he sought for his book. Lesquereux's study shows that interest in and use of colored illustrations continued into the last quarter of the century, as indeed it does to the present. Lesquereux published his illustrations before his text; his work on the Carboniferous flora occupied three volumes appearing over five years, of which the first (1879) was devoted entirely to colored lithographs. The second volume (1880) contained only one color illustration, and the third volume (1884) twenty-six, but the

Leo Lesquereux

Atlas to the Coal Flora of Pennsylvania and the Carboniferous Formation throughout the United States (1879) and *Description of the Coal Flora of the Carboniferous Formation in Pennsylvania and throughout the United States* (1884)

first contained eighty-seven plates, many of them drawn by Lesquereux himself. Others were drawn by Albert M. Rickly. These drawings were then turned over to professional lithographers. The lithography itself for all three volumes was done in Harrisburg, Pennsylvania, by the staff of the state printer, Lane S. Hart. Lesquereux felt it important to use fine-quality color illustrations in his report volumes, to make them more useful to his colleagues. The images in these plates are printed in shades of light tan, which presumably approximated the color of the specimens and matrices. Color plates in all three volumes are printed in the same palettes. Apparently Lesquereux did not have access to any of Pennsylvania's beautiful fossil ferns that are preserved in white and yellow against a black matrix.

Lesquereux was the nineteenth century's foremost expert on the fossil plants of North America. A Swiss, he had come to the United States in 1847. He established himself as a specialist in paleobotany despite the fact that he knew no English when he arrived and was in fact deaf. Lesquereux worked frequently for the U.S. Geological and Geographical Survey of the Territories (the Hayden Survey), and his papers appeared in a number of the Survey volumes. In 1873, Lesquereux was the first to publish specimens of fossil plants from the famous Florissant beds in Colorado, although he did not visit the area personally.[72] His 1879 atlas of fossil plants was one of many paleontology treatises to use color plates in this century. By 1879 color lithography was scarcely new, but it continued to be a valuable medium in the printing of books.

Figure 3.22. Leo Lesquereux, *Atlas to the Coal Flora of Pennsylvania,* 1879. Illustration by Leo Lesquereux.

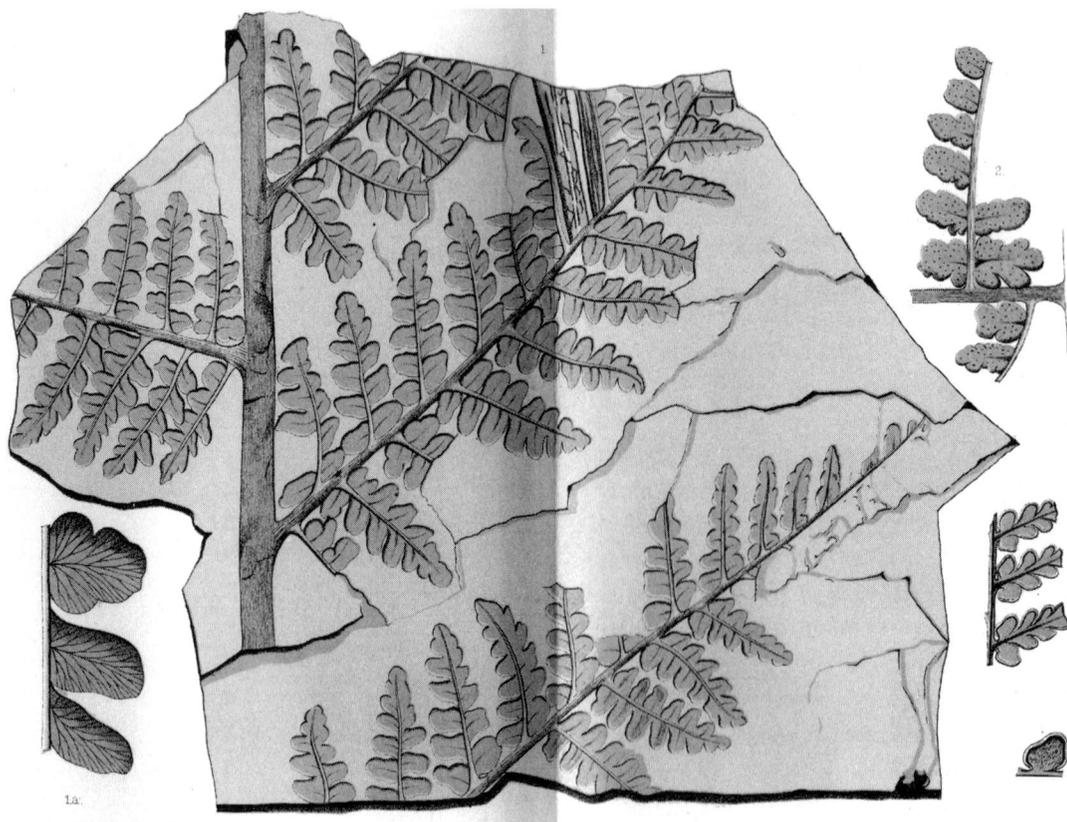

The federal surveys did not study just geology, mining, and vertebrate pale-ontology. Those fields were obviously of considerable interest and, in the case of the geological studies, potential financial importance in the expanding United States of the post–Civil War era. But those who ran the surveys, Hayden and John Wesley Powell and others, wanted to provide a full descrip-tion of the new western territories, as well as other lands, including studies of extant and fossil life forms. The Hayden Survey volumes provide an interest-ing overview of paleontology illustration in the second half of the nineteenth century. Hayden's paleontologists studied vertebrates, but they also turned their attention to fossil invertebrates and plants. Some of the Survey volumes became justly famous. The later volumes were characterized by numerous excellent engravings and lithographs.

Ferdinand V. Hayden (1829–1887) headed the U.S. Geological Survey of the Territories between 1867 and 1878. Hayden, a geologist and medical doctor, had collected fossils and studied geology while he served as a cav-alry surgeon in the Territories in the mid-1850s. Here he explored a number of areas around the upper Missouri River, as well as the upper Yellowstone River, in what was then the Nebraska Territory. He turned over many of the fossils which he collected during this period to Joseph Leidy for study and publication. Between 1863 and 1872, Hayden was a professor of geology and mineralogy at the University of Pennsylvania. When the Civil War ended, Hayden went back to the west to head up the U.S. Geological and Geo-graphical Survey of the Territories. He actually headed a number of field expeditions himself. Hayden's associations with Leidy, Leo Lesquereux, and later with Edward Drinker Cope helped establish him as an important contributor to the new and growing field of North American paleontology in the post–Civil War era.[73] A number of important paleontology treatises (some of which are discussed elsewhere in this book) were brought out under the auspices of what was called the Hayden Survey. Among these were Cope's *The Vertebrata of the Cretaceous Formations of the West* (1875) and *The Vertebrata of the Tertiary Formations of the West* (1883).

The first Hayden Survey publication was a three-part volume covering 1867–1869.[74] Paleontology was included in these early volumes, although it was not dealt with extensively until the survey of 1870. The fossils men-tioned often seem to have been collected by Hayden himself. Hayden's par-ties explored much of western Wyoming during the 1870s. These expedi-tions were highlighted by discoveries made by Cope, Samuel Scudder, and others. The Hayden Survey also sponsored studies of fossil plants from Nebraska, Wyoming, and Colorado by Leo Lesquereux and of various in-vertebrates by Fielding B. Meek (1817–1886), who was an expert in this area of paleontology. The contributions to paleontology made by Hayden and by the scientists who were sponsored during the various campaigns of the Hayden Survey are indeed significant.[75]

Paleontology Illustration in Volumes of the Hayden Survey

Ferdinand Hayden, *A Report of Progress of the Exploration in Wyoming and Idaho for the Year 1878* (1883)

The Hayden Survey volume for 1878 (published in 1883), *A Report of Progress of the Exploration in Wyoming and Idaho,* is among the more interesting, if lesser known, volumes of this noteworthy series.[76] It contains beautiful and finely detailed color lithographs of fossil invertebrates, most of which were collected during the field season of 1878 in Wyoming and Idaho. The plates were printed by Sinclair of Philadelphia. Today, after 129 years, the background color of the lithographs varies from soft cream yellow to soft pink. Undoubtedly the colors were stronger when the book was first printed. Perhaps they were meant to suggest shades of the rock matrices.

Printing of these plates was supervised by the artist W. H. Holmes.[77] Holmes was famous for his finely drawn landscape illustrations. He is well known for his illustrations of the Grand Canyon and of sites in Wyoming. Holmes made some of the drawings from which the Sinclair lithographs were executed. Other artists whose work was supervised and selected for lithography in this volume included F. D. Owen (a landscape of the Pine Lake area, plate 11; and some illustrations in plate 12 depicting corals, bivalves, and various mollusks), A. R. Rossier (several ammonites, plate 18), and J. C. McConnell (the bivalve *Exogrya winchelli,* plate 13; oysters, plate 14; ammonites, plate 15; and crinoids, plate 40). R. P. Whitfield and McConnell collaborated on plates 16 and 17. Plate 16 is an exquisite depiction of *Paramithrax walkeri,* a fossil lobster. The fossil seems to have been exceptionally well preserved and the illustration shows its details beautifully. Plate 17 also depicted *Paramithrax,* together with various bivalves. (See figure 3.23 and color plate 4.)

In his letter of transmittal, dated January 1, 1879, Hayden wrote about the expedition's activities in the field.

> The headquarters for the Survey was at Cheyenne, Wyo., the same as the preceding season. Four parties were organized but in such a manner that in case of necessity they could be divided for special duty. All our outfit and animals were transported from Cheyenne to Point of Rocks and Green River Stations, on the Union Pacific Railroad and from thence the parties pursued their way northward to their respective fields of labor.

The text was written by C. A. White, who stated that F. B. Meek had worked on it prior to his death and that, while most of the fossils had been collected by the survey during the field season, some were provided by Arthur Lakes and Benjamin Mudge.[78]

Leo Lesquereux, *The Cretaceous and Tertiary Floras* (1883)

Leo Lesquereux, of course, had a long-standing relationship with the Hayden Survey. At the same time he was publishing his work on the Carboniferous flora of Pennsylvania, Lesquereux also published *Contributions to the Fossil Flora of the Western Territories,* a three-volume Hayden Survey text. It is interesting to compare the illustrations in the third volume of this text, *The Cretaceous and Tertiary Floras* (1883), with those in his *Atlas to the Coal Flora*

Figure 3.23. Ferdinand V. Hayden, *Twelfth Annual Report of the United States Geological and Geographical Survey of the Territories,* 1883. Drawing by J. C. McConnell depicting crinoid specimens.

(1889), because some of the lithographs in the atlas were made from drawings by the same artist who worked on *The Cretaceous and Tertiary Floras.* This was Albert M. Rickly. Rickly's drawings for *The Cretaceous and Tertiary Floras* were lithographed by the Sinclair firm. There were a total of fifty-nine full-page color lithographs, showing leaves. They were all printed in a light yellowish tan on a very light tan background, clearly modeled on the lithographs in the 1879 *Atlas.* While Lesquereux did not make any preliminary drawings for the 1883 volume, he clearly had considerable influence on the presentation of the images. The lithographs in the later volume are of lower quality than those of the *Atlas,* which is surprising in that the Sinclair Company generally put out a fine product.

These two volumes must have been in simultaneous preparation. Lesquereux's letter of transmittal to Hayden for the third volume of the Survey text is dated September 30, 1882.[79]

Samuel H. Scudder, *The Tertiary Insects of North America* (1890)

The fossil beds at Florissant, Colorado, have produced a wealth of outstanding specimens, especially of insects and plants. Herbert W. Meyer, who is an expert on the Florissant insects, has noted that there are at least forty thousand fossil specimens from the site in museums around the world. In his 2003 book Meyer presented an overview of the insects and other fossil life at Florissant by means of his own color photographs. *The Fossils of Florissant* is a beautifully illustrated book that demonstrates the best of modern-day paleontology illustration, utilizing the medium of photography in a book that the general reader can enjoy as much as a scientist.[80]

The Florissant beds attracted attention from the Hayden Survey as early as 1873, when A. C. Peale, a geologist with the Survey, made some preliminary observations of the area. Others had visited the site in 1871 and collected fossils. One of the early visitors to Florissant was Theodore Mead, who brought back fossils that came to the attention of Samuel H. Scudder (1837–1911). Scudder was a Bostonian who had studied at Harvard under Louis Agassiz and was recognized as one of the world's authorities on fossil insects and arachnids. He went to Colorado several times, beginning in 1877. His first visit was made with Arthur Lakes, who was to become famous for his own discoveries of dinosaurs. Scudder worked for the U.S. Geological Survey from 1886 to 1892, and during this period he produced *The Tertiary Insects of North America* (1890), his wonderful book on the fossil insects and arachnids of Florissant.

So few fossil insects had been discovered before the work Scudder reported in this book that, he wrote, "[t]he first ten plates herewith transmitted [in *Tertiary Insects*] contain very nearly all the extra-Florissant insects known ten years ago."[81] *The Tertiary Insects of North America* is an enormous book of folio size that runs to 734 pages. Its plates were prepared as colored lithographs by George S. Harris and Sons and the Sinclair firm, both of Philadelphia, and most of the illustrations were drawn by J. Henry Blake. Scudder also drew a few of the insect specimens. Some of the plates are printed on light cream yellow backgrounds. The use of this color was probably a matter of taste at the printing houses, as the color does not match that of the Florissant strata. The Scudder plates do, however, nicely match the plates in Lesquereux's 1883 Survey volume. It is obvious that these two books were designed to complement each other. Blake's drawings of fossil insects are stunning. Some of the plates contain dozens of specimens. The images were probably drawn using a camera lucida and magnification; they are beautiful and their fidelity to actual specimens is very high. (I am always interested in the reactions of laypeople who look at paleontology illustrations in these older texts. When I showed a friend Scudder's plates, he commented, "These are drawings? How in the world did he do that?" That comment says it all.) While many of the plates show fossil insects from Florissant, one group of plates contain images

That creatures so minute and fragile as insects, creatures which can so feebly withstand the changing seasons as to live, so to speak, but a moment, are to be found fossil, engraved as it were, upon the rocks or embedded in their hard mass, will never cease to be a surprise to those unfamiliar with the fact. . . . The pages and plates of the present volume bear testimony to the fact that our tertiary strata have preserved remnants of an ancient host, so varied in structure, so closely also resembling their brethren of today. . . . While often fragmented and crushed . . . a not insignificant number are sufficiently preserved for us to repopulate the past.

Samuel H. Scudder, 1890

Figure 3.24. Samuel Scudder, *The Tertiary Insects of North America,* 1890.

THE FLORISSANT BASIN.

HEMIPTERA. (HETEROPTERA—LYGAEIDAE)

of insects from Green River, Wyoming, and some other sites, including several in Canada and beds at Port Kennedy, Pennsylvania.[82] As his title indicates, Scudder was attempting to cover Tertiary insects in general, not just those from one location.

It is little wonder that other paleontologists immediately turned to *The Tertiary Insects of North America* for reference. This book became the standard by which to study fossil insects and arachnids. Its illustrations had an immediate impact on other scientists; they were reused almost at once, even in books published in Europe. An example of this is Félix Bernard's *Éléments de paléontologie,* published in 1895.

Félix Bernard
Éléments de paléontologie (1895)

Félix Bernard (1863–1895) was a French paleontologist whose specialty was Mollusca. He did his degree research on them and wrote a few treatises, but his magnum opus, *Éléments de paléontologie,* is only in part concerned with mollusks and other invertebrates. The *Éléments de paléontologie* is a massive book of 1168 pages of text and 612 engraved illustrations. It covers invertebrate fossils extensively—as one might expect, given Bernard's specialty—but Bernard also discussed fossil vertebrates and plants. He even gave brief mention to the topic of fossil humans. Bernard commented in his preface that he wanted to write a book in the French language as a companion to other general studies of paleontology, such as those by Karl Zittel and by Henry Nicholson and Richard Lydekker. He also wanted to expand upon their work and provide additional and newer scientific data.[83] It appears that lengthy compendia of paleontology had a following in the education communities of Europe at the end of the nineteenth century.

Éléments de paléontologie is fascinating for its illustrations, which are all engravings. Most were derived from earlier publications, but their quality is quite good.[84] A few appear to be photogravures. Photogravure prints were executed by making an engraving of the photograph, but incising the design on a metal drum rather than a flat metal plate. This was a high-speed mechanical form of printing that became quite popular toward the end of the nineteenth century. Photogravure prints can be discerned from engravings made on flat metal plates by their "softer," less distinct appearance. Most of the illustrations are small, but they are finely detailed and serve to instruct the reader in the appearance of the specimens. This was in keeping with Bernard's purpose; he wanted to apprise his readers of contemporary scientific literature. Two engravers can be identified in these illustrations, A. Jobin and Swoboda. It is evident that Swoboda was making fresh copies of earlier works, since we find the name attached to prints with which he would not have been originally involved. For example, figure 506 (page 917) depicts views of a skull of *Tillotherium fodiens* Marsh, images taken from Marsh. Similarly, figure 509 (page 927) is a print of Cuvier's restored skeleton of *Megatherium,* originally by E. Krell. Swoboda's and Jobin's representations of vertebrate fossils probably varied in their usefulness to the reader. They are of a good technical quality, but some are so small that the individual bones in a skeleton cannot be seen. But there were many illustrations of specific bones, and the restora-

tions were good enough to allow readers to identify a mounted specimen if they saw one at a later time.

Most of this book is about invertebrate fossils. There are hundreds of illustrations of Mollusca specimens, as well as specimens of other invertebrates. For instance, figure 189, on page 377, depicts a group of wings of fossil insects. These too were taken from various previous publications, which Bernard cited, but the images are grouped together for comparison. They are beautifully presented. Figures 150 and 151, on pages 312 and 313, show finely detailed illustrations of fossil echinoderms. Many of these illustrations were taken from Scudder, the American expert on fossil insects, whose works are beautifully illustrated. Scudder's prints are of a much higher quality than these copies in Bernard, but nonetheless Bernard's illustrations achieve their purpose. And his book shows the wide diversity of materials that he used in preparing it.

A Late-Century Study of Fossil Invertebrates and Flora

Leo Lesquereux et al.,
Geology of Minnesota: Paleontology (1895)

This chapter began with discussions of several publications that dealt with fossil invertebrates, fossil plants, and ichnofossils. While the nineteenth century may be remembered by many people as a golden age of great discoveries in vertebrate paleontology, important work was done in other areas of paleontology as well. As in vertebrate paleontology, several important studies came out under the sponsorship of state and federal surveys. Authors and the illustrators who worked with them devoted as much attention to the accuracy and quality of their illustrations as did the creators of vertebrate texts.

Toward the end of the century, Leo Lesquereux contributed to another survey study. *Paleontology,* the 1895 volume of the Geological and Natural History Survey of Minnesota, was published under the aegis of the University of Minnesota and the direction of Newton H. Winchell (1839–1914), the state geologist. Lithography for this volume was done by two Cincinnati printers, MacBriar Lithography and Henderson-Achert-Krebs Lithography. Some of the lithographs are unsigned, and they may have been done in-house by Johnson, Smith, and Harrison, the Minnesota state printers. In general, the lithographs are of a good quality and compare well to the late volumes of the Hayden Survey (such as Scudder's and Lesquereux's) in style and the attention given to details. Like the Hayden Survey volumes, this one is also illustrated with lithographs in which large numbers of specimens are depicted on each page. These government publications, state and federal, evidently had something of a uniform artistic style.

Lesquereux's chapter in *Paleontology* deals with Cretaceous plants in the state of Minnesota. In this case, Lesquereux did not make preliminary drawings for the lithographs. The drawings were executed by Edward O. Ulrich (1857–1944), who did many of the preliminary drawings for the book and prepared some of the lithographic plates, as well as contributing the introduction, a historical sketch of paleontology in Minnesota, and a chapter on bryozoans.

Another artist who provided drawings for this volume was Charles Schuchert (1856–1942). Schuchert, along with Winchell, also wrote two

Figure 3.25. Leo Lesquereux et al., *The Geology of Minnesota: Paleontology,* 1895. Art by Charles Schuchert.

chapters for the book. These dealt with brachiopods and with various other invertebrates, such as corals, sponges, and graptolites. Charles Schuchert was a very skilled draughtsman and an expert on invertebrates. The lithographs for which he did the drawings are noteworthy for their finely drawn details and complex designs. As a young man, Schuchert had become

friends with Edward O. Ulrich, who shared Schuchert's interest in invertebrate fossils. Many of the specimens shown in this volume were taken from Schuchert's collection. In 1892 Schuchert went to work as a preparator for Charles E. Beecher at Yale. After a year at Yale, he worked for the U.S. Geological Survey and the U.S. National Museum. In 1904 he went back to Yale as a professor of geology and head of the Yale Peabody Museum. Schuchert may be better known now from his tenure at that museum and his 1940 biography of O. C. Marsh.[85] Schuchert, Ulrich, and Lesquereux were among the many artist-paleontologists who illustrated their own scientific publications. Their works demonstrate again the apparently seamless connection between art and paleontology.

William Holbrook Beard (1824–1900) was an American genre painter whose works generally contained animal imagery. Many of his works can be categorized as nineteenth-century romanticism, and they may at times border on kitsch: the nineteenth century's equivalent of the infamous modern depictions of dogs playing poker. They certainly do not belong in the category of scientific illustration. But some of Beard's subjects indicate that he was influenced by contemporary scientific illustrations. In a broader assessment, his work is a very late example of singerie: art depicting animals in human clothing and poses. Singerie paintings became popular in the late sixteenth century and continued as a serious component of genre throughout the seventeenth century. Such works were especially popular in the Netherlands. There are singerie paintings and prints in the works of the Brueghel family and their followers, with important examples of the style being found in the works of artists like David Teniers II (1610–1690). While William Holbrook Beard was obviously creating his animal fantasy paintings for different patrons than were these seventeenth-century artists, influences in Beard's works can certainly be traced back to artists like Teniers. Beard's *Bar Room* (art trade, 2000, present whereabouts unknown) and *Pre-Adamite* (present whereabouts unknown) are taken from singeries by Teniers and others in which apes dressed as humans are shown in tavern settings. Beard's apes are dressed as middle-class gents rather than as soldiers and peasants, as they were depicted in earlier paintings. An undated Beard painting, *The Dog Congress* (Wadsworth Athenaeum), is reminiscent of the works of the Dutch painter Cornelis Saftleven (1607–1681), a follower of Teniers. In this work Beard leaves his dogs undressed and looking properly doglike, just as Saftleven frequently depicted the subjects of his animal paintings.

Like many nineteenth-century American artists, Beard went to Europe to train and to observe both contemporary and Old Master works firsthand. We know that he was there in 1856 and that he stayed for several years.[86] There is in Beard's work an element of the sinister and what one might describe as a dark, almost angry approach to some topics. That darkness is not found in the earlier singeries he was emulating. It gives his works a certain edginess and makes them more interesting to the modern observer. This sinister quality was commented upon by Beard's contemporaries.[87] His frightening 1862

Scientific Illustration's Impact on Fine Art: William Holbrook Beard

painting *Santa Claus* (Rhode Island School of Design, Museum of Art) shows Santa's sleigh drawn by reindeer across an almost blood-red sky filled with the aurora borealis while Santa sprinkles toys down a chimney (one doll is shown dropping headfirst into the chimney with its legs splayed outward). This is no Clement Moore or Thomas Nast Santa.

Beard's paintings ridiculed such topics as forced engagements and divorces, and, more interestingly here, he made fun of contemporary science, including the rather new science of paleontology. Because of this, Beard has become an inadvertent part of the history of paleontology illustration, for while his singeries joked about contemporary scientists and their theories, his fossil animals were presented according to contemporary artistic models. The title of his *Pre-Adamite* seems to indicate that Beard was keeping up with discussions about evolution. Was he making a comment on Darwin and Huxley in this painting? Or was he commenting on other theorists who were content to permit evolution to exist, as it were, prior to the Special Creation of humanity? Beard satirized scientists themselves in his 1894 painting *Scientists at Work*. It shows a group of apes dressed in human clothing at work in an interior. Some are discussing a text, while others intently observe what one is writing on a slate. In the manner of earlier singeries by Teniers and his followers, one ape scientist is shown peeping in at a partially open door. Such voyeurs are a cliché in Teniers genres and singeries. Beard certainly arrived at the topics of evolution and paleontology in 1891 with a painting entitled *The Discovery of Adam*. Seven apes of various ages are on a beach. They are engaged in a careful examination of what appears to be a Galapagos tortoise. One ape bends over the reptile and has employed a magnifying glass in order to get a better view of "Adam." It can be safely assumed that the ape scientists intent upon the rather primitive-looking reptile are Beard's commentary on theories of human evolution. Herein one sees a slightly lower branch of the family tree of *Homo*. Viewers are left to draw their own conclusions as to whether Beard agreed with Darwin and his proponents or not. The humor is there notwithstanding. But the special part of this painting is the vignette in the background, in which one sees an earlier part of the story of evolution: a plesiosaur confronting a pterodactyl. The two animals seem almost to be engaged in a lively conversation. Are they placed in the scene to make further fun of the serious "scientists" at work on the beach? It would seem that "Adam" cannot be the progenitor of the apes after all, since animals from earlier eras are included along with these properly dressed nineteenth-century "gentlemen" scientists. The observer is left to wonder just what is going on in this painting. Was Beard satirizing science, Darwin, or those who still believed in the Special Creation, or was he making a fairly straightforward comment upon the findings of modern paleontology?

If Beard was giving the viewer a paleontology lesson, so to speak, then his fossil animals are problems, for their anatomies are not well understood or depicted. It is obvious that they interested Beard, but they are almost cartoons. The anatomy of the pterodactyl is better depicted, providing one does not look too closely. That of the plesiosaur is truly peculiar. Beard has also placed the plesiosaur on land; it sits on a rocky outcrop. By the time Beard

executed this painting in 1891 much was known about the anatomy of the plesiosaur as well as that of the pterodactyl. Certainly Beard might have consulted a number of books as visual references. Yet his animals look similar to those found in popular books from roughly the first half of the nineteenth century. Did Beard turn to such sources because they were available to him, or did he set out to find images of the animals in a landscape? If Beard had visited England in his travels, he might have seen the collection of fossils that Gideon Mantell had sold to the British Museum in 1838. Even though he did not, he may have been aware of George Richardson's 1838 *Sketches in Prose and Verse Containing Visits to the Mantellian Museum,* a published description of Mantell's fossil collection which contains a scene of restored animals. Beard's pterodactyl somewhat resembles the one in that scene. Richardson was Mantell's curator in Sussex until Mantell sold his collection. Richardson's book was illustrated with a frontispiece drawn by George Nibbs and rendered into lithograph by George Scharf, the same artist who made De la Beche's famous *Duria antiquior.* The frontispiece is entitled "The ancient weald of Sussex" and shows a plesiosaur, but this animal does not resemble Beard's later rendition in *The Discovery of Adam.*[88]

If Beard did not see the Richardson illustration, it is quite possible that he did know the frontispiece of David Thomas Ansted's 1863 *The Great Stone Book of Nature.* It depicted several examples of representative fossil animals, including a pterodactyl and a plesiosaur, in a landscape setting. Ansted took pains to note that these animals did not exist together in time, but that the illustration is merely a representation of various types of known fossil life.[89] The pterodactyl and plesiosaur look quite similar, in their anatomy and poses, to those painted by Beard in *The Discovery of Adam.* Ansted's plesiosaur is even placed on land as well. This was, of course, a rather common way to depict plesiosaurs throughout the nineteenth century. Since the illustrations in Ansted's English and American editions of 1863 are exactly the same, it is possible that Beard could have seen either or both of them. Beard's animals are livelier than Ansted's and they seem almost to be conversing with one another, but his painting is a singerie and such latitude is to be expected. Whether Beard used this popular book on geology and paleontology as a source or not, the close similarity of his fossil reptiles to Ansted's makes clear that Beard chose older and more established views of fossil animals for his references.

Beard's use of fossil animals in a singerie painting was unusual but not novel in the nineteenth century. We have seen some similar treatments in the satires of De la Beche. The difference is that Beard was not a scientist, nor was he creating scientific illustrations. His work reflects the impact of scientific illustration on the general public.[90]

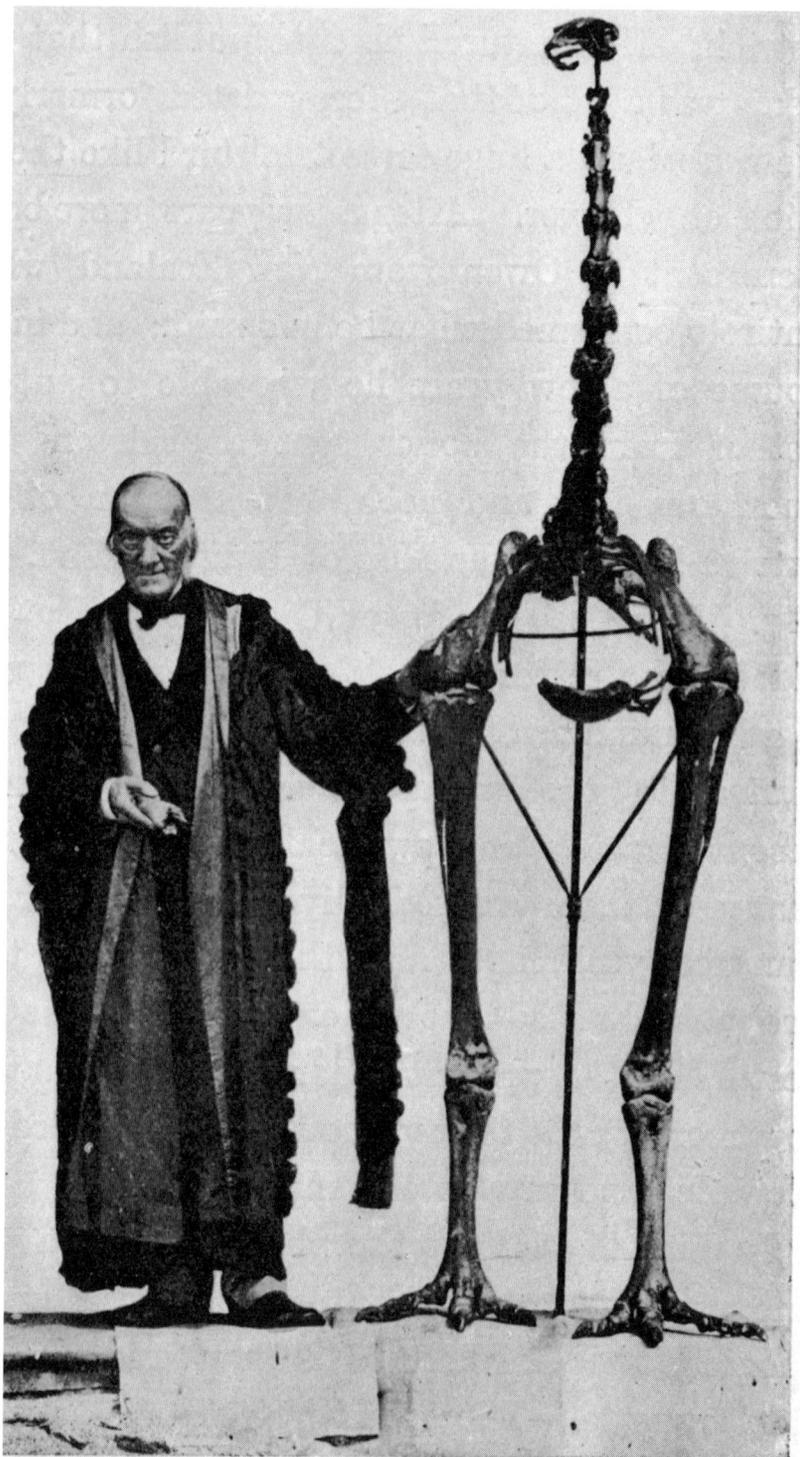

44.—Photograph of Sir Richard Owen standing beside the restored skeleton of the New Zealand Moa (*Dinornis maximus*). From a memoir by Owen.

69

THE PALEONTOLOGIST
POSES WITH FOSSILS

4

Fossils frequently bring those who discover or study them a certain fame. This is especially true of fossils that are examples of newly discovered genera or species, or perhaps look strange. Before us is an organism like nothing we have ever seen before. And the visual impact is considerably enhanced if the fossil in question is a vertebrate. Since at least the early decades of the nineteenth century, paleontologists have had a penchant for being pictured with fossils, especially striking or unusual ones. In some cases they posed in a formal or laboratory setting, but they also came to enjoy having themselves depicted "working" in the field. From the beginning paleontologists were shown supposedly in the act of retrieving a famous fossil. The genre remains highly popular. If a new fossil is found, it will soon show up in the visual media (in the newspapers, on television, and on the Internet) with its discoverer alongside. What follows is not an all-inclusive catalogue of every image of a paleontologist with a fossil, but a representative sampling of the genre. It is a very popular genre, and it is part of the character of paleontology illustration.

Such images are not particularly metaphysical or symbolic. For the most part they show the fossil and the scientist or some other observer, and that is it. They are used as representations, designed to convey data and to show the human observer or discoverer of the fossil. They also give a sense of the fossil's size as it compares to an adult human. There is nothing particularly unusual in such a mundane use of art. Many years ago I had my photograph taken in the Louvre Museum beside one of Michelangelo's extraordinary *Slaves*. These magnificent male nudes were designed to be placed above ground level on the tomb of Pope Julius II, and so the Louvre displayed them on pedestals. The photographer had a sense of humor, as did the human subject. The result was a photograph in which I appeared to be carefully examining the figure's gluteus maximus. There was nothing complex about this image. The photograph was intended to show the statue, its scale, and the astonishing technical skill with which it had been created. It was also intended to provoke a laugh from my thesis advisor. If my students who see the image think it is humorous, there is no harm in that. At the same time, they can look at the human in the photograph, who now stands before them in the classroom, and understand precisely the scale of the statue.

There have been times in which representations of fossils and scientists similarly became entertaining, rather than strictly reportage. Louie Psihoyos's 1994 *Hunting Dinosaurs* is an example of what can ensue when paleontologists and fossils are shown for entertainment value. The book is filled

Figure 4.1. Sir Richard Owen, from E. Ray Lankester, *Extinct Animals,* 1906.

with wonderfully innovative photographs. Many are fine art. But, unfortunately, the text does not measure up to Psihoyos's imagery.

The practice of picturing paleontologists with their fossils may have begun with the Philadelphia artist and naturalist Charles Willson Peale (1741–1827). In 1806–1808, Peale painted himself directing the excavation of the famous mastodon found on the farm of John Masten in Newburgh, New York. Later in his career (in 1822) Peale displayed his fossil almost teasingly in a second painting, entitled *The Artist in His Museum*. Peale is shown drawing back a large curtain so that the viewer may see into his museum, where is displayed the restored skeleton of the mastodon as well as cases filled with all sorts of natural history specimens. Other observers walk among these cases, looking at them. Peale, in the foreground, is thus larger than life. Near his feet are a portion of the mastodon's lower jaw and its femur. This is a fascinating pose that Peale has struck. He invites you into his museum and teases you with what you will see there. In the meantime you get a close-up look at parts of his famous fossil and a great view of Peale himself. The meaning is clear: here is a famous man and here is what made him famous. But the painting is also pedagogical, as is the earlier *Exhumation of the Mastodon*. There are fossils to be seen, excavation procedures to behold; and there is a record of what Peale's Museum looked like in 1822.[1]

A similar combination of themes may be found in a sketch of William Buckland (1784–1856) lecturing, surrounded by the many fossils with which he enhanced his discussion. This sketch was possibly done by Henry De la Beche, although the lithograph of it that survives was made by George Rowe. Since De la Beche had given many fossils to Buckland for his use in his Oxford lectures, this illustration again served several purposes. It spoke to the expertise of the scholar in ammonites, ichthyosaurs, coprolites, and many other items, and it reminded people that most of these things came to Buckland via De la Beche. It also showed the viewer what Buckland's fossils looked like. This illustration is a far cry from De la Beche's infamously funny cartoon *A Coprolitic Vision*, but the two were probably drawn around the same time.[2]

Other nineteenth-century paleontologists were also shown with their fossils. There were several such representations of Richard Owen. Many paleontologists today will be familiar with the photograph of Owen standing beside a restored moa skeleton. This photograph was probably taken about 1877.[3] The installation of the models of dinosaurs and other prehistoric beasts at the Crystal Palace exhibition in 1850 gave rise to a similar display of men and prehistoric animals, although these animals were models rather than actual fossils.

Joseph Leidy gained much attention in the emerging field of paleontology for his work on the dinosaur *Hadrosaurus foulkii*. This was the first dinosaur found in the United States and, as Leonard Warren has noted in his biography of Leidy, it was the most complete dinosaur find to that date.[4] Leidy had himself photographed twice alongside a *Hadrosaurus* tibia in 1859, and other photos were taken of the tibia, tibia and femur, ulna, radius, first phalanx and metatarsal, humerus, first phalanx and metatarsal, and vertebrae. These seem to be the earliest photographs taken of dinosaur bones; one is dated March 27

(or 29?), 1859. Some of the prints showing Leidy were then turned into stereo-pair photographs. Earle E. Spamer has made a considerable study of these photographs of Leidy, and believes that they were made up into stereopairs by an amateur photographer. They are not inscribed with any professional photographer's name and their technical quality is rather crude. Spamer also thinks that they were taken with natural light only. The better of the two pictures of Leidy became so famous it is even reproduced today in posters.[5]

In 1868, Waterhouse Hawkins came to the United States with the intention of creating a set of displays in New York City similar to those he had created for the Crystal Palace Exposition. Around this time, he posed beneath his and Joseph Leidy's restored skeleton of *Hadrosaurus foulkii* as it was mounted in the Academy of Natural Sciences in Philadelphia. A print was made of this photograph.[6] Placing Hawkins with his restored fossil gave the viewer a good idea not just of what the fossil looked like but also of its size relative to an adult human. Spamer believes that the photograph may have been taken slightly later than 1868, but notes that photographs of the mount existed by February 22, 1869, when Hawkins wrote to Leidy concerning one. The print of Hawkins standing beneath the fossil is heavily retouched. Spamer has called it a "horrid image," because of the uneven illumination produced by what he believes, again, was the use of natural lighting. "The photograph is so heavily retouched that it is nearly a painting in itself. . . . Were it not for the great likelihood of Hawkins having posed with such an important piece of work . . . one could question whether the artist [meaning Hawkins, the mount-maker] was in fact really present."[7]

For all his interest in and use of imagery in his publications, O. C. Marsh seems never to have posed with a fossil in a photograph. He was photographed several times in his career with his students and laboratory assistants. All these pictures are staged and formal. The men are shown seated outdoors, presumably near the Yale Peabody Museum, or they are grouped together, dressed in their working attire, as in photographs of the members of the Yale Peabody Museum expeditions of the 1870s. There are also photographs of Marsh alone. But I cannot find any in which he is accompanied by one of his famous discoveries. And yet we find images of his dinosaurs, his large fossil mammals known as titanotheres, his remains of fossil horses, and his toothed birds, all standing alone as well. Marsh was certainly not averse to publicity. He tended to sign copies of everything that he published (one purveyor of rare books told me, "Oh, O. C. Marsh wrote his name on everything"); it is strange he did not pose with his fossils.

Some vignettes of Marsh's collectors at work in Morrison, Colorado, and at Como Bluff, Wyoming, appear in charming watercolor sketches by Arthur Lakes (1844–1917), which Lakes probably did about 1888–1889. Lakes, who had been a teacher and later taught natural history at Jarvis College in Golden, Colorado, worked for Marsh in the field and left visual records of himself, Benjamin Mudge (1817–1879), and two other diggers, William H. Reed and Edward Kennedy. He may have been prompted to make these sketches not only by his own field experiences with Marsh's crews but by the notes he made in his field journals for the years 1878–1880. The men are shown in the

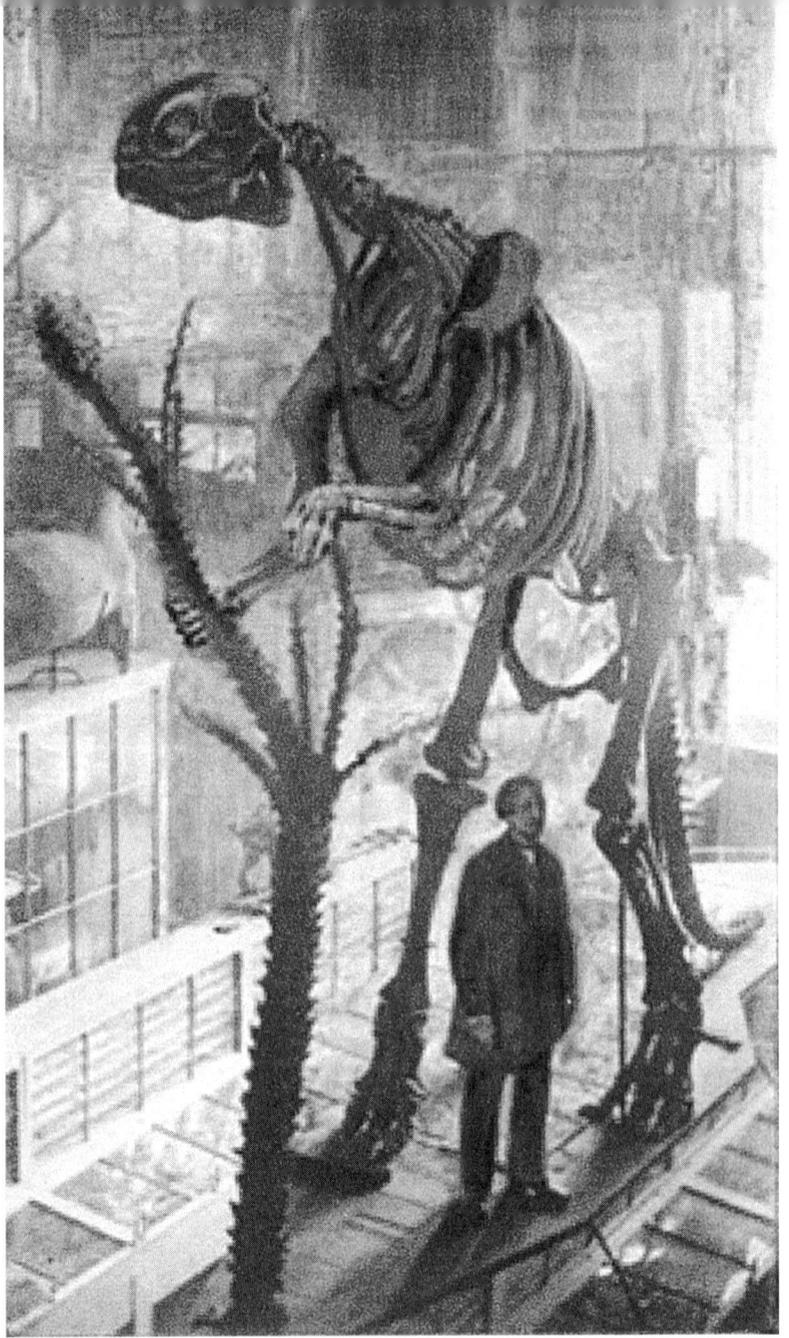

Figure 4.2. Waterhouse Hawkins posed with *Hadrosaurus foulkii*. *The Academy of Natural Sciences. Ewell Sale Stewart Library, Collection 803, #18.*

field and working at the quarries. Mudge, for example, is shown sitting under a makeshift sunscreen beside the quarry face, busily examining fossils. One vignette shows Marsh in the field, but he is shown at lunch with Reed and another of his crewmen, Edward G. Ashley. This picture is thought to represent Marsh's visit to an area at Como called Robber's Roost on June 5, 1879. But while we see Marsh in the field, we see no fossils and no work being done.[8]

I was recently asked whether there are any illustrations of any kind showing Edward Drinker Cope at work in the field. I know of none. This also seems a little odd, considering that Cope went into the field frequently, in places where he might easily have encountered a photographer working alongside the U.S. Geological Survey or the Union Pacific Railroad crews.

There are, however, at least two photographs of Cope posed with a fossil. One shows him as a young man of about thirty-three (according to Henry F. Osborn), standing beside a skull of his famous *Loxolophodon cornutus* and perhaps holding on to one of the skull's metal supports. Cope almost appears to be delivering a lecture on the fossil, as he is dressed in a suit. In another photograph, taken toward the end of Cope's life, we find him seated at his study desk in his laboratory on Pine Street in Philadelphia. He is shown with several fossils, as though he were busy at work. He is dressed rather formally, but he does not even look into the camera; the photograph is taken from the side, and he seems lost in thought. Henry Osborn, who published this picture, captioned it as follows:

> Cope at his study table about the year 1895. The pose and dress are very characteristic; also the crowded appearance of the room, although the objects on the center table itself were especially rearranged for the photograph. The room contains a tall slender femur of *Amphicoelias altus* beside the door; a skull of the Stegocephalian, *Eryops,* leaning against the morocco-bound volumes of Cope's collected writings. Near his right hand is a vertebra of *Camarasaurus* and below this the drawer from which he drew forth his Marshiana notes for his critique of Marsh's work, which appeared in the *New York Herald* on January 12 and 19, 1895. The table and Cope's collected writings are now in the American Museum as a gift from his family. Chairs were placed around this table and Cope's coffin rested upon it during the silent ceremonial tribute by his scientific friends.[9]

Osborn himself was also photographed with fossils. One was taken in 1923 in the preparation laboratory of the American Museum. It shows Osborn and William Diller Matthew as they watch two technicians, Otto Falkenbach and Carl Sorensen, working on the skull of an Oligocene rhinoceros from Mongolia, then known as *Baluchitherium* (known today as *Indricotherium* or *Peraceratherium*). Falkenbach and Sorenson hold parts of the fossil skull in place so the other two scientists can see how they are arranged. Matthew also appears in a photograph taken in 1899 at the Bone Cabin site's Nine Mile Quarry, accompanied by the paleontologists Richard Swan Lull and Peter Kaisen. Walter Granger and Osborn were also present on this dig, and while we do not know who took this photograph, it was most likely crew member Al Thompson, or perhaps Granger. The fossil they are excavating is already partially encased in plaster and thus difficult to identify.[10]

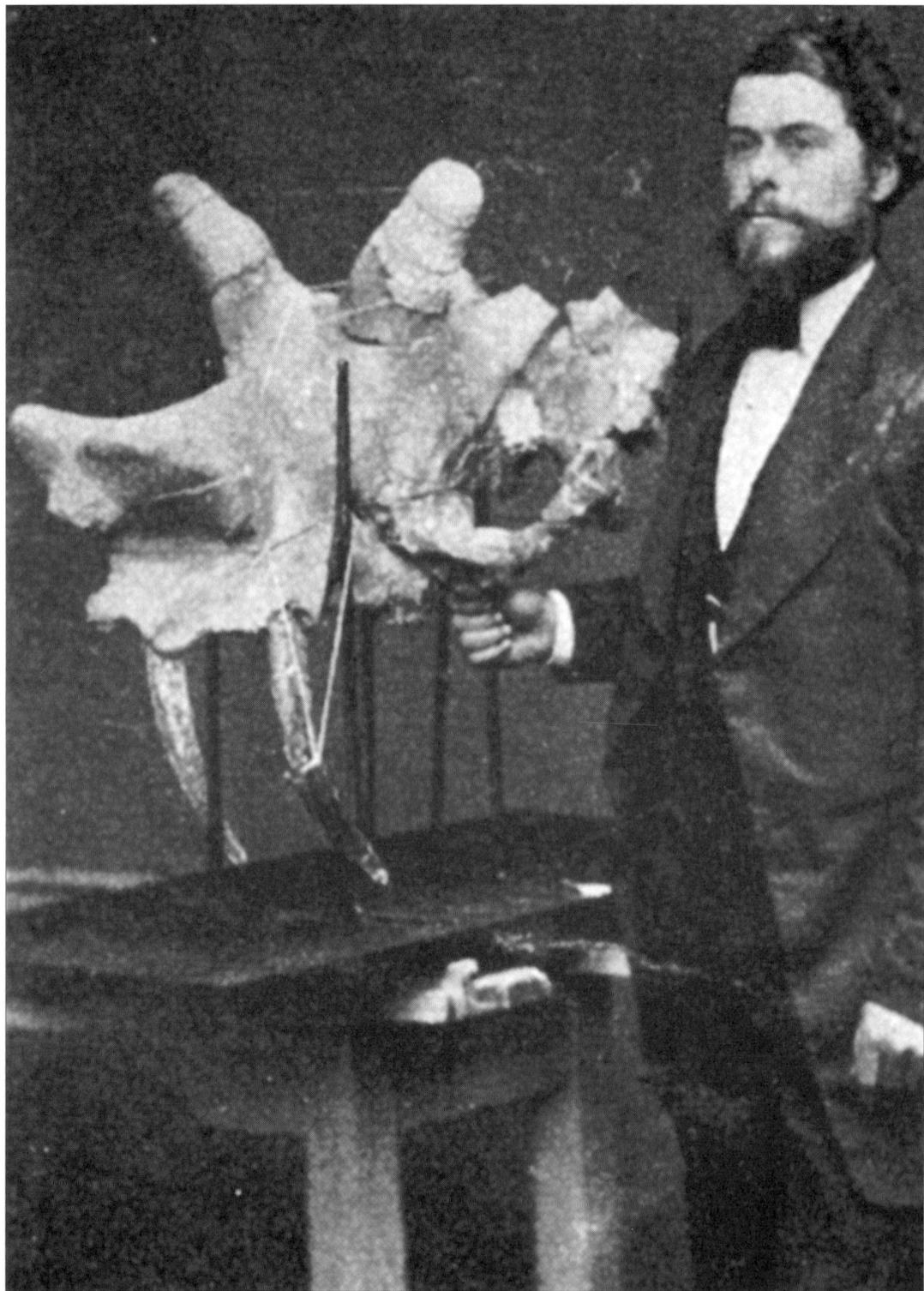

Figure 4.3. Henry Osborn,
Cope: Master Naturalist, 1931.
Photograph of E. D. Cope as
a young scientist.

Fig. 2. COPE AT HIS STUDY TABLE ABOUT THE YEAR 1895. The pose and dress are very characteristic; also the crowded appearance of the room, although the objects on the center table itself were especially re-arranged for the photograph. The room contains a tall, slender femur of *Amphicoelius altus*, beside the door; a skull of the Stegocephalian, *Eryops*, leaning against the morocco-bound volumes of Cope's collected writings. Near his right hand is a vertebra of *Camarasaurus* and below this the drawer from which he drew forth his Marshiana notes for his critique of Marsh's work, which appeared in the *New York Herald* on January 12 and 19, 1895. The table and Cope's collected writings are now in the American Museum, as a gift from his family. Chairs were placed around this table and Cope's coffin rested upon it during the silent ceremonial tribute by his scientific friends, described on pages 587, 588.

Illustrations showing a scientist with a fossil were often used to give the viewer an idea of the fossil's scale. This may have been the purpose of a photograph that was printed in Richard Swann Lull's 1931 *Fossils: What They Tell Us of Plants and Animals of the Past.* At the beginning of this small book, designed for the general reader, there is a photograph of the Yale Peabody Museum's mounted skeleton of the animal at that time called *Brontosaurus.* It stands in the museum hall alongside specimen cases which give some sense of the fossil's scale. More useful, however, are two people who stand nearby. One is Richard Swann Lull himself. He is dressed in a business suit and is standing underneath the abdominal area of the animal. Another man stands to one side, behind the specimen. While Lull's caption for this photograph informs the reader of the fossil's dimensions, his presence in the belly of the beast, so to speak, does more than a mere list of numerical dimensions could ever do. And it gives readers an opportunity to meet the author and to see what an important specimen this is. For a few seconds readers are so completely taken in by this scene of a man as if swallowed by a dinosaur that they do not notice the obviously restored parts of

Figure 4.4. Henry Osborn, *Cope: Master Naturalist,* 1931. Photograph of E. D. Cope in his study in 1895.

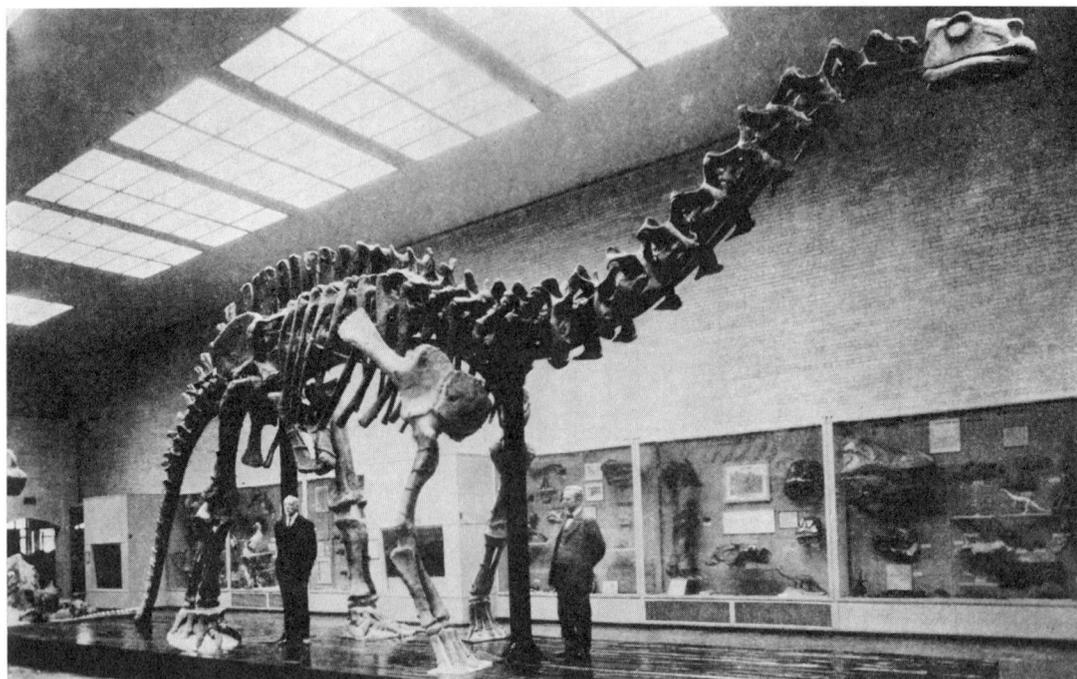

SKELETON OF BRONTOSAURUS AT YALE PEABODY MUSEUM
Nearly 70 feet long, 16 feet high, and weighs 6½ tons; it was found at Como Bluff, Wyoming, and is probably 120,000,000 years old
The author is standing under the great reptile on the left

Figure 4.5. Richard S. Lull, *Fossils: What They Tell Us of Plants and Animals of the Past,* 1931. Photograph of Richard Lull standing under *Apatosaurus.*

the skeleton, which are clearly apparent in the photograph. In a few moments, perhaps, they notice that part of this dinosaur is what Osborn called *Plasterosaurus.* But they also begin to notice how it is mounted, what sort of supports it rests on, its general stance, and so on. The photograph did its job. It identified the scale of the animal, it honored the author of the book and his fine museum, and then, eventually, it conveyed more information about the skeleton and how it was presented to the public. In this photograph there are no ropes or restraints to prevent anyone from walking underneath the fossil. One has to wonder if that was the case in 1931, or if the ropes were taken away for the photograph.[11]

Was a fossil's discovery sometimes staged in this genre of paleontologist posed with fossil? Undoubtedly that happened. Peale's *Exhumation of the Mastodon* shows him supervising the dig, which he did. Whether he supervised precisely as we see him in the painting is another question. One of the earliest staged representations appeared as the frontispiece of Barthélemy Faujas-de-Saint-Fond's *Histoire naturelle de la Montagne de Saint-Pierre de Maestricht,* published in Paris in 1799. This engraving depicts the discovery of the first European specimen of a mosasaur, but the scene is clearly concocted and most likely shows neither the actual discoverer of the famous Maastricht fossil nor the means in which it was excavated. In all probability, the image was not intended to represent a real, historical scene to the reader. Rudwick has called it an "imaginative reconstruction." The fossil skull is shown in the scene already prepared, as it would have been after weeks or months of treatment in the laboratory, but the implication is

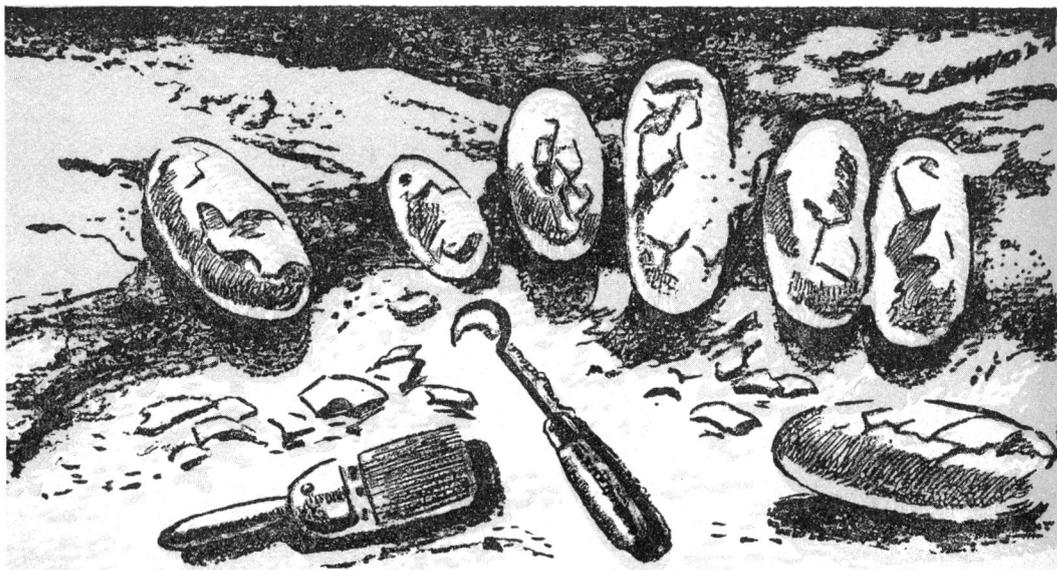

Dinosaur Egg Hunting

that the skull was dug up in such a state.[12] It would be fortuitous and amazing indeed if all fossils were recovered already prepared for exhibition.

A similar vignette is found in the frontispiece of Johannes Scheuchzer's (1672–1733) *Museum diluvianum*, 1716, which shows a very well dressed gentleman in a tricorne hat and a wig pointing out a group of well-prepared fossils that have evidently just been dug out of a mountainside nearby. The workman who must have retrieved these treasures is still hacking away at the strata with his pick. The pile of fossils includes ammonites, fossil fish, mollusca, and others, but these images are not terribly useful for the scientific identification of the specimens. Above it all, high in the mountains, stands the ark of Noah. Scheuchzer, of course, was a firm believer in the biblical Flood and believed that fossils were the remains of that event.

Some scenes of a paleontologist discovering a famous fossil were certainly staged but were meant to be realistic. Such was the case with the famous find of dinosaur eggs made by Roy Chapman Andrews's Central Asiatic Expedition in 1923. The photographs and motion pictures taken on this expedition show Andrews and his crews working in the field, excavating various fossils. While the images are not unbelievable, the nature of the setting

Figure 4.6. Roy C. Andrews, *All about Dinosaurs,* 1956. Drawing of a dinosaur nest by T. W Voter. © *1956 Random House.*

in which they were working and the difficult physical conditions make it likely that the excavations were staged for the camera. A famous photograph by J. B. Shackelford shows twelve intact *Protoceratops* eggs (now understood as *Oviraptor* eggs) surrounding many fragments, together with paleontologist's tools, including a paint brush (used to remove dirt and sand). The arrangement is certainly deliberate, and does not reflect how the eggs were originally found. The photograph was not entirely misrepresentative; fossil eggs were deposited in clutches and in roughly circular groupings. But the presence of a round dozen is not plausible. This is not to say that Shackleford took only concocted photographs of the dinosaur eggs. There are also photographs of the eggs as found in situ.[13]

Did Andrews always bother to tell his audiences that this image was set up for the camera? Perhaps he did. In his 1956 children's book, *All about Dinosaurs,* an illustration by T. W. Voter shows a sketch of seven eggs, some fragments, and the same tools that Shackleford had placed in his photograph in 1923. But Andrews told his young readers that crew member George Olsen had first found three eggs; then, later, the expedition found a cluster of five, and finally a cluster of nine eggs.[14] He also noted that a block of matrix that he examined after returning to the American Museum contained a set of thirteen eggs. "In the center of the stone lay thirteen beautiful eggs in a circle of two layers." No mention was made of a dozen.[15]

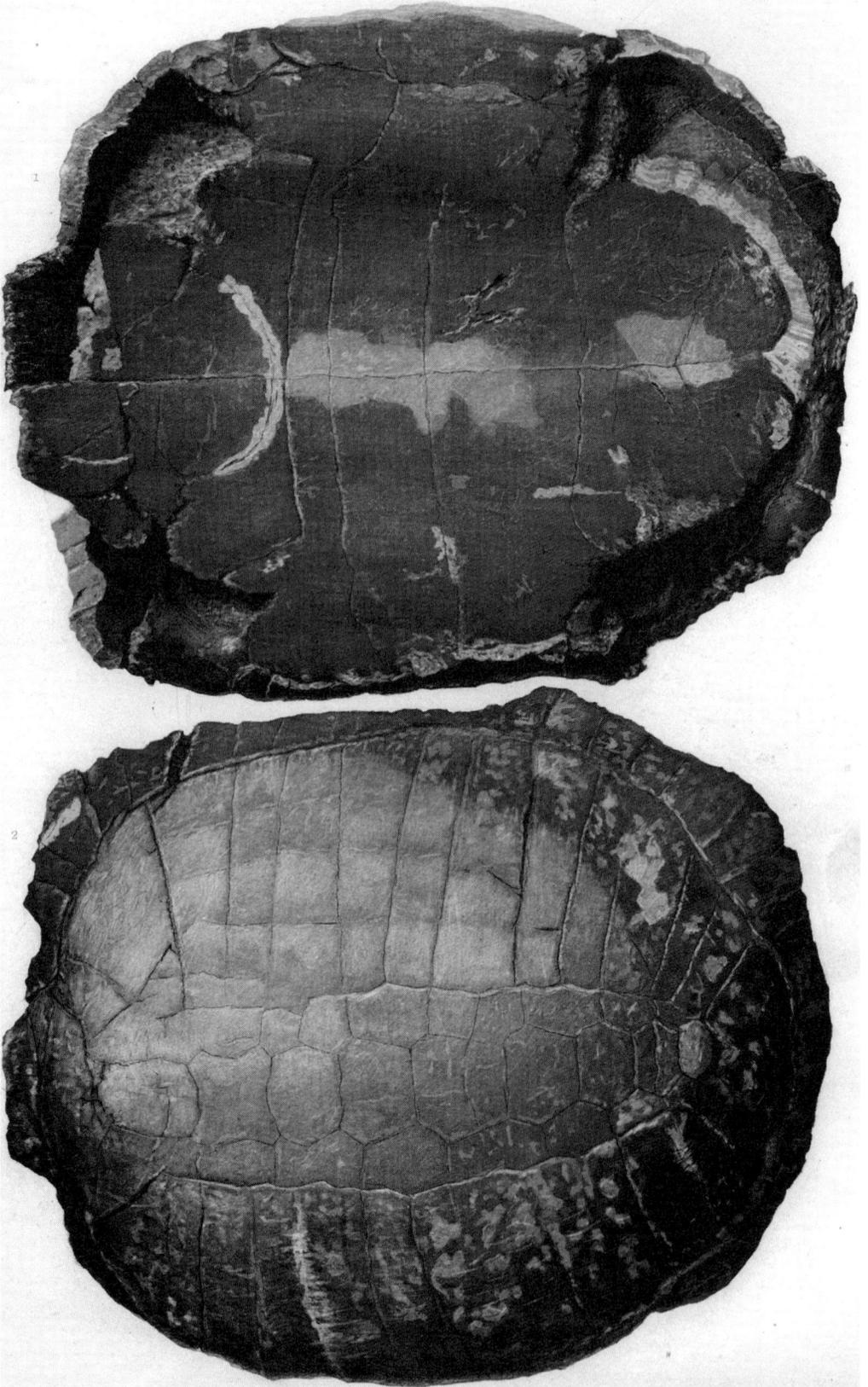

EARLY PHOTOGRAPHY IN PALEONTOLOGY, 1840–1931

5

Paleontology illustrations of fossils seem to fall into two categories of accuracy and quality. Those in the first category were made by illustrators and scientists (often the two were the same person) who worked assiduously to create images of the highest quality they could. Science obviously required high-quality and accurate illustrations. If the observer could not see the fossil in person, as Waterhouse Hawkins noted in the middle of the nineteenth century, then the next best thing was a good—and it had to be good—artistic representation of it. To this end paleontologists and illustrators used new visual media as they were developed in an continual effort to upgrade the quality of their illustrations. Illustrations in the second category, however, were made by artists, printers, and even, at times, paleontologists who were not terribly concerned with visual accuracy, or with newer and better visual media. These two categories are apparent at the beginning of scientific paleontological illustration, and they remain so in the twenty-first century. A scientific journal with ostensibly impeccable credentials may carry miserably bad illustrations that do the reader almost no good, even though they were produced using the most modern of photographic techniques.

There has always been variation in the quality and accuracy of images. This is part of how art and illustration are done. Such variation was by no means confined to scientific illustration. But, while many scientists were concerned with pictorial quality and accuracy, these were, as has been noted, not an absolute necessity in every case. No single explanation of this can suffice. Poor quality was sometimes due to the publisher's or printer's desire to cut expenses, but at times the scientists seem to have gone along with such cheeseparing. Even digital images in modern online journals, which we might expect to be technically superior, turn out to be less than satisfactory; the images in the printed editions are better.

High-quality illustrations are to be found in many earlier published sources, just as they continue to be included in publications now. Some appear where one might expect to see them, for instance in a well-funded, government-sponsored publication. But one also finds high-quality illustrations in books written for the public, in museum guidebooks, and even in children's books. Perhaps the most interesting observation that can be made is that many high-quality illustrations appeared in paleontology publications. Many of them were photographs, which were becoming more common as the century progressed. The following are a few examples of photographs that appeared in paleontology publications in the nineteenth and early twentieth centuries. These photographs were often made with new technologies, more sophisticated than older ones.

Figure 5.1. David D. Owen, *Illustrations to the Geological Report of Wisconsin, Iowa and Minnesota*, 1852.

Photographs of fossil invertebrates were made at least as early as 1839, when Daguerre took a picture of an arrangement of fossil shells,[1] many of which were ammonites. In 1839, Levett L. Ibbetson devised a method of making etchings from daguerreotypes and produced etchings of various fossils from the Isle of Wight, including one of a starfish. In 1840 he is said to have made a daguerreotype, through a microscope, of a section of coral. The etchings were published in 1849, although Christopher Duffin suggests that the original photographs may have been circulated prior to that date. S. M. Andrews believes that a calotype made of a dermal scute of *Stagonolepis robertsoni* in 1844 is most likely the earliest photograph of a vertebrate fossil. The fossil had been discovered in August of that year, and the photograph is now in the archives of the Geological Society, London.[2]

Perhaps the first photographs of dinosaur bones were taken by an anonymous person at the Academy of Natural Sciences in March 1859. These photographs (discussed in chapter 4) show various bones of *Hadrosaurus foulkii;* in two, Joseph Leidy is posed with its tibia. They were apparently never disseminated or published. The copies in the archives of the Academy of Natural Sciences are the only ones known. The photographs were probably taken just as an experiment in the use of the camera. One cannot help wondering whether Leidy and the unknown photographer realized that they were taking the first photographs of dinosaur bones.

Nineteenth-century paleontology treatises that were published with the financial and logistical support of the U.S. Geological Survey frequently were enhanced with excellent illustrations made using the newly emerging artistic technologies. The USGS wanted to show the scientific community what the fossils were like. As museums began to issue guidebooks for their patrons' use, they imitated government-sponsored publications by attempting to use good and innovative illustrations. This was true both of institutions in the United States, such as the American Museum and the U.S. National Museum, and of those in Europe. European museums were influenced by publications put out by various geological societies, counterparts to the U.S. Geological Survey. Several state surveys and the Smithsonian Institution also included high-quality illustrations in their scientific reports during this century. Some of these illustrations were photographs, or prints based on photographs. What follows is a sampling of various paleontology publications in which photographs were used. This small sample will serve to illustrate how important this new medium became in scientific illustration.

David Dale Owen

Illustrations to the Geological Report of Wisconsin, Iowa and Minnesota (1852)

Together with colleagues, David Dale Owen (1807–1860) published a large report on the geology of Wisconsin, Iowa, and Minnesota in 1852. The illustrations were published in a separate volume the same year, and they represent a variety of experiments in technique. Owen, who was also an artist, was responsible for some of the illustrations. Although the book does not include photographs as such, it does present five engravings made from daguerreotypes of fossils.[3] The prints are of a fine quality. They are clear and have excellent details. They were made by two firms, J. M. Butler

and W. H. Dougal, and the names of some of the engravers are known: A. B. Walter engraved plate 10 (showing a skull of *Oredon,* among other fossils) and J. McGoffin engraved plate 12 (showing turtle carapaces).

R. Whitechurch and B. F. Newman, who worked for Butler, also made medal-ruled engravings for this volume. Medal ruling was a means of tracing a drawing onto the plate using a connected stylus: one point traced the drawing, and a second echoed its movements on another surface. The technique could be employed to create an intaglio print, from an engraving incised directly into a metal plate, or a lithograph, which is a print made from an image drawn on stone rather than incised on metal. Medal-rule engraving was invented in the early nineteenth century and soon perfected to a point where the printer could actually run one point of the stylus machine over an irregular surface, like a coin or a medal (hence the term) and achieve a more three-dimensional effect in the resulting print, as the second point incised the wax on the plate or the stone to a corresponding depth. Owen's tables 7 and 8 are medal-ruled prints that contain images of various fossil bivalves and also of ammonites. Owen stated in the captions of his figures that his prints were "executed by the medal-ruling process, from original specimens." Does this mean that the stylus was actually run over the fossils themselves? It seems unlikely. If this was done, it was an amazing experiment in printmaking.[4]

John Warren (1778–1856) was chief surgeon at the Massachusetts General Hospital (as well as an associate of Edward Hitchcock), and like his colleagues he was interested in photography as a scientific tool. (Stanley Burns, who has written extensively about medical photography in the early nineteenth century, contends that the number of photographs used as aids to medical research was actually quite large. Perhaps this early use of photographs in medical study was an influence on paleontologists.) In 1854, Warren published his *Remarks on Some Fossil Impressions,* and its frontispiece is probably the first actual photograph (as opposed to a lithograph or engraving of a photograph) to appear in an American scientific publication. It is a tipped-in print showing a slab with fossil footprints and apparent trackways. It may have been an ambrotype, but its appearance makes it more likely that it was an albumen print. (Ambrotypes were made in much the same way as daguerreotypes, but the photographic image was developed on paper or glass rather than on a metal plate. The process had been invented in 1852 and remained popular into the early 1860s. Albumen printing, in which egg white was mixed with a photosensitive silver solution and applied to paper, was only a few years older.[5])

In 1854, Warren was president of the Boston Society of Natural History, and at his death he willed his fossils to the Society.[6] (His own skeleton was willed to what was then known as the Warren Anatomical Museum at Harvard, and today is in the custody of the Harvard Medical Library.) Besides his study of fossil footprints along the Connecticut River, Warren authored a book on *Mastodon giganteus* (now called *Mammut americanum*) in 1852.[7] The title page shows the skeleton of a mastodon resting in a landscape. It is not particularly useful from a scientific standpoint, although it does indicate the

John Collins Warren

Remarks on Some Fossil Impressions in the Sandstone Rocks of Connecticut River (1854)

We are indebted to Photography for enabling us to represent the remarkable slab from Greenfield, and its numerous objects, in a small space, yet with perfect accuracy.

John Warren, 1854

Figure 5.2. John C. Warren, *Remarks on Some Fossil Impressions in the Sandstone Rocks of Connecticut River,* 1854.

appearance of the bones. Warren had bought the mastodon skeleton in 1846 for the rather large sum of $5000, had it assembled, and then displayed it publicly. Charles Lyell, who was in the United States at the time, saw it, and Warren gave Lyell a daguerreotype of the skeleton to take home with him. This may well have been the first photograph of an American mastodon.[8]

Warren's *Remarks on Some Fossil Impressions* is much less detailed than his book on the mastodon, and, at fifty-four pages, barely a quarter its length. The photograph Warren commissioned of his sandstone slab was taken by a Mr. Silsbee, who must have been part of the Boston photography firm of Silsbee and Case. Silsbee and Case are known to have in business in the 1850s and 1860s.[9] Warren referred to "Mr. Silsbee, our photographist," and explained proudly, "The surface represented in the plate may by the aid of a magnifier be studied without the presence of the stone itself; for the photographic art displays the most minute objects without alteration or omission."[10] The slab had ichnofossils on both sides, but only one side is photographically represented in the book. (Warren had Silsbee draw one of the footprints on the other side, and the book includes an engraving of that drawing.) The slab itself was one

inch thick, and Warren seems to suggest that its reverse showed some of the same impressions as the photographed side. That is, his specimen of matrix may have included both true tracks and transmitted prints. But he also commented on tracks and prints that were different on each side. Like everyone else at the time, he didn't understand what he was observing. (Like Hitchcock, he believed that these footprints had been made by big birds, not understanding them as dinosaur tracks.) But the text conveys his delight in the specimen. He clearly enjoyed studying the slab and presenting it in this small book.

The photograph is tipped in as a frontispiece. The example I have seen is slightly yellowed and so faint that the details of tracks and prints can be easily overlooked. Warren's proud description of it makes one wonder what has happened to the photo since 1854. The fading and discoloration seen today are most likely a result of the improper use of fixatives. Either Silsbee did not use the acidic fixative he should have, or he did not sufficiently rinse the fixative out of the paper. The presence of both discoloration and fading makes the latter error more likely; an improper fixative may result in either discoloration or fading, but the presence of both is usually due to improper rinsing. In effect, the fixative went on fixing. It is my understanding that prints in other copies of Warren's 1854 book show the same deterioration, so it seems likely that the entire run of prints was improperly rinsed during developing.[11]

Warren and his medical colleagues no doubt had an impact on Edward Hitchcock, who was also interested in using photography for scientific illustration. Hitchcock not only knew of developments in medicine in Boston, but he would have had access to a number of good photographers and lithographers as well.

Edward Hitchcock

Ichnology of New England (1858) and *Supplement to the Ichnology of New England* (1865)

They are fraught with strange meanings, these footprints of the Connecticut.

Edward Hitchcock, quoting Hugh Miller, 1858

Such was the Fauna of sandstone days in the Connecticut Valley. What a wonderful menagerie! Who would believe that such a register lay buried in the strata? . . . Many a new page I fancy will yet be opened, and many a new key obtained to the hieroglyphic record.

Edward Hitchcock, 1858

Clergyman, professor, president of Amherst College, and geologist, Edward Hitchcock (1793–1864) became famous for his extensive studies of fossil footprints and trackways. These he began to publish in 1836, when he described trackways found two years earlier in an article in the *American Journal of Science*. Hitchcock initially believed that these tracks were those of birds. As he came upon more specimens and consulted with other scientists in the United States and Europe, he began to suggest that some of them had been made by quadrupeds. What he didn't realize was that his original finds of "bird tracks" had been made by bipedal dinosaurs. Nonetheless, Hitchcock's publications of fossil prints and tracks were extremely important contributions to the development of paleontology in the nineteenth century. His 1836 paper was considered so important that William Buckland had its images copied into his Bridgewater Treatises, published in the same year.

When Hitchcock published his *Ichnology of New England* in 1858, he viewed it as a summary of his work of the previous thirty years; its bibliography runs to sixty-two items, many of them written by Hitchcock himself. This book is remarkable for its illustrations. Some are chromolithographs, including the first plate, which shows the quarry from which the fossil trackways were taken, but many are high-quality photolithographs made from ambrotypes of various specimens. (Hitchcock referred to his illustrations as

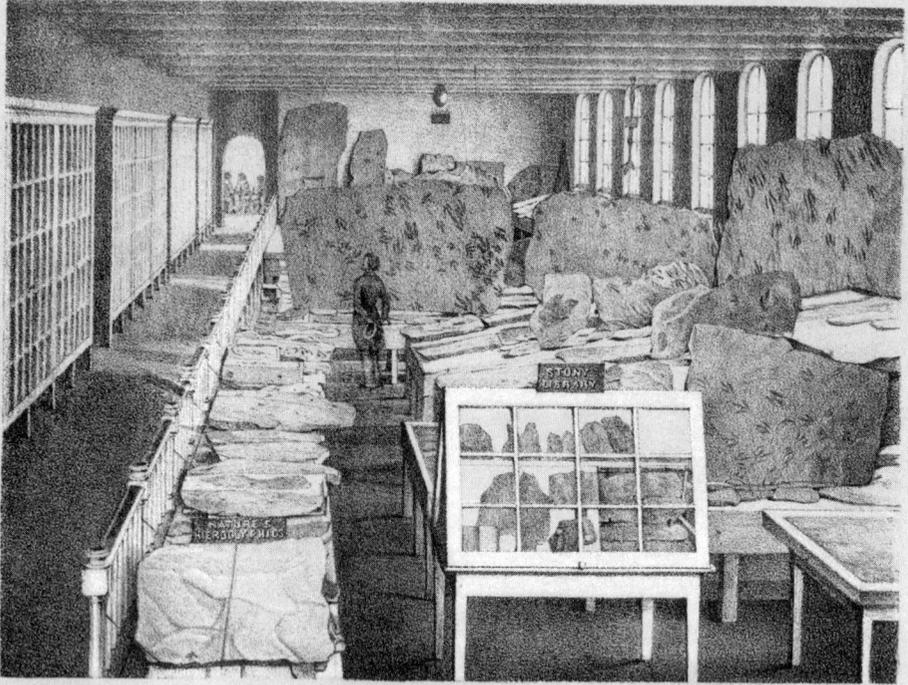

THE ICHNOLOGICAL CABINET

Fig. 2.

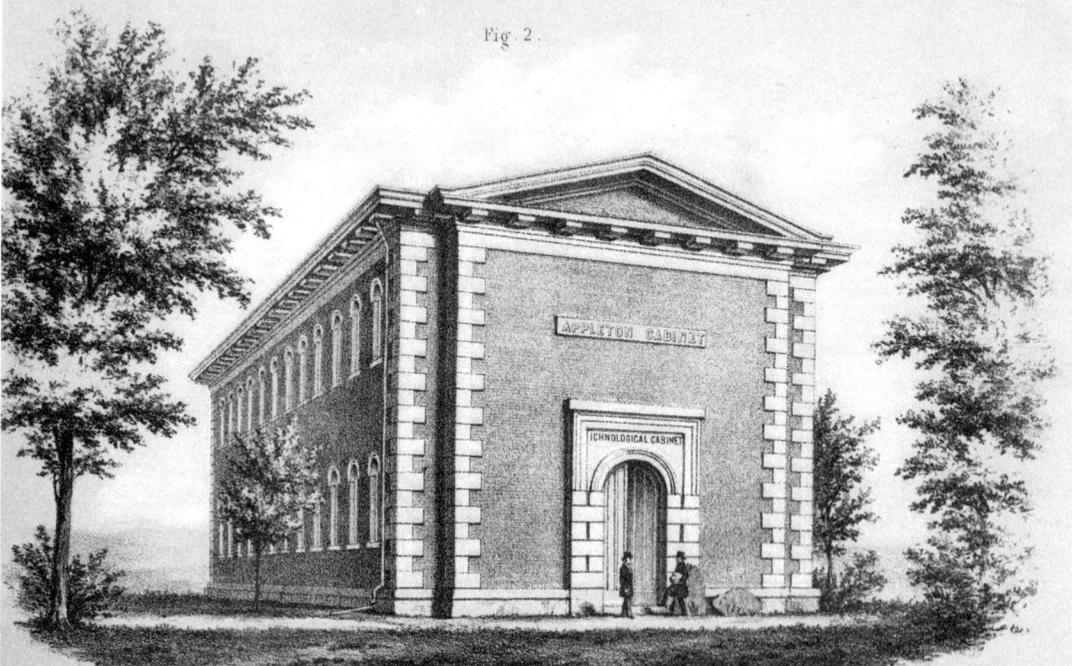

Figure 5.3. Edward Hitchcock, *Ichnology of New England*, 1858.

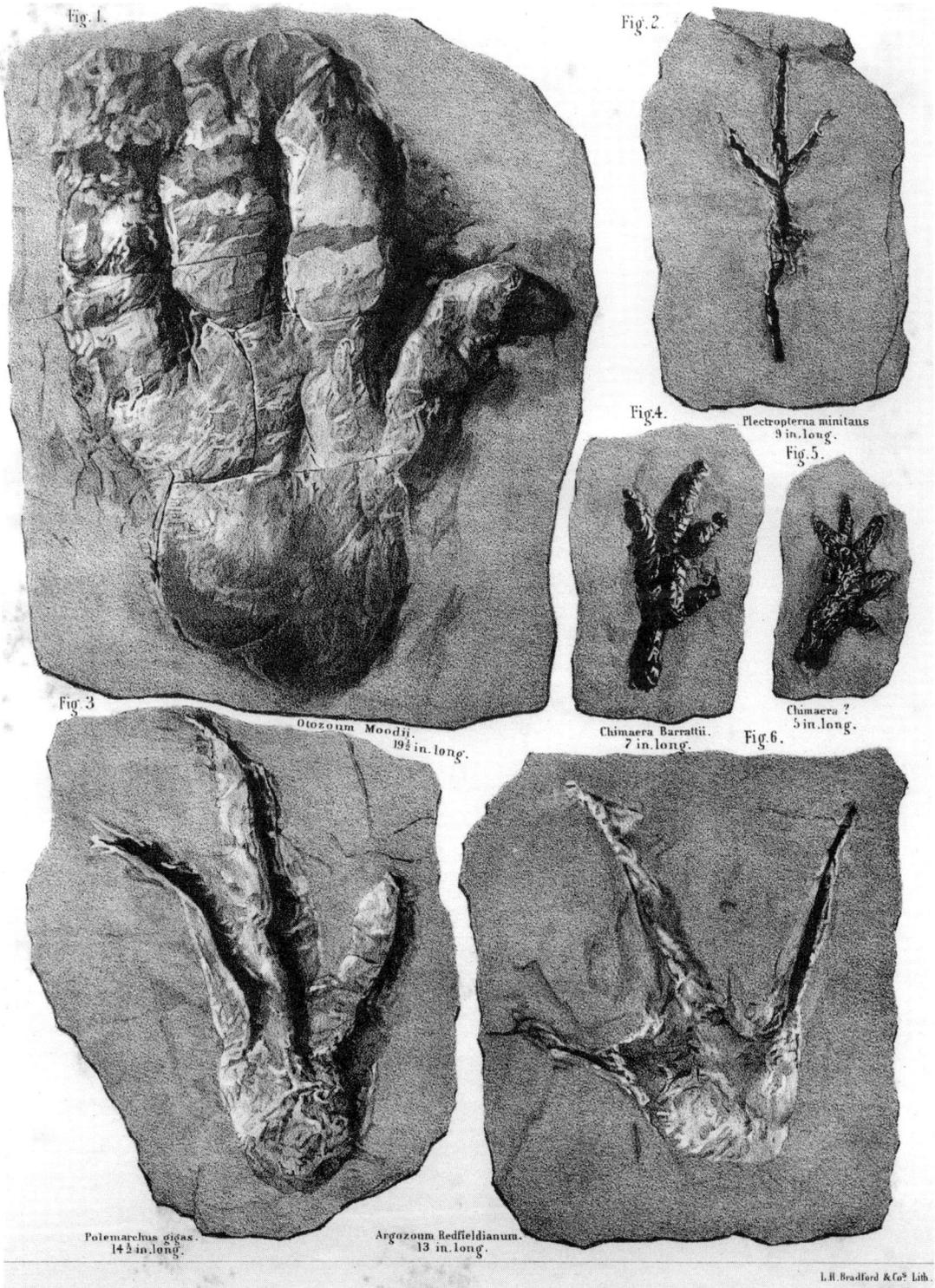

Figure 5.4. Edward Hitchcock, *Ichnology of New England,* 1858. Photolith from ambrotype.

"ambrotype sketches.") Chromolithographs are merely colored lithographs, either hand-colored or made by re-inking the lithographic stone several times in different colors. A photolithograph or photolith, as its name implies, is a lithograph made from a photograph. (It is also sometimes called an electroplate.) Hitchcock's plates 38–60 contained photoliths; in all, 137 photographic images were rendered into lithographs for this book. For 1858, this was an astonishing number of photographs and an equally astonishing number of photoliths. The images show various slabs with tracks and prints, as well as a number of specimens that were revealed when the matrix was broken open. The two halves of the rock are shown hinged together in the photographs; the hinge allowed the rock to be opened up to show the tracks, or closed to show how it had looked when first found. Plate 57 is a particularly good image of several tracks produced as a lithograph drawn from the original photograph. The lithographs were produced by L. H. Bradford and Co., but the name of the photographer was not recorded.

The *Supplement*, published posthumously in 1865, contained actual photographs tipped in to the volume. These are plates 13–19. (See color plate 5.) Hitchcock's son Charles H. Hitchcock, who completed and edited the book, notes in the preface, "The photographs were executed by J. L. Lovell of Amherst, who has attained a high degree of efficiency in this department of photography."[12] Each also bears Lovell's name. Charles Hitchcock does not specify whether these photographs are ambrotypes or daguerreotypes. They are detailed and have good resolution, although they have a slight sepia tint which may not have been visible in the 1860s. But the sepia color is reminiscent of the red sandstone matrices of the fossils. These photographs are certainly among the first to be used in a paleontology publication. This volume also contained lithographs of specimens, made by A. Meisel. The cost of producing these books, especially the second one, must have been quite high. One wonders whether it was covered by the state of Massachusetts, or if Amherst College provided funds as well. Perhaps the endowments for the Appleton Cabinet, as Hitchcock's museum of fossil trackways was originally called, were used to cover costs. The 1865 volume includes Charles H. Hitchcock's appendix B, "Descriptive Catalogue of the Specimens in the Hitchcock Ichnological Cabinet." There were a total of 21,773 specimens in this collection by 1865.

Plate 4 of the *Ichnology of New England* contains a lithograph of the interior of the Appleton Cabinet, showing it as a very congested space filled with specimens of slabs. Visitors would have entered at one side, walked past large display cabinets that reached nearly to the ceiling, and then moved into the main display area, which was separated from the walkway by a railing. Such an arrangement of specimens was commonplace in mid-nineteenth-century museums. Visitors could observe a large amount of material in each case and could inspect the floor displays more closely, perhaps even touch the fossils.[13]

Looking at this image, I wondered whether the photographs in the 1865 volume had been taken in this room or out of doors. Setting up photography equipment would have been difficult in the crowded gallery shown; even visitors must have had difficulty threading their way among the cases. Professor Peter Goin tells me that artificial light sources could

FIG. 2. FIG. 1.

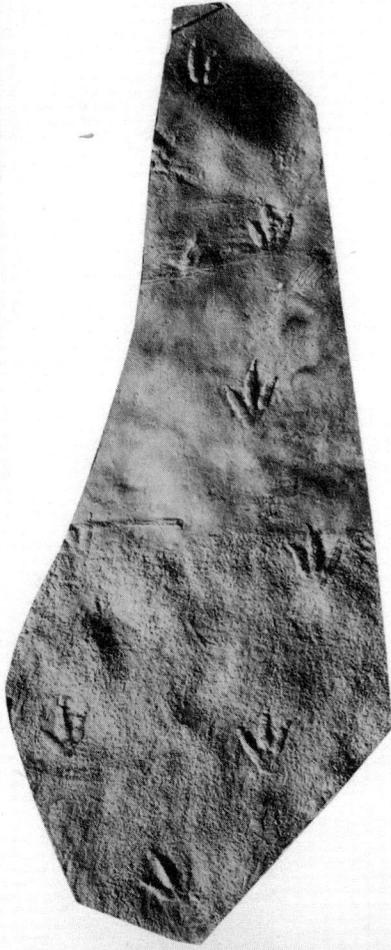

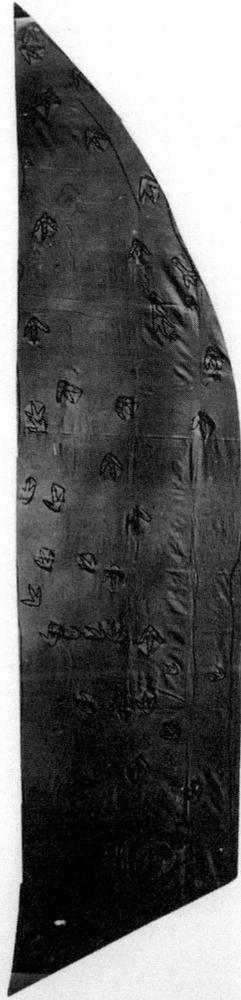

Anomœpus curvatus. Anomœpus intermedius.

Figure 5.5. Edward Hitchcock, *Supplement to the Ichnology of New England,* 1865. Plate 15.

have been used, in the form of hurricane lamps or candles and mirrors. (Magnesium was known, but it was not used until the end of the century, because of its volatility; at this time there was no sure way to prevent an explosion.) But it was certainly common in mid-nineteenth-century museum documentation to use natural light, perhaps with a long exposure time: the cameras of the 1850s made it easy to leave the iris open. The lithograph shows windows in the Appleton Cabinet, but natural daylight might not have been sufficient. The photographs in the 1865 *Supplement* show sharp, dark shadows on the fossil specimens. Goin thinks that these could have been produced by either natural or artificial lighting; artificial light may have been employed, or the slabs taken outside, or they might have been somewhere else when the photographs were taken. Just where and how these photographs were taken remains a mystery when all we have to

work with is the photographs themselves. But regardless of the lighting source, these are beautiful and carefully detailed photographs.

The plates in the 1865 *Supplement* include fifteen individual photographs that have been tipped in. These seem to have been trimmed to approximate the shape of the photographed slab. That is, they have no margins. Several of these photographs are large. Plate 13, which depicts *Climacodichnus corrugatus,* contains a photograph that measures approximately 8 × 5 inches. Plate 19 contains a photograph of *Anomoepus major* that measures approximately 9.75 × 5 inches. It is cut into a trapezoidal form. Plate 14 is 7.75 × 9 inches and shows a large slab containing a number of trackways labeled *Aenigmichnus multiformis,* "a group of various enigmatic tracks." This slab is shown with its wooden framework in place. The chromolithograph of the interior of the Appleton Cabinet in plate 4 of the *Ichnology of New England* shows similar wooden frames on slabs. The slabs were placed throughout the room: some were in cases, others in frames such as shown in the photograph, and still others on tables or stands. One of the photographs in plate 15 shows a slab containing tracks, some of which have been outlined in ink painted directly onto the rock.

O. C. Marsh and Photography in Paleontology Illustration

O. C. Marsh (1831–1899) placed two photolithographs of fossils ("Vertebrae of the *Eosaurus acadianus*" and "Vertebrae of *Eosaurus,* with magnified sections") in a paper published (probably at his own expense, because of the cost of the plates) in the *American Journal of Science and Arts* in 1862. Each occupied a full page. Since photolithography had been in use since only about 1855, these illustrations are quite early examples both of the use of the camera and of this printmaking technique in paleontology illustration. Charles Schuchert states that they are "very fine engravings on copper made by A. H. Ritchie."[14] I think that these two plates are not true engravings, but rather photolithographs. Photoengravings were generally not used in printed journals until close to the end of the nineteenth century, when photogravure machinery made it feasible and inexpensive to publish them. These illustrations are not tipped in. They are a part of the printed journal. Photolithography was not common in 1862, but it was in use.

Photolithography was used experimentally as early as 1841–1842. Several processes for making photoliths of daguerreotypes were also available by 1862.[15] It is most likely that Ritchie used a drawing made from the photograph to create these images. Schuchert thought they were engravings because the signatures on the plates read "Engd. By A. H. Ritchie." However, and very importantly for this discussion, the plates also read "Photo by M. W. Filley." These illustrations were rendered from photographs. Schuchert took "Engd." literally, to mean "engraved," but I think that the abbreviation was a means to say "lithographed." It is not at all unusual for engravers—or lithographers, for that matter—to use the word "sculpted" to mean that they made the plate. That word does not mean they sculpted anything; it refers to the intaglio process. Such discrepancies in the terminology used to identify works made by various printmaking technologies are commonplace.

Figure 5.6. O. C. Marsh, "Description of the Remains of a New Enaliosaurian," 1862. Photolith illustration.

Given the early date (1862), the photos from which these photolithographs would have been made were probably daguerreotypes, though they might have been ambrotypes. They have very good visual resolution, and ambrotypes did not generally produce as fine detail as daguerreotypes.[16] The photographer, Myron W. Filley, is known to have worked with both processes. He was a New Haven photographer, while Ritchie worked out of New York City.[17] It is

likely that Marsh paid for these daguerreotypes and the lithograph plates himself. He was just beginning his career, and may have been trying to impress not only his colleagues at Yale, but colleagues abroad as well. This paper was one of Marsh's first scientific publications. Of course, in time the *American Journal of Science* would become his mouthpiece, but at this point Marsh was still finding his way into the scientific world. A. J. Ritchie, the printmaker, would go on working for Marsh for many years to come. And this use of photographs demonstrates Marsh's early interest in using this technology for paleontology illustrations, which he retained throughout his career.

The presence of these two pages of photoliths is all the more remarkable when one looks through contemporary volumes of the *American Journal of Science*. In the 1850s and 1860s the journal did not contain many illustrations at all, and those it did were normally engravings. More illustrations began to appear in the journal in the 1870s, and by the 1880s there were even larger numbers. But they continued to be the traditional engravings or lithographs. Marsh's use of photography in the *American Journal of Science* was quite unusual.

Other early photographs of fossils are contained in Marsh's "The Dinosaurs of North America," which was a part of the 1894–1895 annual report of the USGS.[18] Most of the illustrations in this document are photolithographs made after line drawings of various fossils or of reconstructed dinosaur skeletons. These illustrations are quite detailed for photolithographs. They are not of the exquisite quality of earlier traditional lithographs, such as those in Leidy's *Ancient Fauna of Nebraska*, 1853, but they are excellent for photolithographs.

Marsh's lithographs depict bones, endocranial casts, and so on. In no case did Marsh try to "flesh out" the dinosaurs in life restorations. The reconstructions are of skeletons only. But the treatise does include two photographs of specimens that Marsh or his collectors found. Marsh's choice of them is interesting. They are photographs of fossils from the Yale Museum, and are of high technical quality. His figure 2 (page 146) is captioned "Slab of Connecticut River Sandstone, Showing Footprints of Two Dinosaurs on a Surface Marked by Raindrop Impressions." This specimen was one of the first items Marsh added to the collections at Yale after he took up a professorship there. According to Marsh's biographers, he never published an account of it, only mentioning it briefly in his 1896 *Dinosaurs of North America* as the sort of fossil that people had once thought was a record of bird tracks.[19] The photograph was incorporated into the text page and measures approximately 4.5 × 3.25 inches. The prints are clearly discernible, as are the raindrop impressions. Marsh's other photograph is plate 59 (facing page 326), showing the "skull and lower jaw of *Triceratops prorsus* Marsh; seen from the left side, one-ninth natural size, Cretaceous, Wyoming." Of course both of these specimens were photographed after they had been prepared for display in the Yale Museum. The photograph of the *Triceratops* skull is particularly interesting because it shows how Marsh's assistants placed the skull and dentary on a stand, as well as the fossil's state of preservation and reconstruction in 1894. Eventually the en-

Figure 5.7. O. C. Marsh, "The Dinosaurs of North America," 1896.

tire restored skeleton of *Triceratops prorsus* would be mounted in the U.S. National Museum.[20]

The photograph of the skull was published again in 1907 in John Bell Hatcher's *The Ceratopsia*. Hatcher modestly noted that he had been called upon to finish Marsh's monograph on the ceratopsians; it was actually completed after Hatcher's own death by Richard Lull. Nonetheless, most of the work was Hatcher's; the book was Hatcher's grand monograph, containing his pioneering work on ceratopsian dinosaurs. It is still considered one of the outstanding paleontology monographs of the first half of the twentieth century. The treatise is lavishly illustrated. Many of the illustrations, including the photograph of the skull, were taken from Marsh's 1896 work; some were taken from the works of others, such as Cope. Some of the lithographs that Marsh had planned to include appeared as fold-outs that are simply astonishing in their quality and detail. The lithographs were executed by Emile Crisand from drawings made by Frederick Berger. Berger was also responsible

Figure 5.8. O. C. Marsh, "The Dinosaurs of North America," 1896. Photograph of skull of *Triceratops prorsus*.

for pencil drawings within the text. These men worked in Marsh's labs, and Hatcher now took pains to give them credit for their work and, as he put it, their "skill and patience."[21] A large number of pen and ink drawings in the *Ceratopsia* were executed by Sydney Prentice. Others were done by Rudolph Weber, who worked in the American Museum. It is because of Hatcher's kindness and sense of justice—a term he actually used—that we know the names of those who produced the art for this book.

Crisand had been employed in the lithography firm of Crisand, Punderson, and L. Shierholz, which was working for Marsh by the late 1860s, and this firm was responsible for the lithographs that appeared in Marsh's 1880 *Odontornithes*. The plates for that book cost $8000. The firm came under Emile Crisand's control in 1881, and Charles Schuchert and LeVene commented that after 1881 the firm was paid about $60,000 for prints to be used in Marsh's publications.[22] In the 1880s and 1890s that was a staggering sum of money. Hatcher noted in the preface to *The Ceratopsia*, "Unfortunately only 19 of the lithographic plates planned by the original author . . . were completed . . . and, since the Survey discontinued lithography for illustrations of this character, the uniformity and artistic effect which is shown in the plates of Professor Marsh's other monographs are wanting in the present volume." Considering how much these plates were costing the government, it is not surprising that not all of those planned for *The Ceratopsia* materialized after Marsh's death.

Figure 5.9. John B. Hatcher, *The Ceratopsia*, 1907.

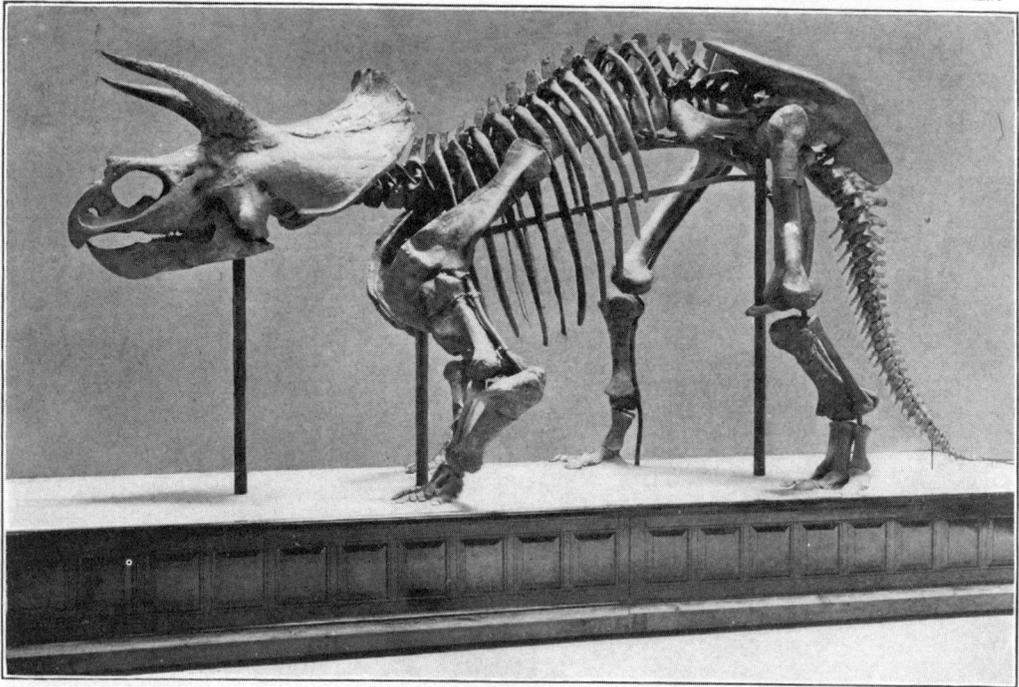

A

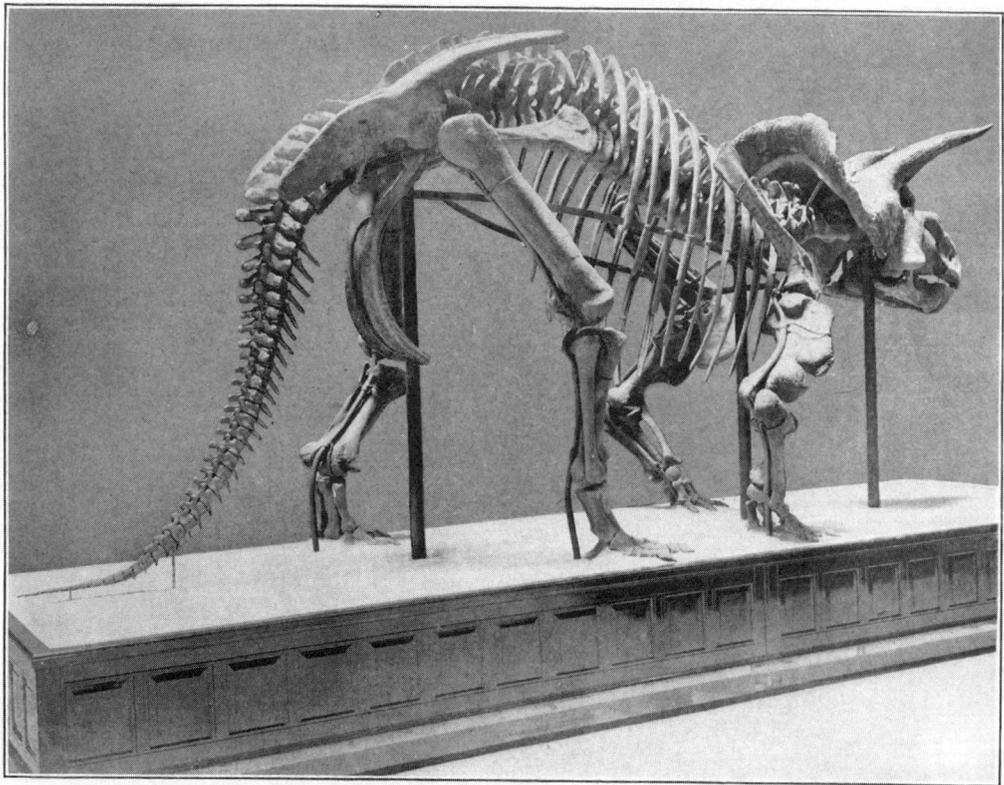

B

RESTORATION OF TRICERATOPS.

Views of mounted skeleton in United States National Museum. *A*, Side view; *B*, oblique rear view.

Hatcher's plate 49 includes two views of the U.S. National Museum's restoration of the skeleton of *Triceratops prorsus* Marsh.[23] One shows a side view, and the other shows a view from the opposite side and slightly to the rear. It is fairly obvious where the actual fossil material has been supplemented for the restoration. There does not seem to have been a problem with "Plasterosauri" here.

The Ceratopsia was a cutting-edge scientific publication for the quality and diversity of its illustrations. Hatcher even included a photograph of Charles R. Knight's painting of *Triceratops,* from the Carnegie Museum in Pittsburgh.[24] Every attempt was made to provide the reader with as much accurate visual information as possible. Readers can study the fossils in the elegant and beautiful fold-out illustrations, and illustrations within the text provide more information about individual bones of various species. Finally, they might see the original restoration of the skull and dentary made under Marsh's direction and Charles W. Gilmore's mounting of the entire skeleton, and then compare those to Knight's lifelike restoration. Herein we see close collaborations between scientists and artists, including the photographers, since Hatcher had been appointed curator of paleontology and osteology at the Carnegie Museum in 1900. A government publication such as this, or indeed Marsh's 1896 *Dinosaurs of North America,* must have inspired Henry Osborn in the art direction of his book for a more general readership, *The Origin and Evolution of Life* (1918). In fact, Osborn had written a foreword and a biographical introduction for *The Ceratopsia* in his role as chief of the USGS's Division of Vertebrate Paleontology, a position that Marsh had held until his death.

John S. Newberry

Fossil Fishes and Fossil Plants of the Triassic Rocks of New Jersey and the Connecticut Valley (1888)

By the 1880s, some of the USGS publications included examples of photography and photolithography. Some of these illustrations were of lesser quality and detail, such as those in John S. Newberry's (1822–1892) *Fossil Fishes and Fossil Plants of the Triassic Rocks of New Jersey and the Connecticut Valley,* but it is noteworthy that the USGS and the Government Printing Office tried to stay abreast of newer technologies in order to provide the best scientific illustrations in its reports. Newberry's report on Triassic fishes contained twenty-six full-page plates. In a number of cases it appears that the original photographs used as sources for the plates were not of good quality. There are some exceptions, however, and some plates are well detailed, not fuzzy or out of focus. In some plates the illustrators combined traditional lithographs with photographs. For example, plate 18 combined photographic images with at least three traditionally drawn lithographs to illustrate specimens of two species, *Dictyopyge* and *Catopetrus.*

Paleontologists at the American Museum of Natural History turned early to photography and to motion pictures to bolster their publications and record their field expeditions. Much of this early use of photography was probably due to the impetus of Henry Fairfield Osborn and Walter Granger. They were, in turn, no doubt influenced by the early use of photography in the various USGS surveys. Granger himself took most of the surviving photographs of early American Museum field expeditions. While these do not always show fossils, they do give the observer an idea of what the sites were like and how the paleontologist's crew worked in the field. The American Museum archives today contain a remarkable collection of photographs of field expeditions to Wyoming, Montana, Nebraska, and other parts of the west between 1895 and 1919. There are also photographs of expeditions mounted to Alaska, Egypt, and Mongolia (this last in 1928). Most of these photographs were taken by members of the expeditions, i.e., scientists and crew members, and are in essence amateur photography. This in no way diminishes their historical value. What it means is that in the early years of photography in the field, many expedition members had to learn to manipulate complex camera equipment, including wet glass plates. The technology of the time required pictures to be taken at a certain temperature and humidity, so that the chemicals would react correctly. Also, one had to consider the impact—in the literal sense—of blowing dirt or dust. In badlands this could present a devastating problem to a photographer. It was not easy to take these field photographs. Their existence is a tribute to the men who both took them and managed to get the glass plates home intact to New York.[25]

The American Museum staff were equally quick to use photography in paleontology publications at the turn of the century. Henry F. Osborn's 1904 article "The Great Cretaceous Fish *Portheus Molossus* Cope," printed in the *Bulletin of the American Museum of Natural History,* was illustrated with several drawings of parts of the skeleton made with the help of a camera lucida. There is also a reproduced drawing of the whole skeleton of the fish as it had been reconstructed for display. But the most interesting illustration is a photograph of the restored skeleton of *Portheus.* The photo-

The American Museum of Natural History and Photography in Paleontology at the Turn of the Twentieth Century

Figure 5.10. John S. Newberry, *Fossil Fishes and Fossil Plants of the Triassic Rocks of New Jersey and the Connecticut Valley,* 1888.

graph was apparently taken by Abram E. Anderson, who was employed by the Museum as a photographer. The fish had been found in 1900 by Charles H. Sternberg in Logan County, Kansas. It was purchased by the Museum in 1901. The reconstruction and mounting were done by Adam Hermann under Osborn's direction. This is a very large specimen, measuring over fifteen and one half feet in length. Anderson's photograph, plate 10, shows the reconstructed and mounted specimen reproduced at 1/23 scale. The fish is a specimen of what is now called *Xiphactinus audax* Leidy, known to many paleontologists by its rather charming nickname "the X fish." (Most scholars still consider the name *Portheus molossus* a junior synonym.) Whether Osborn deliberately used the name Cope had given the specimen even though it had already been discarded or simply did not realize he should have called the fish *Xiphactinus* is a mystery. Mike Everhart, who has written about Osborn's confusion of nomenclature, has suggested that Osborn may have intended to honor Cope.[26]

Samuel Wendell Williston and Early Published Photographs of Fossils (1898–1913)

Samuel Wendell Williston (1851–1918) was as well known for his work as an entomologist as he was for his activities in paleontology. He became a specialist in marine reptiles, and also published on fossil sharks, pterosaurs, and other reptiles. In many of his paleontology treatises he used numerous photographs. Williston's contributions to the University Geological Survey of Kansas volumes for 1898 and 1900 contained photographs of fossil shark teeth and marine reptiles. The 1898 volume was illustrated with 120 images, including both engravings and photographs. The engravings were made by Van Insensnyder. Williston took many of the twenty-one photographs himself, which may explain why there were so many. Obviously he enjoyed photography. Others were taken under his direction. Many of the photographs depict marine reptiles; others show invertebrate fossils, including crinoids (e.g., plate 112) and images of *Tylosaurus proriger,* a mosasaur from the Western Interior Sea (e.g., plates 68–70). The volume also includes drawings, some of which are life restorations by Sydney Prentice and Mary Wellman, graduates of the University of Kansas. Williston was also an artist, and he supervised these two contributors.[27] The 1900 volume includes photographs of various invertebrate fossils and shark teeth, as well as *Xiphactinus audax,* the great fish. Like the 1898 volume, it was designed to allow readers to compare the actual fossils to drawings or other illustrations of them.

Williston published a number of papers and small paleontology studies at the turn of the twentieth century in which he used photographs as illustrations. Many of these concerned fossil marine reptiles. It is probably safe to assume that many of the photographs in these works were his as well, although he did not always so specify.

In 1903 Williston published a short study, *North American Plesiosaurs,* through the Field Columbian Museum in Chicago. The small treatise runs to only seventy-nine pages, but it has twenty-nine full-page illustrations: nineteen photographs as well as additional engravings. Most of the photographs show fossil bones of *Dolichorhynchops Osborni,* although plate 1 is

Figure 5.11. Samuel W. Williston et al., *The University Geological Survey of Kansas,* vol. 6, 1900.

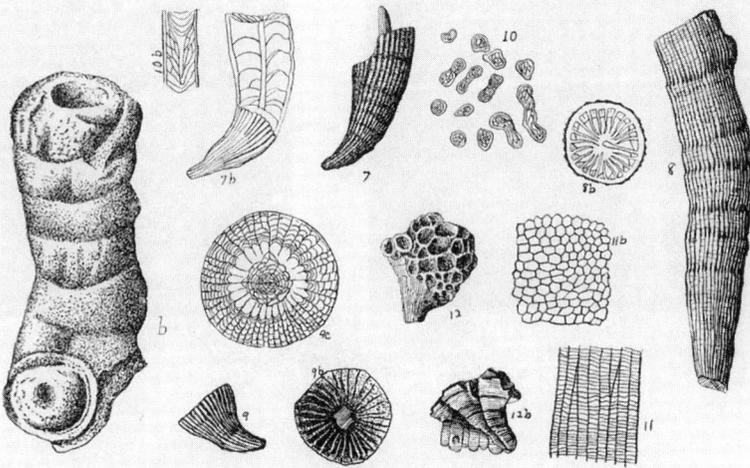

SOMPHOSPONGIA, 1-5. LOPHOPHYLLUM, 7, 8. CHÆTETES, 11.
AMBLYSIPHONELLA, 6. AXOPHYLLUM, 9. MICHELINIA, 12.
SYRINGOPORA, 10.

a photograph of a restored skeleton of the specimen. Plate 29 is a photograph of a number of assembled gastroliths from a plesiosaur. This work well demonstrates the importance that Williston attached to photographs of his fossil specimens, and the large number of these photographs indicates that he considered this medium quite important.

Figure 5.12. Samuel W. Williston, *North American Plesiosaurs*, 1903.

Toward the end of his career, Williston published *Water Reptiles of the Past and Present* (1914). In this more popularized study, Williston again included photographs of fossils and skeletal restorations as well as a large number of his own drawings of life restorations of various animals. Photographs include figure 78, which is a to-scale photograph of scales of *Tylosaurus proriger*. Several of Williston's life restoration drawings showed the animals in natural settings. He also included a copy of Charles R. Knight's painting of an ichthyosaur, which Knight had done for the American Museum of Natural History. *Water Reptiles* has become one of Williston's better-known works.

Not all of Williston's paleontology studies were concerned with marine reptiles. Williston, E. C. Case, and M. G. Mehl published an interesting study in 1913 that dealt with a specimen of a reptile recovered from New Mexico. The animal was *Ophiacodon* Marsh, and the specimen was discovered in 1911 in Rio Arriba County, New Mexico, by Williston and E. C. Case. Earlier fragmentary remains had been discovered in the same area in 1878–1879 by David Baldwin, who was working for O. C. Marsh at the time. The 1913 study, published by the Carnegie Institution, contained a photographic montage of three images of the fossil, made by Cockayne in Boston. There was an image of the specimen still in its matrix, one of the restored and mounted skeleton, and a view to scale of ventral rib material.[28]

Photographs were not confined to scientific treatises; they appeared early on in popular books as well as other materials designed for use by the general public. Two early twentieth-century examples of the use of photography to illustrate paleontology works for the general reader were written by members of the staff of the British Museum. E. Ray Lankester (1847–1929) was director of the Natural History Department of the British Museum in 1906 when he published a series of lectures he had delivered for young people during the Christmas holidays of 1903–1904 at the Royal Institution in London. The book was profusely illustrated with some 218 images, most of which were photographs. Lankester utilized lantern slides in his lectures to the young people, and these, he informed the reader, had been converted into "process blocks," or printing plates, for the illustrations that appeared in the book. It is obvious that Lankester and his colleague Arthur Smith Woodward, the keeper of the Geological Department of the British Museum, were aware of the pedagogical value of photographs and slides in the teaching of paleontology, especially to people who could not see the actual specimens. Lankester's use of lantern slides is actually quite early in the history of presentations using projected images. Lankester and Woodward were on the cutting edge of new technologies in 1903; Lankester's use of lantern slides is comparable to the use of computerized imagery, IMAX theaters, or interactive computer terminals in museums today. Lankester commented, "Many of these [slides] were photographs specially prepared under my direction for the lectures and are from specimens in the Natural History Museum. My desire was as far as possible to illustrate what I said by photographs taken from actual specimens."[29]

Lankester referred to the assistance he received from Woodward in preparing his lantern slides, and noted that he also obtained photographs and lantern slides (which also became process blocks) from various other scientists at the British Museum. Among them were Richard Lydekker (1849–1915), an expert on fossil mammals and the author of several large catalogues of fossils in the British Museum; Francis A. Bather (1863–1934); Charles Andrews (1866–1924); and William P. Pycraft (1868–1942). Additionally, Lankester obtained slides from Professor William J. Sollas (1849–1936) at Oxford.[30] Some photographs were taken from earlier Museum guidebooks written by Woodward.[31] The list of colleagues from whom he obtained images indicates

E. Ray Lankester

Extinct Animals (1906), and the British Museum's *A Guide to the Fossil Mammals and Birds in the Department of Geology and Palaeontology*, by Arthur Smith Woodward (1909)

I trust that this volume will not be regarded as anything more ambitious than an attempt to excite in young people an interest in a most fascinating study. . . . To learn more . . . the reader should visit many times the Natural History Museum, see the actual specimens and by the aid of the illustrated guidebooks get to know more details about them.

E. Ray Lankester, 1906

Figure 5.13. E. Ray Lankester, *Extinct Animals*, 1906.

that photography was becoming an established medium in both scientific and general publication at the turn of the twentieth century. It also demonstrates that the British Museum staff worked together on projects and publications that were appearing under the aegis of the Museum.

Lankester's book was an international undertaking. It was published by Henry Holt in New York City, but the plates (or process blocks, as Lankester called them) were produced in England. The books themselves were printed in England by Butler and Tenner, the Selwood Printing Works, Frome and London.

This book, like the lectures it was based on, dealt with a wide variety of topics, including some basic geology, extinct elephants, giraffes, sloths, and giant kangaroos. As well, Lankester taught his audience about dinosaurs and extinct marine reptiles and fish. Closing out the series were comments on trilobites, belemnites, brachiopods, scorpions, and stone lilies (crinoids). The photographs showed individual specimens of fossils and more recent extinct animals, displays from the British Museum and other museums, and reproductions of museum murals from various sources, including the American Museum of Natural History.[32] Looking at these pictures and reading the commentary on them, one cannot help imagining Lankester and his assistant in some darkened hall, talking to the children and showing them these wonderful images. A few examples will give the flavor of the lectures. Lankester showed a slide of a skull of *Titanotherium*. After this, he told the children, "As large as the rhinoceros but having a very different arrangement of the bones of its wrists and ankles and very different teeth and horns are the extraordinary creatures known as *Dinoceras,* whole skeletons of which have been disinterred from the Upper Eocene of Wyoming in the United States. As many as two hundred individuals were studied by Professor Marsh who has written a large treatise on them." This image was followed by slides showing a restored *Dinoceras* skeleton and a sketch of the animal in life, and then, amazingly, a slide captioned "Photographs of plaster casts of the brain-cavity of *Dinoceras;* Hippopotamus, Horse and Rhinoceros."[33]

At one point Lankester talked about what he called "reptiles found in nodules." Here he discussed the discovery, restoration, and mounting of skeletons of *Pareiasaurus*. While the images must have been interesting to the audience in 1903, they are probably more intriguing today, as they show early attempts to mount this animal and to position its limbs. The section on *Pareiasaurus* specimens begins with a photograph of people (he points out that they are "peasants") opening a quarry at Archangel and "removing the nodules containing the skeletons of great reptiles." The next picture shows the nodules in the Warsaw laboratory of Professor Amalitzky, and then the mounted skeletons are shown in place in the Warsaw Museum. The fossils are stand in a row in the gallery and are lit with gas lamps. These are wonderful pieces of historical documentation.[34]

The lectures treated invertebrates as well. In the section on "stone lilies," or crinoids, Lankester relied on photographs provided by Dr. Bather, who was the Museum's specialist in invertebrate fossils.[35]

Sir Arthur Smith Woodward also used lantern slides to accompany his lectures on foreign fossils, to show his audience what the fossils were like. A noteworthy instance is his 1912 slide lecture presented to the London branch of the German Colonial Society. The lecture was entitled "The Great Finds of Fossil Bones in German East Africa," and it covered specimens from the German Tendaguru Expedition in what is today Tanzania.[36]

Sir Arthur Smith Woodward's *Guide to the Fossil Mammals and Birds in the Department of Geology and Palaeontology* was published by the British Museum in 1909.[37] This ninth edition of the guide includes numerous illustrations (including several photographs and eighty-six engravings), a geological

Figure 5.14. E. Ray Lan-
kester, *Extinct Animals,* 1906.

timetable, and a plan of the galleries. The illustrations are found throughout this compact one-hundred-page guide. The engravings are of good quality and their scale is labeled, so that readers know how the size of an illustration compares with the size of the actual fossil. Along with illustrations of individual bones, there are illustrations of teeth and skeletal restorations. Some were borrowed from publications by Cope, Marsh, and Cuvier and are so labeled. For example, illustrations of *Hesperornis* and *Ichthyornis* from Marsh are included.

Photographs like those in this guidebook were made utilizing wet plate methods and flash pans for illumination. The quality of the photographs is actually quite good, considering that they were printed at a rather small size; the largest are only about 4.5 × 6.25 inches. Certainly the plates were larger than that. Plate 2, which faces page 2, is captioned "Block of Lower Pliocene Marl from Pikermi, Greece, Crowded with remains of Mammals and a few bones of Birds." The photograph is also labeled with the number of the display case in which the specimen is to be found. Like the engravings, the photograph is accompanied by an indication of its scale; this one is about one-fifth the size of the actual specimen. In this photograph one can clearly discern various bones, including parts of the skull of a mammal. This, we are told in the text, is a partial skull of *Hipparion,* a "three-toed horse." The text provides information about the fossil and its discovery. Plate 3, facing page 3, presents the reverse of the block seen in plate 2. Plate 4, facing page 74, contains two photographs captioned "Skin of Extinct Ground-sloth *(Grypotherium listai)*." These are wonderful photographs, clearly showing details of tissue and fur. Another similar photograph shows the skeleton of a moa.

As well as these illustrative plates, smaller photographs were inserted into the text. Figure 3, on page 11, shows a "model of skull and lower jaw of a supposed aquatic Lemur, *Megaladapis insignis,* from a cavern in Madagascar." Figure 40, on page 50, shows a photograph of a mounted skeleton of *Phenacodus primaevus.* This photograph is important because the specimen was actually in the American Museum of Natural History, not the British Museum; readers could learn about fossils and their displays elsewhere as well. This photograph also supplements engravings throughout the text that show skeletal restorations of various specimens.

The last photographic illustration is probably the most spectacular and the most interesting. It is plate 6 (facing page 94), showing *Archaeopteryx.* The caption reads, "Fossil Lizard-tailed Bird, *Archaeopteryx macrura,* from

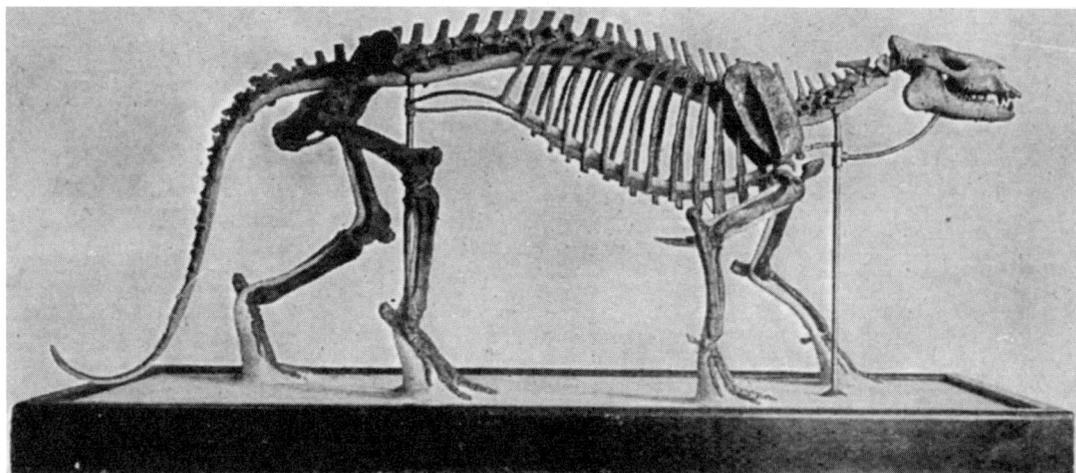

the Lithograph Stone (Upper Jurassic) of Eichstadt, Bavaria," and the text explains, "The piece of limestone in which the skeleton is preserved has split along the plane of weakness caused by the presence of the fossil itself. . . . it is thus necessary to exhibit the two slabs side by side." A furcula (a forked bone like a wishbone) is visible, and "the hind leg is exactly that of a perching bird. The long tail, however, comprises a row of twenty slender vertebrae each bearing a pair of feathers." We learn further that the Museum also had a cast of a specimen from Berlin, which was placed next to their own specimen for comparison. And, perhaps even more interesting, the observer is told to look at "a photograph of the specimen [that] is fixed head downwards on the wall near the window, to show the lizard-like sprawl assumed by the skeleton at the time it was buried."[38] This was a sophisticated display combining two famous fossils, one real and one cast, with a photograph used to suggest something of the animal's perching posture, or at least its taphonomy.

While the guidebook was designed for general readers and museum patrons, it was useful to scientists who might be visiting the Museum as well.[39] The 1909 British Museum guidebook, together with Lankester's illustrated lectures, provides insights into how Woodward ran his paleontology museum. It tells us much about his interest in photography as a medium of education and scientific recording, and as an element of museum displays.

Figure 5.15. British Museum (Arthur Smith Woodward), *A Guide to the Fossil Mammals and Birds,* 1909. Mounted skeleton of *Phenacodus primaevus.*

The autobiography of Charles Sternberg (1850–1943), *The Life of a Fossil Hunter,* is a fascinating historical document, filled with Sternberg's experiences retold in his wonderful hyperbolic manner. The book concludes with his description of the discovery of the "dinosaur mummy," the specimen of *Trachodon mirabilis* that would be described, with incredible photographs, in Henry Osborn's 1912 paper "Integument of the Iguanodont Dinosaur *Trachodon.*" While Sternberg's autobiography is not a scientific document, but rather more of a combination of advertisement and memoir, it deserves attention here because it does include a number of photographs. The Sternberg family, his "race of fossil hunters," used photography to re-

Charles H. Sternberg

The Life of a Fossil Hunter (1909)

I hope [the volume] may awaken a wide interest in the study of ancient life. . . . Thank God I have raised up a race of fossil hunters.

Charles H. Sternberg, 1909

cord specimens they had found and places where they had worked. Some photographs were used to advertise specimens for sale, and others found their way into *The Life of a Fossil Hunter*. Also included in this volume were several of the American Museum's photographs, including the one by Abram Anderson of a specimen of *Xiphactinus audax*. Sternberg also used a number of photographs showing fossils he had discovered that were now on display in the American Museum. For example, figure 41 (following page 266) shows a specimen of *Hesperornis regalis* in a slab of matrix.

Along with the photographs, Sternberg included reproductions of several of Charles R. Knight's life restorations of various animals. These appeared, as Sternberg told the reader, through the courtesy of Osborn and the American Museum. In many aspects, this book is an ersatz guidebook to the American Museum's fossil collections.[40]

Charles Sternberg and his two sons, Levi and George, were at work in what was then Converse County, Wyoming, when George discovered the "mummy" of *Trachodon mirabilis*. No one tells the story better than Charles himself:

> While we were taking out our skull [a *Triceratops* specimen], George and Levi ran nearly out of provisions and the last day of our absence lived on boiled potatoes. But in spite of this they had removed a mass of sandstone 12 feet wide, 15 feet deep, and 10 feet high. Shall I ever experience after again such joy as when I stood in the quarry for the first time, and beheld lying in state the most complete skeleton of an extinct animal I have ever seen, after forty years of experience as a collector! The crowning specimen of my life work! A great duck-billed dinosaur, a relative of *Trachodon mirabilis*, lay on its back with front limbs stretched out as if imploring aid.[41]

Henry F. Osborn

"Crania of *Tyrannosaurus* and *Allosaurus*" (1912) and "The Integument of the Iguanodont Dinosaur *Trachodon*" (1912)

Shortly after the publication of *The Life of a Fossil Hunter*, Henry Osborn (1857–1935) published two important papers, one of which discussed George Sternberg's discovery. The *Trachodon* specimen and the two skulls discussed in the other paper were among the most famous dinosaur fossils that would ever be in the American Museum. The papers together made up the June 1912 volume of the *Memoirs of the American Museum of Natural History*, and were in essence a preliminary report on the research that had been done on the museum's specimens of *Tyrannosaurus rex* and *Trachodon*. The volume was folio-size and the photographs of the specimens were taken by Abram E. Anderson. In addition to Anderson's stunning photographs, drawings were made of aspects of the fossils by Erwin S. Christman. These are wonderful works of art as well. The *Tyrannosaurus rex* skull that was chosen for most of the photographs is that of the second specimen found by Barnum Brown at the Hell Creek, Montana quarry, in 1907 (AMNH 5027). In addition, Anderson also photographed AMNH 5117, another *Tyrannosaurus rex* skull. The photographs were produced in 1910.

While these illustrations are spectacular, still more breathtaking are the photographs that appeared in the second paper, which described the fossil identified as AMNH 5060, *Trachodon mirabilis*.

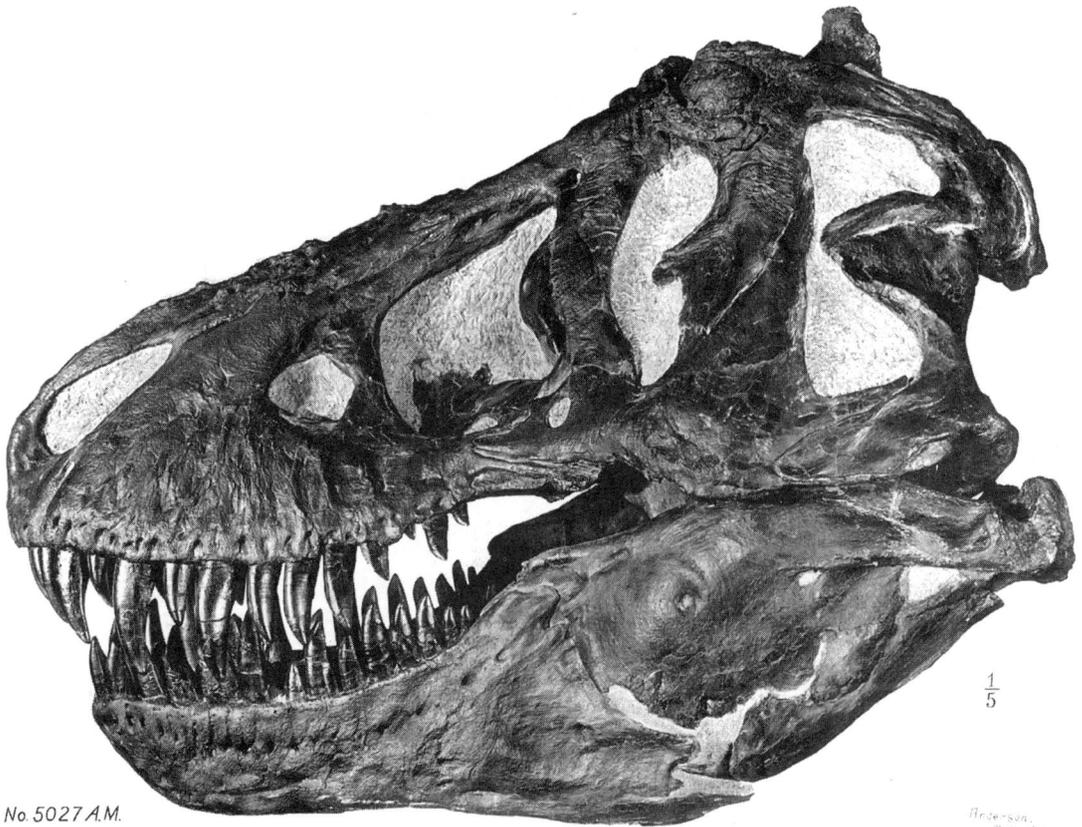

No. 5027 A.M.

$\frac{1}{5}$

Anderson.

Figure 5.16. Henry F. Osborn, "Crania of *Tyrannosaurus* and *Allosaurus*," 1912. Photograph by Abram Anderson.

In August, 1908, the veteran explorer Charles H. Sternberg and his son George F. Sternberg were working in the Upper Cretaceous deposits of Converse County, Wyoming, which had been rendered famous by the prolonged and successful explorations of Hatcher (1889–1892) for remains of Ceratopsia. . . . It was in the lowest levels or basal sandstones of this series that the younger Sternberg made the welcome discovery of a specimen of *Trachodon annectens* [now *Edmontosaurus annectens*], almost complete, encased in the "impression-cast" of its integument. . . . this precious record of the outer covering of an iguanodont dinosaur is preserved to a large extent. . . . Mr. Sternberg thus added another most important contribution to palaeontology. . . . When the skeleton was found the hind feet as well as the posterior portion of the pelvis and the entire tail had been eroded away. . . . the remainder of the animal as discovered and as now prepared in the American Museum . . . now lies on its back with all the bones connected; the knees are drawn up. The chest is open and upturned; the fore limbs are outspread; the neck and skull are sharply twisted downward and backward to the right side; the dorsal frill of the neck is turned to the left. This position is that of an animal which died a natural death.[42]

Osborn went on to explain that some of the impressions of the integument had probably been lost in the course of the excavation, and noted that future scientists should take care if they ever found another such specimen with integument intact. And what a specimen it was. Even after seeing photographs of the entire specimen, an encounter with the actual fossil is

Plate VII. Abdominal integument. Natural size photograph of the epidermal area marked $\overset{v}{B}$ in Fig. 1a.
This shows the alternating arrangement of the large pavement tubercle clusters surrounded by the smaller rounded
tubercles and more or less diamond-shaped areas. Photograph by A. E. Anderson.

an unforgettable experience. This is a very large specimen. Anderson's photograph of the entire fossil on its ventral side (plate 5) measures approximately 14 × 10.5 inches, and it is on a 1/9 scale. Other photographs were done to a 1/13 scale. These photographs are quite impressive, but nothing compares with the full-page photographs of parts of the integument that Anderson made to scale with the specimen. Plates 6 and 7 measure approximately 11.25 × 8.25 inches and are life-size photographs of portions of the pectoral integument and the abdominal integument of the specimen. It is worth remembering that Anderson was still working with glass plates and flash powder pans, and yet the images are crisp and sharp. The patterning of the scutes, which Osborn called "tubercules," is shown in complete detail and relief. Anderson's lighting of these two photographs is splendid. Nothing is left unclear.[43]

Henry Osborn

The Origin and Evolution of Life (1918)

Henry Osborn's *The Origin and Evolution of Life,* published in 1918, contained expanded versions of a series of lectures in honor of George Ellery Hale, given by Osborn at the National Academy of Sciences in Washington, D.C., earlier that year. The book was evidently popular and quickly went through several editions, one per year in the first three years of its existence.[44] This is a book designed to be accessible to the general adult reader. Approximately half of it deals with Osborn's opinions on theories of the origins of the universe, the solar system, and the earth itself, and is not of much interest as regards paleontology illustration. After expounding his views on these topics, Osborn turned his attention to a survey of the evolution of life on earth. His discussion is thorough, beginning with cellular life and finishing with *Homo*.

The images of invertebrate and vertebrate fossils and their reconstructions are quite intriguing, since they tell us what several of the displays in the American Museum of Natural History were like at this point. And the images combine several illustrative techniques. It is the combining of various types of illustration for the purpose of comparison that makes this book so interesting. Such formatting was still rather unusual at this point. Photographs like these still had to be produced using wet plates and flash powder, and the technical challenges of placing photoliths on the same page with other lithographs meant that this book's design was quite advanced. When it was published, Osborn was curator of vertebrate paleontology at the American Museum. He published photographs of dioramas from the Museum as well as of mounted fossils, many of which were his work or that of William Diller Matthew (1871–1930). An example is figure 51 (page 170), which shows models of restored fish found in the Old Red Sandstone in Scotland. Additional illustrations of restored fossils included lithographs made from line drawings by artists and scientists such as William King Gregory (1876–1970) and Richard Deckert. One such lithograph, Figure 60 (page 179), "Chief amphibian types of the Carboniferous," is followed by an actual photograph of the skull and vertebral column of an amphibian, *Diplocaulus* figure 61 (page 180).

The book also included reproductions in black and white of a number of Charles R. Knight's paintings. The use of Knight's illustrations indicates how

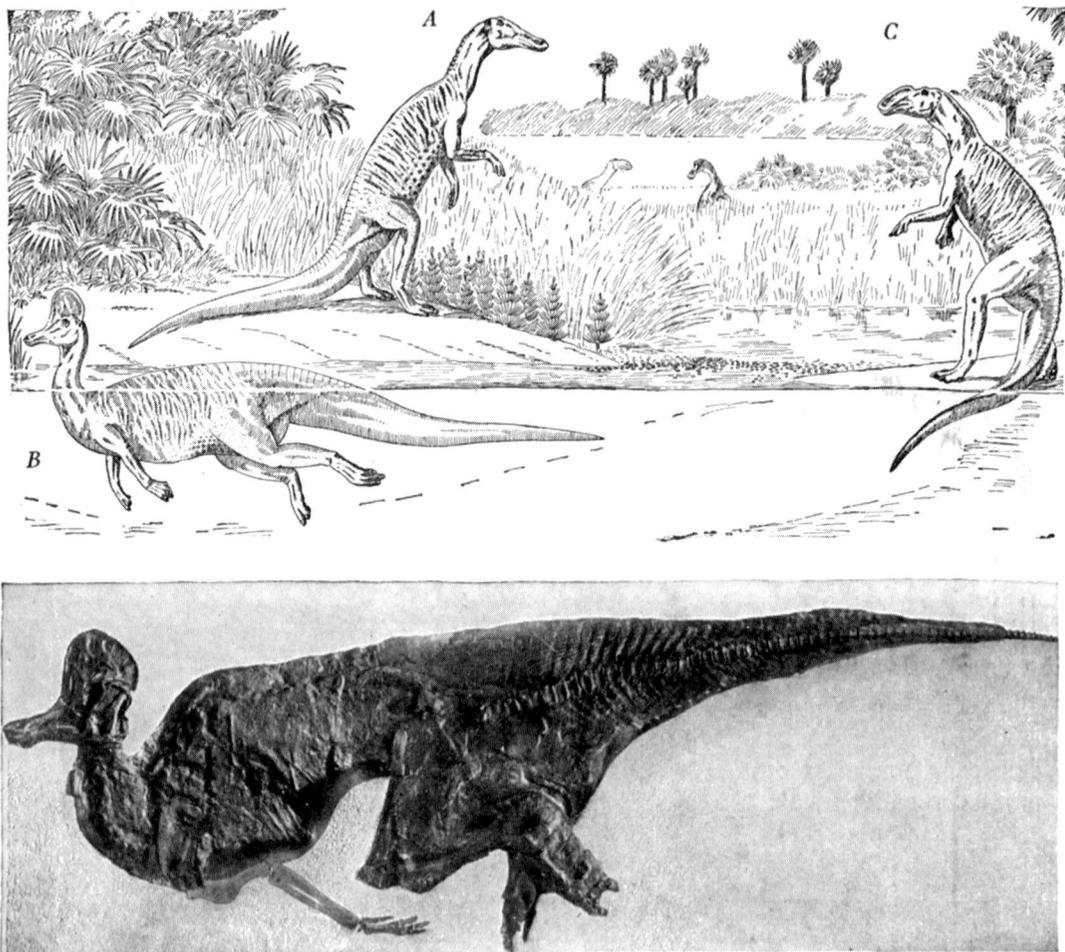

FIG. 101. ADAPTIVE RADIATION OF THE IGUANODONT DINOSAURS INTO THREE GROUPS.

(Upper.) Three characteristic types: *A*, Typical "duck-bill" *Trachodon*; *B*, *Corytho-saurus*, the hooded "duck-bill," with a head like a cassowary, probably aquatic; *C*, *Kritosaurus*, the crested "duck-bill" dinosaur. Restorations by Brown and Deckert.

(Lower.) Mounted skeleton of *Corythosaurus* in the American Museum of Natural History, recently discovered in the Upper Cretaceous of Alberta, Canada, with the integument impressions and body lines preserved.

Figure 5.18. Henry F. Osborn, *The Origin and Evolution of Life*, 1918.

Osborn and Knight collaborated to prepare displays for the American Museum. For example, figure 100 (page 222) is a dual illustration, pairing two mounted *Trachodon* skeletons in the Museum with Knight's restoration of the two animals in a natural ecological setting. The goal was to give readers an idea of how the animal looked in life and how it might have behaved.

This goal could get the paleontologist and the artist into difficulty, however. On the following page, figure 101, "Adaptive radiation of the Iguanodont dinosaurs into three groups," contains a line drawing of three restorations of dinosaurs in a natural setting, done following restorations by Barnum Brown

and Deckert. Below this is a photograph of a beautiful fossil *Corythosaurus*, discovered in Alberta, Canada, which had recently been placed in the American Museum. The animal was preserved in a pose which seemed to suggest swimming to Osborn; his caption notes that the animal was "probably aquatic," and it is actually shown swimming in the line drawing.[45] The idea that the pose was due to the way the animal had lain down and died, or the way its body had sunk and rested prior to petrifaction, rather than to its having died instantaneously while swimming, seems to have passed Osborn by. Generations of readers no doubt thought this was a great example of a swimming *Corythosaurus*.[46]

Sometimes the fossil record allowed the scientists to draw better conclusions about the life of the animal in question. Such is the case with the ichthyosaurs shown in figure 81 (page 204). Osborn placed photographs of fossils from the Museum's displays alongside a line drawing of one of them. The caption read:

> Extreme Adaptation of the Ichthyosaurs to Marine Pelagic Life. Although primarily of terrestrial origin, the ichthyosaurs became quite independent of the shores through the viviparous birth of the young as evidenced by a fossil female ichthyosaur (upper figure) with the foetal skeletons of seven young ichthyosaurs within or near the abdominal cavity.

This book is a time capsule of art, photography, scientific reconstructions, and restorations of fossils and paleontology theories from the period around the First World War. At this point in the early twentieth century the American Museum of Natural History and the U.S. Geological Survey were publishing scientific treatises illustrated with the occasional photograph. Some show mounted fossils on display; others are photographs of specimens. Usually these photographs are of a high technical quality and show plenty of detail; they surpass other book illustrations of the time. The photographs in *The Origin and Evolution of Life* are no exception.

Charles Whitney Gilmore (1874–1945) was a vertebrate paleontologist at the Smithsonian's U.S. National Museum. In 1914, when he published *Osteology of the Armored Dinosauria in the United States National Museum, with Special Reference to the Genus Stegosaurus,* he was assistant curator of fossil reptiles; by 1920, when he published *Osteology of the Carnivorous Dinosauria in the United States National Museum, with Special Reference to the Genera Antrodemus (Allosaurus) and Ceratosaurus,* he had been promoted to associate curator in what was now called the Museum's Division of Paleontology. These two works, bulletins 89 and 110 of the National Museum, were similarly conceived and illustrated. In both works Gilmore utilized several types of illustrations: engravings, photoengravings, and photographs.[47] What makes these two works very interesting is that Gilmore included photographs not only of fossils but also of paintings and drawings showing life restorations of the animals, not only of mounted skeletons in museums but also of sculptures. The two works thus are not only interesting from the standpoint of the history of science, they are also catalogues

Charles W. Gilmore

Osteology of the Armored Dinosauria in the United States National Museum (1914) and *Osteology of the Carnivorous Dinosauria in the United States National Museum* (1920)

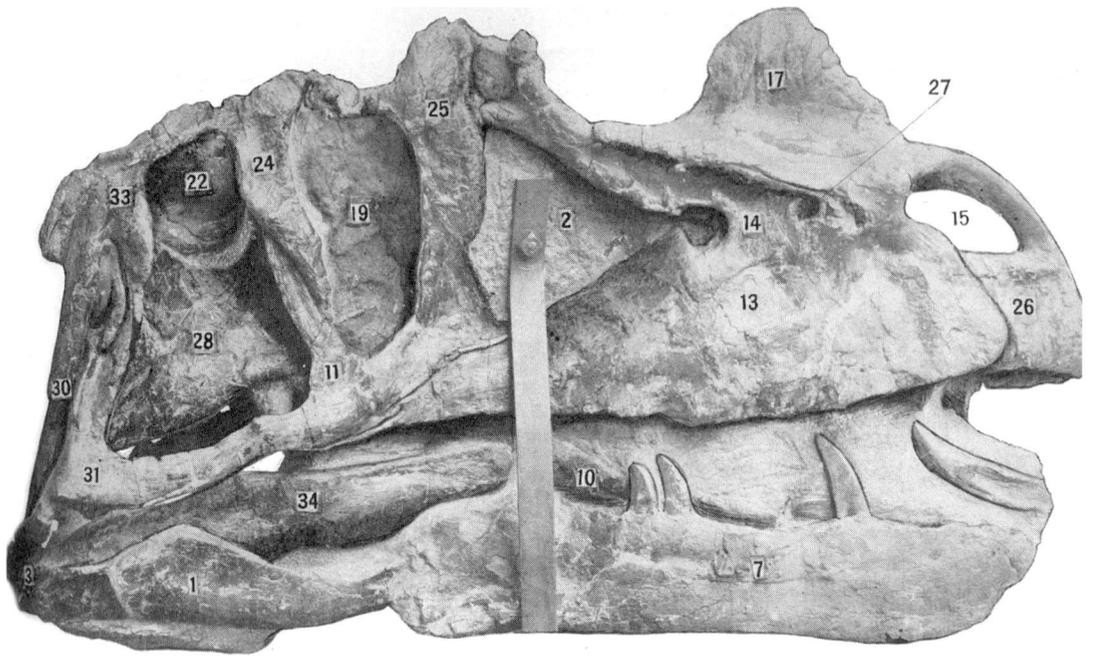

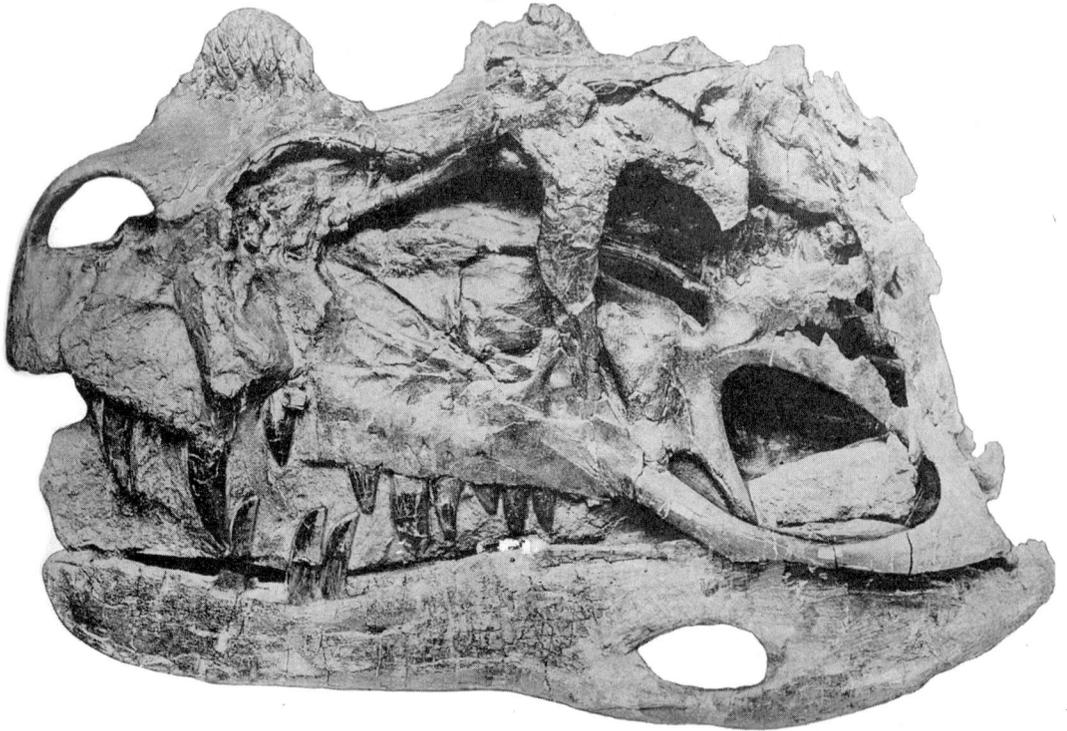

Figure 5.19. Charles W. Gilmore, *Osteology of the Carnivorous Dinosauria in the United States National Museum*, 1920.

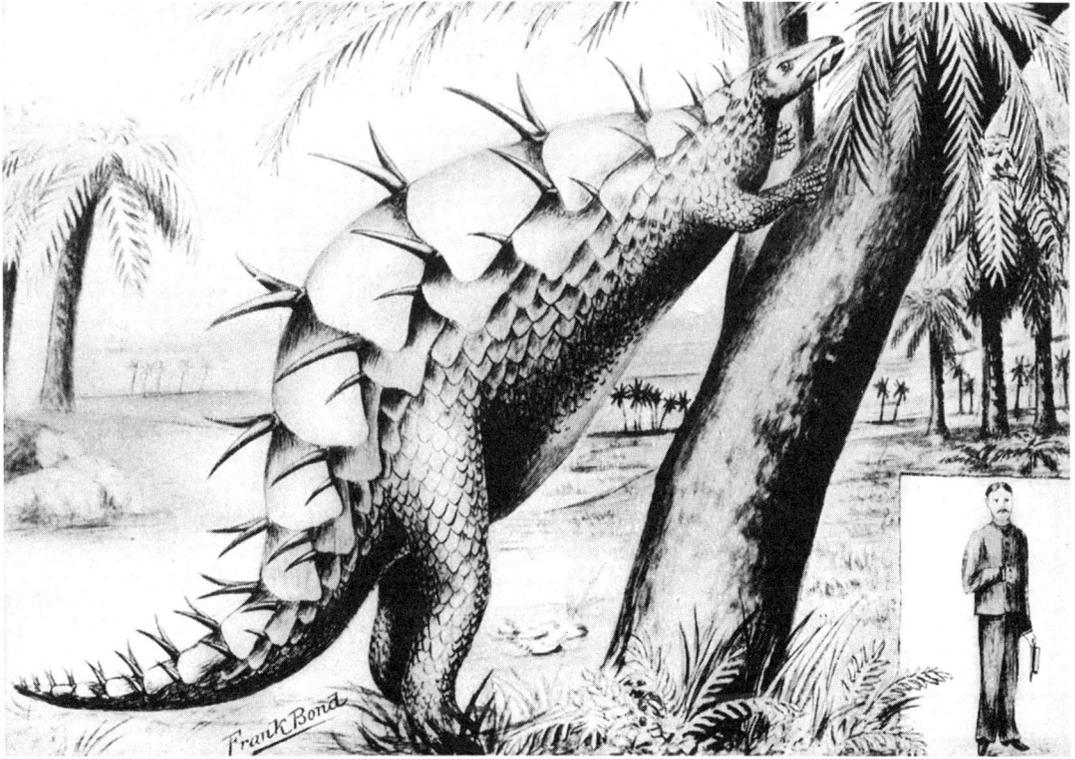

Figure 5.20. Charles W. Gilmore, *Osteology of the Armored Dinosauria in the United States National Museum,* 1914.

of what Gilmore and the Smithsonian thought were important examples of paleontology illustration in the era of the First World War.

The first volume dealt with *Stegosaurus* material found by crews working for O. C. Marsh. Much of this material came from Como Bluff, Wyoming. It arrived at the U.S. National Museum between 1898 and 1899, and was worked on from 1906 to 1913; *Osteology of the Armored Dinosauria* was published in late December 1914. Artists who worked on it included Frederick Berger, a draughtsman who was in O. C. Marsh's employ at Yale, and Rudolph Weber, who took over the task of making drawings for the volume (and the later one) after Berger's death. All photographs in the volume were taken by T. W. Smillie, who was a Museum employee.[48] The same artists were employed (or at least their work was used) for *Osteology of the Carnivorous Dinosauria* in 1920.

The 1914 volume is illustrated with a number of photographic plates (more than the 1920 volume has) containing views of various skeletal parts of *Stegosaurus* as well as life restorations and a museum display of a mounted skeleton. It has thirty-seven full-page plates; the last is actually a fold-out engraving of a map of Quarry 13 at Como Bluff, showing where various bones had been excavated. Little outlines of the bones mark the sites.

Many of the plates depict works of art. Plates 32 and 35 contain life restorations of *Stegosaurus* by J. Smit, taken from the 1893 and 1911 editions of H. N. Hutchinson's *Extinct Monsters.* The one from the 1911 edition looks much as *Stegosaurus* usually did in representations by other artists, such as Charles R. Knight. But the one from the 1893 edition is quite different. It is shown crawling out of the swamp in a posture like that of an iguana. The dorsal plates are

Figure 5.21. Charles W.
Gilmore, *Osteology of the
Armored Dinosauria in the
United States National Mu-
seum,* 1914. *Stegosaurus.*

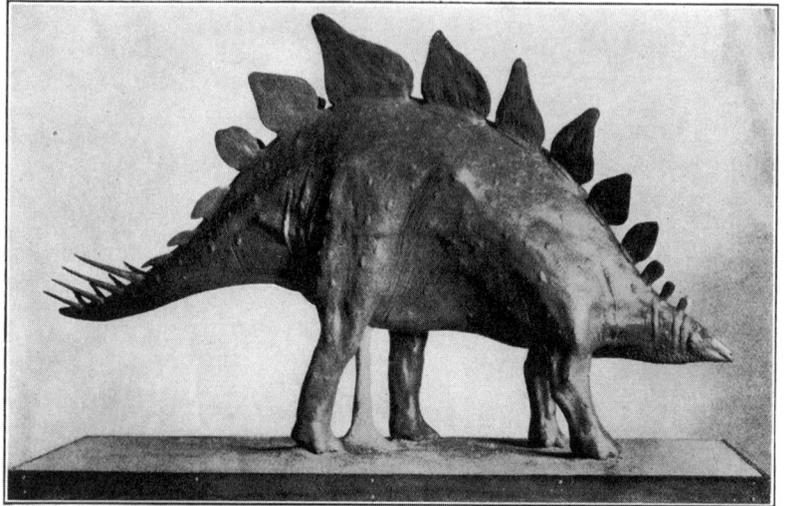

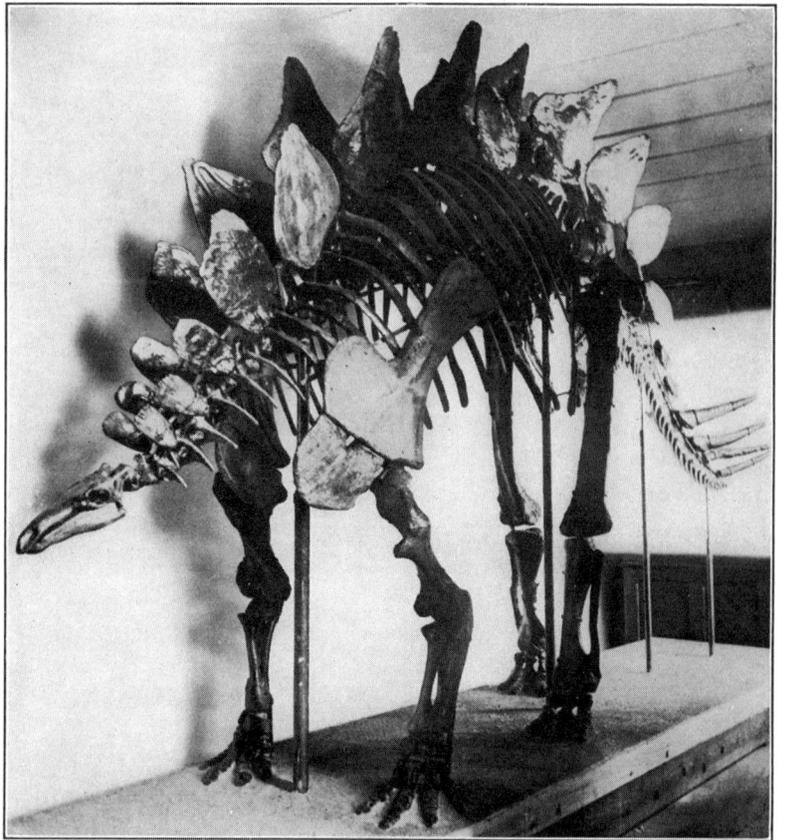

there, and so are the spikes on the tail. Otherwise it would be hard even to rec-
ognize the animal. A similarly fanciful stegosaur is found in plate 33, in a
drawing done by Frank Bond in 1899 under the direction of University of Wy-
oming professor W. C. Knight. The animal is shown standing up on its hind
legs, leaning against the trunk of a tree in which is it foraging. The most amaz-

ing thing about this animal is how Bond treated the plates. Instead of placing them along the vertebral column, he placed them like armor on the sides of the dinosaur, and along its back he placed spikes like those on its tail. It is an astonishing image. Bond also included in the drawing a man neatly dressed in a suit and holding a Panama hat. He is there to give a sense of scale, but he is also special in himself, because this little figure is without question Edward Drinker Cope! If O. C. Marsh saw this illustration prior to his death in 1899 he must have been stunned to see Cope standing there alongside "his" dinosaur. Plate 33 also contains a photographic reproduction of Charles R. Knight's stegosaur, taken from Frederic A. Lucas's *Animals of the Past* (1901).[49]

Osteology of the Armored Dinosauria contains two photographs of sculptures. Gilmore provided some historical background for these. Plate 34 depicts a model of *Stegosaurus* by Charles R. Knight, made under the direction of Frederic A. Lucas. The model was then executed as a life-sized sculpture that was displayed at the St. Louis World's Fair in 1904 and subsequently made part of the displays at the U.S. National Museum. Plate 36 shows a life restoration sculpture of *Stegosaurus* made for the Yale Peabody Museum by Richard Swann Lull in 1910. It is shown with a mounted skeleton that was on display at the Yale Peabody Museum.[50]

Gilmore published an additional life restoration that he took from Lankester's 1905 *Extinct Animals*. This restoration Gilmore did not like, and he made little secret of his disdain for it.

> In 1905 Lankester published the restoration of Stegosaurus shown in Plate 35 . . . and was the first to depict the animal with a color pattern of irregularly rounded black spots upon a lighter body color. The hooked raptorial bird-like beak, the puffed-up proportions of the body, and the increased number (10) of dermal spines are without warrant. In fact, there is little to commend in it. It may be of interest to know, however, that Sir Arthur Conan Doyle used this restoration as an illustration in his story of The Lost World.[51]

This is an interesting critique. Perhaps now paleontologists would be more kindly disposed to a dinosaur with color patterns, although on balance they would tend to agree with Gilmore.

Gilmore's 1920 *Osteology of the Carnivorous Dinosauria* was designed in precisely the same format and included the same types of illustrative materials as the earlier volume. The *Allosaurus* and *Ceratosaurus* materials in the National Museum had been collected by USGS parties under the direction of O. C. Marsh in 1898 and 1899. Gilmore informed the reader that "only a small part of the carnivore material was in condition for study," and thus serious preparatory work did not begin until 1911. It continued until 1918. Because of the association with Marsh, many of the wash drawings in the volume were done by Frederick Berger under Marsh's direction. Rudolph Weber continued Berger's work for this volume as he had for the earlier one. One of Berger's drawings deserves special note here, because it is one of the large plates. Plate 30 depicts a restored skeleton of *Ceratosaurus nasicornis* in a fold-out engraving. The portions of the skeleton that had actually been found are beautifully detailed; the conjectural remainder is shown in outline.

The photographs for the book were produced by two photographers in the employ of the National Museum. They were T. W. Smillie, who had done the photography for the 1914 volume, and L. M. Beeson, who succeeded Smillie at the time of his death. In addition, photographs of *Antrodemus* (*Allosaurus*) at the American Museum were provided for the volume through the aegis of Walter Granger. While Gilmore didn't say, it is likely that the American Museum photographs were taken by Abram Anderson.[52]

Osteology of the Carnivorous Dinosauria has thirty-six large plates as well as numerous interior engravings. Seventeen of the plates are derived from photographs. Noteworthy among the photoengravings is plate 3, which depicts two views of a plaster cast of the skull of *Antrodemus valens*. The casts were sent to Gilmore by Richard S. Lull.[53] Like all photographs of Marsh's restorations, these images are quite interesting. Plate 13 is a photograph of a mounting of the hind limbs, pelvis, and sacrum of *A. valens* as it appeared on display in the National Museum. It compares favorably to a photograph by Anderson in plate 16 of the famous American Museum mount of *Allosaurus* dining on the remains of its *Apatosaurus* prey, which had been erected in 1908 under Osborn's direction. Plate 16 also contains a photograph of Charles R. Knight's life restoration of the scene preserved in the bones.[54]

Plate 18 presents two views of the skull of *Ceratosaurus nasicornis*. In one the bones are numbered. This photograph appears to have some retouched areas outlining some of the teeth, but the retouching is obvious enough that it does not reduce the authenticity of the material shown. A large metal bracket holding the skull is also visible.

Like the 1914 volume, the 1920 one includes photographs of works of art as well as of fossils. Plate 27 shows a skeletal restoration of *Ceratosaurus* as it appeared in Marsh's 1892 "Restorations of *Claosaurus* and *Ceratosaurus*." It also contains a photographic reproduction of an 1899 drawing by Frank Bond of a life restoration of two *Ceratosaurus* individuals. It is a rather fanciful drawing in which the animals have prominent nasal horns, evidently a reference to their scientific name and the possibility that they had such appendages.[55] Supplementing these illustrations are other photographs that show additional life restorations of *Ceratosaurus*. Plate 28 contains a photograph of a beautiful drawing made in 1901 by J. M. Gleeson under the direction of Charles R. Knight. The animal is shown investigating the remains of some prey. It is a lively and very believable *Ceratosaurus* one sees herein. Gleeson took special care in drawing the animal's head so that it corresponds well to the skeletal structure of the fossil skull. One can certainly see Knight's influence in the lifelike pose of the dinosaur as it sniffs at a potential lunch. This photograph was produced by McClure, Phillips and Co. and bears the photography studio's copyright statement, as well as the signatures of Gleeson and Knight. Plate 28 also contains a photograph of a life restoration scene done in 1911 by J. Smit. Here one sees three ceratosaurs in a tropical landscape. One is shown in a pose similar to that in which a leg and pelvis are mounted at the National Museum. The other two animals are seen in the background in the act of devouring a dinosaur limb bone. All three have nasal horns. The scene also includes tracks made by the animals, a nice touch that mitigates somewhat the

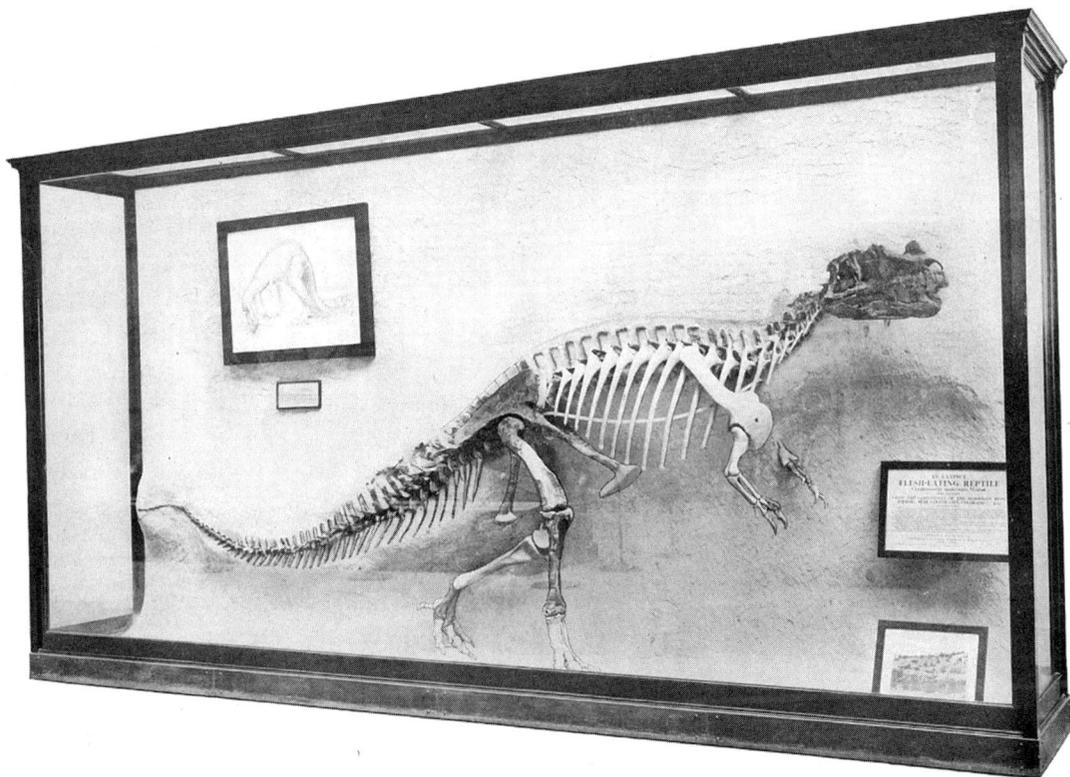

Figure 5.22. Charles W. Gilmore, *Osteology of the Carnivorous Dinosauria in the United States National Museum*, 1920.

rather inferior quality of the drawing. The most impressive restoration shown in Gilmore's photographs is in plate 31, a sculpture of *Ceratosaurus* engaged in eating prey. C. W. Gilmore himself made this sculpture in 1915. The animal is shown eating, in a pose that mimics that of the *Allosaurus* mount at the American Museum; Gilmore informed the reader that its victim was *Camptosaurus nanus,* "an herbivorous contemporary and one which could well have been the prey of this carnivorous brute." The head and limbs (for which there were some partial extant fossils) are much better sculpted than the body and tail. While it is not an entirely successful life restoration (it has neither the artistic quality nor the realism of Gleeson and Knight's drawing), Gilmore's sculpture does convey the sense of a large animal in the act of chewing up its meal. It is interesting for being one of very few sculptural life restorations.[56]

The last illustration in the 1920 volume which deserves special note here is plate 29. In this photograph one sees Gilmore's own museum display of the restored skeleton of *Ceratosaurus.* Within the display case are several framed informational texts, including a drawing in which the animal is posed much as it is in Gleeson and Knight's drawing. The restoration clearly indicates which parts of the skeleton are plaster and which are fossil material. But the odd thing about this photograph is that it has certainly been retouched. Parts of the left side of the case seem to be missing or distorted. And further, the perspective is wrong. One seems to be looking at the case from two different angles at once. Perhaps the photographer had problems with reflections from the glass in the case.

Photography in the *American Journal of Science* in the Early Twentieth Century

The *American Journal of Science* published photographs frequently in the early twentieth century. The presence of these photographs is testimony to the value that the journal's authors and editors placed on this medium. Photographs depicted all sorts of things. There were microphotographs of mineral specimens, images of geological features such as volcanoes, images of scientific instruments, and, also, photographs of fossils.[57] Even as early as 1902, several photographs of trilobites were featured in Charles E. Beecher's "The Ventral Integument of Trilobites." These photographs depicted full-length views of several specimens, as well as close-ups of some of their ap-

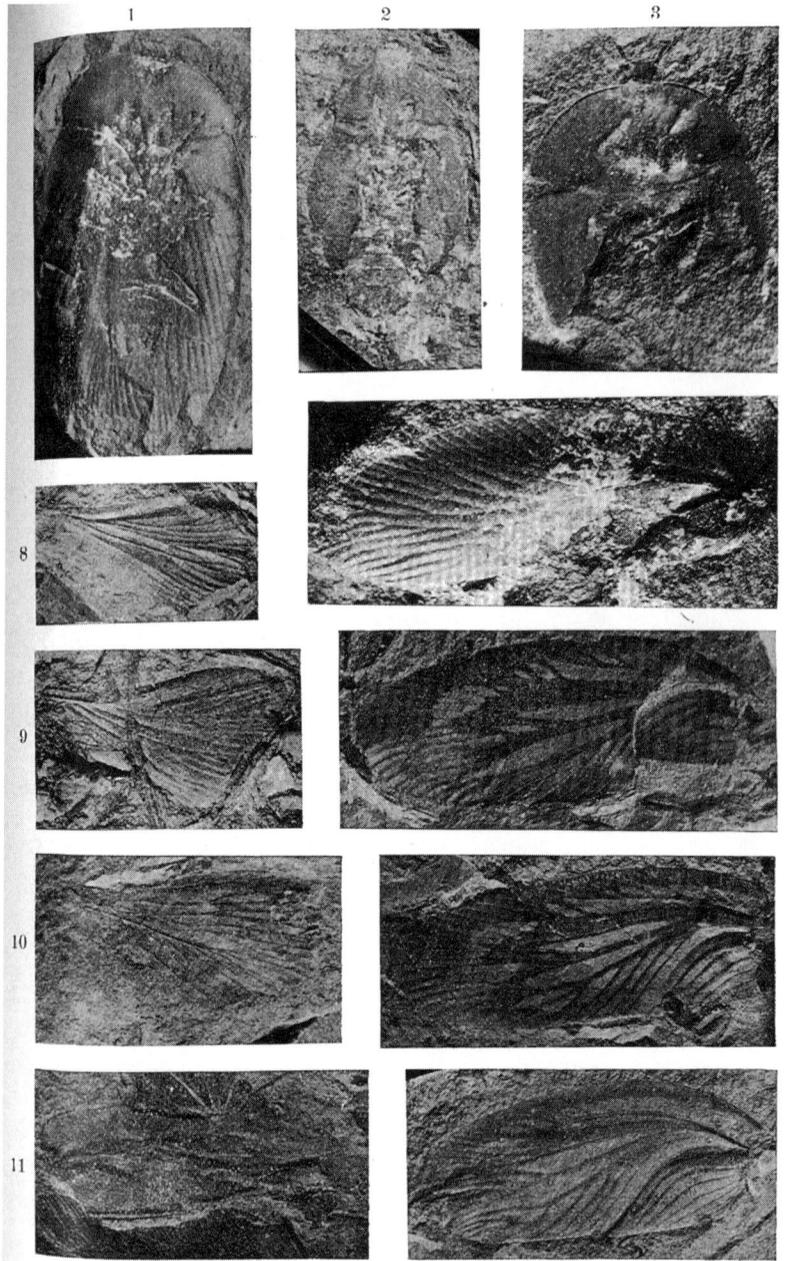

Figure 5.23. Elias H. Sellards, "A Study of the Structure of Paleozoic Cockroaches," 1904.

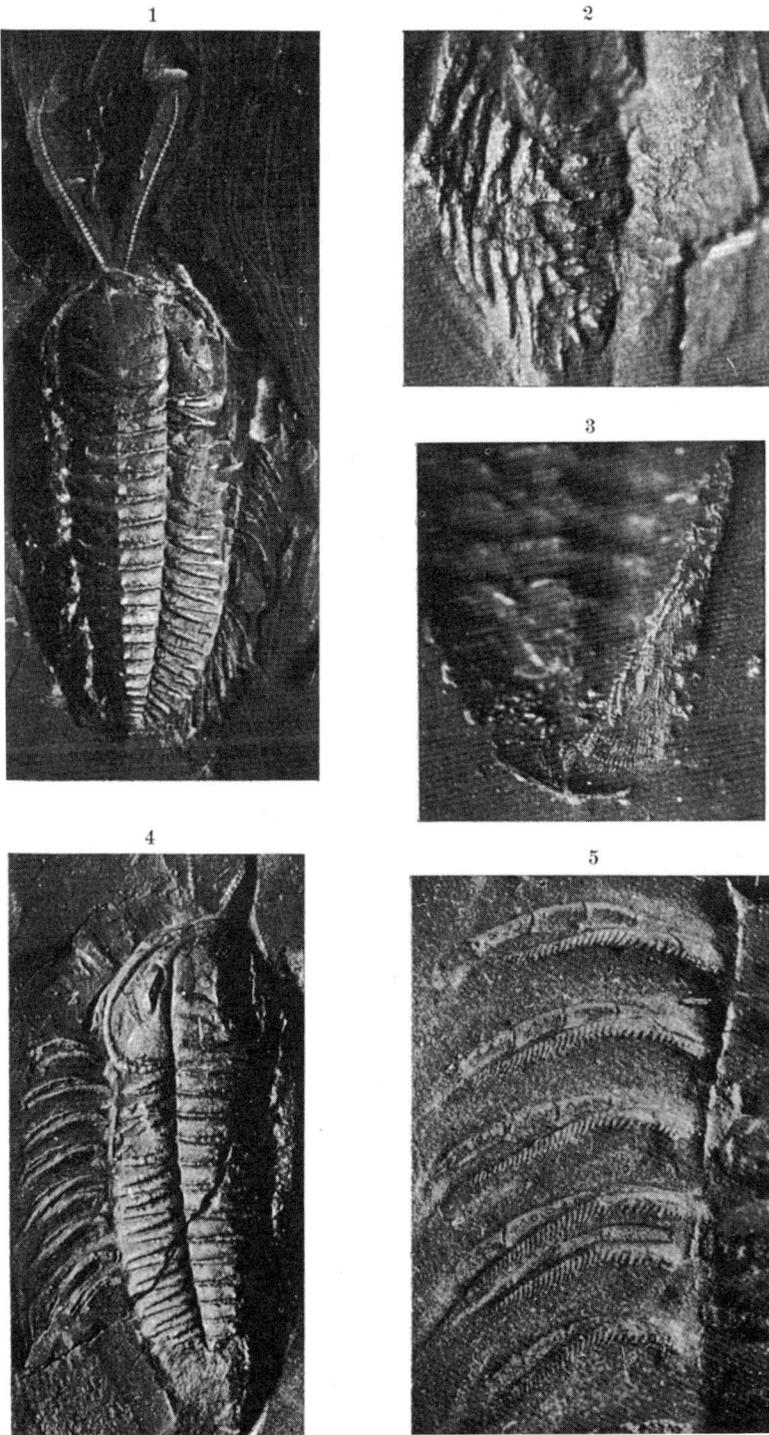

Figure 5.24. Charles E. Beecher, "The Ventral Integument of Trilobites," 1902.

pendages. Elias H. Sellards published three articles on fossil cockroaches in 1903 and 1904, and two of these articles were illustrated with photographs.[58] And there were photographs of various bones of marine reptiles in an article by Samuel W. Williston published in 1906. Williston's "North American Plesiosaurs: *Elasmosaurus, Cimoliasaurus* and *Polycotylus*" contained four plates

showing specimens from the collections of the Yale Museum. Williston had been using photographs in his publications since the late nineteenth century.

The *American Journal of Science* did not confine its articles on fossils to vertebrates and invertebrates. Its early-twentieth-century volumes also featured photographs of trace fossils. Two articles from the journal in 1917 contained photographs of a partial trackway and some additional trace fossils believed to be from the upper Cambrian. The July 1917 issue contained an article by Willard R. Jillson entitled "Preliminary Note on the Occurrence of Vertebrate Footprints in the Pennsylvanian of Oklahoma," which featured a photograph of a partial trackway found in sandstone at Elm Creek. Jillson suggested that the footprints had probably been made by an amphibian. This was a very literal preliminary notice, and the author invited others to comment upon his findings. The photograph showed the slab with tracks, alongside of which the photographer had placed a geologist's pick as a by-now-familiar way of showing scale. The November issue contained a similarly speculative article in which the author, Lancaster D. Burling, presented a discussion and several photographs of what he believed to be trails or trackways in Upper Cambrian rocks from several sites in North America. Burling was not certain what sorts of animals might have made these trails—if indeed they were trails. Like Jillson, he invited the opinions of others, and like Jillson, he hoped the photographs would assist readers in forming their opinions.

Richard Swann Lull (1867–1957) wrote *Fossils,* a small survey work, in order to provide a book for the general reader. Though it was intended to double as a guide to the Yale Peabody Museum, Lull also included discussions and images of fossils in other museums. The book opens with a wonderful photograph showing Lull himself standing beneath the museum's restored skeleton of *Brontosaurus.* Lull, of course, was associated with Henry Fairfield Osborn, but he also owed much to Marsh, and it is fair to say he was Marsh's protégé as well. When Lull wrote this little handbook, he was a

Richard Swann Lull

Fossils: What They Tell Us of Plants and Animals of the Past (1931)

professor of paleontology at Yale and also the director of the Yale Peabody Museum. In addition, he was an artist, and his sketches of fossil animals are marked with a certain liveliness. He shows the animals with facial expressions (although obviously he could not have known what their expressions might have been like) and sometimes in motion. Lull's attempt to enliven his fossil animals may show the influence of his contemporary Charles R. Knight, or even that of Edward Drinker Cope himself. A number of Lull's sketches are reproduced in this little handbook, including line drawings of a *Smilodon* (figure 16, page 28) and a rhinoceros, *Diceratherium* (figure 19, page 31), the latter "drawn from the Yale Museum specimen restored by the author." One rather wonderful image, in which Lull resorted to the visual cliché of presenting human alongside fossil animal, is a drawing of *Tyrannosaurus* (figure 41, page 65). Next to the beast—which is shown standing upright, of course—is a full-grown gentleman in a business suit.

Lull also resorted to photography, at times using photographs he had taken himself or reprinting ones he had used in earlier publications. These images are fascinating because they show what some contemporary museum displays and some discovery sites were like. Figure 32 (page 33) is a photograph of "a group of gazelle camels (*Stenomylus*)." Lull had himself collected and mounted these three skeletons. There was also a photograph of *Hesperornis* in a swimming pose (figure 47, page 69), one of Marsh's famous finds. And the guide could not be complete without a photograph of the mounted skeleton of Marsh's famous *Stegosaurus* (figure 35, page 59). While Bernard's *Éléments de paléontologie* had offered an engraving of *Compsognathus longipes,* Lull included a photograph of a cast of the fossil that was owned by the Peabody Museum (figure 18, page 30). Some photographs of invertebrate fossils were used as well. Figure 14 (page 23) is *Globigerina.* Figure 10 (page 14) is a trackway. And one of the most marvelous photographs in the book is figure 6 (page 11), "The Skin Impression of *Chasmosaurus,* a Horned Dinosaur." It is small, because the book itself is small, but one can make out fine details of the petrified integument.

My own favorite photograph is one which Lull took himself. Figure 24 (page 36) shows *Brontosaurus* limb bones and vertebrae partially excavated at Bone Cabin Quarry in 1899. Lull even included the geologist's hammer for scale. It is a wonderful vignette of late-nineteenth-century paleontology.

> The region, now over 6000 feet above the level of the sea, was once low-lying, and the sediments were the accumulations near an ancient shore line or the sloping bank of a muddy estuary or lagoon. Here the dinosaurs must have lived, not far from the place where they lay buried. Rarely does one find an approximately complete skeleton; the remains consist largely of articulated limbs or tails or possibly the neck . . . after the partial dismemberment of the carcass.[59]

This is precisely what the photograph shows.

THE TWENTIETH CENTURY

6

The style of illustrations in paleontology publications has remained amazingly uniform for nearly the last two hundred years. Early-nineteenth-century book-length studies frequently included some type of illustration, reconstructing the animals and perhaps also placing them in an imagined ecological setting. In that way, representations of the fossil flora could be included as well. This sort of illustration was followed by images of the individual fossils themselves. These images might be engravings, woodcuts, line drawings produced with the assistance of a camera lucida, lithographs, or, eventually, photographs, or lithographs or engravings of photographs. If the animal was a vertebrate, these images were combined with smaller illustrations of specific bones or sections of the skeleton. While skeletons were commonly depicted, outline drawings designed to indicate the general morphology of the fossil animal were presented as well. These formats were used for illustrating scientific studies, but also appeared in books written for the nonscientist, such as the works of David Thomas Ansted. While these styles of illustration derived logically from the way in which the data were presented, there is no clear reason why a particular visual format should have been so rigorously maintained from work to work, decade after decade. Nor is there any reason why such formats should continue to be used in the twenty-first century. But the nature of the fossil materials themselves makes these formats logical. It is important to show how the fossil looked in its rock matrix and how it looks outside the matrix. If the fossil is that of an animal or plant, its presumed appearance in life needs to be shown; if it is the fossil of a vertebrate, the skeleton and its components need to be shown as well. Still, some aspects of this time-honored set of formats, such as mere outline drawings, seem at times incongruous in art today. Yet they persist in scientific illustration. It would seem that outlines have not lost their utility.

Another consistency in paleontology illustration has been its inconsistency in quality and detail, even of illustrations within a single work. Nineteenth-century books and papers couple excellent engravings and lithographs with rather crudely prepared woodcuts. Today, photographs that show excellent resolution of perhaps even microscopic details of the specimen may be placed in the same work with crude outline drawings of the animal or with photographs so small and lacking in resolution as to be generally useless to the reader. These discrepancies may tell us more about the history of publishing than they do about the history of paleontology. For the most part, I think it is fair to say that scientists always tried to ensure accurate and high-quality illustrations in their papers and books, but they did not always succeed. Can

Figure 6.1. Richard Ellis, *Sea Dragons*, 2003. Illustration by Richard Ellis.

we put these inconsistencies down to editors' desires to cut corners and save money? Scientists, too, may not wish to spend money on high-quality art if their findings can be adequately presented in a less expensive manner. Not everyone had the fortunes of paleontologists like O. C. Marsh and Edward Cope. Undoubtedly such considerations are part of the answer.

Is there also a historical legacy at work here? By this I mean, do editors decide, in effect, "Well, we have always done things this way, and all illustrations need not be of equal technical quality because there is no replacement for seeing the real fossil anyway?" There is some truth to this too. And yet we have scientists and artists, such as Benjamin Waterhouse Hawkins and Henry A. Ward, who did their best to assist those who could not see a specimen by giving them good-quality reproductions. We have seen Henry F. Osborn demand outstanding photographs done to scale of sections of the fossilized integument of his "mummy" hadrosaur.

Inconsistencies in the quality of illustrations are not unique to paleontology. Books and journals in other fields show similar discrepancies. This may not have been much of a problem if the book contained, for example, religious iconography. A topic such as that was essentially mythical anyway, even if the reader believed that the images depicted truth, so it mattered less if book after book used the same old-fashioned ones. But when scientific illustration is involved, it seems quite peculiar that images were not always as accurate and high-quality as possible. More flexibility might be allowable in life restorations or even outline drawings of fossil animals, as no one knew what these creatures looked like in life anyway. Some guesses could be made by, for instance, comparing the dinosaurs to reptiles. The osteological evidence indicated that these new animals must have been reptiles or at least reptile-like. Thus the term "fearfully great lizard" made its appearance in the nomenclature. But while some early dinosaur specimens, like *Iguanodon,* were first restored to look like big iguanas, the scientists and artists seem to have given themselves less leeway when it came to coloration of the integument. For well over a century and a half, illustrators showed most dinosaurs in neutral grayish or green colors. Presumably they did so out of the belief that dinosaurs were slow-moving, stupid, torpid critters, cold-blooded reptiles. This is odd in itself, as there were always scientists, including Huxley, Cope, and John Ostrom, who noted that some dinosaurs were not like that. Eventually, with new discoveries that made the relationships between dinosaurs and birds more obvious (at least, to most scientists), there came a change in how integuments were colored. Suddenly it became almost de rigueur to show one's dinosaur with spots, stripes, and even day-glo colors. Similarly, when some specimens were found with feathers, dinosaurs almost immediately received all manner of feathery appurtenances. From a strictly aesthetic standpoint, these changes have become almost irritating. One gets tired of brightly colored fauna traipsing about the landscape. There is something distressing about a *Mamenchisaurus* the color of mushy watermelon, such as Frank Hood's restoration in a recent popular book about dinosaurs.[1] One gets weary of wattles and feathered displays ostensibly used to attract mates. We don't know that dinosaurs were spotted, striped, brightly colored, or feathered. Yet,

more and more often, such animals stand before us in life restorations. Similarly, we do not know that certain species of prehistoric fish were colored in certain ways. Nor do we have any evidence that marine reptiles were all bluish or greenish. Perhaps ichthyosaurs were bright red. Perhaps they had spots and stripes. It becomes almost refreshing to find an artist like Richard Ellis, who did all his marine animals in black and white.[2] A similar starkly powerful image is the black-and-white photograph by Mark Westerby that adorns the dust cover of Michael J. Benton's *When Life Nearly Died: The Greatest Mass Extinction of All Time.*[3]

I suspect that some of the artists who have adopted colorful palettes have been influenced by the fantasy art of the second half of the twentieth century. As a result, these artists have ventured into a new area of paleontology illustration. While fossils were always used as decorative items, restorations of fossils were not. Some twentieth-century artists and, for that matter, some scientists are now doing so.

There can be no question that paleontologists and the artists who illustrate their work have been influenced by popular books such as William Stout's 1981 *The Dinosaurs.* This book presents aspects of what life may have been like for various dinosaurs, and it is filled with Stout's beautiful color renditions of life forms in ecological settings. Most of the dinosaurs are depicted in fairly traditional camouflage colors, but not all of them. Some are highly colored; others could almost be tarot card images. This is a beautiful book. Who can resist a *Camarasaurus* poking its head up, like an alligator, out of a lake filled with what looks like big duckweed? Is the color of its integument realistic? Who knows? These are dinosaurs that are decorative art.

Dougal Dixon's marvelous *The New Dinosaurs,* which appeared in 1988, is indeed a complete work of fantasy. But Dixon utilized his abilities as scientist and artist to present fascinating creatures just at the edges of plausibility. Again, some of these animals are shown with quite amazing coloration and marking. Today when we look at *The New Dinosaurs,* we have almost twenty years of familiarity with these "day-glo" dinosaurs, and the book may have lost some of its initial impact. I recall showing it to a friend, a professional herpetologist, when it was new. He glanced at it and commented that he didn't want to look at it much because his mind was jammed with images and scientific names of lizards that he had to remember for his work, and images like Dixon's tended to stick in his mind as reality, when of course they were not. I think this statement has much to say about the impact of Dougal Dixon on future artists.[4]

But, even if they did not know the skin or eye color of an extinct animal, scientists certainly knew the positions of muscle attachments in some specimens. The strange-looking life restorations from the turn of the twentieth century, even by artists, such as Charles R. Knight, who carefully studied the anatomy of living animals and the skeletons of their fossil creatures, cannot be excused by arguing that the artists didn't know where muscles would have been attached. In a sense, there has always been an element of fantasy in paleontology illustration, although neither the scientists nor many of the artists intended it. This is due to artistic creativity and to the tendency of scientists, artists, and their publishers to keep things as they had always appeared. Some-

how consistency in images lends an air of truth to the work. If you don't think this is true, reread what I said above about the day-glo dinosaurs.

Representations of fossil life and fossil ecology were incorporated comfortably into the new art form of the twentieth century, the motion picture. While this study cannot begin to discuss the enormous number of motion pictures that have featured prehistoric life, I will make mention of a few important examples. Motion pictures and their technologies are, in my opinion, the United States' most significant contribution to the arts in modern times. Most representations of fossil life in films were guided by fantasy, rather than scientific illustration. As a result, restorations of fossils have been the subjects of works by some of the century's most important fantasy artists. Several of the most important animators, including Ray Harryhausen and the teams at Walt Disney Productions, devoted attention to fossil life.[5] But that did not preclude the filmmakers from looking at contemporary paleontology illustration. There is a connection between entertainment and scientific illustration.

Later in the century, of course, film and television would be used in scientific illustration. Here too there is enough visual diversity to allow discussion of the verisimilitude of particular restorations or patterns of behavior. Computer animations have enhanced our understanding of how an animal may have moved, but they have also caused more discussion and perhaps confusion, as opinions tend to vary in these matters.

Paleontology Illustration in the First Half of the Twentieth Century: Some Representative Examples

He was an artist who enjoyed working in close association with paleontologists . . . in order to depict as accurately as possible numerous animals never seen by man. He was an artist with great powers of imagination. . . . His restorations had a vitality that made them remarkably convincing. He was truly a pioneer.

Edwin H. Colbert, quoted in Sylvia Massey Czerkas and Donald F. Glut, Dinosaurs, Mammoths and Cavemen, *1982*

Charles R. Knight (1874–1953)

At the turn of the twentieth century, the painter and sculptor Charles R. Knight was all over the place. One could scarcely open a book, whether scientific or popular, without finding Knight's art. As the century progressed, his murals became famous old friends to visitors at the American Museum of Natural History. They were what visitors and probably many scientists alike thought various paleoecologies were like. As the century progressed, Knight's work appeared in Chicago at the Field Museum of Natural History, in Pittsburgh at the Carnegie Museum, and in Los Angeles at the Los Angeles County Museum of Natural History. The murals in the Field Museum are particularly interesting because Knight went to considerable pains in these to recreate ancient landscapes as well as to present restorations of fauna. His 1925 mural in the Los Angeles County Museum of Natural History depicts a vignette of the landscape around the La Brea Tar Pits as it would have appeared in prehistoric times.

And he didn't stop there. Knight's restorations of fossil animals and ecological settings appeared in *National Geographic Magazine* in February 1942. This brought his prehistoric worlds to many people who had not been to the big museums. And Knight's art had an impact on the artists who drew and animated the *Rite of Spring* sequence in Walt Disney's landmark animated motion picture *Fantasia,* which appeared in limited release in 1940 and general release in 1941. He was popular. He was good at what he did. And he used to his advantage the connections that he had formed early in his career. Moreover, his restorations were infused with a lifelike quality

that made them seem real to the observer. Whether the behaviors he depicted were accurate was something for later generations to discuss. Suffice it to say that Knight did the best he could to be scientifically informed, and without question many believed his art was accurate.

Here I do not propose to discuss Knight's murals in detail, because they are well known and images of them are readily available on the Internet. Details of his life are equally well presented in published materials.[6] Instead, I will briefly survey Knight's impact on paleontology illustration, with the hope that some of these examples may be less well known to some readers.

Knight and Osborn's Models of Extinct Vertebrates

Knight was sketching taxidermic specimens at the American Museum as early as 1894. He met Jacob Wortman at this time and created a life restoration of the prehistoric mammal then called *Elotherium* for him. In 1896 he met Henry F. Osborn. Through this association Knight came to work with the young William Diller Matthew, but, more importantly, he also met Edward Drinker Cope.[7] At this point, Cope was near the end of his life. He died on April 12, 1897. Cope collaborated with Knight and another author friend of his, William H. Ballou, to produce an illustrated article, "Strange Creatures of the Past," that appeared later that year in *The Century Magazine*. This article put Knight on the artistic map, so to speak.[8]

Henry F. Osborn wrote a short article in *Science* in 1898 in which he discussed the importance of making images of fossils and fossil restorations available to the general public. He presented several photographs of models made by Charles R. Knight under the direction of Osborn and his staff, and also reproduced paintings and drawings Knight had done of the animals as they might have appeared in life.[9] Knight routinely made preparatory drawings, but he also built wax models before beginning a painting. These models evolved, as it were, into plaster casts, small sculptures that are interesting in their own right.

Osborn's article is a logical extension of Knight's "Strange Creatures of the Past," which had appeared the previous year in *The Century Magazine*. Both articles were designed to publicize Knight's art and Osborn's American Museum, suggesting that the Museum could furnish such models to other institutions. Osborn also wanted such models, packaged together with reproductions of Knight's art, made available to schools so that students could study them. Osborn was able to get J. P. Morgan to purchase the Knight models and then donate them to the American Museum, essentially both paying Knight for his services and raising funds for the Museum.[10]

This idea of making models of life restorations was certainly not new, as scientists had been sharing casts and models of fossils (including restorations of fossil vertebrates) for decades. Edward Hitchcock sent casts of his trackways abroad, and Benjamin Waterhouse Hawkins made small models of his Crystal Palace restorations. Copies of the latter were sold by Henry Ward. What makes Knight's models interesting is that they were inspired by the art of Edward Drinker Cope as well as the scientific input of Osborn and his colleagues at the American Museum. Osborn's article is important because it il-

It is a coldly accurate representation of what science thinks went on.

Deems Taylor, opening words of the Rite of Spring *sequence in the film* Fantasia, *1940*

The New York Academy of Science asked for a private showing of *The Rite of Spring* . . . because they thought its dinosaurs better science than whole museum loads of fossils and taxidermy.

John Culhane, referring to a contemporary article in Time Magazine, *1983*

Figure 6.2. Frederic A. Lucas, *Animals of the Past*, 1901. Photograph of model of *Triceratops* by Charles R. Knight.

lustrates paleontologists' attitudes toward scientific illustration at the turn of the twentieth century and their desire to work with artists.

Just as Owen, Hawkins, and Ward had commented decades earlier, Osborn again stated that large museums like the American Museum needed to share their contents with others, and not incidentally, encourage support and donations. Osborn did not mince words.

> There are certain obligations resting upon the curators of metropolitan museums from which curators of university museums should enjoy a grateful immunity. These mainly involve the difficult undertaking of arousing interest and spreading accurate information among a very large class of inquisitive but wholly uninformed people. If these obligations are unfulfilled the metropolitan museum fails in its purpose and deserves the withdrawal of public support. With this general idea in mind, members of the Department of Vertebrate Paleontology at the American Museum have been making a special study of all the legitimate methods of attracting the attention and interest of visitors. Among these methods are the series of water-color restorations of extinct vertebrates, executed by the animal painter, Mr. Charles Knight, with the aid of various scientific suggestions and criticisms. The preparation of these drawings involves a far more careful preliminary study than would generally be supposed. The artist begins by making a number of models in wax, based upon the actual proportions and muscular indications of the skeleton, and by a series of preliminary anatomical studies representing different attitudes and feeding habits. . . . Out of the necessity of giving the restorations a complete and natural artistic relief, the wax models have been made with increasing care, and it finally occurred to the writer that with a little more elaboration, the models themselves might be made well worthy of preservation in plaster form first finished in wax and then cast from a carefully prepared plaster model, as represented in the accompanying photographs. . . . Professor Cope, shortly before his death, gave Mr. Knight the benefit of many criticisms and ingenious suggestions.[11]

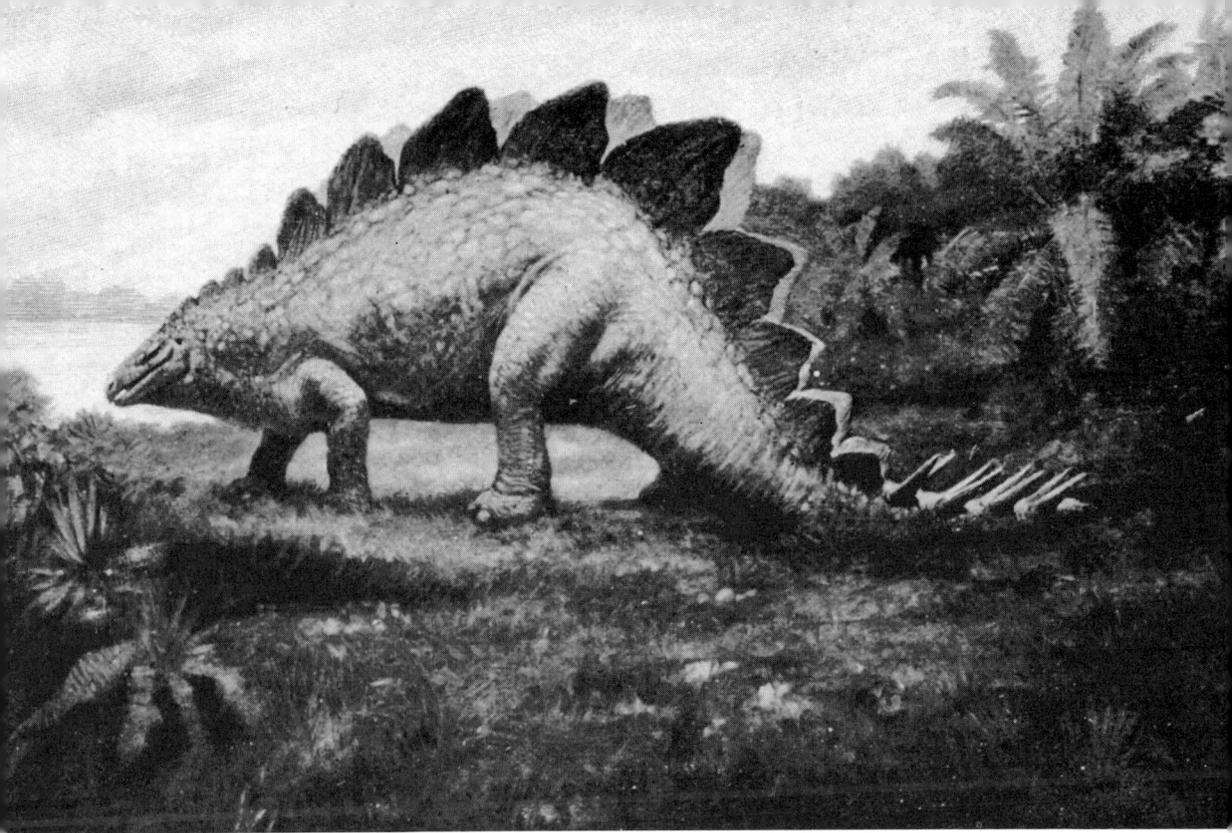

Figure 6.3. Frederic A. Lucas, *Animals of the Past*, 1901. Photograph of painting of *Stegosaurus* by Charles R. Knight.

When Osborn published this article four models had been prepared, and these were presented in photographs. (This is another example of the American Museum's early interest in using photography.) Anyone familiar with Knight's paintings of these restorations will immediately recognize his work in these models. They were of three dinosaurs and one primitive reptile, and were identified as *Agathaumus sphenocerus* Cope, *Hadrosaurus mirabilis* Leidy, a pair of fighting *Megalosaurus (Laelaps, Dryptosaurus aquilungis* Cope—today *Dryptosaurus*) and *Naosaurus claviger* (now *Edaphosaurus*) Cope, a sail-back reptile.[12] The ceratopsian *Agathaumus sphenocerus* Cope is based, Osborn said, on the restoration done for Marsh of *Triceratops prorsus*, although this is a different genus and species. "The tubercular character also given by Mr. Knight to the epidermis is conjectural."[13] By mentioning this as well as the collaboration of Cope and others, Osborn was stressing that the appearance of these models was based on the most up-to-date science.

Photographs of various paintings by Knight appeared in a number of scientific and popular publications in the early decades of the twentieth century. Many of them have already been discussed in the context of photography. A photograph of a sculpture of *Triceratops* by Knight was depicted in Lucas's *Animals of the Past* in 1902.[14] Osborn's 1918 *Origin and Evolution of Life* includes several depictions of Knight's work, some placed alongside illustrations of the fossils themselves so that the reader may compare the fossil with the "living" animal.

Fantasia

One of the most interesting effects of Knight's work is the impact it had on the animation of the segment of Walt Disney's *Fantasia* that was based on Stravinsky's *Rite of Spring.* Planning for the film began in 1937, and the animation was underway in 1938. In this segment the animators told the story of the creation of the galaxy, the solar system, and the earth, and of the origin of life. Then they proceeded to depict how that life evolved, taking the viewer through the age of the dinosaurs and what caused their demise. Contemporary publicity materials for *Fantasia* credited Stravinsky; indeed, he came to Los Angeles to consult with the animators and Disney himself on the film, and he was paid for the use of his work.[15] But there is not one mention of Charles R. Knight. Certainly Knight's work was quite well known by 1938, and the filmmakers were in contact with scientists at the American Museum of Natural History, yet Knight's name is not brought up in connection with the film. I find this just amazing. And although it seems obvious that the animators were influenced by Knight, I know of no studies of this influence. Perhaps the animators weren't aware of Knight's impact on their work.

Fantasia is a splendid motion picture. Both its animation techniques and its sound reproduction were innovative. It was a pioneering venture into an entirely novel world of movie making. This motion picture was almost entirely created using single-cell animation photography, with each cell individually drawn by hand. Models were made for sequences like the *Rite of Spring.* But even in these sequences, details of the background were drawn. Art students today are accustomed to the use of computerized animation in motion pictures. They must be reminded over and over that each nuance of motion in *Fantasia,* each slight change of color, every detail that is different from how it appeared a moment ago, represents another drawing and another photographic cell. *Fantasia* is a masterpiece. Without question it is the finest example of single-cell animation ever made.

The sound track of the movie is equally astonishing. *Fantasia* was recorded in eight-track stereophonic sound. Special equipment was necessary to play this movie in theaters so that the "surround sound" (to use a modern term) could be heard correctly. This was the first time stereophonic sound was used in a motion picture, which is why the sound track has a segment devoted to it, as one of the stars of the movie. The sound engineers at Disney were justifiably proud of themselves. Successful sound motion pictures were still fairly new in the late 1930s. This is a mere decade after *The Jazz Singer,* the first film to incorporate sound (in 1927). And when Al Jolson's character spoke in that film, the sound of his voice was provided by a record player placed behind the projection screen. Disney's technicians had come light years forward, and now eight-track stereophonic recorded sound could be played through a system of multiple speakers stationed throughout the movie theater.

Several of Knight's paintings depict landscapes similar in coloration to some of those depicted in *Fantasia.* The hadrosaurs he painted before the film's release were based on Cope's work, and the hadrosaurs in *Fantasia* are quite similar, in their anatomy and stances, to Knight's. The scenes Knight painted for the Field Museum between 1926 and 1930 come closer to various

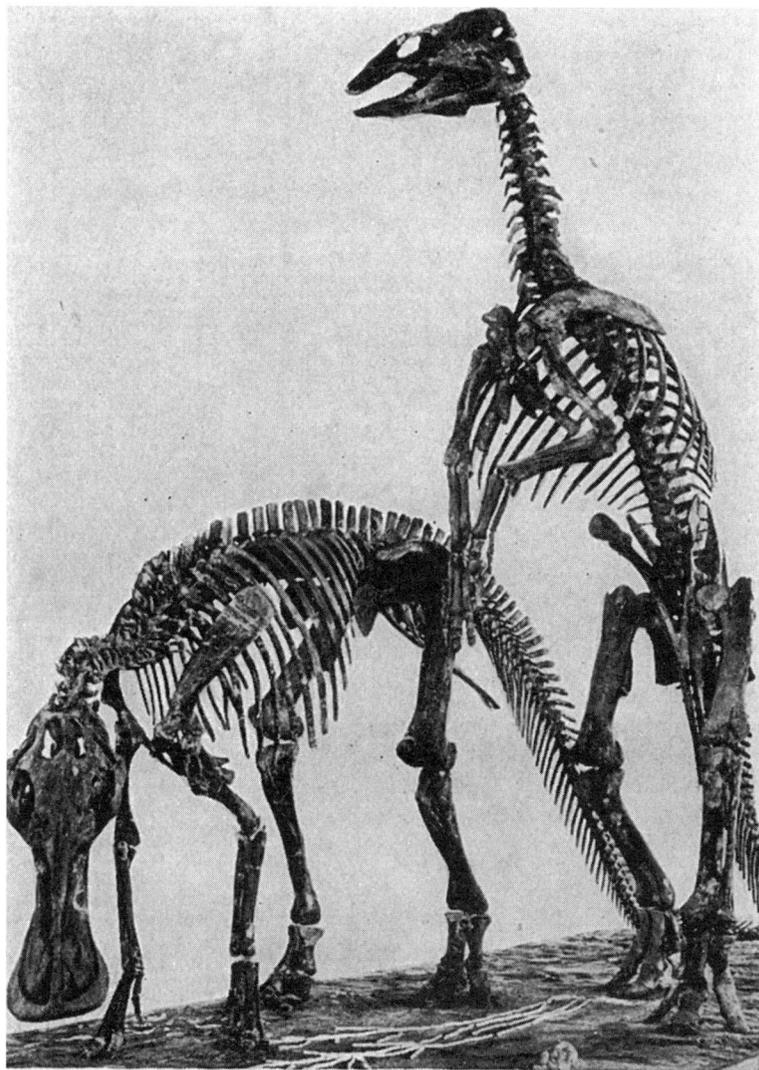

Figure 6.4. Henry F. Osborn, *The Origin and Evolution of Life*, 1918. Photograph of painting of hadrosaurs by Charles R. Knight, after Edward D. Cope.

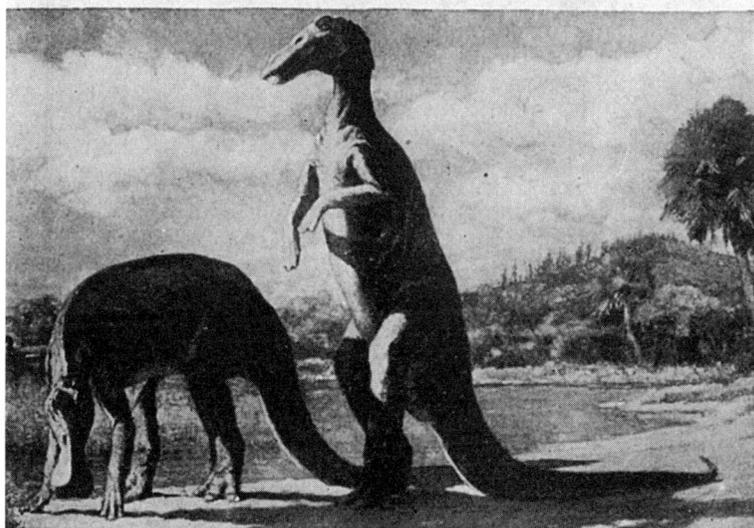

sequences in *Fantasia* than does his work for the American Museum. In particular, a vignette of plesiosaurs and an ichthyosaur foraging is very similar to a scene in the film. Knight's depiction of North American dinosaurs of the Upper Cretaceous shows foraging *Parasaurolophus* and *Struthiomimus* specimens which are again quite similar to those in the movie.

The illustrations that Knight created for his 1942 *National Geographic* article were not particularly innovative, but they did make it possible for even more people to see his concepts of ancient life forms. Interestingly, some of the illustrations look quite similar to some of the scenes in *Fantasia*. We do not know whether Charles R. Knight went to see *Fantasia*, and this article was published almost simultaneously with the general release of the movie. But the similarities are striking. Does this bolster the contention that the Disney artists were influenced by Knight? Possibly they influenced him as well. One illustration shows *Diplodocus* specimens swimming or floating in a lake. Knight had shown sauropods in lakes before, but in the 1942 scene the animals' necks seem to extend out of the water much as they did in *Fantasia*. Knight also depicted a mosasaur leaping from the ocean to snatch a pterosaur. The same image appeared in *Fantasia*, but that is such a commonplace motif, going well back into the nineteenth century, that it is not really significant here.

Much more significant is Knight's painting of *Allosaurus* fighting a stegosaur, also at the Field Museum. In earlier murals and paintings, he had shown a battle between *Tyrannosaurus rex* and ceratopsian dinosaurs. Portraying the life-and-death struggle between dinosaur predator and prey was not new, but the prey had changed. When the animation team drew the *Rite of Spring* sequence, they reflected the idea, popularized by Osborn and others, that *Tyrannosaurus rex* was an aggressive predator of herbivorous dinosaurs. They also showed a variety of forms of prehistoric life, reptiles and early mammals, much as twentieth-century murals did. It was not considered very important to picture together only animals that were thought to be of the same eras, or to have roamed the same places. Museum displays, as well as motion pictures, juxtaposed specimens in ways that thus suggested incorrect relationships among them. Certainly Benjamin Waterhouse Hawkins knew that mammoths and dinosaurs had not coexisted, yet he placed them in the same displays. Knight's new vignette in Los Angeles, featuring an impossible scene between predator and prey, may indicate that the artist went to the movies.

Henry F. Osborn and Charles C. Mook, *Camarasaurus, Amphicoelias, and Other Sauropods of Cope* (1921)

Henry Osborn and Charles Mook's book on Cope's sauropods deals in detail with several specimens in the Cope Collections of the American Museum as well as other sauropod discoveries made by Cope. It contains a variety of illustrations: photographs of quarry sites, maps, line drawings of reconstructed skeletons, life restorations, and even photographs of sculptures and engravings based upon photographs of specimens. The text was written by Charles Craig Mook (1887–1966) and Osborn with the assistance of William King Gregory (1876–1970) and Walter Granger (1872–1941). Art for the book was for

Figure 6.5. Henry F. Osborn and Charles C. Mook, *Camarasaurus, Amphicoelias and Other Sauropods of Cope*, 1921. Sculpture by Erwin Christman.

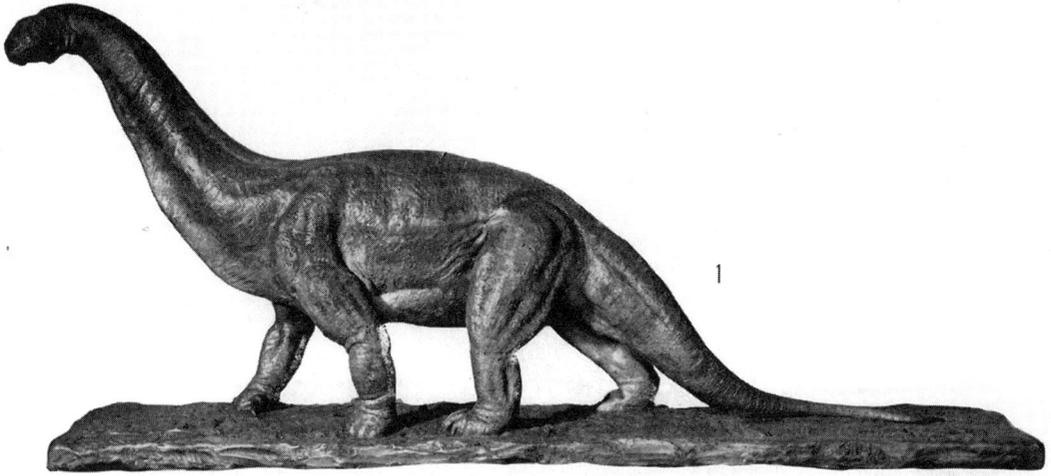

1

2

3

4

Figure 6.6. Henry F. Osborn and Charles C. Mook, *Camarasaurus, Amphicoelias, and Other Sauropods of Cope*, 1921. Restorations of head of *Camarasaurus* by Erwin Christman.

A

B

C

the most part furnished by Erwin Christman (1885–1921) and his assistants. Christman is frequently remembered for his sculptural restorations, and plate 85 shows four photographs of his model of *Camarasaurus*. Charles R. Knight had influence on this book as well. The caption for plate 85 indicates that Christman made this model with Knight's technical advice. There is also a reproduction of Knight's painting of restored *Amphicoelias* specimens in an ecological setting. Osborn noted in the preface that Gregory and Granger had also worked with the artistic team. "The restoration studies have been made with the co-operation of Dr. William King Gregory from the standpoint of musculature and locomotion . . . [and] some difficult morphological problems."[16] There are numerous fold-out plates of bones and reassembled skeletons. These were drawn by Christman, and they are exceptional. Rudolph Weber, Margarette B. McMullen, and Wesley Seim helped him in this work, although the large drawings seem to be by him alone. Since Christman died in 1921, this was obviously one of his last artistic productions. The publication would, I think, have made Edward Drinker Cope proud. It was certainly in keeping with his high standards for illustrations.[17]

Arthur C. Seward, *Fossil Plants for Students of Botany and Geology* (1898–1919) and *Plant Life through the Ages* (1933)

Arthur Seward (1863–1941) was a paleobotanist who worked with the British Museum of Natural History and was also a professor at Cambridge. His books, which are written at the college level and deal with living and extinct plants, are interesting examples of trends in illustration in the first half of the

Figure 6.7. Arthur C. Seward, *Plant Life through the Ages*, 1933.

twentieth century. Like many twentieth-century volumes, Seward's books contained many illustrations, and these were in a variety of media: drawings, restorations, photographs of fossils and modern ecologies, and even drawings of ancient ecologies. Volume 2 of *Fossil Plants* (1910) contains 265 illustrations, including photographs and also a large number of drawings by Seward and his wife, who was also an illustrator. *Plant Life through the Ages* (1933) is noteworthy for several line drawings that show restored ancient landscapes. These were made by Edward Vulliamy of King's College, Cambridge. They are done with a clean economy of design, and are populated by large numbers of representative specimens of fossil life. Each of the plants is identified on the illustration's legend. Figure 48 is "a later Devonian landscape," figure 107 shows the flora of the Cretaceous period in Greenland, and figure 119 depicts the "Oligocene landscape of the Isle of Wight." While these drawings are black-and-white, they were done with such an appreciation for detail that the reader can easily compare them to photographs of modern landscapes. Vulliamy organized his perspectives just like those of a photograph. The effect is quite realistic and wonderful.

Frank Springer, *American Silurian Crinoids* (1926)

American Silurian Crinoids is a humble-looking book, sitting on library shelves with many other studies of paleontology. The volume, which presents a small selection of Frank Springer's (1848–1927) vast collection of fossil echinoderms, was published just before his death. Springer, a businessman and attorney in New Mexico, had published on fossil echinoderms since 1877. He had a lifelong interest in them, and in 1911 he and his colleague of twenty years, Charles Wachsmuth, donated their collection of specimens as well as a large library of literature on echinoderms to the National Museum of Natural History. They were shipped by rail in 269 boxes that weighed a total of more than twenty-four tons. Today the Springer Echinoderm Collection is, according to the Smithsonian, the largest collection of fossil crinoids in the world.[18]

Springer's book was illustrated with drawings and engravings of specimens he had collected. Most of the art was done by Kenneth M. Chapman. What makes the book's illustrations quite interesting is that Chapman usually first photographed the fossils and then drew his illustrations from his own photographs. In a few cases he worked from photographs taken by others. Each plate contained illustrations of a number of specimens, generally drawn to scale. At first glance, they look like photoengravings. There are only thirty-three plates in *American Silurian Crinoids,* but these are beautifully prepared, both as works of art and as visual references. Perhaps Chapman and Springer thought that the medium of engraving would better present details of the crinoids.

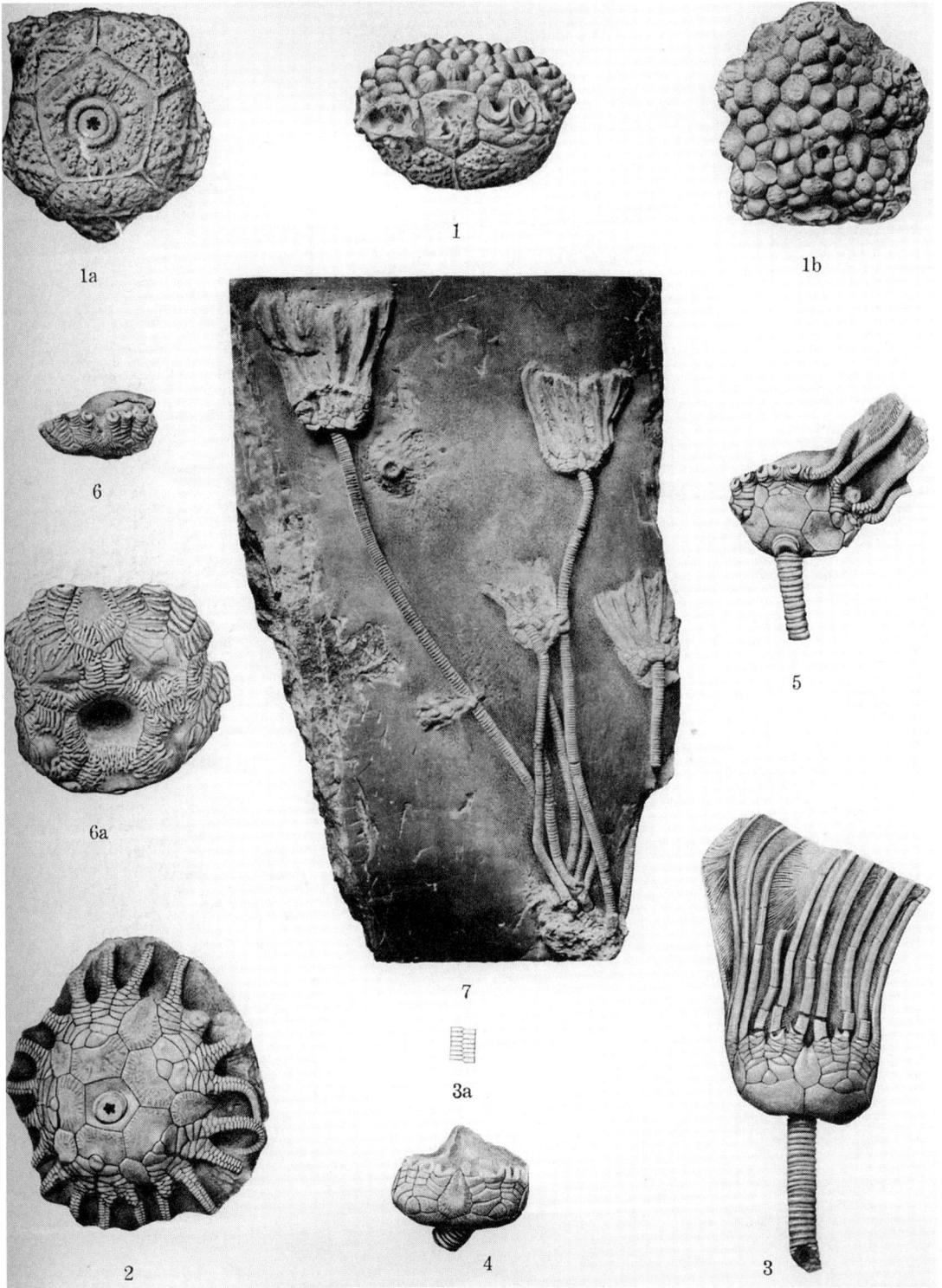

Figure 6.8. Frank Springer, *American Silurian Crinoids,* 1926.

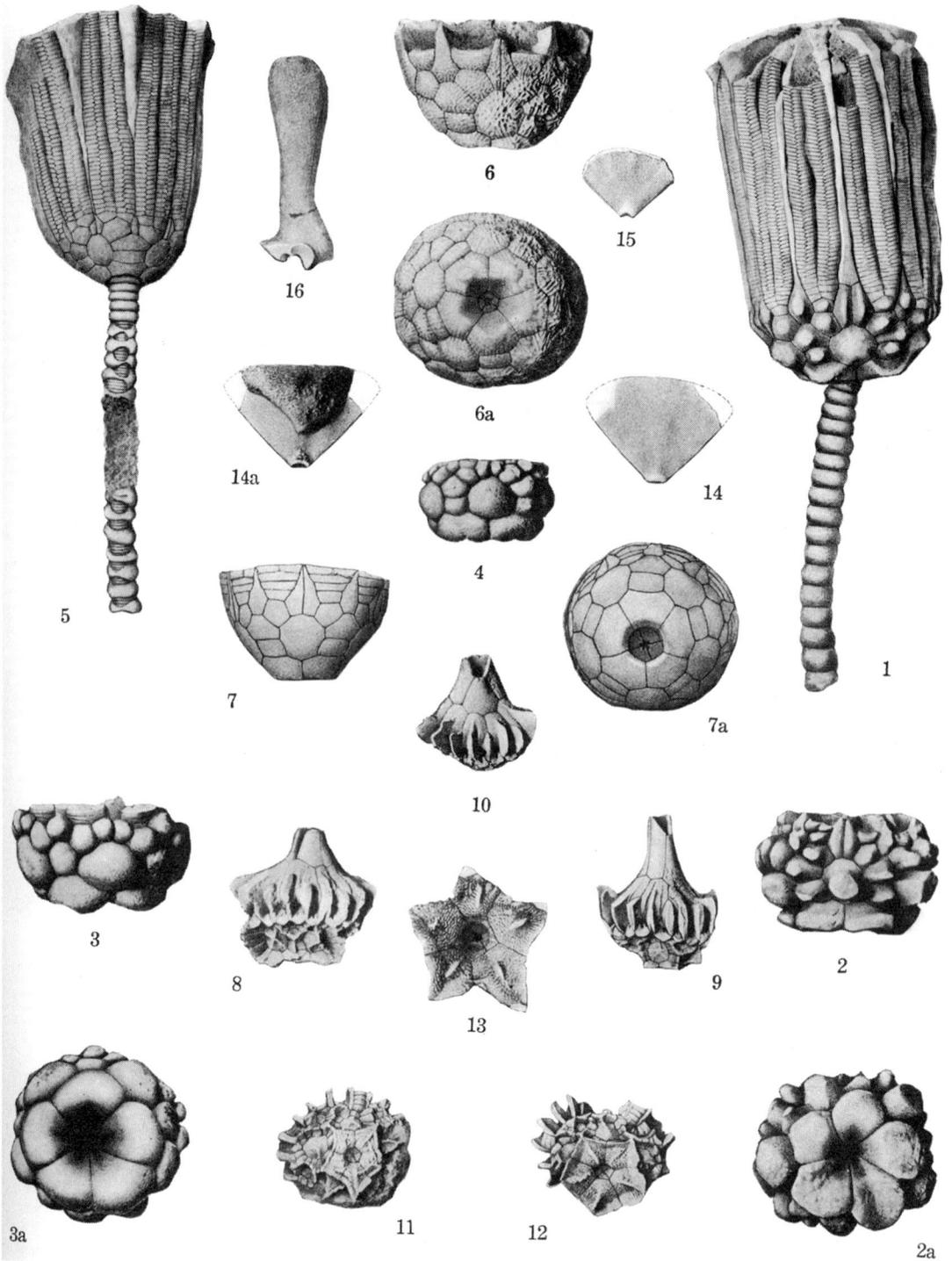

Figure 6.9. Frank Springer, *American Silurian Crinoids,* 1926.

Poses, Postures, and Pictures of *Tyrannosaurus rex*

Whole books have been written about *Tyrannosaurus rex*. One which is a delightful presentation of the story of the specimens, as well as how reconstructions changed over the twentieth century, is John Horner and Don Lessem's

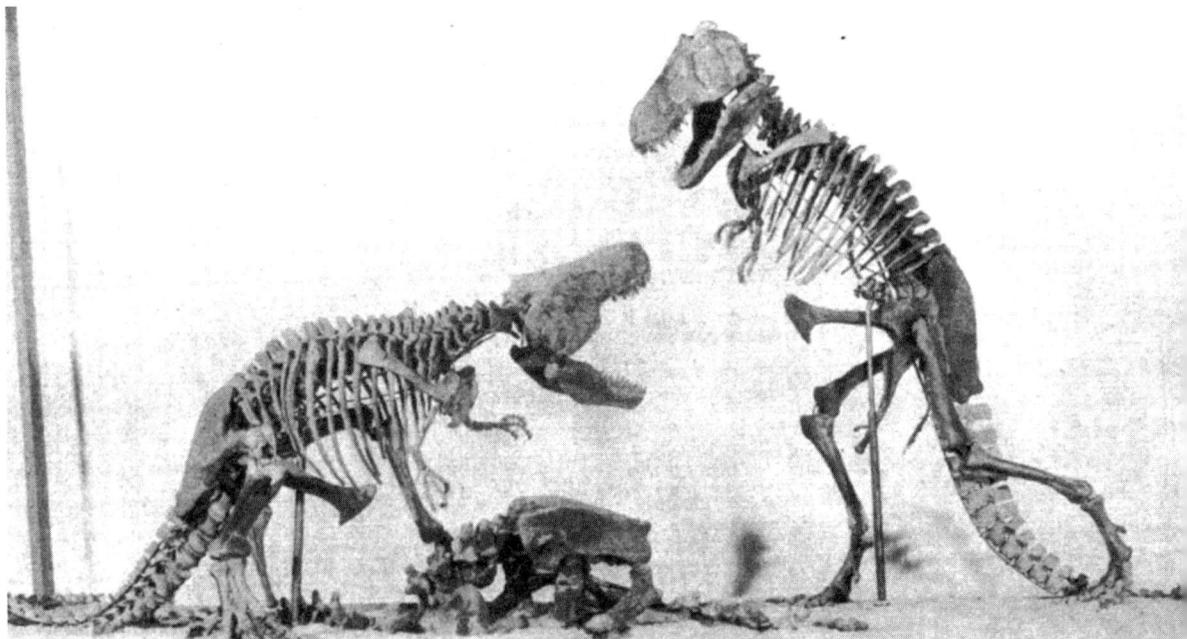

The Complete T. rex, published in 1993. This book appeared right after the original mount of *Tyrannosaurus rex* at the American Museum was taken down in 1992 so that the skeleton might be reassembled in a new pose, leaning forward rather than standing upright. The book documents visualizations of the animal to that point in the twentieth century, as well as new artistic restorations of how the animal was now thought to have stood and moved. As over a decade has now passed, and people have become used to the new pose and stance of the skeleton in the American Museum, *The Complete T. rex* has itself become part of the history of paleontology illustration. It is now a time capsule.

Tyrannosaurus rex remains today one of the best-known dinosaurs, if not the best known of all. Its skeleton had been reconstructed by 1915 (largely from Barnum Brown's 1908 second specimen), and the reconstruction presented the animal in its most familiar upright pose. But Henry F. Osborn knew that *Tyrannosaurus rex* did not stalk about on its hind legs, as the reconstruction showed it. The skeleton was assembled upright essentially because this was the only way in which the enormously heavy rocks could be mounted. Horner and Lessem discussed this problem, noting that "here were animals nearly twenty feet high and twice as long whose heavy bones needed iron braces to support them. Once the metal frame was attached it was impossible to reposition the bones."[19] Osborn originally wanted his *Tyrannosaurus rex* to be posed in a much more agile position. He seems to have had in mind poses similar to those of the restorations made by Cope and then Knight (after Cope) of *Dryptosaurus.* Osborn had the American Museum's sculptor, Erwin Christman, prepare various small wooden models that were actually movable. Three separate poses were created, as well as a pair of animals fighting over the remains of prey. But these were also deemed impossible

Figure 6.10. Henry F. Osborn, "*Tyrannosaurus:* Restoration and Model of the Skeleton," 1913. Photograph by Abram Anderson of models of *Tyrannosaurus rex.*

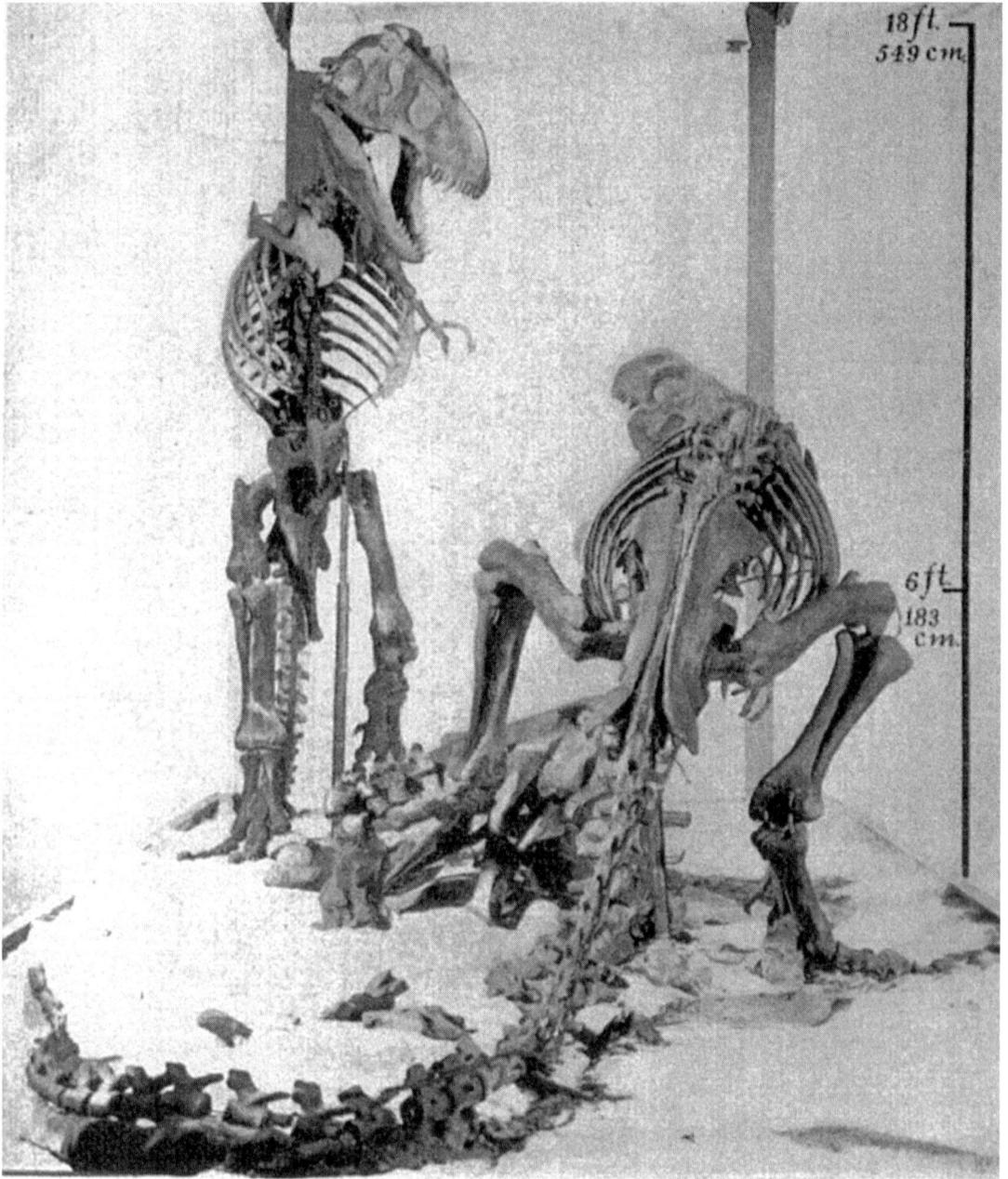

Figure 6.11. Henry F. Osborn, "*Tyrannosaurus:* Restoration and Model of the Skeleton," 1913. Photograph by Abram Anderson of models of *Tyrannosaurus rex.*

to build. The models can be seen in a 1913 article by Osborn with a series of photographs probably taken by Abram Anderson. They indicate how these models appeared and how the poses of the skeletons differed from the upright poses of the finished mounted individuals.[20]

All these poses were eventually abandoned because of the sheer weight of the specimen and the need for strong metal rods to support the display. Some of them could not be built using the metal support rods available.[21] And the eventual restoration took into account the ceiling of the hall in which the displayed skeleton would stand. So, in the end, Osborn settled

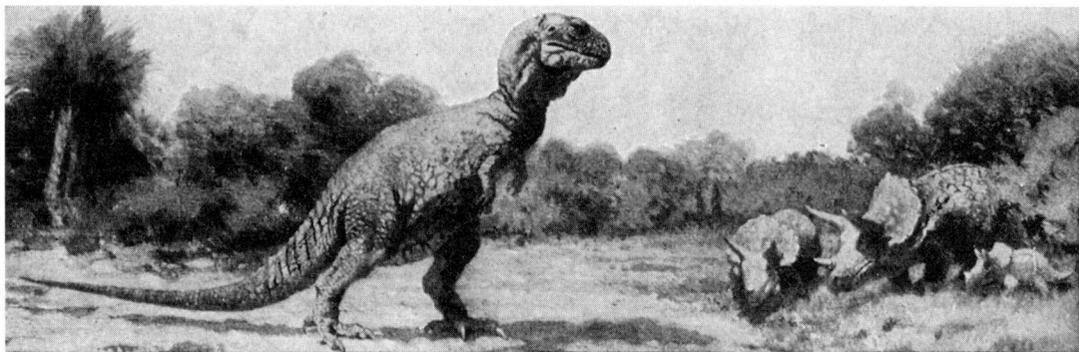

Figure 6.12. Henry F. Osborn, *The Origin and Evolution of Life,* 1918. *Tyrannosaurus rex,* after Charles R. Knight.

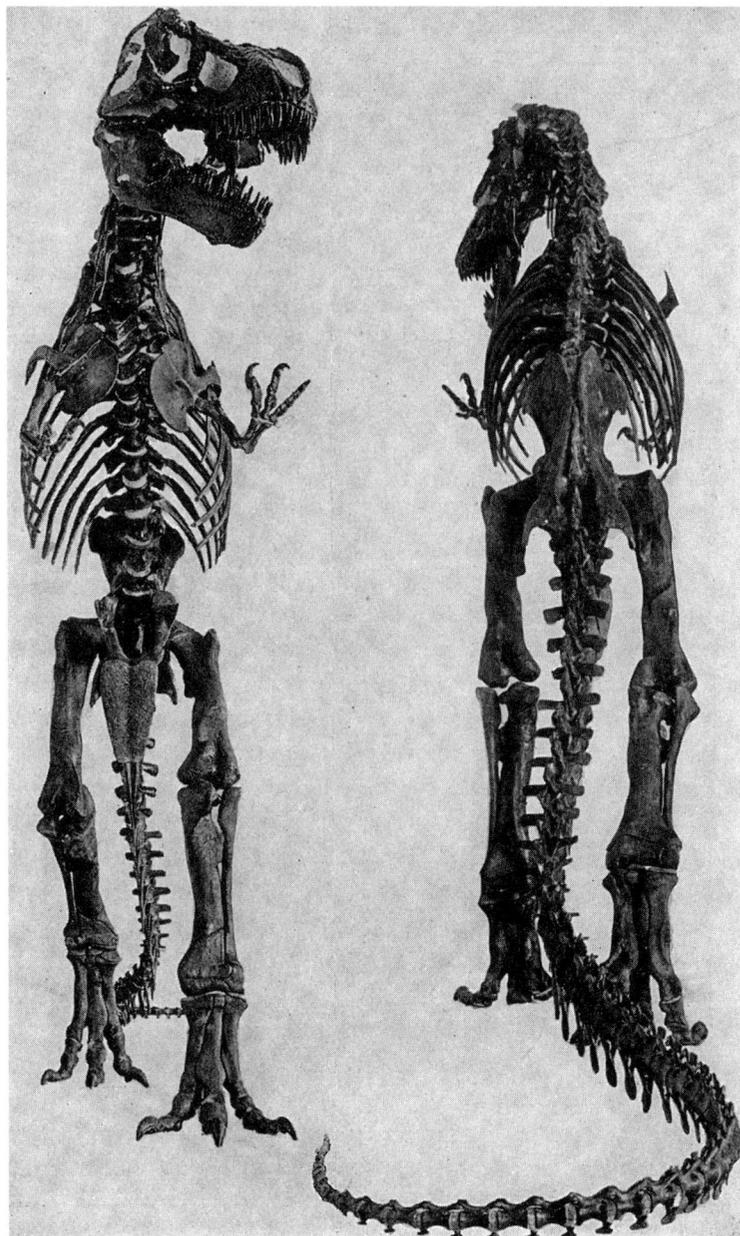

Figure 6.13. Henry F. Osborn, *The Origin and Evolution of Life,* 1918. Photograph by Abram Anderson of *Tyrannosaurus rex* skeleton. "The King of the Tyrant Saurians."

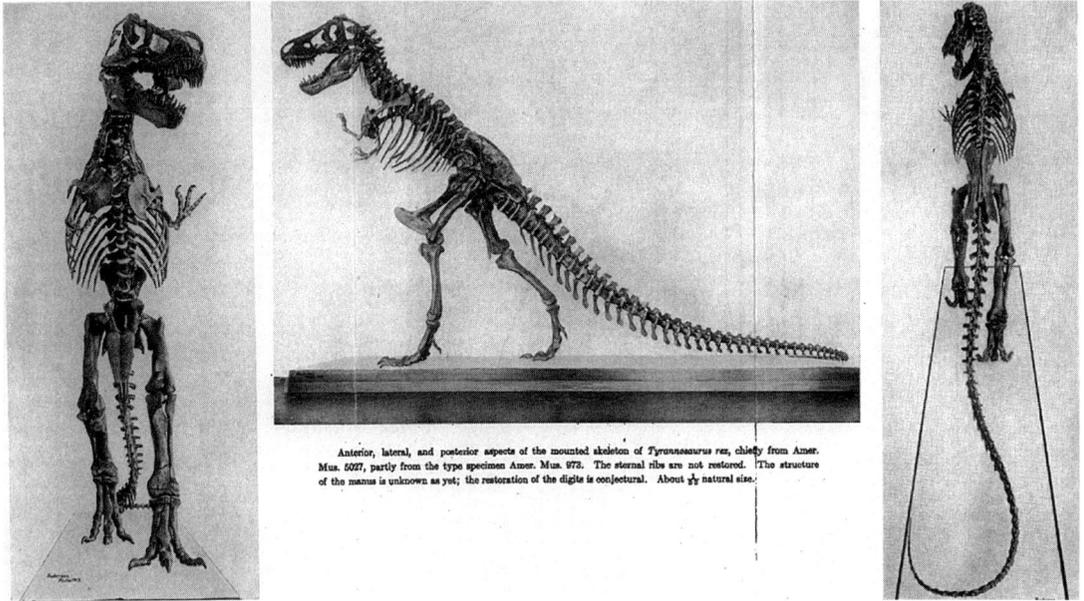

Anterior, lateral, and posterior aspects of the mounted skeleton of *Tyrannosaurus rex*, chiefly from Amer. Mus. 5027, partly from the type specimen Amer. Mus. 973. The sternal ribs are not restored. The structure of the manus is unknown as yet; the restoration of the digits is conjectural. About $\frac{1}{18}$ natural size.

Figure 6.14. Henry F. Osborn, "Skeletal Adaptations of *Ornitholestes, Struthiomimus, Tyrannosaurus,*" 1916. Photograph by Abram Anderson of various poses of *Tyrannosaurus rex* model.

for one upright skeleton, slightly stooped from the most upright pose so it would not bump its skull on the ceiling.[22]

Osborn's restored skeleton was photographed by Abram Anderson, the house photographer. The images were published in Osborn's 1916 article, and these, as well as the actual mount, became the sources of numerous artistic reproductions, including those of Charles R. Knight. Anderson photographed the skeleton from the front, side, and rear. In his published photographs he retouched the images so that none of the structural mounts remained. The effect was spectacular. *Tyrannosaurus rex* almost came alive, even if it was stumping clumsily along. Osborn made no secret of the retouching. He called the photographs "superb" and noted that after Anderson took them in 1915, they were "subsequently perfected by his skilful retouching of the negatives whereby all trace of the powerful steel frame work which supports the mounted skeleton has been removed." Osborn used Anderson's photographs of the skeleton face on and from behind as the frontispiece to his 1918 *Origin and Evolution of Life,* in which he called the dinosaur "[t]he climax among carnivorous reptiles of a complex mechanism for the capture, storage and release of energy. The King of the Tyrant Saurians."[23]

Osborn's 1916 paper was his third publication on *Tyrannosaurus rex*. Interestingly, in his second, the 1906 "*Tyrannosaurus,* Upper Cretaceous Carnivorous Dinosaur," he included a restoration drawing by L. M. Sterling that showed the specimen in a slightly more stooped pose than it would have in 1916. Sterling gave the animal a more flexed neck and a much shorter tail. The resulting effect is that the animal seems less upright. It is still erect, but its pose suggests its modern stance.

The daunting, upright *Tyrannosaurus rex* remained reality for most of the twentieth century. It is probably safe to say that most who saw the skeleton thought this was how the animal had stood and moved.

One of the delightful aspects of Horner and Lessem's farewell to the 1915 image of the upright *Tyrannosaurus rex* is that they included many modern, often popular, representations of the animal. They published stills from science fiction motion pictures, newer models displayed by various museums after paleontologists began to discard the traditional Osborn pose, and illustrations by Douglas Henderson, David Peters, Greg Paul, and Mark Haslett. Their book contains a color reproduction of Knight's mural from Chicago, but also shows a number of contemporary works of art in which the animal's new pose is seen. However, the artists were not inventive when it came to integument coloration. The animals are still shown in relatively subdued browns and greens, like military camouflage. These artists were evidently not prepared to suggest highly colored birdlike integuments for this dinosaur.

Horner and Lessem's illustrations show the tyrant saurian, as Osborn called it, and one large illustration depicts the animal in a complete ecological setting, a forest, standing as though it has sensed something. In some of these illustrations, *Tyrannosaurus rex* scavenges; in others, it hunts. The question of whether *Tyrannosaurus rex* had been a predator, as Osborn had envisioned it, or an opportunistic scavenger was being debated in the early 1990s. The edges of the later pages of *The Complete T. rex* are adorned with little cartoon-like animals. Riffling these pages, one can see an animation of the dinosaur either running up to grab prey or just feasting on a discovered carcass. Which scene appears depends on which direction one riffles the pages.

Lowell Dingus's 1996 *Next of Kin: Great Fossils at the American Museum of Natural History* depicts in color photographs the new pose of *Tyrannosaurus rex*. Photographs also show the process of reassembling the new mount. This was in keeping with the Museum's own historical approach of giving its visitors the history of both the old display and the making of the new one. This book, like Horner and Lessem's, is a historical document as well as a repository of scientific illustrations.[24]

In the third quarter of the twentieth century, paleontology artists began to be much more comfortable experimenting with the coloration of their dinosaurs. This of course reflected the new belief that these animals had not been cold-blooded, and that some of them might even have had feathers. *Tyrannosaurus rex* has become a colorful beast as well. After all, no one knows what colors the animals displayed. Luis Rey's joyous celebrations of integument colors, for which he is sometimes criticized by colleagues, are shown in his rendering of *Tyrannosaurus Rex* specimens in the popular book *A Field Guide to Dinosaurs*. Luis Rey and his co-author, Henry Gee, created imagined scenarios for their dinosaurs. They freely state that their book is largely a work of fiction, because we don't know much about the actual living habits (or colorations) of these animals. And so it is fair to show a trio of *Tyrannosaurus rex* individuals in pinkish orange and green. The authors describe them as "blue-grey on the dorsal surfaces, grading to deep red or even purple on the flanks, legs and underparts." To my eyes, they are watermelon tourmaline.[25]

Gertie the Dinosaur (1914), *The Lost World* (1925), and *King Kong* (1933)

While this book is not primarily concerned with popular films, a few pioneering motion pictures do deserve attention because they featured restorations of fossils. Winsor McCay's (1863–1934) animated film *Gertie the Dinosaur* appeared in 1914. Gertie was a cartoon animation of a sauropod, perhaps a brontosaur (apatosaur), that first appeared with McCay in a vaudeville act. He would stand on stage and address the figure of Gertie on the screen. Gertie then seemed to respond to his commands. The drawings were made by McCay and George McManus. Some sources indicate that McCay made as many as ten thousand separate drawings, which were photographed for the finished film. McCay and McManus also appeared in live action at the end of the film. In 1914 the combination of an actor on stage and a cartoon figure was quite innovative and no doubt entertaining. A similar illusion was used in 1940 in *Fantasia,* when Mickey Mouse seemed to appear on the podium with Leopold Stokowski. It is a famous vignette, but it was not a novelty.

It didn't matter to the audience that Gertie had a run-in with a mastodon. Most probably didn't know any different. This was certainly science fiction. Like all good movies, *Gertie* inspired a knock-off version, which appeared in 1915. This movie, also entitled *Gertie the Dinosaur,* was produced by John R. Bray. And, like all good movies, *Gertie* also had a sequel. *Gertie on Tour* appeared in 1917. Winsor McCay, John McCay, and John Fitzsimmons were the animators. This film has not survived intact and only a small portion of it is known.[26]

The 1925 version of *The Lost World,* based on Arthur Conan Doyle's yarn about the discovery of life forms thought to be extinct, was the artistic creation of animator Willis O'Brien (1866–1920). Several restorations have been made of this motion picture and they remain entertaining, although it is unclear whether any of these actually recreate the entire film. Some of the original footage may have been lost.[27] Unlike Gertie, the prehistoric creatures shown in *The Lost World* were created using stop-motion animation. That means that each cell of the film was created by photographing posed models. Every movement of the animals required the models to be repositioned and photographed again. O'Brien had used animated prehistoric beasts in an earlier film called *The Ghost of Slumber Mountain* (1919), which ran about fifteen minutes. *The Lost World* sits chronologically between this movie and O'Brien's masterpiece, *King Kong* (1933). All of these films were made using stop-motion animation.

King Kong (1933) certainly contains some of the most famous motion picture sequences ever of dinosaurs and other prehistoric fauna. Directors Merian C. Cooper and Ernest B. Schoedsack hired Willis O'Brien to do the animation for this film as well—including animating the famous ape itself. Again it is well to remember that this was a landmark film for its special effects as well as for its use of sound. Veteran composer Max Steiner's musical score and the special sound effects of technician Murray Spivak enhanced this movie and made it truly terrifying to audiences. Aficionados of this genre

tend to consider it the best of the King Kong motion pictures in spite of its antiquity. The sequel, *Mighty Joe Young,* won O'Brien an Oscar for special effects in 1949. It also brought animator Ray Harryhausen into association with O'Brien. O'Brien's influence on Harryhausen was considerable, and of course Harryhausen became famous for several stop-motion animation movies in which he also depicted prehistoric life.[28] *Mighty Joe Young* is a touching motion picture. The quality of the model work, which of course now bore Harryhausen's stamp as well as that of O'Brien, is very high. Even modern audiences are still touched by the lifelike pathos of Mighty Joe.[29]

Carroll Lane Fenton, *Life Long Ago* (1937) and Carroll and Mildred Fenton, *The Fossil Book* (1958)

Carroll Lane Fenton (1900–1969), a geologist and paleontologist, published a number of works on geology, paleontology, evolution, evolutionary theory, and genetics. His paleontology books were illustrated with a variety of media. They contained black-and-white photographs, color and black-and-white illustrations, and engravings. Some of the illustrations were based on works by other contemporary artists, such as Knight, William King Gregory, Heilmann, and Gilmore. Many of these were redrawn by Fenton for use in his own books. He included restorations of fossil life forms and also depictions of fossil ecologies in both his college-level texts, of which *The Fossil Book* (cowritten with his wife, Mildred Adams Fenton) is an example, and in his numerous books for children, such as *Life Long Ago.* The latter is quite remarkable for the number of its illustrations, several of which are in color. Young readers could learn about many life forms, including plants, vertebrates, and invertebrates, and see how they looked and where they lived. *Life Long Ago* was published in 1937 and went through several editions. *The Fossil Book was* published in 1958 and also went through several editions, the most recent of which appeared in 1989. The Fentons provided many of its illustrations, again basing some of them on works by others, to whom they were careful to give credit. The style and design of these books are fascinating. As is typical in twentieth-century book design, both set out to provide many visual representations. But these books are memorable because of Fenton's texts and his artistic style. The 1937 book was dedicated, "To the men who took me fossil-hunting when I was a boy. They showed me how much fun it was to . . . understand the ways of ancient animals and plants."

Carroll Lane Fenton took several generations of young readers fossil-hunting through his publications. Those of us who grew up devouring every word of *Life Long Ago* remember it most fondly. It had a lasting impact. Recently I looked at a copy, having not seen one in decades, and the images came back to my mind just as familiar as they were when I was in third grade and read it over and over, believing every single word and trying hard to pronounce the scientific names correctly. There was no doubt in my mind that this was how life had been, "long ago." Fenton loved his fossils, and he conveyed to his readers just how much fun they were.

Rudolph Franz Zallinger (1919–1995)

Rudolph Franz Zallinger's major contributions to scientific illustration were his large frescoed murals in the Yale Peabody Museum. These were painted in the technique of *fresco secco,* on dry plaster. The first of these murals, *The Age of Reptiles,* was executed between 1943 and 1947. This mural was actually awarded a Pulitzer Prize in 1949. The second mural, The *Age of Mammals,* was commenced in 1953 but was left unfinished due to financial constraints until the 1960s. In both of these, Zallinger attempted to show a progression of fossil life through time and to create ecological settings for the animals and plants. His goal was to give the viewer a sense of a landscape typical of each prehistoric period. *The Age of Reptiles* begins with the Devonian and proceeds through the Cretaceous. Zallinger's murals are, of course, always compared to those of Charles R. Knight. The comparison is largely a matter of

Figure 6.16. C. L. Fenton, *Life Long Ago*, 1937. Illustration of invertebrates in a reconstructed environment by C. L. Fenton.

aesthetic taste. Each artist was commissioned to enliven walls in museum galleries with images that would help the viewers understand what the fossils around them would have been like in life. In keeping with the twentieth century's penchant for offering information in multiple media, the idea was to show the viewers the fossil, sometimes in its skeletal restoration, together with life restorations. Both artists made serious efforts to work with contemporary paleontologists in order to be realistic. Knight is usually thought to have been more able to make his animals lifelike in their activities and perhaps their appearances. But Zallinger also tried to show his fauna engaged in plausible activities. As to integument coloration, both artists worked with

similar palettes. In addition, Zallinger and others, including John Ostrom, wrote a brief book that outlined the making of *The Age of Reptiles* and the paleontology behind the life forms seen in the mural. This book includes a pull-out color section showing the entire series of paintings.[30]

The Past Goes toward the Future: Paleontology Illustration in the Second Half of the Twentieth Century and Beyond

Patterns that define the types of illustrations used in paleontology illustration were defined long ago, and these patterns have remained popular. Scientists continue to be artists. They continue to work with artists toward the goal of accurate and well-crafted imagery. Artists continue to study scientific publications in order to make their restorations more correct. Scientific and popular books and articles continue to contain illustrations in a variety of media. We still see reproductions of paintings, sculptures, drawings, even microscopic photographs of specimens. Large, freestanding sculptures seem to have become more common, but they were not novel in the last decades of the twentieth century. Benjamin Waterhouse Hawkins made large sculptures. More late-twentieth-century art may depict fossil ecologies, although these motifs were found throughout the nineteenth century and the first half of the twentieth century as well. Artists and scientists are using new media techniques, such as animatronics models, computer animation, and images made from CAT scans, but while these media are new, the idea of using new media is not. Has anything changed? Is paleontology illustration in the twentieth and twenty-first centuries a stagnant stack of visual clichés? These are questions we must examine as writing and illustrating the past history of life proceeds toward tomorrow.

What should be the position in scientific illustration of television programs, such as the BBC's popular Walking With series, which began with the 1999 *Walking with Dinosaurs*? The programs in this series featured computer-generated restorations of various forms of fossil life, along with stories designed to involve the viewers in what prehistoric life might have been like. Are programs like these to be considered scientific illustration? Does the inclusion of a made-up story line, making animals into named characters, take away from the scientific validity of such materials? I pose these questions without attempting to answer them. Perhaps it is too early to analyze such programs. It should be remembered, however, that scientists have been writing about what they thought prehistoric life was like since at least the 1860s. Even Edward Drinker Cope posited a set of activities for the animals he described in his article "Fossil Reptiles of New Jersey," although he didn't give them cute personal names. But the desire to teach what a fossil life form was like when it was not a fossil, but a living organism, is scarcely novel. We must ask again whether anything has changed in paleontology illustration since the nineteenth century.

Zdenek Burian: Prehistoric Communities

Zdenek Burian (1903–1981) was a prolific artist who devoted much of his career to making paintings of restorations of prehistoric life and ecologies.

His works number in the thousands. As a paleo artist, he is known primarily for the series of works he illustrated for the paleontologist Josef Augusta (1903–1968). The first to be published in English, *Prehistoric Animals,* appeared in 1957, and it was followed by five others. Burian illustrated many other books as well, filling them with hundreds of color illustrations and black-and-white drawings. His books are thus typical of such twentieth-century works in being profusely illustrated. His paintings are distinguished by their beauty of design and coloration. In addition, Burian was interested in placing his fossil life into settings and communities.[31]

Elizabeth Winson: Restorations of Fossil Communities

The Ecology of Fossils, edited by W. S. McKerrow, was published simultaneously in Britain and the United States in 1978. It contains a number of highly detailed and intricately drawn restorations of fossil marine communities by Elizabeth Winson. The book was a collaborative effort by several paleontologists, all of whom worked with McKerrow and Winson in order to produce the illustrations, which are noteworthy for their beauty and informative quality. Winson provided 125 line drawings showing cutaway sections of ocean floor, illustrating how marine communities at the different levels would have appeared. This book probably had an impact on subsequent studies in which one finds similar reconstructions of communities of organisms, although Winson's drawings are not novel, but only exceptional examples of the style.[32]

John G. Maisey and His Artists: *Discovering Fossil Fishes* (1996)

John G. Maisey's 1996 book, *Discovering Fossil Fishes,* is an outstanding example of how twentieth-century paleontology studies could incorporate various visual media. Maisey's text was greatly enhanced by a combination of color photographs of various fossil fish by Craig Chesek and Denis Finnin, color "portrait" restorations by Ivy Rutzky, and reconstructions of the fish in their habitats by David Miller. In some cases, Miller posed the fish according to the shape of the fossil animal. Thus, one could look at the fossil in its matrix and then see it come to life, as it were. The combination of highly informative text and excellent illustrations gave the reader an overview of the evolution of fish, as well as a tour of ecological settings of various times. This book stands nicely on the border between scientific and popular publications and was certainly valuable to a wide group of readers. This is a beautiful book, in itself a work of art.

Dan Varner: Ancient Marine Ecologies

Dan Varner specializes in depicting fossil marine life in ecological settings. His works are displayed in several museums and appear in various publications as well as on Michael Everhart's website *Oceans of Kansas Paleontology.* Varner also illustrated Everhart's recent book *Oceans of Kansas.*[33]

Modern paleo artists usually work carefully with scientists, or use current scientific materials, in order to create restorations that correctly depict morphology and behavior. Varner is no exception here. He tries to keep up with new studies on posture and locomotion. He makes every effort to show his fauna in plausible marine settings, although usually the animals are shown foraging or swimming alone or with other fauna; one does not see a large variety of attendant life. Varner is not trying to show an entire community. Rather, he concentrates on a specific creature. He places the viewer into the underwater world, much as Henry De la Beche did in his *Duria antiquior* long ago. Varner uses an impressionist style and takes care with the effects of natural light and color in his paintings. He tries to look carefully at the fossil for characteristics that "contribute to the uniqueness of the animal. I show my brushwork, which is going out of style in this digital age."[34] (See color plate 6.)

Gregory S. Paul and Luis Rey: Line versus Color

Not everyone has a taste for the splendidly colorful restorations of Luis Rey. These are executed in his unique style, which relies heavily on showing the animals with dramatically colored integuments. As noted already, no one knows whether Rey's imaginative colors are right or wrong. They are beautiful to some; to others they are strident. Either way, his work is unforgettable, and that is the important thing. He is creating memorable paintings that will continue to impress future viewers. (See color plate 7.)

Greg Paul seems to work at the opposite extreme of paleontology illustration from Rey. His works are distinctive and unique, but they are frequently line drawings in black and white. While he may be best known for these illustrations, he also works in color. Paul's 2002 *Dinosaurs of the Air: The Evolution and Loss of Flight in Dinosaurs and Birds* well represents his art. Paul is both scientist and artist, and this book contains many of his delicate and beautiful drawings. The dust jacket, which shows a *Sinosauropteryx* hunting *Confuciusornis,* is executed in color. It is quiet color, it is not Luis Rey's color, but the illustration certainly gets its point across. Paul has opted for a realistic ecological scene to show this ancient conflict and the possible advantage of being able to fly.

Four Sculptors in Search of a Dinosaur

Sculptural restorations of fossil vertebrates seem to have become more common as the twentieth century ended. A book written by a sculptor, Allen and Diane Debus's *Paleoimagery,* even included a number of these works among its illustrations. Modern paleo artists usually place their works in virtual galleries on the Internet, and the four sculptors discussed below are no exceptions. This raises the question, again, of what position we give to Internet sites as types of paleontology illustration. They and their contents are often ephemeral, and unless the art itself is digital and created solely for that website, then we may suggest that this is not paleontology illustration, but only a

way to see it for a period of time. The question is, does an exhibition of art equal art? The reader may decide. In the meantime, the Web makes it possible for many to see art they might otherwise miss. These sculptors have used the Internet to showcase and advertise their work.

I have referred before to Allen and Diane Debus's 2002 book, *Paleoimagery*. Since Allen Debus is a sculptor, this book seems to be partly a work of history and partly an art book. It presents artists and works which excited Debus and no doubt in some cases influenced him. In a sense, *Paleoimagery* is a big artist's statement, and it includes several photographs of sculptures. Debus has published a photograph of Stephen Czerkas's recent *Stegosaurus,* which he shows along with a *Stegosaurus* by Knight (figure 11-5, page 78). He includes earlier works as well, such as Christman's model of *Camarasaurus* and restorations of *Triceratops* and other animals by the German sculptor Joseph Pallenberg (1882–1946). These were produced prior to the First World War (figure 12-4, pages 91–92).

Naturally Debus also published pictures of some of his own sculptures, as well as those of Brian Cooley, Dougal Dixon, and Michael Trcic, among others. The book contains sections devoted to large-scale outdoor sculptures of dinosaurs. These may stretch the definition of scientific illustration somewhat, but there is no doubt that they reinforce the contention that sculptures of fossil restorations have become increasingly popular. But before we call them novel, it is well to remember again Hawkins and also Joseph Pallenberg, whose sculptures were located outside.[35]

Brian Cooley is featured in the Debuses' book. Cooley may at present be best known for the restoration of the skull of the *T. rex* called "Sue" that he created utilizing Christopher Brochu's CAT scans. Cooley's recent works feature feathered restorations of some dinosaurs, such as *Bambiraptor* and *Protarchaeopteryx robusta*. Images of these sculptures have been published as well.[36]

Don Lorusso's sculpture has been featured in recent scientific publications, and examples of his works can also be seen at his website, *The Dinosaur Studio*. Lorusso's work is probably more traditional than Cooley's in its conception, but Lorusso also works to create a range of fossil sculptures that may be used from everything from toys to museum displays. His business has furnished sculptures to a number of museums, and he tries to maintain what he calls "close working relationships" with paleontologists and other artists.[37]

The last of the four sculptors I discuss here is Michael Trcic. His work is published in the Debuses' book as well as in other books and on his website. Trcic's works also seem somewhat more traditional than Cooley's, but this is a matter of style and medium. He worked for many years as a special effects artist, counting among his credits *Jurassic Park,* for which he was one of the animators of the *Tyrannosaurus rex*. Trcic has also done television animation, including for the Discovery Channel's 2002 film *When Dinosaurs Roamed America*. For non–special effects work, Trcic comments that he too consults with paleontologists in the interest of accuracy.[38] Trcic's works are excellent examples of the twentieth-century's style of multi-media art. (See color plate 8.)

David Grimaldi and Michael S. Engel,
Evolution of the Insects (2005)

The turn of the twentieth century saw the publication of Samuel Scudder's work on fossil insects, with its numerous excellent images. At the turn of the twenty-first century David Grimaldi and Michael Engel produced a profusely illustrated study that without question would have made Scudder smile, and feel jealous. *Evolution of the Insects* is a massive book of 755 pages. It contains more than nine hundred photographs and electron micrograph images of fossil and extant insects. Besides these, a number of line drawings are juxtaposed with the photographs in order to make details of various fossils clearer. The artwork for this book, which is chiefly photography, was created for the most part by Tam Nguyen and Steve Thurston, both on the staff of the American Museum of Natural History. This book is daunting. One does not sit down and read it through. The images are marvelous and enhance the work considerably. Some of the graphics are designed to show components of an insect's body, as though it had been dissected. Others depict the entire animal. And there are many photographs made with a scanning electron microscope. Thus the book blends together newer technologies with more traditional ones. The use of color in most of the images and photographs (not those taken with the SEM) greatly enhances the book's educational value, as well as making it beautiful. Reviewer Thomas Eisner has described *Evolution of the Insects* far better than I. He commented that this book is "a landmark contribution . . . beautifully conceived, splendidly written, and exquisitely illustrated."[39]

CAT scans and SEM photographs are being used in paleontology illustration. Such new technologies may not produce what we traditionally call art, but they are without question valuable assets in scientific illustration. The SEM photographs used throughout *Evolution of Insects* have already been mentioned. Other examples include computer-generated illustrations showing the interior morphologies of microfossils. Philip C. J. Donoghue and his colleagues have used synchrotron-radiation X-ray tomographic microscopy to produce such images. Their results appear as illustrations in a letter recently published in *Nature.*[40] Christopher A. Brochu and Richard A. Ketcham's 2002 CD provides the viewer with CAT scan images of the skull of the *Tyrannosaurus rex* specimen dubbed "Sue" and with Brochu's earlier computer-generated brain cast of the skull. A similar animated set of scans of the skull of a Jurassic crocodilian is presented in a CD prepared by Ronald S. Tykoski and colleagues.[41]

In Conclusion

Although paleontology illustrations continue to appear more rapidly than scientists or other lovers of paleontology can keep up with them, we can nonetheless draw some conclusions at this point. There is a huge amount of paleontology illustration. I began this study by commenting that no one book could possibly cover it all. I have tried here to present a selection of typical, and some atypical, illustrative forms from a number of media. Pa-

leontology illustrations appear in popular publications and programming as well as in strictly scientific materials, as well as the whole universe of fantasy images of fossils. These were not my concern here, but it is undeniable that fossils have made a tremendous impact on fantasy art.

We can say with certainty that this paleontology is inextricably bound to art and illustrative representations. There is no paleontology without imagery, except in the strict sense of looking at the specimens in museums or the field. But even then, paleontologists immediately make sketches, photographs, etc. of what they find and what they collect. The early-nineteenth-century scientists rightly realized that it is impossible to see all the fossils. But one can see images in place of visiting the fossils themselves. Few of us will be able to watch CAT scans or SEM scans as they are made, but we can all read the journals in which these images appear. We all can insert a CD into our computer and enjoy a tour of Sue's skull. Paleontology and its illustrations have developed in concert. The illustrations were there before there was a professional science of paleontology, and thus we can say that there has never been paleontology without its imagery. I think that illustrators have generally tried to represent fossils realistically. There are those, I am sure, who will not agree with this premise, but I think that the materials I have presented here well support this contention. I have been surprised by how many paleontologists were themselves artists. I am not quite sure what this means, but it does reinforce the importance of art to the paleontologist.

A few years ago I proposed a new course in History of Paleontology Illustration at my university. The kind members of the college's curriculum committee inquired whether there was such a thing as paleontology illustration and, if there was, was there enough material to make up a course? I came to their meeting armed with my rare books and other illustrative materials, including that CD on *Tyrannosaurus rex,* and I went away with a newly approved course.

I have tried to demonstrate that there is a genre of art that we may call paleontology illustration, which developed its distinguishing characteristics early on. These characteristics included realism and careful attention to details. Paleontology illustration derived its emphasis on realism and detail from renaissance artists whose new style was based on accuracy. Renaissance scientists, some of whom were artists as well, also wished to depict fossils accurately and carefully. All of this was part of the newly developing empirical sciences of the sixteenth century. The artistic styles of the seventeenth century, which grew out of renaissance art, also emphasized realism. Again, paleontology illustrators followed not only the art theory of their day but the wishes of scientists. With the seventeenth century, a new stylistic aspect entered paleontology illustration. This was the desire of baroque artists to depict rare and beautiful objects. Fossils easily fit into the category. I think that many of paleontology illustration's unique characteristics originated in the styles of the Renaissance and the seventeenth-century baroque. Further, paleontology illustrators always experimented with new visual media, such as new forms of printmaking and, later, photography, in order to make their images more accurate and more detailed. This interest in new art techniques is also a part of

the unique style of paleontology illustration. In concurrence with this, the art of paleontology began to use media other than printmaking, painting, and photography. Artists worked in sculpture and designed museum displays. Later artists used motion pictures, animation, and computerization to achieve their aims in representing fossil life. While new media have continued to appear in paleontology illustration, the artists and scientists have never departed from their initial desire to be accurate and detailed in their work.

This book began with a dedication to four men who have inspired me as a historian. Edward Drinker Cope and my godfather, Ernest Jones, were artists. Cope, of course, was a paleontologist (that is rather like saying Secretariat was a racehorse), and my godfather was an amateur paleontologist in the best sense of that word. My uncle Carter Qualls was trained in another field of science, but he loved paleontology and indeed was a good friend of a well-known American paleontologist. My dad, Robert W. Pierce, began as a teacher and finished his career running three petrochemical plants. He loved history and geology, and he liked fossils too. I give these details to point out that paleontologists and artists cannot be separated, and that many of us who are neither still love the fossils and their images. I think that, as the past goes into the future, this will always remain true.

NOTES

1. The first art historian to state that Christus was Van Eyck's student was Gustav Waagen, in the middle of the nineteenth century. Subsequent art historians have followed Waagen or suggested other masters for Christus, such as Robert Campin (see Upton 1990, 3).

2. Ibid., 33. The painting today is part of the Robert Lehman Collection and the Museum traces its provenance back to 1815. The work is signed and dated "m petr[us] xpi me.. fecit. 1449." An artist's emblem is painted by the signature line and date.

3. Ibid., 34.

4. Van Coppenalle 1944, 22–23, 37.

5. Shea 1991, 425. Johann Weyer was a German Protestant physician of Netherlandic descent. He carefully examined the issue of witchcraft, and concluded that most purported witches were merely elderly or mentally ill persons, those who had been marginalized by society, who behaved strangely as a result of mental defect and not because they consorted with the Devil. It was dangerous to state such doubts in print in sixteenth-century Germany. Weyer's book was published in five Latin editions and a number of French ones before 1600.

6. Paré 1678, 630, 674, 606–607.

7. Christopher Duffin, personal communication, 2004. Duffin points out that Christus depicts gems such as rubies, which were also used in medicine and magic, in the saint's shop. I thank him for kindly sharing his unpublished mss on fossil shark teeth and their uses.

8. Leonardo da Vinci 1970, note 985 (p. 208).

9. Ibid., notes 986–987 (pp. 209–210, 216). Clearly da Vinci had made a careful examination of the strata.

10. Ibid., note 987 (p. 211).

11. Ibid., note 988 (p. 211).

12. "On fossil objects" is Martin J. S. Rudwick's translation of *De rerum fossilium,* although I think the term "fossils" is sufficient.

13. Rudwick 1976, 5–7. Rudwick states that Gesner hired the draughtsmen and the engravers himself and personally supervised them, although he does not provide a citation for this statement. See also Gregorius Agricola, *De natura fossilium lib. X* (Basiliae, 1542), and Christophorus Encelius, *De re metallica . . . libri III* (Francofurdi, 1557).

14. Ulrich Molitor was a canon lawyer from Basel. His book is one of only a handful that expressed open doubts about the activities of witches. Most doubters were not brave enough to publish their points of view. *De lamiis* was an immediate success. At least three editions were brought out in 1489 by different printers, and thirteen had been published by 1500. More were issued in the next century. All were illustrated. The vignette of the male witch riding the wolf was taken from a trial that Molitor himself attended in the 1470s. For a lengthy discussion see Davidson 1987a.

15. Rudwick 1976, 11–13.

16. For a brief description of these works see Edwards 1967, 21. Edwards's book includes examples of Imperato's illustrations.

17. Cooper 1995. Thanks to Ed Rogers for useful information concerning the *Metallotheca* and the 1719 second edition. Rogers's online catalogue of rare geology and paleontology books is a marvelous bibliographic asset: http://www.geology-books.com. For a discussion of the role played by Mercati and the Vatican's museum in the study and dissemination of imagery of fossil shark teeth, see Davidson 2000, 331–332.

18. McBrien 1997, 291–294.

19. Aldrovandi 1642, 1668.

20. Such reuse or close copying of illustrations had been common since the invention of

printing. For example, an illustration depicting witches holding a sabbat dance on Blocksberg Mountain in Germany, printed in Johann Praetorius's 1653 *Blockes-Berges Verrichtung* (A Description of the Blocksberg), was closely copied by D. Lemkus for the 1693 edition of Nicolas Remi's *Daemonolatria.* The Lemkus engraving reversed some of the elements of the earlier illustration, so that witches and demons are shown dancing from left to right in the 1693 print, but from right to left in the earlier work. Lemkus's illustration also contains a vignette of a witch working at her cauldron while standing inside a magic circle inscribed on the ground. That motif comes straight out of several works by the painter David Teniers the Younger. I think that the repetition of illustrations or parts of illustrations resulted more from the printer's striving for authenticity than for economy. The illustration represented "truth" to the reader of the book. For a discussion of these works, see Davidson 1987a, 74–75, 82–83, and illustrations 35 and 36.

21. A growing number of studies, both articles and monographs, deal with the printing industry in early modern Europe. Some, like Miriam U. Chrisman's *Bibliography of Strasbourg Imprints, 1480–1599* (New Haven, Conn.: Yale University Press, 1982), list hundreds of titles, grouped into subjects and printers. A fascinating and extensively detailed study of the early history of printing in Europe is found in Johns 1999.

22. According to the entry on Verstegan written by J. H. Pollen in the classic 1907–1914 edition of the *Catholic Encyclopedia,* Verstegan's grandfather was Dutch. He and his family had immigrated to England and changed their name to Rowlands. If this is correct, it would help to explain Richard Rowlands's interest in Dutch literature and his move to the Netherlands. Pollen also indicates that Rowlands maintained close connections with the Jesuits in France, Italy, and England. That being the case, Verstegan would not have been welcome in James I's England. *The Catholic Encyclopedia, Classic 1914 Edition,* CD edition by Kevin Knight (distributed by New Advent, 2003). This is also available online at http://www.NewAdvent.com. See also Rombauts 1933.

23. Probably the best known Dutch author in this genre was Jacob Cats (1577–1660). Cats wrote voluminously on humor, aphorisms, historical topics, folklore, and how to be a good husband or wife. His work on the conduct of a proper Calvinist marriage, *Houwelijck* (1625), became a staple in seventeenth-century Dutch homes. Historians have observed that any good Dutch home had its Bible, but it also had some works by Cats. Verstegan seems to have been trying to emulate Cats and other native Dutch writers. Interestingly, Cats served the government of the United Provinces of the Netherlands on two different occasions as an envoy to England. Many of his works were translated into English and printed in England. These two writers had parallel careers: Verstegan, the Englishman, styled himself a Dutch writer, and Cats, the Dutchman, went to England, where he was well known and his works became quite popular.

24. I have written extensively about Verstegan's interest in fossils and his contribution to the early development of paleontology in Davidson 2000. For information on Verstegan's life, publications, and travels, see especially p. 331.

25. Verstegan 1605, 103–104.

26. Some discussion of Colonna's works and belief in the organic origin of fossils may be found in Rudwick 1976, 42–44. For an excellent discussion of Colonna and other members of the Accademia dei Lincei, see Freedberg 2002.

27. According to the *Catholic Encyclopedia*'s entry on Kircher, written by Adolf Muller, Kircher worked with and studied Latin, Greek, Hebrew, Chaldaic, Syrian, Samaritan, Arabic, Armenian, Coptic, Persian, Ethiopian, Italian, German, Spanish, French and Portuguese. His study of the Sphinx and attempt to translate hieroglyphs are famous because his was one of the first such attempts and because his educated guesses as to the hieroglyphs' meanings were so incredibly wrong.

28. Prices around $40,000 to $50,000 are not unusual for the first edition, and I have seen the 1678 edition priced at $11,000.

29. See Rudwick 1976, 56–58, for a discussion of Kircher's opinions of fossils, which I have paraphrased here.

30. See Stephen Jay Gould, "Father Athanasius on the Isthmus of a Middle State: Understanding Kircher's Paleontology," in Findlen 2004, 221–225.

31. Steno 1667, 6–8. For a more detailed discussion of Steno and his theories of fossil shark teeth, as well as his use of the plates of Antoni Eisenhout, see Davidson 2000, especially 329–332, 339–340.

32. See Davidson 2000, 340. I use Gustav Scherz's translation of Steno's Latin (Steno 1969). According to Scherz, Steno called the plates bronze, but of course this was not correct

as bronze is not used to make engraving plates. Additional information on the printing of Steno's 1667 work and its illustrations may be found in Garboe 1958.

33. An excellent study of Scilla and his contributions to the history of paleontology may be found in Accordi 1978. Accordi argues throughout his essay that Scilla was the first naturalist to demonstrate through experiments that fossils "were once living beings." This may be the case, but it can easily be demonstrated that Scilla was by no means the first naturalist to *think* that. For a brief discussion of Scilla as a collector of unusual items, see Connors 1992, 23.

34. Harris 1977, 42 n. 106.

35. Scilla's theories are briefly discussed in Rudwick 1976, 56–59. See also Accordi 1978.

36. I am using Scilla 1752, the Latin translation of *De vana speculazione.* (Other eighteenth-century editions have the same number of plates and pages.) With it was bound Fabio Colonna's *De glossopetris dissertatio,* originally published in Rome in 1616. Obviously the publisher intended to reinforce Scilla's contentions that fossils were of an organic origin by appending Colonna's work. Colonna also believed that fossils were of organic origin and that they had been deposited by the Great Flood. Thanks to Christopher Duffin and Dr. David Ward for kindly providing me with a facsimile.

37. Davidson 1987a. In Teniers's paintings there are at least two different genera of *Cyclura* as well as *Iguana iguana.*

38. Rudwick 1976, 59.

2. The Late Seventeenth Century and the Eighteenth Century

1. There are many sources for biographical information on Robert Plot, including the *Dictionary of National Biography.* His successor at the Ashmolean, his assistant Edward Lhwyd (1660–1709), contributed a biographical account of him to the second edition of *The Natural History of Oxfordshire,* published in 1705. Another early source is *Biographia Britannica* (London, 1747–1766), 5:3368–3369. Information about him can also be found online at the Galileo project (http://galileo.rice.edu/Catalog/NewFiles/plot.html) and on the website of the Oxford Museum of Natural History (http://www.oum.ox.ac.uk/learning/htmls/plot.htm).

2. Plot dedicated this book to Charles II. One cannot resist wondering whether the king ever read it. The dedication may have been only a publicity move on Plot's part. Such grandiose dedications were not at all unusual in this era.

3. This book was printed within a decade of the London plague epidemic of 1664–1667. The paper on which it was printed might have been manufactured from rags that had once been the clothing or bedding of the victims of the plague. A second edition was published in 1705.

4. This is most likely Sir John Cope (1634–1721), who held an Oxfordshire seat in the House of Commons.

5. Plot 1677, 32–35 and passim in chapter 1.

6. Because of the cost of copper, engraving plates were sometimes quite tiny. Rembrandt (1606–1669), who was Plot's contemporary, produced hundreds of etchings executed on copper plates. Some of these were the size of postage stamps; others were smaller than standard post cards. This use of tiny plates allowed him to show his skills as a printmaker, and it saved him money. Rembrandt also reused several of his copper plates, engraving, say, his face, that of another person, and a genre scene all on the same piece of copper. He was using these plates for study pieces and technical practice. He did not waste his valuable copper by making every study print on a separate plate.

7. Plot 1677, 92–93.

8. Ibid., 109–111 and passim in chapter 5. For a modern transcription of Plot's comments on the dinosaur fossil he called a portion of petrified giant thighbone, as well as a reproduction of his plate 4, see Weishampel and White 2003, 9–17.

9. Plot 1677, p. 2.

10. Ibid., pp. 132–136.

11. Ibid., p. 136.

12. Weishampel and White 2003, 2.

13. Ibid., 2, 7 n. 4. See Brookes 1763; Robinet 1768.

14. See Edwards 1967, 24–25, for a brief discussion of Lister's contributions to geology and paleontology.

15. James and Devon Gray Booksellers, *Catalogue 24,* issued winter 1999, item 131c, p. 60.

16. A copy of Lhwyd recently passed through the art trade. It was lot 34 in the Sotheby's catalogue *Natural History, Travel, Atlases, and Maps,* May 10, 2007. Sotheby's says that no copy of Lhwyd had come on the art market since 1979.

17. Rudwick 1976, 84–86. Another interesting précis of Lhwyd's theories may be found on the website of the Oxford University Museum of Natural History, at http://www.oum .ox.ac.uk/learning/htmls/lhwyd.htm. The PDF version of this document is well illustrated, and identifies sixteen of the fossils depicted in *Lithophylacii Britannici ichnographia* as held in the Museum's collections: http://www.oum.ox.ac.uk/learning/pdfs/lhwyd.pdf.

18. Lhwyd's illustration of fossil plants works wonderfully as a scientific reference tool. I once showed it to some students alongside several pieces of shale containing fossil ferns. The rocks and the pictures were precisely the same. The students were quite impressed with the accuracy of this three-hundred-year-old illustration.

19. For a brief discussion of Hooke and his theories about fossils, see Edwards 1967, 28–32.

20. Edwards reproduces this beautiful illustration and comments that Hooke formulated the concept of index fossils, the idea that extinction had in fact occurred, and the idea that fossils might show what paleoclimates had been like. See also Hooke 1665, 1705.

21. Stukeley 1719, 964–968.

22. Bourguet 1742, 81. I am indebted to Bruce McKittrick for information concerning the printing of the illustrations for this book.

23. Ibid., 90–91. A student of mine, a geology major, commented that it might have been easy to confuse this fossil with the remains of a human, because the skull of the animal might have appeared to Scheuchzer and Bourguet as a pelvis. But Bourguet clearly saw it as a human skull.

24. A "nice copy" of this book today runs about $2000. One can't help wondering what it cost when it was new.

25. In his bibliography Bourguet cited Charles-Nicolas Lang, *Essai pour l'histoire naturelle des fossiles de la suisse* (Venice, 1707), and Johan Jacob Scheuchzer, *Essai sur les fossiles de suisse* (Zurich, 1702), and French and German editions of the latter, published in 1706 and 1718 respectively. These are the sources for the illustrations he took from them. Several other works are listed in the bibliography, although not Scheuchzer's 1726 work that discussed the petrified human. Certainly Bourguet knew that work, as he referred to it in the text and patterned his illustration of it after Scheuchzer's (p. 90).

26. Bourguet 1742, 86.

27. Antoine-Joseph Dézallier d'Argenville, *Enumerationis fossillium, quae in omnibus Galliae provinciis reperiuntur, tentaminia* (Paris: J. de Bure, 1751) and *La conchyliologie, ou Histoire naturelle des coquilles de mer, d'eau douce, terrestres et fossiles. . . .* (Paris: G. de Bure, 1780).

28. I understand the desire to display fossils among one's books. One of the fossils in Klein's portrait is an ammonite. In my office bookcase, quietly lurking in a corner and watching the proceedings, is another: a specimen of *Placenticeras meeki*.

29. Thanks to Ed Rogers for information on the trench and on Burtin's research.

30. Rudwick 2005, 194.

31. See Rudwick 2005. Rudwick has published extensively on Cuvier; particularly worth attention are *The Meaning of Fossils* (New York: Science History Publications, 1985), *Georges Cuvier, Fossil Bones, and Geological Catastrophes* (Chicago and London: University of Chicago Press, 1997), and essays 9 and 10 in Rudwick 2004, which discuss Cuvier's art and his working methods as an artist. Other interpretations of Cuvier's contributions to science may be found in A. B. Adams, *Eternal Quest: The Story of the Great Naturalists* (New York: Putnam, 1969), and J. C. Smith, *Georges Cuvier: An Annotated Bibliography of His Published Works* (Washington, D.C.: Smithsonian Institution Press, 1993).

32. Rudwick, 2005, 413.

33. Rudwick (2005, 404) discusses Cuvier's art and reprints several of the drawings he made for the engravers. Some engravings were based on the work of others For example, Cuvier's essay on fossil crocodiles (vol. 4, part 5, no. 3) was illustrated with engravings by Couet, based on drawings by Laurillard.

34. Ward 1866, 11–13 and insert illustration taken from an engraving by Frauenberger; and Ward 1864. In the introduction to the latter, Ward described the origin of the cast and Sibley's donation of it. For a detailed discussion of Ward's activities and his catalogue of casts, see chapter 3.

1. James Parkinson, *An Essay on the Shaking Palsy* (London: Printed by Whittingham and Rowland for Sherwood, Neely and Jones, 1817).

2. For a discussion of Parkinson's belief in evolution and the impact of Continental science on his book, see Rudwick 2005, 432–434, 496–498, and passim; and "Encounters with Adam" in Rudwick 2004.

3. Ole Daniel Enersen, "James Parkinson," http://www.whonamedit.com/doctor.cfm/392.html.

4. Among the artists working for Agassiz were Jonathan Stiven and Joseph Dinkel. Lady Gordon Cumming, who provided Agassiz with specimens of fossils, may also have drawn some fossils for him. For discussions of the work of Dinkel (1807?–after 1873) and the contributions of Lady Gordon Cumming (Eliza Maria, c. 1798–1842) and Jonathan Stiven (c. 1799–1872), see Andrews 1982, 54–55, 72–73, 70, respectively. August Sonrel made many of Agassiz's lithographs before he and Agassiz migrated to the United States in 1847. Sonrel went into business in Boston and created some of the stunning lithographs in Joseph Leidy's 1853 *Ancient Fauna of Nebraska*.

5. Christopher Duffin pointed this out to me in 2006 and suggested that Agassiz was "rushing through things," because "the Glacial Theory was beginning to consume his attention." Whatever the reason, the illustrations were uneven in quality, and those in the *Monographie* were not so well printed.

6. For a brief outline of Buckland's theories, see Rudwick 1976, 135–138.

7. Buckland 1837, 1:vii.

8. Davidson 2002.

9. Sir Richard Owen (1807–1892) was trained as a surgeon and was Hunterian Professor at the Royal College of Surgeons, London. He was considered one of the foremost paleontologists of the first half of the nineteenth century. A follower of Cuvier, Owen became well known for his studies of fossil marine reptiles and for his contribution to Benjamin Waterhouse Hawkins's restorations of dinosaurs, pterodactyls, and marine reptiles at the Crystal Palace Exhibition. Owen's reconstruction of the skeleton of the moa as well as his concept of an "archetype" primitive vertebrate skeleton also helped establish his importance in nineteenth-century paleontology. He was an accomplished artist and drew some of his own illustrations for his lithographers; plates 2 and 3 in Owen 1864 (which is reprinted in Weishampel and White 2003) were based on his drawings. See Rudwick 1976, 210–212, for a brief explanation of Owen's "archetype" vertebrate skeleton.

10. Buckland 1837, 2:39–42.

11. Sharf also illustrated Richard Owen's 1840 "A Description of a Specimen of the *Plesiosaurus Macrocephalus*, Conybeare," including details of the skull and various bones and a beautiful image of the entire specimen in its matrix, and Owen's 1851 *Monograph on The Fossil Reptilia of the Cretaceous Formations*. (Here, too, his work is noticeably better than that of the other illustrator, in this case, J. Erxleben.) On Scharf's role in early scientific publications, see Rudwick 1992, 43–44, 65, 77.

12. Mary Anning (1799–1847) came from the seacoast town of Lyme Regis, in Dorset, and made a living collecting fossil specimens, both vertebrates and invertebrates, which she sold to scientists and others. Probably her most famous discovery was the complete skeleton of a plesiosaur, in 1821. This fossil was named *Plesiosaurus dolichodirus* by William Conybeare and is the type specimen of this genus and species. It is thought that Mary Anning is the subject of the children's chant "She sells sea shells by the seashore." Torrens 1995.

13. In this early paper De la Beche and Conybeare assigned the animals to genera but not species. In 1824 Conybeare presented the famous type fossil found by Anning and named it *Plesiosaurus dolichodeirus*. The much-reproduced lithograph showing the nearly complete fossil of *P. dolichodeirus* lying in its matrix was made by George Scharf after a drawing by T. Webster. The equally famous and also much-reproduced lithograph of the skeletal restorations of *Ichthyosaurus communis* and *P. dolichodeiros* was drawn by Conybeare himself and again made by Scharf. According to the caption of Conybeare's plate 49, some of the ichthyosaur fossil material shown in the lithograph actually belonged to De la Beche, who therefore must have played some role in the preparation of Conybeare's paper.

14. For a short discussion of this sketch see McCartney 1977, 57–58. This book also contains a biographical essay on De la Beche, outlining his early activities in Jamaica as well as his later scientific activities with the Geological Society of London and the Geological

Survey of Great Britain, founded in 1835 with De la Beche as director. In this capacity he founded the Museum of Economic Geology, which opened in London in 1851.

15. Ibid., 50–51, 72.

16. Ibid., 58–59.

17. Rudwick 1992, 44. Rudwick states (after Hugh Torrens) that Buckland used a version of De la Beche's illustration in his lectures.

18. Ibid., 47. A painting entitled *An Interior with a Parrot, a Goose, and an Aquarium-Bird Cage,* by a Leiden artist about 1700, shows a bowl containing living goldfish that surrounds a perch on which sits a bird that appears to be a canary. The design gives the illusion of the bird's being under water. This painting was lot 232 in the Sotheby's catalogue *Important Old Master Paintings,* January 27, 2007.

19. Paleontologists have long debated the foraging habits and postures of extinct marine reptiles, and still do. Even E. D. Cope weighed in on the topic in the 1870s; see, for example, Everhart 2005b.

20. Rudwick 1992, 46; McCartney 1977, 48–49. Both authors note that despite the vulgarity of these works (and the hilarity of *A Coprolitic Vision*), De la Beche also wished to educate his viewers. Buckland discussed ichthyosaur coprolites from Lyme Regis in a paper presented to the Geological Society of London in 1829 (McCartney 1977, 70), and would later discuss them in his famous Bridgewater Treatises. Analysis of the contents of coprolites allowed scientists to discern some of the feeding habits of prehistoric marine reptiles.

21. McCartney 1977, 48.

22. Rudwick 1992, 183–186.

23. Figuier 1872; Tenney 1876; Davidson 2003. Worrall drew heavily on an illustration by Cope himself for part 2 of his 1867–1869 "The Fossil Reptiles of New Jersey" that is justly notorious for showing *Elasmosaurus* with a short neck and long tail. Davidson 2002.

24. Lockley and Hunt 1995, 67–79. This discussion is illustrated with simple outlines of the animals that Lockley and Hunt suggest made the trackways.

25. Buckland 1837, 2:36–37. Buckland explains the name: "Professor Kaup has proposed the provisional name of Chirotherium for the great unknown animal that formed the larger footprints, from the distant resemblance, both of the fore and hind feet, to the impression of a human hand" (1:265n).

26. Ward 1866, 78.

27. The making of Hawkins's Crystal Palace models is such a famous event in nineteenth-century paleontology that virtually every history of paleontology has a commentary on it. A good short description can be found in Deborah Cadbury, *Terrible Lizard* (New York: Holt, 2000), 293–299.

28. B. Hawkins 1854.

29. Ibid., reprinted in Weishampel and White 2003, 219–220.

30. Ibid., reprinted in Weishampel and White 2003, 223.

31. Mantell 1848, 550–551, 555–556.

32. For a reproduction and discussion of the print, see Rudwick 1992, 92–93.

33. Ibid., 112, 115.

34. Ibid., 139.

35. Hitchcock 1856, 178–179. Hitchcock said the animal he showed made the *Chirotherium* trackways, and cited Buckland, Mantell, and the *American Journal of Science,* vol. 30.

36. Ibid., 179.

37. Figuier 1867, 173–174 and plates 13–14; see also Figuier 1872, 154 and figures 101–102.

38. Figuier 1867, 169–170 and figure 81.

39. Hooker 1884, 239–240 and figure 139.

40. Lucas 1902, 43.

41. Ward's archival materials may be found in the Rare Books and Special Collections Department of the River Campus Libraries of the University of Rochester. Indices to these collections are available online at http://www.library.rochester.edu/index.cfm?PAGE=171. During the latter part of the nineteenth century Ward's Natural Science Establishment was run by his cousin, Frank A. Ward. The company was donated by the Ward family to the university in 1928, and in 1930 a fire destroyed much of the company's inventory. Eventually the university sold the business back to the Ward family, who owned it until 1970.

Sales of Ward's casts have continued into the twenty-first century. In 1893 some of Ward's

casts were purchased by the Field Museum of Natural History. Recently these have been purchased from the Field Museum by a private fossil dealer in the northeast United States, who has offered some of them for sale on the Internet. (Personal communication from Al Prandi, 2004.)

42. The fossil rain is item 1209 in Ward 1866. In 1874 Ward published a pamphlet on the Rosetta Stone, which included images of it.

43. Ward 1866, iii–iv.

44. Ibid., 50 (items 189–192).

45. Ibid., vii–viii.

46. Ibid., 62.

47. These casts are items 207, 225, and 227 in Ward 1866 (pp. 57, 60, 61).

48. Al Prandi, personal communication, 2004.

49. Ward 1866, 79 (item 297).

50. Ibid., 80–81.

51. B. Hawkins 1854.

52. Ward 1864.

53. For a discussion of these, see "Benjamin Waterhouse Hawkins Album Images, 1872–1878?" Ewell Sale Stewart Library, Philadelphia Academy of Natural Sciences, http://www.ansp .org/library/getty_findaid/hawkins803.xml. The images are annotated by Earle E. Spamer, with excerpts from typed notes made on the collection in 1985 by Donald Baird, which are also in the Academy archives. The original inventory of the material was made by Carol Spawn, longtime soul of the Academy Library.

54. Item 20 is a print showing a proposed design for a display of prehistoric life in the Smithsonian, dating from 1871. Donald Baird's notes indicate that the original drawing may be among the Hawkins papers in the British museum. The design is similar to Hawkins's designs for the Central Park Museum. Baird suggested that item 21, a photographic print of another museum display design, might be related to the Smithsonian project. Hawkins left a lengthy description of the scene in a letter written to Joseph Henry on April 10, 1871, which is now in the Smithsonian Institution (Henry Papers 54412). Baird included a transcription of it in his notes on this item. This design also contained scenes of Native Americans and a restoration of a mammoth, shown fleshed out on one side and as a skeleton on the other. Baird notes that this was a very innovative idea that did not come to fruition until 1910, when William Swann Lull used it in a miniature restoration of *Anchisaurus.*

55. "Benjamin Waterhouse Hawkins Album Images, 1872–1878?" Ewell Sale Stewart Library, Philadelphia Academy of Natural Sciences, http://www.ansp.org/library/getty _findaid/hawkins803.xml.

56. For a detailed discussion of Cope's restorations of *E. platyurus,* see Davidson 2002.

57. This was an enormous banquet. The menu in Prestwick's invitation mentions seven courses and a choice of five wines. There were three soups, three selections of fish and four of fowl, four large meat entrees, three selections of game, seven sweets, and eight desserts.

58. The Department of Special Collections of the University of Pennsylvania library has an extensive collection of color lithographs from the Sinclair firm. These may be seen online at http://www.library.upenn.edu/collections/rbm/keffer/sinclair.html. Thomas S. Sinclair (c. 1805–1881) was a Scotsman who emigrated to the United States. In 1838 he founded a lithography firm in Philadelphia, where in 1843 he became one of the first lithographers in Philadelphia to print in color. The Sinclair lithography press became a family affair in the middle of the century, when Sinclair's brother, and later his son, joined him in the business. Book illustrations from the Sinclair firm were always of high technical quality. Leidy employed them, E. D. Cope employed them, and many of the illustrations in USGS survey publications were printed by Sinclair.

59. I own a copy of this book, and recently showed it to my history of paleontology illustration seminar. Several of the students were art majors. They were amazed at the technical quality of the lithographs and the detail in the drawings from which they had been made. The students were even more impressed when they compared Sonrel's illustrations of an *Oredon* skull (plate 2) with an actual fossil skull of a specimen of *Oredon culbertsoni* in the University of Nevada's Keck Museum. By looking at the actual fossil, they could see just how faithfully Sonrel had observed and drawn his specimens. They also realized how hard Leidy and his artist team had worked to ensure the accuracy and quality of the prints. The specimen in the Keck Museum was collected at a site on Cheyenne River, South Dakota.

60. Andrews 1982, 77 n. 207.

61. Some specimens of skulls of *Oredon culbertsoni* are preserved in what may be a weathered condition. Indeed, the skull in the Keck Museum shows less detail of bone structure and teeth than does Leidy's illustration of one. Owen's illustrations may depict such weathered specimens, which might also account for their poorer detail.

62. The modern biography of Cope is Davidson 1997. See also Osborn 1931, which is primarily a transcription of Cope's letters and papers in the possession of the American Museum of Natural History, together with personal observations and reminiscences by Osborn and others of Cope's contemporaries. Osborn's book is very laudatory of Cope, and Cope's daughter Julia paid for its publication, but nonetheless it is an important contribution to our understanding of the man and his impact on the sciences of biology and paleontology.

63. Osborn 1931 and Davidson 1997 reprint many of Cope's drawings and sketches, including juvenilia, that are held by the American Museum and the Philadelphia Academy of Natural Sciences. Some of his early artistic efforts are also held in the Quaker Collection of the Haverford College Archives. Alfred Cope also encouraged his son to learn to make maps, a skill that was no doubt useful to Cope as a paleontologist. He sketched terrain and strata, as well as fossils, in his field journals, some of which are held by the American Museum of Natural History and the archives of Haverford College; the American Philosophical Society has film copies of some.

64. Cope's *Primary Factors of Organic Evolution* contained a number of images that he had taken from the publications of others. He carefully credited these to the original authors, even one that he had obtained from a publication by his hated rival, O. C. Marsh. This is figure 3, in which Cope compared the structure of digits in two fossil mammals, one of which was *Eobasileus mirabilis,* in an illustration taken from Marsh's *Dinocerata.*

65. Cope could be cheap, and he was always in a hurry. He would use hotel stationery on his field trips. He wrote out little requests for small amounts of cash, which his wife took to the accountant of the Cope family shipping firm, just as one would write out a check. These little requests were dashed off on all kinds of scraps of paper. One has to wonder what the accountant thought, or indeed, what Cope's father Alfred, who paid them, thought about these little scraps of paper. Examples of these can be found today in the Thomas P. Cope Family Papers collection in the Special Collections Department of the Haverford College Libraries.

66. The work is indeed worthy of the nickname it immediately received: "Cope's Bible." It runs to 1009 pages of text and sixty-six numbered plates, but many of these are further numbered "a," "b," etc., so that there are over one hundred plates in all. Within each individual plate are numerous images, sometimes dozens. The book weighs approximately fifteen pounds! When I take mine from home to show to my students, I transport it in a little rolling suitcase. The students are astounded when I open up the case. Much of the material in this book had been previously published, but the editing and printing of this volume must have been a nightmare. Cope wrote out his publications himself, in longhand, rather than dictating to a secretary. Such a huge book represents a profound pile of papers, all in Cope's formidable handwriting. Setting it in type was a daunting undertaking as well.

Years later (sometime between 1889 and 1897, according to Henry Osborn [1931, 464]), Cope hired Anna Brown as a part-time secretary. However, Osborn says only that Brown worked on Cope's bibliography toward the end of his life. I have seen literally thousands of Cope's papers: letters, bills, texts of articles, even the article that he was at work on when he died, and not one piece of this material is in anyone's hand except his, with the exception of three letters written by Annie Pim Cope, his wife, when he was too ill to write. How did he accomplish so much in forty short years?

67. Cope 1883, vii.

68. Ibid, xxix. Cope's report on the paleontology work he did in New Mexico while working for the Wheeler Survey was also published during this period (Cope 1877). Again there are a large number of lithographic plates (eighty-one in this case) made by Sinclair, and none is labeled with the name of an artist. The quality of these prints compares with those in Cope's *Tertiary Vertebrata* (1883) and *Cretaceous Vertebrata* (1875).

69. Davidson 2002.

70. The famous reconstruction of *Elasmosaurus platyurus* appears in Cope 1867–1869, part 2. The sketch of *Laelaps aquilungis* is reprinted in Davidson 1997, figure 10.

71. Osborn 1931, title page.

72. Mayer 2003, 10.

73. For an extensive discussion of Cope's association with F. V. Hayden, see Davidson 1997.

74. The three years were bound together and published by the U.S. Government Printing Office in 1870. Volume for 1867: *First Annual Report of the United States Geological Survey of the Territories Embracing Nebraska.* Volume for 1868: *Second Annual Report of the United States Geological Survey of the Territories Embracing Wyoming.* Volume for 1869: *Third Annual Report of the United States Geological Survey of the Territories Embracing Colorado and New Mexico.*

75. For Scudder, see below. Fielding Bradford Meek worked off and on for the Hayden Survey. Among his publications under the auspices of the Survey is *A Report on the Invertebrate Cretaceous and Tertiary Fossils of the Upper Missouri Country,* Report of the United States Geological Survey of the Territories, part 3 (Washington, D.C.: U.S. Government Printing Office, 1876).

Leo Lesquereux published a number of reports under the aegis of the Hayden Survey, including several chapters in the *Annual Report of the United States Geological and Geographical Survey of the Territories . . . 1874* (Washington, D.C.: U.S. Government Printing Office, 1876), which contained descriptions of some fossils from Point of Rocks, Wyoming, that had been collected by Hayden himself, and *Contributions to the Fossil Flora of the Western Territories,* U.S. Geological Survey of the Territories, vol. 8 (Washington, D.C. U.S. Government Printing Office, 1876), which contained early information on the extensive fossil plants of Florissant, Colorado.

76. Hayden 1883.

77. Ibid., xiii, xviii.

78. Ibid., pp. 5–6.

79. Lesquereux 1883, xi. In his letter to the Secretary of the Interior (p. vi), Hayden says that the plates were "engraved by the well-known firm of Thomas Sinclair & Son of Philadelphia and are fine examples of their work." But these were not engravings, nor were they really the best Sinclair could do.

80. Meyer 2003, ix–x.

81. Scudder 1890, 15.

82. Ibid., 1–41.

83. Bernard 1895, v–vi. He is referring to Zittel 1880–1893 and Nicholson and Lydekker 1889.

84. As one might expect, Bernard selected his illustrations from the works of the authorities on vertebrates. He frequently cited Cope, Marsh, and Owen, among others.

85. For a brief biography of Charles Schuchert, see "Charles Schuchert," Yale Peabody Museum, http://www.yale.edu/peabody/archives/ypmbios/schuchert.html. Schuchert's biography (with Clara Mae LeVene) of O. C. Marsh, *O. C. Marsh: Pioneer in Paleontology* (1940), remains the only full-length biographical study of Marsh. It was for many decades the companion piece, as it were, to Henry F. Osborn's 1931 biography of E. D. Cope. As a fellow artist, Schuchert took pains in his biography to discuss and publish photographs of the men who worked for Marsh as illustrators, preparators, and research assistants. It was a small tribute to his own beginnings. There was much controversy over how much credit Marsh may have taken for work completed by others. Such accusations were a part of the public conflicts between Marsh and Cope in the 1880s and 1890s. To his credit, Schuchert made a good attempt to treat with objectivity Marsh's relationships with the scientists who worked for him at Yale. It is my opinion that Schuchert's biography of Marsh is less slanted than is Osborn's biography of Cope.

86. Beard studied in northern Germany, Switzerland, and Italy. Most American artists of his generation felt that a stay in Italy was an obligatory part of their training, but William Gerdts believes that Beard would have been more interested in studying in Germany (Gerdts 1981, 6–8).

87. Samuel Benjamin, writing about Beard in 1879, commented on themes which were not lighthearted. One Beard painting, *The Witches' Convention,* bordered on the sinister and macabre. This painting, which shows a group of broom-riding witches and black cats gathering in a landscape, emulated many scenes of witches executed by Teniers and Saftleven. Benjamin referred to the work as a "terrible composition" (Gerdts 1981, 8). While Beard's works were discussed in a number of nineteenth-century journals and magazines, little was written about his work after his death in 1900. W. H. Gerdts's 1981 exhibition catalogue, *William Holbrook Beard: Animals in Fantasy,* is one of very few publications on him. Gerdts's short essay is useful in that he cites several of Beard's contemporary critics.

88. For a discussion of George Richardson's book and its illustrations, see Rudwick 1992, 75–77.

89. Ansted 1863, xv.

90. Beard's paintings command respectable prices in today's art market. Several passed through Sotheby's in New York in the late twentieth century. Prices asked and received at auction may be noted at http://www.sothebys.com. *Scientists at Work* was priced at $16,800 in 2001, *The Discovery of Adam* was priced at $17,250 in 1998, and *The Witches' Convention* was priced at $79,800 in 1993.

4. The Paleontologist Poses with Fossils

1. For a lengthy and detailed discussion of the history of the mastodon and Peale's involvement in its presentation to the public, see Semonin 2000, especially chapters 13–15.

2. See the National Portrait Gallery collection archives online at http://www.npg.org .uk for information about this print and other portraits of Buckland, some of which also depict him with fossils. (One is reproduced in Cadbury 2000, 59, and a don in full academic regalia in a view of the Hunterian Museum on p. 189 may also be Buckland.) McCartney (1977, 44–46) commented that many of Buckland's specimens came from De la Beche.

3. The biography written by his grandson, Richard S. Owen, in 1894 states that the photograph was taken about 1877. That date agrees with Owen's elderly appearance in the photo; he would have been in his seventies. See Richard S. Owen, *The Life of Richard Owen* (New York: Appleton, 1894), photograph following 2:232. An equally famous photograph shows Owen posed with the leg bones of a moa. According to his grandson, it dates from about 1846 and was originally a daguerreotype (ibid., following 2:319).

4. L. Warren 1998, 84.

5. For years someone at the Philadelphia Academy of Natural Sciences had this poster placed in an office window, facing out, so that it was visible to passers-by. It was rather startling to come down the sidewalk and see Leidy with his fossil as though he were looking out the window. The original photographs are in the archives of the Academy of Natural Sciences, Ewell Sale Stewart Library. For a discussion of them, see Spamer 2004, especially 110–114. Spamer says (109) that they are the first ever taken of dinosaur bones.

Spamer believes (personal communication, 2006) that these photographs were simply experiments by Leidy and the unknown photographer at the Academy, who were "just messing around" with the new medium. To his knowledge, the copies in the Academy archives are the only ones in existence.

6. This print is frequently reproduced. An original of it is in the archives of the Philadelphia Academy of Natural Sciences. For discussion of it see, among others, L. Warren 1998, 84–87.

7. Spamer 2004, 116–119. I am indebted to Earle Spamer for kindly sharing his thoughts on the Leidy photographs and the other images of *H. foulkii*, as well as his research, with me.

It is clear that the photograph of Hawkins was retouched; Spamer thinks (personal communication, 2006) that Hawkins did so himself. The photograph has areas of violet to milky-white discoloration that look similar to what is known as "bloom" on paintings, caused by the degradation of varnish. The discoloration may be a result of chemicals having decomposed because of the overpainting or simply the passage of time.

8. Lakes's field journals for 1878–1880 are today held by the Smithsonian. The water-colors are owned by the Yale Peabody Museum. Marsh bought them from Arthur Lakes in 1889. See Kohl and McIntosh 1997, xii–xiv; for a discussion of the watercolor in which Marsh appears, see 105–107.

9. Osborn 1931, figure 29 (facing 584; Cope with the skull) and frontispiece (Cope in his study). Osborn alludes here to Cope's extended conflict with Marsh. For years Cope collected notes on Marsh's errors and foibles as a scientist: his "Marshiana." "One day," Osborn writes, "he slyly opened the lower right hand drawer of his study table and said to me, 'Osborn, here is my accumulated store of Marshiana. In these papers I have a full record of Marsh's errors from the very beginning, which at some future time I may be tempted to publish'" (583). See also Davidson 1997, 88, 201. A detail of the photograph of Cope with the skull appears in Brochu et al. 1997, 20, where it has been colorized! While this small illustration is a minor component of this book, the colorization is rather unsettling. If nothing else, I suspect Cope's hair was much greyer when this photograph was taken than it appears. The original photograph was neither colored nor retouched.

10. These photographs are today in the archives of the American Museum of Natural History. See Colbert 1992, captions to figures 27, 42; see also pp. 67–70. Some of the Bone Cabin photographs appear online at http://paleo.amnh.org/photographs/index.html.

11. Schuchert's 1940 biography of Marsh contains another photograph of this display, presumably taken about the same time. Plate 25, facing page 396, shows the mounted skeleton of *Brontosaurus,* and next to it, toward the center of the room, is the mounted skeleton of *Morosaurus lentus.* These fossils are surrounded by a restraint rope. A man standing behind the display is resting his hand on one of the rope support poles. He rather resembles Charles Schuchert, but he is actually George R. Wieland, a paleobotanist at the museum. Wieland was responsible for the discovery of a skeleton of the huge turtle *Archelon,* another famous possession of the museum. *Archelon* is also shown in this photograph, mounted and placed close to the two dinosaur mounts, making this photograph also an example, though a subtle one, of a paleontologist posed with his fossil. Thanks to Barbara Narendra, archivist at the Yale Peabody Museum, for the identification.

12. Rudwick 2005, 69. Thanks to Mike Everhart, Eric Mulder, and Earle Spamer for some insightful help regarding the accuracy of this engraving. The fossil was recovered in 1780.

13. Such a photograph was included in Morgan and Spencer 2002, 33, along with several others of Granger, George Olsen, and a local crewman nicknamed Buckshot, who are shown working in the field collecting fossils. Photographs of paleontologists and fossils still continue to enchant.

14. The science of paleontology has always had ample room for people not formally trained as scientists. The names are many and famous, including Mary Anning, Charles H. Sternberg, and Edward Drinker Cope. George Olsen, the discoverer of the dinosaur eggs that made Andrews famous, was another. Olsen came from Laramie, Wyoming, and had worked as a cook and teamster for a number of early American Museum expeditions in Wyoming, most of them headed by Walter Granger. When Granger went to work on Andrews's Asiatic expeditions, Olsen went as well.

15. Andrews 1956, 108–113.

1. An image of this photograph may be seen on the website of the Visual Media Center of Columbia University, http://www.mcah.columbia.edu. The daguerreotype may have been taken as early as 1837.

2. Ibbetson 1849; Andrews 1982, 32–33; Christopher Duffin, personal communication, 2006.

3. D. Owen 1852. The main text of this report was profusely illustrated with woodcuts and engravings, and this volume of large plates was published as an adjunct. It contains engravings executed on copper and steel, as well as lithographs. Some of the illustrations are maps, but there are also twenty-seven plates of fossils. Some of the original engravings were bound into the volume; the plate scars are visible on certain pages.

4. For a general discussion and brief history of the technique of medal ruling, see Gascoigne 1988, 62.

5. Albumen printing was invented in the 1840s and became quite popular, as prints could be made on a glass plate or a paper surface. Unlike a daguerreotype, an albumen print could be made into a negative image and replicated. Daguerreotypes, printed directly onto a silver-coated copper plate, were one-of-a-kind photographic images; they could not be reproduced.

Warren was for a long time a professor of medicine at Harvard. He was a pioneer in various types of surgery and an expert on tumors. He was the first person to use ether as an anesthetic during a public demonstration of surgery, at Massachusetts General Hospital in 1846, and in his 1848 book *Etherization* he discussed the results of using ether in more than two hundred cases. He was a strong proponent of etherization, and his work helped make it more popular in the United States. He later published on the effects of chloroform in surgery and on anatomy and heart disease.

6. Hitchcock 1858, 2.

7. J. Warren 1852. The study is illustrated but does not include a photograph, even though at least one daguerreotype had been made of the reconstructed skeleton.

8. Semonin 2000, 387, 403. The Warren mastodon now belongs to the American Museum of Natural History. It was purchased in 1906 by Henry F. Osborn with money provided by J. P. Morgan and put on display the next year. It is still on display. Today it is housed

5. Early Photography in Paleontology, 1840–1931

alongside the skeleton of an Irish elk and the American Museum's justly famous display of fossil horses. See Dingus 1996, 138–139, 149. The photograph on 138–139 also shows the contemporary setting of some of Charles R. Knight's murals.

9. Some photographs by Silsbee, Case, & Co. (*cartes de visite,* or visiting cards) are owned by the library of the Massachusetts Historical Society; see the finding aid for the Homans Family Civil War *Carte de Visite* Album at http://www.masshist.org/findingaids/doc.cfm?fa=fap013.

10. J. Warren 1854, 54.

11. Burns (1979, 1262) thought this print was an ambrotype, but the fading suggests that it may be an albumen print instead. Fading was common in improperly fixed albumen prints. I am greatly indebted to Professor Peter Goin of the University of Nevada, Reno for sharing his expertise in old photographs and the history of photography with me (personal communication, 2006). He tells me that during the 1850s some photographers did not fully understand the chemical reactions involved in developing photographs. Consequently they sometimes used very odd substances for fixatives. Even sodium chloride was tried. Similarly, they did not always know how long to rinse the prints. My understanding of the results of the these errors is due to him. Ed Rogers (personal communication, 2006) tells me that he has seen a number of copies of J. Warren 1854, and in all the frontispiece is faint and yellowed.

12. Hitchcock 1865, x.

13. Most nineteenth-century geology and paleontology museums almost overwhelmed their visitors with specimens. They seemed to want to display everything in their collections. In some respects, however, a museum display of this sort was more user-friendly than those of today. Hitchcock's Appleton Cabinet of fossil trackways was no exception, and neither were the displays designed and in some cases built by Waterhouse Hawkins at mid-century. Fortunately for historians, some museums have survived almost intact from this era. The Wagner Free Institute of Science in Philadelphia, a natural history museum that contains a number of rocks, minerals, and fossils (including Cope's type specimen of *Camarasaurus*), is one. Dating from 1855, it was designated a National Historic Landmark in 1990. The museum's founder, William Wagner (1796–1885), lived nearby and helped to endow it so that anyone could attend free lectures and classes and see the specimens. The building was designed by John McArthur (1823–1890) on the model of Federal architecture, so that it has the appearance of a compact Greek temple (as did the Appleton Cabinet). Visitors to the main display gallery and the lecture room at the Wagner are transported into the era of Joseph Leidy and Edward Drinker Cope, both of whom lectured there. The lecture room is somewhat modernized, but it retains the feel of a nineteenth-century college hall. And the museum still looks very nearly as it did in the 1800s. The display cases seen today were assembled in the 1880s, and some specimens still have hand-written labels. The museum's interior is very similar indeed to that of the Appleton Cabinet. The visitor is confronted with case after case of displays, so many that the space is congested. It is almost physically wearing to walk about and try to take everything in. Visitors can study the displays in order of their age, or investigate all examples of a given type of geological specimen, and learn as they walk and observe. The museum functions as an open book. Students can still attend a lecture and then look firsthand at the specimens, just as they did when Leidy and Cope spoke there.

The Keck Museum at the University of Nevada also retains a typical nineteenth-century design, with most of its display cases on the main level and a gallery housing additional displays. Visitors can look over the gallery railing to see the main-level displays from above. It is not so cluttered as the Wagner Free Institute of Science, however; the Keck staff do not attempt to display the museum's entire collection. But the arrangement of cases filled with specimens retains the feel of the original museum, founded a century ago.

14. Schuchert 1940, 292. Alexander Hay Ritchie (1822–1895) came to the United States from Scotland and lived in New York. He is best known for prints depicting historical personages and events. The Library of Congress holds some of his prints of such subjects in its American Memory Collection. Ritchie worked in various intaglio media, engraving, etching, and mezzotinting, and I think he also dabbled in lithography.

15. Gernsheim 1982, 120–129 (daguerreotypes in the nineteenth century), and 114, 116–118, 126–128, 160–161, 545–546 (photolithography at this time). The engraving processes of rotogravure and photogravure were developed later in the nineteenth century, although there had been some earlier experiments with engraved photographic illustrations.

16. Ibid.

17. A brief biographical note on Filley is in John S. Craig, *Craig's Daguerreian Registry*, 2nd ed. (Torrington, Conn.: J. S. Craig, 2003), http://www.daguerreotype.com.

18. Marsh 1896. Other papers in this report were furnished with photographs as well. The USGS spent much time and money on the production of this volume. Marsh did not give credit to his illustrators or photographers, even though many of them were in his employ at the Yale Museum.

19. Schuchert 1940, 386.

20. The *Triceratops* skeleton was mounted at the Smithsonian by C. W. Gilmore in 1919. The restorations seen in Marsh's 1896 report indicate its status in 1894. See Hatcher 1893, 142; Gilmore 1905. The history of this fossil and its various presentations is discussed in Schuchert 1940, 415–416.

21. Hatcher 1907, xxix, xxx. Frederick Berger had at one point been in Crisand's employ. Berger also worked in the Yale Museum as an illustrator, producing drawings of fossils between 1875 and 1892, and off and on after that until 1898. From these drawings Crisand and his firm made lithographs and another artist, William F. Hopson (1849–1935), made elegant engravings and woodcuts that were also used in Marsh's publications. Schuchert 1940, 292–293.

22. Schuchert 1940, 292.

23. Hatcher was on Marsh's payroll and also that of the U.S. Geological Survey after 1891, so the results of his collecting trips were divided between the Yale Museum and the U.S. National Museum. See Hatcher 1907, xix, for biographical material on him, written by Osborn.

24. The painting is Knight's *Restoration of Triceratops; Trachodon in the Distance.* Two triceratops are shown, one walking past the observer and the other stopping to face outward. *Trachodon* are foraging in the trees in the distance. This painting today belongs to the Smithsonian.

25. The Division of Paleontology of the American Museum of Natural History has made these photographs from 1895 through 1928 available online at http://paleo.amnh.org/photographs/index.html. Considering how hard it was to make these images in the first place, their presence for all to see on the Internet is a fitting tribute to the men who did so.

26. Everhart (personal communication, 2006) suspects that Osborn was deliberately "coming out on the side of Cope, and not of science, dumb thing to do in a publication that people are going to look at more than a hundred years later." See Everhart 2005, 76–77, for a history of the nomenclature of *Portheus* and discussion of Osborn's use of the name in his 1904 publication.

27. Williston et al. 1898, 10–12; Williston et al. 1900. Mike Everhart (personal communication, 2006) believes the photographs of shark teeth in the 1898 volume are probably the first ones of this type of fossil. Similarly, Williston's 1903 *On the Osteology of* Nyctosaurus (Nyctodactylus), *with Notes on American Pterosaurs* contains a photograph that Everhart believes is the first ever published of an American pterosaur.

28. Case, Williston, and Mehl 1913. See especially part 5, 37–60. David Baldwin was a fossil hunter who worked from time to time for Marsh and also for E. D. Cope. See Davidson 1997, 98–99. Ermine Coles Case (born 1871) was a paleontologist attached to the American Museum. Like many of the American Museum's scientists at the turn of the twentieth century, he was no stranger to the use of photographs. In 1910 Case published a description of the skull of a specimen of *Dimetrodon incisivus* that he had found in 1906 in Texas. The article includes five photographic plates, four of which show aspects of the skull while the fifth shows the entire mounted specimen. The photographer was not named, but the photographs are excellent. Especially noteworthy is plate 18, which shows posterior and anterior aspects of the skull. The view of the animal "nose to nose" with the reader is quite striking.

29. Lankester 1906, v. Lankester referred to his audience as "juvenile," but did not specify their ages. The language of the book, however (and presumably of the lectures on which it was based) suggests that his audience were children. It must have been a great experience for them.

30. Francis A. Bather was an expert on crinoids. He wrote the Museum's guide to invertebrates, which was published in 1907. Charles Andrews was also a paleontologist at the Museum and published on topics as diverse as studies of *Bryozoa* and *Elephas.* W. P. Pycraft is remembered for his study of and commentary on the Museum's fossil of *Archaeopteryx.* This was published as "Archaeopteryx, original notes taken from the London and Berlin Fossils," 1893.

William Johnson Sollas, a geologist and paleontologist, had a very distinguished career at Oxford. He is known for his study of prehistoric and primitive humans.

31. Lankester 1906, v–vi.

32. See for example, figure 152, p. 212, which is Charles R. Knight's rendering of *Dimetrodon*. Lankester did not generally bother to cite the source of such images.

33. Ibid., 147, 150 (figures 103, 106). In this book Lankester referred to Marsh and Cope as though they were still alive.

34. Ibid., 215 (figures 155–157).

35. Lankester's figure 215, depicting various specimens of crinoids from the United States, was used later in Woodward's guidebook.

36. For a discussion of this expedition, see Maier 2003, 104.

37. British Museum 1909. Woodward (1864–1944) wrote several editions of this guidebook, beginning with the eighth (in 1904). In the 1909 edition he included a section on fossil humans. He also published on this topic, of course, and was perhaps involved in the Piltdown Man hoax. He had begun work at the British Museum when he was eighteen, and became keeper of the Geological Department in 1901. He was a specialist in fossil fish. For more information, see Minnesota State University eMuseum, "Sir Arthur Smith Woodward, 1864–1944," by Britta Walstrom, edited by Marcy L. Voelker, http://www.mnsu.edu/emuseum/information/biography/uvwxyz/woodward_arthur.html; and Gerell M. Drawhorn, "Piltdown: Evidence of Smith-Woodward's Complicity," paper presented at the 1994 annual meeting of the American Association of Physical Anthropologists, http://www.talkorigins.org/faqs/piltdown/drawhorn.html.

38. British Museum 1909, 93–95.

39. The copy with which I worked is owned by the University of Nevada DeLaMare Library, which is devoted to holdings in geology, mining engineering, and paleontology. Its copy once belonged to a German geologist named Johannes Walther (1860–1937). His owner's stamp (which includes his name and crossed geologist's hammers) appears on the book. Walther wrote extensively on marine geology and marine life, as well as general texts on the geology of Germany and paleontology. He framed what is now known as Walther's Law, describing the relationship between facies and depositional setting. If Walther bought this British Museum guidebook new, he was about fifty when he got it. How his copy came to be in the possession of the University of Nevada is a mystery. See G. V. Middleton, "Johannes Walter's Law of the Correlation of Facies," *Geological Society of America Bulletin* 84 (1973): 979–988; and University of South Carolina, Geology Department, "Walther's Law and Uniformitarianism," *USC Sequence Stratigraphy Web,* http://strata.geol.sc.edu/terminology/walther.html.

40. Sternberg 1909, iii. Mike Everhart (personal communication, 2006) comments that the Sternbergs took many of their own photographs and used them to advertise fossils they had for sale to museums.

41. Sternberg 1909, 274–275.

42. Osborn 1912b, 39.

43. I showed these photos to several people in the University of Nevada's photography department. All of them remarked on their quality. When informed that the photographs had been taken about 1910, they were astounded.

44. There were subsequent editions in 1923, 1928 and 1930. A French translation was published in 1921, a German translation in 1930, and a Japanese translation in 1931.

45. Osborn 1918, 223.

46. Some of the photographs of hadrosaurs that appeared in this book were used again as late as 1942 in Lull and Wright's landmark study, *Hadrosaurian Dinosaurs of North America.*

47. Neither publication contains tipped-in photographs; all the illustrations based on photographs were reproduced by printmaking techniques. Because I am here emphasizing the photographic reproduction of artworks and museum displays, I am calling them photographs.

48. Gilmore 1914, 1–2.

49. Gilmore always took pains to discuss his artists' contributions. He noted (123) that Smit's and Bond's restorations displayed postures and dermal armor that most scientists no longer believed correct. The idea that the dorsal plates belonged on the animal's sides seems to have been Charles R. Knight's. Their placement was being debated even at this early date. Gilmore comments that Knight was the first to show them this way in a life restoration. Of course this placement had already been suggested by O. C. Marsh.

50. Ibid., Gilmore, 1914, pp 124 and 136 and Plate 36.

51. Gilmore 1914, 128. The 1905 edition of Lankester's *Extinct Animals* is essentially the same as the 1906 edition I have used.

52. Gilmore 1920, 2.

53. Ibid., 4.

54. For some historical notes on this mount and various photographs, both old and modern, of the dining *Allosaurus*, see Dingus 1996, 84–86. Photographs of the mount appear throughout the book. In fact, a beautiful color photograph of the specimens graces the dust jacket. Dingus also reproduces Anderson's 1909 photograph on page 84.

55. Gilmore 1920, 153.

56. Ibid., 116, 153, and plate 28. Perhaps because he was an artist himself, Gilmore took pains to name the creators of the works he published and give some of their history (115–116). He reported on the status of life restorations, and hence of scientific speculations about how the animals might have looked when alive. Gilmore wrote that Frank Bond's 1899 drawing, shown in plate 27, was prepared under the direction of Professor W. C. Knight of the University of Wyoming. Gilmore believed that this was the first life restoration of *Ceratosaurus*. He noted that the *Ceratosaurus* drawing by Gleeson and Charles R. Knight, which he called "the best and most artistic portrayal of the probable life appearance of *Ceratosaurus* that has yet appeared," had originally been published as figure 23 in F. A. Lucas's 1911 *Animals of the Past*. (I am not sure whether Gilmore is referring to a later edition of Lucas 1902, or to an edition of a guidebook for the American Museum that Lucas published under the same title. Although I have not found an edition of the guidebook earlier than 1913, I do think this is more likely.)

For a modern reproduction of Gleeson's drawing, see Ashworth 1996, 31. This catalogue and the exhibition it documents present a very nice overview of some important works of art that depict dinosaurs.

57. See, for example, C. N. Fenner, "Crystallization of a Basaltic Magma from the Standpoint of Physical Chemistry," *American Journal of Science,* 4th series, 29 (1910): 224, a microphotograph of "normally crystallized basalt"; and T. L. Watson and J. H. Watkins, "Association of Rulite and Cyanite from a New Locality," *American Journal of Science,* 4th series, 33 (1911): 195–201, figures 2–3, containing microphotographs of mineral specimens.

58. Beecher 1902, plates 2–5; Sellards 1903, plates 7–8; Sellards 1904, plate 1.

59. Lull 1931, 36–37.

6. The Twentieth Century

1. Brochu et al. 1997, 139. The whole animal is a soft watermelon pink.

2. Ellis 2003. Ellis has said (personal communication, 2003) that since we don't know what these animals looked like, why not concentrate on their morphology rather than speculate on their coloration?

3. Benton 2003. The book deals with theories of the causes of the Permian-Triassic mass extinction. The landscape image on the dust cover is suitably ghostly.

4. Have other artists been looking at Dixon? Obviously they have. Debus and Debus 2002, for instance, devotes a section to Dixon's work and includes a photograph of Dixon's sculpture of "Crackbeak" (148).

5. Mark F. Berry's 2002 *The Dinosaur Filmography* runs to over 450 pages, indicating the vast amount of motion picture footage that has been devoted to prehistoric life. There are many recent studies of the work of Ray Harryhausen, including several he has authored himself; two of these are listed in the bibliography. See also Webber 2004.

6. Knight's work is well represented on *Welcome to the World of Charles R. Knight,* http://www.charlesrknight.com, a website maintained in part by his granddaughter, Rhonda Kalt. The complete run of *National Geographic* is available on CD. And Czerkas and Glut 1982, while older and somewhat brief, is still useful. It reproduces Knight's murals, the illustrations from *National Geographic,* and the small sculptural models. This book, both an art book and a part of the history of paleontology illustration, is becoming something of a collector's item and is now fetching high prices.

7. Czerkas and Glut 1982, 8–10.

8. Czerkas and Glut published a sketch made by Cope for Knight's use about this time. It details restorations of various animals that seem similar to the scene Cope had drawn decades earlier for "The Fossil Reptiles of New Jersey" (Cope 1867–1869). Knight spent three weeks in March 1897 working with Cope (Czerkas and Glut 1982, 13, 16). Henry F. Osborn published a number of Cope's sketches of various fossil restorations in *Cope: Master Naturalist* (1931), and

alongside these he also published Knight's art which was based on these sketches. Thus *Cope: Master Naturalist* constitutes a collection not only of Cope's art but of Knight's as well.

William Hosea Ballou was a journalist; in 1890 he had written the sensational articles in the *New York Herald* that outlined the "bone wars" between Cope and O. C. Marsh. Ballou was on Cope's side. Cope, and later Osborn, made it appear that Cope had met Ballou only a short time before the publication of these articles. That is untrue. Cope had known Ballou for at least five years and seems to have thought for some time that his talents might be useful in an attack on Marsh. See Davidson 1997, 89–92.

Knight, for his part, no doubt admired Cope's genius, but he also had a decidedly negative opinion of Cope's personality. He commented to Osborn, who quoted him in a letter written in 1930, that "Cope's mind was the most animal" Knight had ever encountered and "his tongue the filthiest" (Davidson 1997, 108–109). It must be remembered that Knight was quite young when he met Cope.

9. Osborn 1898, reprinted in Weishampel and White 2003, 471–474.

10. Czerkas and Glut 1982, 19.

11. Osborn 1898, 842, reprinted in Weishampel and White 2003, 472.

12. *Agathaumus* is now a *nominum dubium*. Cope had in fact called the specimen *A. sylvestris,* but Osborn accidentally used the species name Cope had given to *Monoclonius sphenocerus* (also now a *nominum dubium*). Cope erected *Agathaumus sylvestris* on the basis of a partial pelvis and sacrum. See Weishampel, Dodson, and Osmólska 2004, 496.

13. Osborn 1898, 841, reprinted in Weishampel and White 2003, 471.

14. An additional illustration in this book is of interest here. Lucas depicted a restoration of *Ceratosaurus* feeding which was originally executed by Gleeson. The animal is shown with a hornlike prominence on its snout. There is a similar hornlike prominence on Knight's rendering of *T. rex* in the 1942 *National Geographic* article. Knight had begun to work with Frederic Lucas as early as 1901. For a discussion of some of the association between Knight and Lucas see Czerkas and Glut 1982, 21.

15. Deems Taylor (1885–1966), the narrator of *Fantasia,* also wrote extensively about motion pictures, as a combined critic and historian of the industry. (He suggested the theme of prehistoric life for the *Rite of Spring* segment.) In 1940 he published *Walt Disney's Fantasia* as publicity for the movie. This art book has become a collector's item, selling for as much as ten thousand dollars. It includes color lithographs taken from the scenes of the movie and other color plates tipped in, as well as drawings. It also contains Taylor's commentary on the various segments of the movie, sort of an extended version of the film's minimal script. But he makes no mention of the names of the animators, and certainly none of Knight. John Culhane's 1983 book, also entitled *Walt Disney's Fantasia,* is almost a modern counterpart to Taylor's. Like the earlier work, it is copyrighted by the Disney Corporation. It does provide information on the making of the film, the names of the production teams for the segments, and so on, but it does not mention Charles R. Knight.

Stravinsky consulted on the film in late 1938 and signed the contract allowing his work to be used in January 1939. He was paid $6000. Stokowski and the Philadelphia Orchestra were paid $400,000 for their participation (Culhane 1983, 109–110, 21). According to its publicity statements, the studio worked hard to make the fossil restorations in the *Rite of Spring* segment as scientifically correct as it could. Culhane quotes its statement that "such world-famous authorities as Roy Chapman Andrews, Julian Huxley, Barnum Brown and Edwin P. Hubble volunteered helpful data and became enthusiastic followers of the picture's progress" (120–121). That statement establishes a connection between the Disney production teams and the American Museum of Natural History. It is impossible that the Disney animators could have been unfamiliar with Knight's work.

Although I find it surprising that Disney did not credit Knight, it is consistent with the studio's actions elsewhere. The *Night on Bald Mountain* sequence at the end of the film features flying witches, specters, and demons that are directly taken from a 1922 animated film, *Haxan* (Witches), by the Danish director Benjamin Christensen (1879–1959). The art director and creative mind behind the *Bald Mountain* sequence was Kay Nielsen, a well-known fantasy artist. Nielsen must have known of *Haxan*. See Culhane 1983, 185, for information on Nielsen. Culhane makes no mention of *Haxan.*

The fight between *Tyrannosaurus rex* and *Stegosaurus* could not have taken place, of course. Mark Berry (2002, 103) notes that the original idea was to have a fight between *Triceratops* and

Tyrannosaurus rex, but this was changed for the dramatic effect of *Stegosaurus* fighting with its tail. Berry believes that this decision was made by Walt Disney himself. He has commented, "Let us not nitpick Walt's slight timeline error."

16. Osborn and Mook 1921, 251.

17. My copy of the book is from the collection of Jim Jensen and is inscribed "James A. Jensen, Provo, Utah, Dec. 1963, Gift of Charles C. Mook." Mook died in 1966. This inscription is a testament to the fact that this book stood the tests of time. I am honored to own it now.

18. See "Springer Echinoderm Collection," Smithsonian Institution, Department of Paleobiology, National Museum of Natural History, http://paleobiology.si.edu/springer/paleoSpringer.html, for a brief outline of the lives and contributions of Springer and Wachsmuth.

19. Horner and Lessem 1993, 81.

20. Osborn 1913 includes three photographs of Christman's model of the fighting dinosaurs, taken from various angles.

21. There is an interesting bit of confusion here. Horner and Lessem, and many other writers, speak of the use of "iron" braces for the skeleton. But when Henry Osborn wrote about *Tyrannosaurus rex's* new pose (1916, 763), he called these rods a "powerful steel framework." Iron or steel, the rods could not support an agile-looking, lively pose for *Tyrannosaurus rex.* Osborn also noted that he had conferred with Barnum Brown and Erwin Christensen for a period of "prolonged study" of how the two skeletons should be posed, and concluded, "It is proposed ultimately to mount the pair of skeletons in the offensive and defensive attitudes respectively." This is a strange remark. The restored large skeleton that was publicly displayed in the American Museum had already been finished when this article was published, and indeed the article includes photographs of it. The second skeleton was similarly mounted in an upright pose (Horner and Lessem 1993, 83). It was not displayed, however, and during World War II it was sent to the Carnegie Museum in Pittsburgh. These two skeletons could not have been put into "offensive and defensive" positions in 1916 unless they had been taken apart and reassembled with new structural supports. Was Osborn trying to tell his scientific colleagues that he knew the pose was wrong? Perhaps he was.

22. Horner and Lessem 1993, 81–82.

23. Osborn 1916, 763. The 1918 photograph is a photomontage of the two images of 1915.

24. See especially Dingus 1996, 86–90. Dingus contributed to the total make-over of the Museum's exhibits and displays. The new restoration of *Tyrannosaurus rex* consists, as did the older one, of some cast materials and some actual bones. The restoration team, which included Mark Norell, Phil Fraley, and Jeanne Kelly, actually used Osborn and Christman's wooden model that had been used to make the first restoration (Dingus 1996, p. 88). The old work of art has come full circle.

25. Gee and Rey 2003, 120–121. The first line of the introduction states, "this is a work of fiction." It is a beautiful and delightful work of fiction, in my opinion.

26. Berry 2003, 113–114. As I write, parts of both Gertie films can be found on YouTube (http://www.youtube.com).

27. The most recent restoration dates from 2000 and was published in DVD format by Image Entertainment. For *The Lost World,* see Berry 2003, 240, 245–246.

28. Webber 2004.

29. Berry 2003, 184, 191–195.

30. Scully, Zallinger, Hickey, and Ostrom 1990. Zallinger's murals can be seen in "The Zallinger Murals at the Yale Peabody Museum," Yale Peabody Museum, http://www.peabody.yale.edu/archives/ypmmurals.html.

31. Debus and Debus 2002, 105–107, provides a brief biographical sketch of Burian and comments on his association with Augusta. Several websites offer images of his work.

32. McKerrow 1978. Similar reconstructions of communities of crinoids are found throughout Hess, Bausch, Brett, and Simms 1999, which includes illustrations reproduced from several 1970s works as well as from more recent sources.

33. Mike Everhart's website *Oceans of Kansas Paleontology: Fossils from the Late Cretaceous Western Interior Sea* (http://www.oceansofkansas.com) is an excellent example of the use of the Internet to disseminate information on paleontology and paleontology illustrations. Varner's art appears on the dust cover of and as a color insert in Everhart 2005.

34. Dan Varner, personal communication, 2006.

35. See Debus and Debus 2002, chapter 31, "Building Life-Sized Dinosaurs," for discussions of several "dinosaur parks."

36. For *Bambiraptor,* see plate 7 in Curie et al. 2004; for *Protarchaeopteryx,* see plate 5 in Tanke and Carpenter 2001. The art director of this book was another paleo artist, Michael W. Skrepnick.

37. Dan Lorusso, *The Dinosaur Studio,* http://www.dinosaurstudio.com. A photograph of one of his works is found as plate 10 in Tanke and Carpenter 2001.

38. Michael Trcic, *Michael Trcic Studio,* http://www.trcicstudio.com.

39. Thomas Eisener, dust jacket blurb on Grimaldi and Engel 2005.

40. Donoghue et al. 2006.

41. Brochu and Ketcham 2002; Tykoski et al. 2002.

BIBLIOGRAPHY

Baird, Donald. Typescript of notes made December 16, 1985, covering the B. W. Hawkins ephemera in ANSP Archives. Collection 803. Archives, Academy of Natural Sciences of Philadelphia.

Cope, Edward Drinker. Business correspondence. Archives, American Philosophical Society, Philadelphia, Penn.

———. Papers. Special Collections, Haverford College Libraries.

Hawkins, Benjamin Waterhouse. "Scrapbook." Ephemera collection of Hawkins materials. Collection 803. Archives, Academy of Natural Sciences of Philadelphia.

Likeness of Joseph Leidy. Items 23–24, collection 9. Archives, Academy of Natural Sciences of Philadelphia.

Agassiz, Louis. 1833–1845. *Recherches sur les poissons fossiles.* Neuchâtel: H. Nicolet.

———. 1844–1845. *Monographie des poissons fossiles du vieux grès rouge, ou Systeme Devonien (Old Red Sandstone) des Isles Brittaniques et de Russie.* Neuchâtel: H. Nicolet.

Aldrovandi, Ulisse. 1606. *De reliquis animalibus exanguibus libri quatuor de mollibus, crustaceis, testaceis et zoophytis.* Bononiae (Bologna): J. B. Bellagamba.

———. 1642. *Monstrum historia cum Paralipomenis historiae omnium animalium.* Bononiae: Nicolai Tebaldini.

———. 1648. *Musaeum metallicum in Libros IIII Distributum.* Bononiae: I. B. Ferronij.

———. 1668. *Dendrologiae naturalis scilicet arborum historiae, Libri duo.* Bononiae: J. B. Ferronii.

Ansted, David Thomas. 1863. *The Great Stone Book of Nature.* London: Macmillan; Philadelphia: G. W. Childs.

Augusta, Josef. 1957. *Prehistoric Animals.* Translated by Greta Hort. London: Spring.

Ballou, William H., and Charles R. Knight. 1897. "Strange Creatures of the Past." *Century Magazine* 60:403–428.

Becker, Herman F. *Oligocene Plants from the Upper Ruby River Basin, South-Western Montana.* Geological Society of America Memoirs, no. 82. New York: Geological Society of America.

Beecher, C. E. 1902. "The Ventral Integument of Trilobites." *American Journal of Science,* 4th series, 13:165–174.

Beringer, Johann B. A. 1726. *Lithographiae Wirceburgensis.* Wirceburgi: (Wurzburg) Engmann.

Bernard, Félix. 1895. *Éléments de paléontologie.* Paris: Baillière et Fils. Reprint, New York: Arno, 1980.

Bourguet, Louis. 1742. *Traité des petrifications.* Paris: A. C. Briasson.

British Museum (Natural History). 1909. *A Guide to the Fossil Mammals and Birds in the Department of Geology and Palaeontology in the British Museum (Natural History).* 9th ed., by Arthur Smith Woodward. London: Printed by order of the Trustees by W. Clowes and sons.

Brochu, Christopher A., and Richard A. Ketcham. 2002. CD accompanying *Osteology of Tyrannosaurus rex: Insights from a Nearly Complete Skeleton and High-Resolution Computed Tomographic Analysis of the Skull. Society of Vertebrate Paleontology Memoir 7,* supplement to *Journal of Vertebrate Paleontology* 22, no. 2.

Brookes, Richard. 1763. *The Natural History of Waters, Earths, Stones, Fossils and Minerals, with Their Virtues, Properties, and Medicinal Uses: To Which Is Added, the Method in Which Linnaeus Has Treated These Subjects.* Volume 5. London: Newberry.

Buckland, William. 1824. "Notice on the *Megalosaurus* or Great Fossil Lizard of Stonesfield." *Transactions of the Geological Society of London*, series 2, 1:390–396.

———. 1837. *Geology and Mineralogy Considered with Reference to Natural Theology.* 2 vols. 2nd ed. (first edition published in 1836). London: Pickering. Facsimile reprint. Boston: Adamant Media, 2001.

Burling, Lancaster D. 1917. "*Protichnites* and *Climactichnites*: A Critical Study of Some Cambrian Trails." *American Journal of Science*, 4th series, 44:387–398.

Burtin, Francois-Xavier. 1784. *Oryctographie de Bruxelles, ou Description des fossiles tant naturels qu'accidentels, découverts jusqu'à ce jour dans les environs de cette ville.* Brussels: Le Maire.

Carte, Alexander, and W. H. Baily. 1863. "Description of a New Species of *Plesiosaurus*, from the Lias, near Whitby, Yorkshire." *Journal of the Royal Dublin Society* 4:160–170.

Case, Ermine C. 1910. "Description of a Skeleton of *Dimetrodon Incisivus* Cope." *Bulletin of the American Museum of Natural History* 28, article 19: 189–196.

Case, E. C., S. W. Williston, and M. G. Mehl. 1913. *Permo-Carboniferous Vertebrates from New Mexico.* Carnegie Institution of Washington, publication no. 181. Philadelphia: J. B. Lippincott.

Colonna, Fabio. 1616. *Aquatilium et terrestrium aliquot animalium.* Rome.

Conybeare, William D. 1824. "On the Discovery of an Almost Perfect Skeleton of the *Plesiosaurus*." *Transactions of the Geological Society of London,* second series, 1:381–390, plus addendum and plates 47, 49.

Cope, Edward Drinker. 1867–1869. "The Fossil Reptiles of New Jersey." *American Naturalist* 1:23–30; 2:84–91.

———. 1875. *Department of the Interior. Report of the United States Geological Survey of the Territories,* vol. 2, *The Vertebrata of the Cretaceous Formations of the West.* Washington, D.C.: U.S. Government Printing Office.

———. 1877. *Engineer Department, U. S. Army. Geographical Surveys West of the One Hundredth Meridian,* vol. 4, *Paleontology,* part 2, *Report upon the Extinct Vertebrata Obtained in New Mexico by Parties of the Expedition of 1874.* Washington, D.C.: U.S. Government Printing Office.

———. 1883. *Department of the Interior, Report of the United States Geological Survey of the Territories,* vol. 3, *The Vertebrata of the Tertiary Formations of the West.* Washington, D.C.: U.S. Government Printing Office.

———. 1886. *The Origin of the Fittest.* New York: Appleton.

———. 1891. *Contributions to Canadian Palaeontology,* vol. 3, *On Vertebrata from the Tertiary and Cretaceous Rocks of the North West Territory. I. The Species from the Oligocene or Lower Miocene Beds of the Cypress Hills.* Montreal: Geological Survey of Canada.

———. 1896. *The Primary Factors of Organic Evolution.* Chicago: Open Court Publishing.

Cuvier, Georges. 1812. *Recherches sur les ossemens fossiles de quadrupèdes, où l'on rétablit les caractères de plusieurs espèces d'animaux que les révolutions du globe paroissent avoir détruites.* Paris: Deterville.

Debus, Allen A., and Diane E. Debus. 2002. *Paleoimagery.* Jefferson, N.C., and London: MacFarland.

De la Beche, Henry T., and William D. Conybeare. 1821. "Notice of the Discovery of a New Fossil Animal, Forming a Link between the *Ichthyosaurus* and Crocodile, Together with General Remarks on the Osteology of the *Ichthyosaurus*." *Transactions of the Geological Society of London,* series 1, 5:559–94 and plates 40–42.

———. 1839. *Report on the Geology of Cornwall, Devon and West Somerset.* London: Longman, Orme, Brown, Green and Longmans.

———. 1851. *The Geological Observer.* London: Longman, Brown, Green and Longmans.

Dézallier d'Argenville, Antoine-Joseph. 1755. *L'histoire naturelle éclaircie dans une de ses parties principales, l'oryctologie, qui traite des terres, des pierres, des métaux, des minéraux et autres fossiles. . . .* Paris: De Bure l'aîné. The first edition of this book was published by the same printer in 1742.

Dixon, Dougal. 1988. *The New Dinosaurs.* Topsfield, Mass.: Salem House Publishers.

Donoghue, Philip C. J., et al. 2006. "Synchrotron X-ray Tomographic Microscopy of Fossil Embryos." Letter. *Nature* 442, no. 7103 (August 10): 680–683.

Ellis, Richard. 2003. *Sea Dragons: Predators of the Prehistoric Seas.* Lawrence: University of Kansas Press.

Faujas-de-Saint-Fond, Barthélemy. 1799. *Histoire naturelle de la Montagne de Saint-Pierre de Maestricht.* Paris: H. J. Jansen.

Fenton, Carroll Lane. 1937. *Life Long Ago.* New York: Reynal and Hitchcock.

Fenton, Carroll Lane, and Mildred Adams Fenton. 1958. *The Fossil Book.* New York: Doubleday.

Figuier, Louis. 1867. *The World before the Deluge.* 2nd ed. (translated from the fourth French edition), revised and expanded by Henry W. Bristow. New York: Appleton. The first English edition appeared in 1865.

———. 1872. *La terre avant le déluge.* 6th ed. Paris: Hachette. The first edition appeared in 1863.

Gee, Henry, and Louis V. Rey. 2003. *A Field Guide to Dinosaurs.* Hauppauge, N.Y.: Barron's.

Gesner, Konrad. 1551–1558. *Historia animalium Liber IIII.* Tiguri: Christoph. Froschourum.

———. 1565. *De rerum fossilium lapidum et gemmarum.* Tiguri: Jacobus Gesnerus.

Gilmore, Charles W. 1905. "The Mounted Skeleton of *Triceratops prorsus.*" *Proceedings of the United States National Museum* 29:433–435.

———. 1914. *Osteology of the Armored Dinosauria in the United States National Museum, with Special Reference to the Genus Stegosaurus.* Smithsonian Institution United States National Museum Bulletin 89. Washington, D.C.: U.S. Government Printing Office.

———. 1920. *Osteology of the Carnivorous Dinosauria in the United States National Museum, with Special Reference to the Genera Antrodemus (Allosaurus) and Ceratosaurus.* Smithsonian Institution United States National Museum Bulletin 110. Washington, D.C.: U.S. Government Printing Office.

Grabau, Amadeus W., and Hervey W. Shimer. 1909. *North American Index Fossils: Invertebrates.* New York: A. G. Seiler.

Gregory, William K., and George G. Simpson. 1926. "Cretaceous Mammal Skulls from Mongolia." *American Museum of Natural History Novitates,* no 225:1–20.

Grimaldi, David, and Michael S. Engel. 2005. *Evolution of the Insects.* New York: Cambridge University Press.

Harryhausen, Ray, and Tony Dalton. 2004. *Ray Harryhausen: An Animated Life.* New York: Billboard Books.

———. 2006. *The Art of Ray Harryhausen.* New York: Billboard Books.

Hatcher, John Bell. 1893. "The Ceratops Beds of Converse County, Wyoming." *American Journal of Science,* 3rd series, 45:135–144.

———. 1907. *The Ceratopsia.* Based on preliminary studies by Othniel C. Marsh; edited and completed by Richard S. Lull. Monographs of the United States Geological Survey 49. Washington, D.C.: U.S. Government Printing Office.

Hawkins, Benjamin Waterhouse. 1854. "On Visual Education as Applied to Geology." *Journal of the London Society of Arts* 2:444–449. Reprinted in Weishampel and White 2003, 219–225.

Hawkins, Thomas. 1834. *Memoirs of Ichthyosauri and Plesiosauri: Extinct Monsters of the Ancient Earth.* London: Relfe and Fletcher.

———. 1840. *The Book of the Great Sea Dragons: Ichthyosauri and Plesiosauri.* London: Pickering.

Hayden, Ferdinand V. 1883. *Twelfth Annual Report of the United States Geological and Geographical Survey of the Territories: A Report of Progress of the Exploration in Wyoming and Idaho for the Year 1878; In Two Parts.* Part 1, *Geology, Paleontology and Zoology.* Washington, D.C.: U.S. Government Printing Office.

Heilmann, Gerhard. 1927. *The Origin of Birds.* New York: Appleton. Reprint, New York: Dover, 1972. Originally published in 1916 as *Fuglenes afstamning* (Kobenhavn: Saertryk af Dansk Ornithologist Forenings Tidsskrift).

Hess, Hans, W. I. Bausch, C. E. Brett, and M. J. Simms. *Fossil Crinoids.* Cambridge: Cambridge University Press.

Hitchcock, Edward. 1836. "Ornithichology, or a Description of Footmarks of Birds (*Ornithichnites*) on New Red Sandstone in Massachusetts." *American Journal of Science,* 2nd series, 29:307–341.

———. 1856. *Elementary Geology.* New York: Ivison and Phinney.

———. 1858. *Ichnology of New England: A Report on the Sandstone of the Connecticut Valley, Especially Its Fossil Footmarks.* Boston: W. White. Reprint, New York: Arno, 1974.

————. 1860. *The Religion of Geology.* London: James Blackwood.

————. 1865. *Supplement to the Ichnology of New England.* Edited and with an appendix by C. H. Hitchcock. Boston: Wright and Potter

Hooke, Robert. 1665. *Micrographia.* London: John Martyn and James Allestry.

————. 1705. *The Posthumous Works of Robert Hooke.* With an introduction by Richard S. Westfall. New York: Johnson Reprint Co., 1969.

Hooker, Worthington. 1884. *Science for the School and Family, Part 3: Mineralogy and Geology.* 3rd ed. New York, Harper and Brothers.

Ibbetson, Levett L. B. 1849. *Notes on the Geology and Chemical Composition of the Various Strata in the Isle of Wight.* London.

Illustrated London News. 1853. "The Crystal Palace at Sydenham." Vol. 23, no. 661 (December 31): 559–560.

————. 1854. "The Crystal Palace at Sydenham." Vol. 24, no. 662 (January 7): 22.

Jillson, Willard R. 1917. "Preliminary Note on the Occurrence of Vertebrate Footprints in the Pennsylvanian of Oklahoma." *American Journal of Science,* 4th series, 44:56–58.

Judd, John W., ed. 1896. *The Student's Lyell: A Manual of Elementary Geology.* New York: Harper.

Kircher, Athanasius. 1664–1665. *Mundus subterraneus.* Amsterdam: J. Janssonium & E. Weyerstraten.

Klein, Jacobi Theodori. 1753. *Tentamen methodi ostracologicae, sive, Dispositio naturalis cochlidum et concharum in suas classes, genera et species.* Lugdini Batavorum (Amsterdam): Gerog Jacob Wishoft.

Knight, Charles R. 1942. "Parade of Life through the Ages." *National Geographic Magazine* 81, no. 2 (February): 141–184.

Kohl, Michael F., and John S. McIntosh. 1997. *Discovering Dinosaurs in the Old West: The Field Journals of Arthur Lakes.* Washington, D.C., and London: Smithsonian Institution Press.

Lankester, E. Ray. 1906. *Extinct Animals.* New York: Holt.

Le Conte, Joseph. 1879. *Elements of Geology.* New York: Appleton.

Leidy, Joseph. 1853. *The Ancient Fauna of Nebraska, or, A Description of Remains of Extinct Mammalia and Chelonia from the Mauvaises Terres of Nebraska.* Washington City: Smithsonian Institution.

Leigh, Charles. 1700. *The Natural History of Lancashire, Cheshire, and the Peak in Derbyshire: With an Account of the British Phoenician, Armenian, Gr., and Rom. Antiquities in Those Parts.* Oxford: Printed for the author.

Leonardo da Vinci. 1970. *The Notebooks of Leonardo da Vinci.* Compiled and edited by Jean Paul Richter. New York: Dover.

Lesquereux, Leo. 1879. *Atlas to the Coal Flora of Pennsylvania and of the Carboniferous Formation throughout the United States.* Second Geological Survey of Pennsylvania, Report of Progress. Harrisburg, Pa.: Board of Commissioners for the Second Geological Survey.

————. 1880. *Description of the Coal Flora of the Carboniferous Formation in Pennsylvania and throughout the United States.* Vols. 1 and 2. Second Geological Survey of Pennsylvania, Report of Progress. Harrisburg, Pa.: Board of Commissioners for the Second Geological Survey.

————. 1883. *Contributions to the Fossil Flora of the Western Territories.* Vol. 3, *The Cretaceous and Tertiary Floras.* Report of the United States Geological Survey of the Territories. Washington, D.C.: U.S. Government Printing Office.

————. 1884. *Description of the Coal Flora of the Carboniferous Formation in Pennsylvania and throughout the United States.* Vol. 3. Second Geological Survey of Pennsylvania, Report of Progress. Harrisburg, Pa.: Board of Commissioners of the Second Geological Survey, L. S. Hart Printer.

Lesquereux, Leo, et al. 1895. *The Geology of Minnesota.* Vol. 3, part 1, *1885–1892: Paleontology.* Geological and Natural History Survey of Minnesota. Minneapolis, Minn.: Johnson, Smith, and Harrison.

Lhwyd, Edward. 1699. *Lithophylacii Britannici ichnographia, sive, Lapidorum aliorumque fossilium britannicorum singulari figura insignium.* London.

Lister, Martin. 1678. *Historiae animalum angliae tres tractatus.* London: John Martyn.

Lucas, Frederic A. 1901. *Animals of the Past.* New York: McClure, Phillips.

Lull, Richard S. 1931. *Fossils: What They Tell Us of Plants and Animals of the Past*. New York: The University Society.

Lull, Richard S., and Nelda E. Wright. 1942. *Hadrosaurian Dinosaurs of North America*. Geological Society of America, Special Papers, no. 40. Baltimore, Md.: Geological Society of America.

Lyell, Charles. 1871. *The Student's Elements of Geology*. London: Murray.

Maisey, John G. 1996. *Discovering Fossil Fishes*. New York: Holt.

Mantell, Gideon. 1838. *The Wonders of Geology*. London: Relfe and Fletcher.

———. 1850. *A Pictorial Atlas of Fossil Remains: Consisting of Coloured Illustrations Selected from Parkinson's "Organic Remains of a Former World" and Artis's "Antediluvian Phytology," with Descriptions by Gideon Algernon Mantell*. London: H. Bohn.

Marsh, Othniel C. 1862. "Description of the Remains of a New Enaliosaurian (*Eosaurus Acadianus*), from the Coal Formation of Nova Scotia." *American Journal of Science and Arts*, 2nd series, 34:1–16.

———. 1879. "History and Methods of Palaeontological Discovery: An Address Delivered before the American Association for the Advancement of Science, at Saratoga, N.Y., August 28, 1879, by Professor O. C. Marsh, President." *American Journal of Science*, 3rd series, 18:323–359.

———. 1880. *Odontornithes: A Monograph on the Extinct Toothed Birds of North America*. Washington, D.C.: U.S. Government Printing Office.

———. 1892. "Restorations of *Claosaurus* and *Ceratosaurus*." *American Journal of Science*, 3rd series, 44:343–349 and plates 6–7.

———. 1896. "The Dinosaurs of North America." *Sixteenth Annual Report of the United States Geological Survey to the Secretary of the Interior, 1894–95*, 133–244. Washington, D.C.: U.S. Government Printing Office.

McKerrow, W. S., ed. 1978. *The Ecology of Fossils: An Illustrated Guide*. Cambridge, Mass.: MIT Press.

Mercati, Michele. 1717. *Michaelis Mercati Metallotheca opus posthumum*. Rome: J. M. Salvioni.

———. 1719. *Michaelis Mercati Metallotheca opus posthumum*, with *Appendix ad Metallothecam vaticanam Michaelis Mercati*. Rome: J. M. Salvioni.

Merriam, John C. 1908. *Triassic Ichthyosauria, with Special Reference to the American Forms*. Memoirs of the University of California 1, no. 1. Berkeley: University of California Press.

Newberry, John S. 1888. *Fossil Fishes and Fossil Plants of the Triassic Rocks of New Jersey and the Connecticut Valley*. United States Geological Survey, Monographs, vol. 14. Washington, D.C.: U.S. Government Printing Office.

Nicholson, Henry A., and Richard Lydekker. 1889. *A Manual of Paleontology*. Vols. 1–2. London: W. Blackwood and Sons.

Osborn, Henry F. 1898. "Models of Extinct Vertebrates." *Science*, n.s., 7:841–845.

———. 1904. "The Great Cretaceous Fish *Portheus molossus* Cope." *Bulletin of the American Museum of Natural History* 20:377–378.

———. 1906. "*Tyrannosaurus*, Upper Cretaceous Carnivorous Dinosaur." *Bulletin of the American Museum of Natural History* 22:281–296.

———. 1912a. "Crania of *Tyrannosaurus* and *Allosaurus*." *Memoirs of the American Museum of Natural History*, ns. 1, part 1:1–30.

———. 1912b. "Integument of the Iguanodont Dinosaur *Trachodon*." *Memoirs of the American Museum of Natural History*, n.s. 1, part 2:31–54.

———. 1913. "*Tyrannosaurus*: Restoration and Model of the Skeleton." *Bulletin of the American Museum of Natural History* 33:91–95.

———. 1916. "Skeletal Adaptations of *Ornitholestes*, *Struthiomimus*, *Tyrannosaurus*." *Bulletin of the American Museum of Natural History* 35:733–771.

———. 1918. *The Origin and Evolution of Life*. New York: Charles Scribner's Sons.

———. 1931. *Cope: Master Naturalist*. Princeton, N.J.: Princeton University Press. Reprint, New York: Arno, 1978.

Osborn, Henry F., and Charles C. Mook. 1921. *Camarasaurus, Amphicoelias, and Other Sauropods of Cope*. Memoirs of the American Museum of Natural History, n.s. 3, part 3. New York: American Museum of Natural History.

Owen, David Dale. 1852. *Illustrations to the Geological Report of Wisconsin, Iowa and Minnesota*. Philadelphia: Lippincott, Grambo and Co.

Owen, David Dale, et al. 1852. *Report of a Geological Survey of Wisconsin, Iowa and Minnesota and Incidentally of a Portion of Nebraska Territory.* Philadelphia: Lippincott, Grambo, and Co.

Owen, Richard. 1840. "A Description of a Specimen of *Plesiosaurus Macrocephalus* Conybeare, in the Collection of Viscount Cole." *Transactions of the Geological Society of London,* second series, 5:515–535.

———. 1851. *Monograph on the Fossil Reptilia of the Cretaceous Formations.* London: Geological Society of London.

———. 1864. "On the *Archaeopteryx* of Von Meyer, with a Description of the Fossil Remains of a Long-Tailed Species from the Lithographic Stone of Solenhofen." *Philosophical Transactions of the Royal Society of London* 153:33–47.

Paré, Ambroise. 1678. *The Works of That Famous Chirurgeon Ambrose Parey, Translated out of Latin and Compared with the French.* Trans. Thomas Johnson. London: Mary Clark.

Parkinson, James. 1804–1811. *Organic Remains of a Former World: An Examination of the Mineralized Remains of the Vegetables and Animals of the Antediluvian World, Generally Termed as Extraneous Fossils.* London: Printed by C. Whittingham for J. Robson.

Paul, Gregory S. 2002. *Dinosaurs of the Air: The Evolution and Loss of Flight in Dinosaurs and Birds.* Baltimore, Md., and London: Johns Hopkins University Press.

Plot, Robert. 1677. *The Natural History of Oxfordshire, Being an Essay towards the Natural History of England.* Oxford: The Theatre.

Robinet, Jean-Baptiste. 1768. *Considérations philosophiques de la gradation naturelle des formes de l'être, ou les essais de la Nature qui apprend à faire l'Homme.* Paris: Saillant.

Scheuchzer, Johannes. 1709. *Herbarium diluvianum.* Tiguri: Literis D. Gessneri.

———. 1716. *Museum diluvianum.* Tiguri: Typis Henrici Bodmeri.

———. 1731–1733. *Physica sacra.* Ulmae: Augustae Vindelicorum.

Schulze, Christian Friedrich. 1754. *Kurtze Betrachtung derer versteinerten Höltzer, worinnen diese natürlichen Cörpor sowohl nach ihrem Ursprunge . . .* Dresden and Leipzig: Friedrich Hekel.

———. 1755. *Kurtze Betrachtung derer Kräuterabdrücke im Steinreiche . . .* Dresden and Leipzig: Friedrich Hekel.

———. 1760. *Betrachtung der versteinerten Seesterne und ihren Theile. . . .* Warchau and Dresden: Friedrich Hekel.

Scilla, Agostino. 1752. *De corporibus marinis lapidescentibus quae defossa reperiuntur.* Rome: Venanti Monaldini. Latin translation of Scilla's *La vana speculazione disingannata dal senso* (Naples, 1670).

Scudder, Samuel H. 1890. *The Tertiary Insects of North America.* Report of the United States Geological Survey of the Territories, vol. 13. Washington, D.C.: U.S. Government Printing Office.

Scully, Vincent, Rudolph F. Zallinger, Leo H. Hickey, and John H. Ostrom. 1990. *The Great Dinosaur Mural at Yale: The Age of Reptiles.* New York: Abrams.

Sellards, E. H. 1903. "Some New Characteristics of Paleozoic Cockroaches." *American Journal of Science,* 4th series, 15:307–315.

———. 1904. "A Study of the Structure of Paleozoic Cockroaches, with Descriptions of New Forms from the Coal Measures." *American Journal of Science,* 4th series, 18:113–134.

Seward, Albert C. 1898–1919. *Fossil Plants for Students of Botany and Geology.* 4 vols. Cambridge: Cambridge University Press.

———. 1933. *Plant Life through the Ages.* 2nd ed. Cambridge: Cambridge University Press.

Springer, Frank. 1926. *American Silurian Crinoids.* Washington, D.C.: Smithsonian Institution.

Steno, Nicolas. 1667. *Elementorum myologiae specimen, seu, Musculi descriptio geometrica: Cui accedunt canis carchariae dissectum caput, et dissectus piscis ex canum genere.* Florenti: Ex typographia sub signo Stellae.

———. *Steno: Geological Papers.* 1969. Edited by Gustav Scherz, translated by Alex J. Pollock. Odense, Denmark: Odense University Press.

Sternberg, Charles H. 1909. *The Life of a Fossil Hunter.* New York: Henry Holt.

Stout, William, illust. 1981. *The Dinosaurs.* Narrated by William Service; edited by Byron Preiss; introduction and scientific commentary by Peter Dodson. New York: Bantam Books.

Stukeley, William. 1719. "An Account of the Impression of the Almost Entire Sceleton of a Large Animal in a Very Hard Stone, Lately Presented the Royal Society, From Nottinghamshire,

by Dr. William Stukely, M.D. and R.S. Soc." *Nottinghamshire Philosophical Transactions* 30, no. 360: 963–968.

Taylor, Deems. 1940. *Walt Disney's Fantasia.* New York: Simon and Shuster.

Teissier, Antoine. 1686. *Catalogus auctorum qui librorum catalogos, indices, bibliothe-cas . . . scriptis consignarunt.* Geneva: S. de Tournes.

Tenney, Sanborn. 1876. *Geology for Teachers, Classes and Private Students.* Philadelphia: J. H. Butler. Originally published in 1859.

Topsell, Edward. 1608. *The History of the Four Footed Beasts, Serpents and Insects.* London: William Iaggard. Second edition, London: E. Cotes, 1658.

Tykoski, Ronald S., et al. 2002. "*Calsoyasuchus valliceps:* A New Crocodyliform from the Early Jurassic Kayenta Formation of Arizona." Article with supplemental CD. *Journal of Vertebrate Paleontology* 22, no. 3 (September), pp. 593–611.

Ulrich, E. O., et al. 1942. *Ozarkian and Canadian Cephalopods, part 1: Nautilicones.* Geological Society of America, Special Papers no. 37. Baltimore, Md.: Geological Society of America.

Verstegan, Richard (Richard Rowlands). 1605. *A Restitution of Decayed Intelligence in Antiqui-ties, Concerning the Most Noble and Renowned English Nation: by the Study and Trauaile of R. V. Dedicated to the Kings Most Excellent Maiestie.* Antwerp: Robert Bruney. Subsequent editions were printed in London by John Bill, 1628; John Norton for Joyce Norton and Richard Whitaker, 1634; T. Newcomb for Josuah Kirton, 1653; Newcomb again, 1655; and Samuel Mearne, John Martyn, and Henry Herringman, 1673.

Ward, Henry A. 1864. *Notice of the* Megatherium Cuvieri, *the Giant Fossil Ground-Sloth of South America, Presented to the University of Rochester by Hiram Sibley, Esq.* Rochester, N.Y.

———. 1866. *Catalogue of Casts of Fossils, from the Principal Museums of Europe and Amer-ica.* Rochester, N.Y.: Benton and Andrews.

Warren, John. 1852. *Description of a skeleton of the* Mastodon giganteus *of North America.* Boston: J. Wilson.

———. 1854. *Remarks on Some Fossil Impressions in the Sandstone Rocks of Connecticut River.* Boston: Ticknor and Fields.

Webb, Wiliam. 1872. *Buffalo Land.* Chicago: Hannaford.

Weyer, Johann. 1660. *Johannes Wieri, opera omnia.* Amsterdam: Petrum van den Berge.

White, C. A. 1877. *United States Geographical Surveys West of the One Hundredth Meridian (Wheeler Survey), vol. 4, Paleontology, part 1, The Invertebrate Fossils Collected in Por-tions of Nevada, Utah Colorado, New Mexico, and Arizona, by Parties of the Expeditions of 1871, 1872, 1873, and 1874.* Washington, D.C.: U.S. Government Printing Office.

Williston, Samuel W. 1902. "Restoration of *Dolichorhynchops osborni,* a New Cretaceous Plesiosaur." Kansas *University Science Bulletin* 1:241–244.

———. 1903a. *North American Plesiosaurs.* Publications of the Field Columbian Museum 73; Geological Series 2, no. 1. Chicago: Field Columbian Museum.

———. 1903b. *On the Osteology of* Nyctosaurus (Nyctodactylus), *with Notes on American Pterosaurs.* Publications of the Field Columbian Museum 78; Geological Series 2, no. 3. Chicago: Field Columbian Museum.

———. 1906. "North American Plesiosaurs: *Elasmosaurus, Cimoliasaurus,* and *Polycotylus.*" *American Journal of Science,* 4th series, 4:221–234.

———. 1907. "The Skull of *Brachauchenius,* with Special Observations on the Relationships of the Plesiosaurs." *United States National Museum Proceedings* 32:477–489.

———. 1914. *Water Reptiles of the Past and Present.* Chicago: University of Chicago Press.

Williston, Samuel W., et al. 1898. *The University Geological Survey of Kansas, vol. 4, Paleon-tology, Part 1.* Lawrence, Kans.: Kansas Geological Survey.

———. 1900. *The University Geological Survey of Kansas, vol. 6, Paleontology, Part 2.* To-peka, Kans.: W. Y. Morgan State Printers.

Witham, Henry T. M. 1831. *Observations of Fossil Vegetables Accompanied by Representations of Their Internal Structure as Seen through the Microscope.* London: Cadell; Edinburgh: Blackwood.

Woodward, Henry. 1883. *A Monograph of the British Carboniferous Trilobites, Part 1.* London: Palaeontographical Society.

———. 1884. *A Monograph of the British Carboniferous Trilobites, Part 2.* London: Palaeon-tographical Society.

———. 1897. *A Guide to the Fossil Invertebrates and Plants in the Department of Geology and Paleontology of the British Museum (Natural History)*. London: British Museum.

Zittel, Karl Alfred von. 1880–1893. *Handbuch der Palaeontologie*. Munchen and Leipzig: Oldenburg.

Secondary Sources

Accordi, Bruno. 1978. "Contributions to the History of Geological Sciences: Agostino Scilla, Painter from Messina (1629–1700), and His Experimental Studies on the True Nature of Fossils." *Geologica Roma* 17:129–144.

Ainsworth, Maryan W., ed. 1995. *Petrus Christus in Renaissance Bruges: An Interdisciplinary Approach*. New York: Metropolitan Museum of Art; Turnhout, Belgium: Brepols Publishers.

Andrews, Roy Chapman. 1956. *All about Dinosaurs*. New York: Random House.

Andrews, Shelia Mahala. 1982. *The Discovery of Fossil Fishes in Scotland up to 1845, with Checklists of Agassiz's Figured Specimens*. Royal Scottish Museum Studies. Edinburgh: Royal Scottish Museum.

Ashworth, William B. 1996. *Paper Dinosaurs, 1824–1969: An Exhibition of Original Publications from the Collections of the Linda Hall Library*. Kansas City, Mo.: Linda Hall Library. See also the exhibition's website: http://www.lindahall.org/events_exhib/exhibit/exhibits/dino/index.html.

Arnold, Ken. 2006. *Cabinets for the Curious: Looking Back at Early English Museums*. Aldershot, England: Ashgate.

Benton, Michael J. 2003. *When Life Nearly Died: The Greatest Mass Extinction of All Time*. London: Thames and Hudson.

Berry, Mark F. 2002. *The Dinosaur Filmography*. Jefferson, N.C. and London: McFarland.

Bramwell, Valerie, and R. M. Peck. 2007. *All in the Bones: A Biography of Benjamin Waterhouse Hawkins*. Philadelphia: Academy of natural Sciences of Philadelphia.

Brochu, Christopher A., et al. 1997. *A Guide to Dinosaurs*. San Francisco: Weldon Owen.

Burns, Stanley B. 1979. "Early Medical Photography in America (1839–1883): The Daguerrean Era, Part 3." *New York State Journal of Medicine* 79 (July): 1256–1268.

———. 1983. *American Medical Publications with Photographs*. New York: Burns Archive.

Cadbury, Deborah. 2000. *Terrible Lizard: The First Dinosaur Hunters and the Birth of a New Science*. New York: Henry Holt.

Canemaker, John. 1987. *Winsor McCay: His Life and Art*. New York: Abbeville Press.

Chinsamy-Turan, Anusuya. 2005. *The Microstructure of Dinosaur Bone: Deciphering Biology with Fine-Scale Techniques*. Baltimore, Md. and London: Johns Hopkins University Press.

Colbert, Edwin H. 1992. *William Diller Matthew, Paleontologist*. New York: Columbia University Press.

Connors, Joseph. 1992. "Virtuoso Architecture in Cassiano's Rome." In *Cassiano Dal Pozzo's Paper Museum,* by Jennifer Montagu et al., 2:23–40. Quaderni Puteani 3. London: Olivetti.

Cooper, Alix. 1995. "The Museum and the Book: The *Metallotheca* and the History of an Encyclopedic Natural History in Early Modern Italy." *Journal of the History of Collections* 7:1–23.

Culhane, John. 1983. *Walt Disney's Fantasia*. New York: Harry N. Abrams.

Currie, Philip, et al. 2004. *Feathered Dragons: Studies on the Transition from Dinosaurs to Birds*. Bloomington: Indiana University Press.

Czerkas, Sylvia Massey, and Donald F. Glut. 1982. *Dinosaurs, Mammoths and Cavemen: The Art of Charles R. Knight*. New York: Dutton.

Davidson, Jane P. 1987a. "I Am the Poison-Dripping Dragon: Iguanas and Their Symbolism in the Alchemical and Occult Paintings of David Teniers the Younger." *Ambix* 34 (July): 62–80.

———. 1987b. *The Witch in Northern European Art, 1470–1750*. Freren, Germany: Luca Verlag.

———. 1997. *The Bone Sharp: The Life of Edward Drinker Cope*. Philadelphia: Academy of Natural Sciences of Philadelphia.

———. 2000. "Fish Tales: Attributing the First Illustration of a Fossil Shark's Tooth to Richard Verstegan (1605) and Nicolas Steno (1667)." *Proceedings of the Academy of Natural Sciences of Philadelphia* 150:329–344.

———. 2002. "Bonehead Mistakes: The Background in Scientific Literature and Illustration for Edward Drinker Cope's First Restoration of *Elasmosaurus platyurus*." *Proceedings of the Academy of Natural Sciences of Philadelphia* 152:215–240.

———. 2003. "Edward Drinker Cope, Professor Paleozoic and *Buffalo Land*." *Transactions of the Kansas Academy of Science* 106, nos. 3–4: 177–191.

———. 2005. "Henry A. Ward, *Catalogue of Casts of Fossils* (1866) and the Artistic Influence of Benjamin Waterhouse Hawkins on Ward." *Transactions of the Kansas Academy of Science* 108, nos. 3–4: 138–148.

Dingus, Lowell. 1996. *Next of Kin: Great Fossils At the American Museum of Natural History.* New York: Rizzoli.

Dodson, Peter. 1996. *The Horned Dinosaurs.* Princeton, N.J.: Princeton University Press.

Duffin, Christopher F. 2006. "Lapis Judaicus or the Jews' Stone: The Folklore of Fossil Echinoid Spines." *Proceedings of the Geologists' Association* 117:265–275.

Edwards, Wilfred N. 1967. *The Early History of Palaeontology.* London: British Museum (Natural History). Revision of *Guide to an Exhibition Illustrating the Early History of Palaeontology,* originally written by Edwards and published by the Museum in 1931.

Everhart, Michael J. 2005a. *Oceans of Kansas: A Natural History of the Western Interior Sea.* Bloomington: Indiana University Press.

———. 2005b. "*Tylosaurus proriger* and the Myth of the Ram-Nosed Mosasaur." Paper presented at the annual meeting of the Kansas Academy of Science, Johnson County Community College, Overland Park, Kans., March 18–19. An abstract is published in *Transactions of the Kansas Academy of Science* 108, nos. 3–4 (2005): 167.

———. 2006. "The Occurrence of Elasmosaurids (Reptilia: Plesiosauria) in the Niobrara Chalk of Western Kansas." *Paludicola* 5:170–183.

Findlen, Paula, ed. 2004. *Athanasius Kircher: The Last Man Who Knew Everything.* New York and London: Routledge.

Freedberg, David. 2002. *The Eye of the Lynx: Galileo, His Friends and the Beginnings of Modern Natural History.* Chicago and London: University of Chicago Press.

Garboe, Axel. 1958. *The Earliest Geological Treatise (1667) by Nicolaus Steno.* London: Macmillan.

Gascoigne, Bamber. 1988. *How to Identify Prints.* London: Thames and Hudson.

Gerdts, William H. 1981. *William Holbrook Beard: Animals in Fantasy.* Catalogue of an exhibition at the Alexander Gallery, New York, April 21–May 16, 1981. New York: Alexander Gallery.

Gernsheim, Helmut. 1982. *The History of Photography from the Camera Obscura to the Beginning of the Modern Era.* New York: McGraw Hill.

Glut, Donald F. 2006. *Dinosaurs: The Encyclopedia.* Supplement 4. Jefferson, N.C., and London: McFarland.

Harris, Ann Sutherland. 1977. *Andrea Sacchi: Complete Edition of Paintings with a Critical Catalogue.* Princeton, N.J.: Princeton University Press.

Hendrickson, Walter B. 1943. *David Dale Owen, Pioneer Geologist of the Middle West.* Indianapolis: Indiana Historical Bureau.

Horner, John R., and Don Lessem. 1993. *The Complete T. Rex.* New York: Simon and Schuster.

Hunnisett, Basil. 1998. *Engraved on Steel.* Aldershot, England: Ashgate.

Jahn, Melvin E., and Daniel J. Woolf. 1963. *The Lying Stones of Dr. Johann Bartholomew Adam Beringer, Being His Lithographaie Wirceburgensis.* Berkeley and Los Angeles: University of California Press.

Jensen, Paul M. 1996. *The Men Who Made the Monsters.* New York: Twayne.

Johns, Adrian. 1999. *The Nature of the Book: Print and Knowledge in the Making.* Chicago and London: University of Chicago Press.

Lambrecht, Kalman, and W. and A. Quenstedt. 1978. *Palaeontologi: Catalogus bio-bibliographicus.* New York: Arno Press.

Larson, Neal L., et al. 1997. *Ammonites and the Other Cephalopods of the Pierre Seaway.* Tempe, Ariz.: Geoscience Press.

Lockley, Martin, and Adrian P. Hunt. 1995. *Dinosaur Tracks and Other Fossil Footprints of the Western United States.* New York: Columbia University Press.

MacFadden, Bruce J. 1992. *Fossil Horses.* New York: Cambridge University Press.

Maier, Gerhard. 2003. *African Dinosaurs Unearthed: The Tendaguru Expeditions.* Bloomington: Indiana University Press.

McBrien, Richard P. 1997. *Lives of the Popes from St. Peter to John Paul II*. San Francisco: Harper.

McCarthy, Steve, and Mick Gilbert. 1994. *The Crystal Palace Dinosaurs: The Story of the World's First Prehistoric Sculptures*. London: The Crystal Palace Foundation.

McCartney, Paul J. 1977. *Henry De la Beche: Observations on an Observer*. Cardiff, Wales: Friends of the National Museum of Wales.

Merrill, George P. 1924. *The First One Hundred Years of American Geology*. New Haven, Conn.: Yale University Press.

Meyer, Herbert W. 2003. *The Fossils of Florissant*. Washington, D.C., and London: Smithsonian Books.

Morgan, Vincent L., and Spencer G. Lucas. 2002. "Walter Granger, 1872–1941, Paleontologist." *New Mexico Museum of Natural History and Science Bulletin* 19.

Osborn, Henry F. 1931. *Cope: Master Naturalist*. Princeton, N.J.: Princeton University Press.

Popham, A. E. 1945. *The Drawings of Leonardo da Vinci*. New York: Reynal and Hitchcock.

Preston, Douglas J. 1986. *Dinosaurs in the Attic: An Excursion into the American Museum of Natural History*. New York: St. Martin's Press.

Psihoyos, Louie. 1994. *Hunting Dinosaurs*. With John Knoebber. New York: Random House.

Repcheck, Jack. 2003. *The Man Who Found Time: James Hutton and the Discovery of the Earth's Antiquity*. Cambridge, Mass.: Perseus Publishing.

Rombauts, Edward. 1933. *Richard Verstegen, een polemist der contra-reformatie*. Brussels: Algemeene drukinrichting.

Rossi, Paolo. 1984. *The Dark Abyss of Time*. Trans. Lydia G. Cochrane. Chicago: University of Chicago Press. Originally published in 1979 as *I segni del tempo: Storia della terra e storia delle nazioni da Hooke a Vico* (Milan: Feltrinelli).

Rudwick, Martin J. S. 1976. *The Meaning of Fossils*. 2nd ed. New York: Science History Publications.

———. 1992. *Scenes from Deep Time*. Chicago: University of Chicago Press.

———. 2004. *The New Science of Geology: Studies in the Earth Sciences in the Age of Revolution*. Aldershot, Hampshire, England: Ashgate.

———. 2005. *Bursting the Limits of Time: The Reconstruction of Geohistory in the Age of Revolution*. Chicago: University of Chicago Press.

Schuchert, Charles. 1940. *O. C. Marsh: Pioneer in Paleontology*. With Clara Mae LeVene. New Haven, Conn.: Yale University Press.

Scot, Andrew C., and David Freedberg. 2000. The Paper Museum of Cassiano Dal Pozzo, series B. part 3, *Fossil Woods and Other Geological Specimens*. Turnhout, Belgium: Harvey Miller Publishers.

———. 2004. *The New Science of Geology: Studies in the Earth Sciences in the Age of Revolution*. Variorum Collected Studies Series. Burlington, Vt., and Aldershot, Great Britain: Ashgate Publishing Ltd.

Semonin, Paul. 2000. *American Monster*. New York and London: New York University Press.

Shea, John. 1991. *Witches, Devils and Doctors in the Renaissance: Johann Weyer, "De praestigiis daemonum."* Binghamton, N.Y.: Medieval and Renaissance Texts and Studies.

Shubin, Neil H., Edward B. Daeschler, and Farish A. Jenkins, Jr. 2006. "The Pectoral Fin of *Tiktaalik roseae* and the Origin of the Tetrapod Limb." *Nature* 440, no. 6 (April): 764–771.

Sloan, Kim, and Andrew Burnett. 2003. *Enlightenment: Discovering the World in the Eighteenth Century*. Washington, D.C.: Smithsonian Books.

Spamer, Earle E. 2004. "The Great Extinct Lizard: *Hadrosaurus foulkii*, 'First Dinosaur' of Film and Stage." *The Mosasaur* 7:109–125.

Stone, W. 1934. "Grayson's Micro-rulings." *Journal of Scientific Instruments* 11 (January): 1–6.

Tanke, Darren H., and Kenneth Carpenter, eds. 2001. *Mesozoic Vertebrate Life: New Research Inspired by the Paleontology of Philip J. Currie*. Bloomington: Indiana University Press.

Torrens, H. 1995. "Mary Anning (1799–1847) of Lyme." *British Journal for the History of Science* 25:257–284.

Trcic, Michael. *Michael Trcic Studio*. http://www.trcicstudio.com.

Tucker, Jennifer. 2005. *Nature Exposed: Photography as Eyewitness in Victorian Science*. Baltimore, Md.: Johns Hopkins University Press.

Unwin, David M. 2006. *The Pterosaurs from Deep Time*. New York: PI Press.

Upton, John M. 1990. *Petrus Christus: His Place in Fifteenth-Century Flemish Painting.* University Park: Pennsylvania State University Press.

Van Coppenalle, Maurits. 1944. *Sint Elooi in het volksleven.* Antwerp: Boekuil en Karveel.

Warren, Leonard. 1998. *Joseph Leidy: The Last Man Who Knew Everything.* New Haven, Conn.: Yale University Press.

Webber, Roy P. 2004. *The Dinosaur Films of Ray Harryhausen.* Jefferson, N.C. and London: McFarland.

Weishampel, David B., Peter Dodson, and Halszka Osmólska, eds. 2004. *The Dinosauria.* 2nd ed. Berkeley: University of California Press.

Weishampel, David B., and Nadine M. White, eds. 2003. *The Dinosaur Papers, 1676–1906.* Washington, D.C., and London: Smithsonian Books.

Wilson, Leonard G. 1972. *Charles Lyell, the Years to 1841: The Revolution in Geology.* New Haven, Conn., and London: Yale Univ. Press.

Zittel, Karl Alfred von. 1901. *Geschichte der Geologie und Palaeontologie bis Erde des 19 Jahrhunderts.* London: W. Scot.

———. 1908. *History of Geology and Paleontology to the End of the Nineteenth Century.* Trans. M. M. Ogilvie-Gordon. London and New York: Charles Scribner's Sons. English-language edition of the 1901 text.

INDEX

Page numbers in italics refer to
illustrations.

ABOUT THE AUTHOR

Jane P. Davidson is Professor of Art History at the University of Nevada, Reno, where she teaches courses in the history of art and the history of science. She is the author of *The Bone Sharp: The Life of Edward Drinker Cope* and numerous other books and articles on seventeenth-century Flemish painting, the history of witchcraft, and the history of paleontology.